READY

THE
RANGERS
SHIRT

VSP

Published by Vision Sports Publishing in 2021

Vision Sports Publishing Ltd
19-23 High Street
Kingston upon Thames
Surrey
KT1 1LL

www.visionsp.co.uk

ISBN: 978-1913-412-26-5

Editor: Jim Drewett
Copy editing and production: Ed Davis
Proof-reading: Graham Hughes
Design: Doug Cheeseman and Neal Cobourne
Print production: Ulrika Drewett
Marketing: Toby Trotman
Club liaison: Robert Boyle and Natalie Nairn

Shirt photography: Nedka Nikolova, www.axiompic.co.uk

DEDICATION

Both authors would like to dedicate this book
to the following special people:

David – *To Kirsteen and Erin*
John – *To Christine, Craig, Murray and the grandkids*

The Rangers Football Club
Ibrox Stadium
150 Edmiston Drive
Glasgow
G51 2XD

www.rangers.co.uk

A CIP record for this book is available from the British Library.

Printed and bound in Slovakia by Neografia.

THE RANGERS SHIRT

THE OFFICIAL HISTORY

By David Graham & John Smith

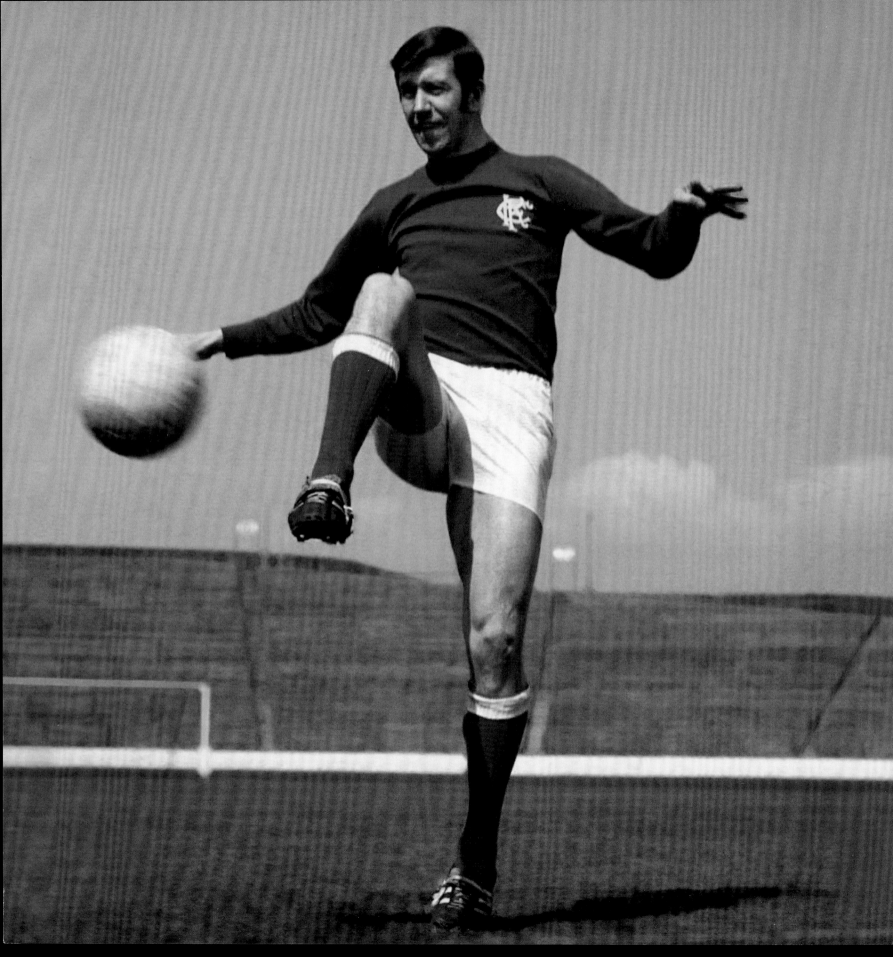

CONTENTS

FOREWORD 6

INTRODUCTION 8

CHAPTER 1 | FOUR LADS HAD A DREAM 1872–1945 12

THE CHANGE SHIRT: THE FIRST 100 YEARS 24

CHAPTER 2 | SCOTLAND'S GALLANT FEW 1945–1978 36

THE KIT ROOM 68

CHAPTER 3 | THE BLUE SEA OF IBROX 1978–1990 78

BETWEEN THE STICKS: GOALKEEPER SHIRTS 104

CHAPTER 4 | BETTER THAN ALL THE REST 1990–2002 128

A MARK OF HONOUR: TESTIMONIAL SHIRTS 184

CHAPTER 5 | KINGS OF SCOTLAND 2002–2013 192

LEST WE FORGET: POPPY SHIRTS 256

CHAPTER 6 | EVERYWHERE, ANYWHERE 2013–2020 262

A RARE BREED: ONE-OFF SHIRTS 294

CHAPTER 7 | EVERY SATURDAY WE FOLLOW 2020– 300

SUPPORTERS LIST 316

ACKNOWLEDGEMENTS 320

FOREWORD

JIMMY BELL, RANGERS KIT MANAGER

I feel very privileged and proud to be asked to write a foreword for *The Rangers Shirt* book and to be able to contribute in some small way to its success.

I have been very fortunate to have been Rangers' kitman for more than 35 years and have worked with some of the club's greatest players and managers during that period – something I'm immensely thankful for.

I am first and foremost a fan of the club; I celebrate the triumphs just as much as any Rangers supporter and feel the pain of defeats just as hard, although thankfully these are more rare.

My main day-to-day role is to ensure the players' needs are met in relation to kit supply, not only on matchdays but also for training during the week. Remembering all the different sizes and players' preferences can be problematic – you need to learn a system very quickly as failure could leave you at the mercy of the players, and trust me they are certainly quick to let me know if I get it wrong...

Looking through the pages of the book it is hard to believe how many different styles of shirts have been worn during the period I have been associated with Rangers. Some I remember more fondly than others but they all bring back memories from their time in use, with possibly my personal favourite being the adidas home shirt from the 1992-94 period.

The laundry staff who work alongside me are the backbone of the kit operation. I have been very fortunate to work with an excellent team through the years – they might not always enjoy some of the tasks requested by me on a tight turnaround but do so with good grace!

During my time as Rangers' kitman I have been fortunate to visit many countries, both on pre-season tours as well as European competitions, and reaching the 2008 UEFA Cup Final in Manchester will always remain a career highlight, despite the result not going our way. We had so many games to play in a short period prior to the final, which made winning the trophy difficult, but being part of the team effort will live long in my memory.

I hope that this book will rekindle many memories from our first 150 years and I trust that you will enjoy the stories and photographs of the shirts featured within.

Jimmy Bell, October 2021

INTRODUCTION

Dreamt up by four young friends as they wandered through Glasgow's West End Park, Rangers Football Club has grown into one of the most famous clubs in football, with an iconic royal blue home shirt that is known wherever the game is played.

The name Glasgow Rangers is one known and respected throughout the sporting world. Immensely proud of its traditions and heritage, Rangers is a footballing institution that has grown from a local boys football club playing on the open public spaces of Glasgow Green in 1872 to a global giant playing at a 50,000 all-seater stadium and with a worldwide fanbase who follow the club from both near and far with utmost fervour. It is a club imbued with professional values and standards, many of which were set in place by the early pioneering managers of the club – William Wilton and his successor, William Struth.

Synonymous with the name of Rangers is the royal blue shirt used since the inception of the club. It is a shirt worn with pride – not just by the players fortunate enough to play for the club but also by the club's loyal and passionate supporters.

Take a walk around Ibrox on any given matchday and you will see thousands of likeminded Rangers fans wearing their favourite Rangers shirt – whether current or retro. All around the world, Rangers supporters have their own favourite shirt from whichever period in the club's history means the most to them. It is a deeply personal choice and a completely subjective one, but what binds everyone together is the love for the Rangers shirt itself and what it represents.

This book has been lovingly and painstakingly put together as a unique record of the shirts worn by the world's most successful football club during its first 150 years of existence. Using actual match shirts throughout wherever possible, the following pages will showcase the story of the famous Rangers shirt, from those early days on Glasgow Green through to the present day side giving their all at the magnificent arena that is Ibrox.

Tradition is of vital important to Rangers, and accordingly the early periods of the club's history saw little need to alter the kit (bar improvements to the material the shirt was manufactured from or minor detail changes such as the addition of a collar), so much so that for the first 80-plus years of the club's existence the home shirt only truly changed style three times. However, the last 50 years has seen the introduction of corporate sponsorship deals and the booming replica shirt market, which has led to increased competition between shirt

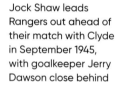

Jock Shaw leads Rangers out ahead of their match with Clyde in September 1945, with goalkeeper Jerry Dawson close behind

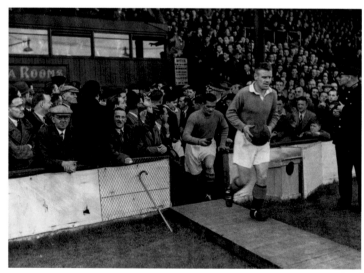

Jim Baxter poses for the cameras in the much-loved 1956-68 home shirt

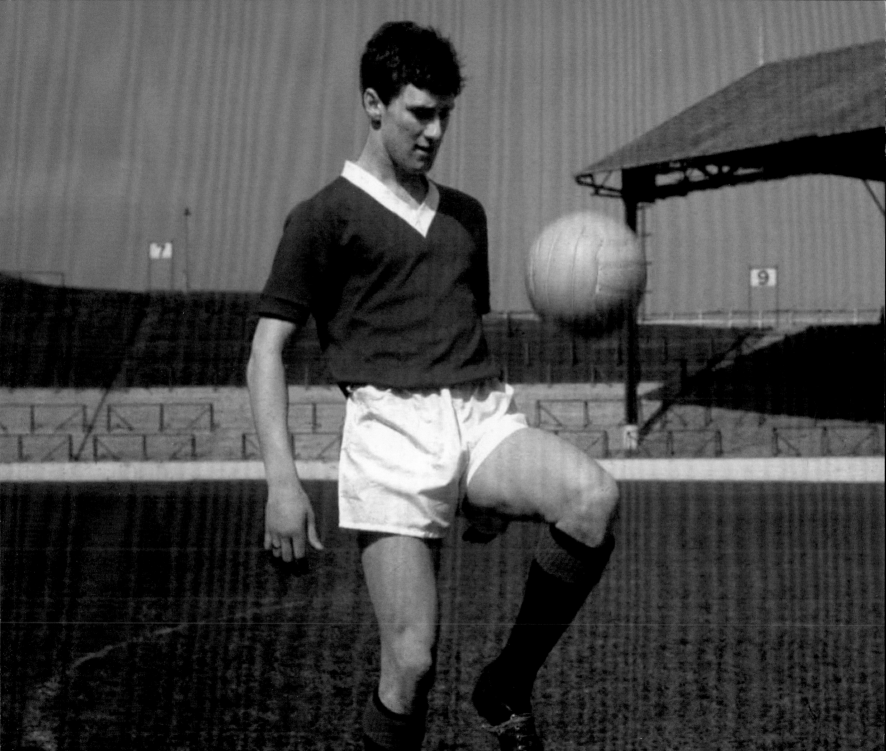

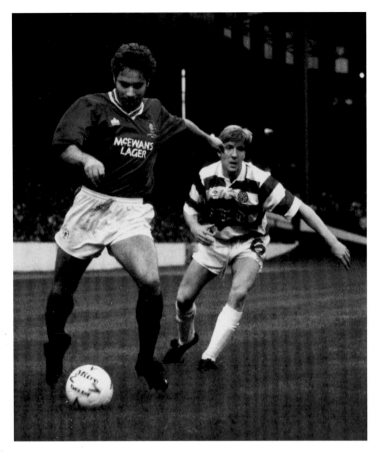

Ally McCoist, wearing the popular 1990-92 home shirt, leaves Celtic's Anton Rogan trailing in his wake

manufacturers, who jostle to be affiliated to the most successful football clubs. Rangers – with a huge worldwide fanbase and a remarkable history of on-field success – is a prime example of such a club.

The last 50 years have seen the club wear approximately 30 different styles of home shirt from seven different shirt manufacturers. Every one of these shirt styles will feature within the book, along with special one-off variants produced during this period.

As important to the book as the home shirt is, however, the club's change shirts also feature heavily in the coming chapters. Since the inception of team sports, colour clashes have occurred and this book will hopefully go a long way to dispel some of the myths and inaccuracies regarding the change shirts used by the club over the years. Remarkably, only three different colours, in

white, blue and red, were used on Rangers' change shirts during the club's first 121 years, with red making its first appearance as late as 1950. While those three colours remain strongly favoured by the various shirt designers to have worked with Rangers, 1993 onwards has seen the addition of further colours – such as purple, orange or black – to the club's catalogue.

The backbone of any team, the goalkeeper, is also covered in detail, demonstrating how fashions and styles have evolved when it comes to this unique position – from the early days of sporting the same shirt as their outfield colleagues through to the garish oversized shirts of the 1990s to today's streamlined shirts.

Unfortunately, despite extensive searching, examples of certain shirt styles could not be sourced. Rangers, like many other football clubs, would very often wear shirts to destruction, with jerseys being re-used by the reserve side before later being worn as training apparel. Even as recently as the early 1980s, Rangers would train in shirts used by the first team some 20 years previously. Players were just not allowed to keep shirts – and swapping them with opponents wasn't even a consideration until more recent times. Only when commemorative details were first applied in the early 1970s were players offered the chance to keep their own. Perhaps examples of some of the shirts that

Rangers proudly wear their poppy shirts ahead of the match with Ross County on 6th November 2016

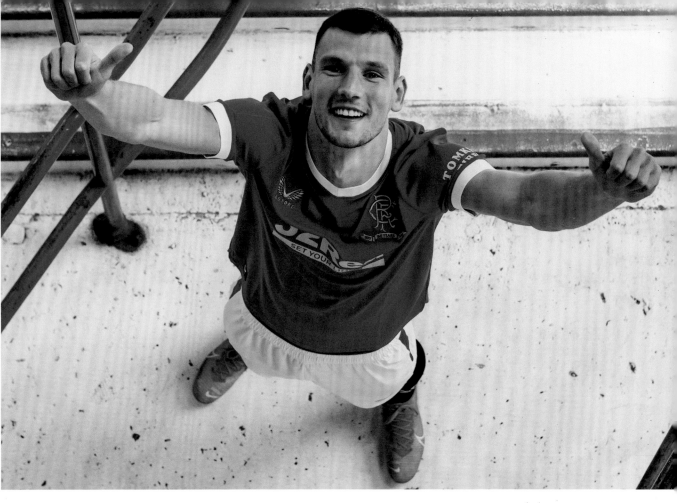

could not be included here will emerge in time for future editions of this book.

All of the shirts displayed in the pages of this book have been worn or at the very least prepared for a Rangers player to wear. They hold history within them, often providing a fascinating snapshot of a moment in time. From the 'Wee Blue Devil' Alan Morton's change shirt of the early 1920s, through to the current squad's expertly engineered 150th anniversary shirts from Castore, this book tells the story of the Rangers shirt during its first 150 years of glory. Featured within is a host of iconic shirts worn by emerging youngsters and club legends alike, shirts that were worn during dramatic league and cup victories – including the famous European Cup Winners' Cup Final triumph over Moscow Dynamo in 1972 – as well as heartbreaking defeats and backs-to-the-wall heroics. Together they trace the evolution of one of the world's greatest football clubs and bring its remarkable history vividly to life.

"To be a Ranger is to sense the sacred trust of upholding all that such a name means in this shrine of football. They must be true in their conception of what the Ibrox tradition seeks from them. No true Ranger has ever failed in the tradition set him.

"Our very success, gained you will agree by skill, will draw more people than ever to see it. And that will benefit many more clubs than Rangers. Let the others come after us. We welcome the chase. It is healthy for us. We will never hide from it.

"Never fear, inevitably we shall have our years of failure, and when they arrive, we must reveal tolerance and sanity. No matter the days of anxiety that come our way, we shall emerge stronger because of the trials to be overcome. That has been the philosophy of the Rangers since the days of the gallant pioneers."

William Struth, 1875-1956

Borna Barišić gives the camera a double thumbs up during the launch of the club's 2021/22 150th anniversary shirt

CHAPTER ONE
EARLY YEARS

1872–1945

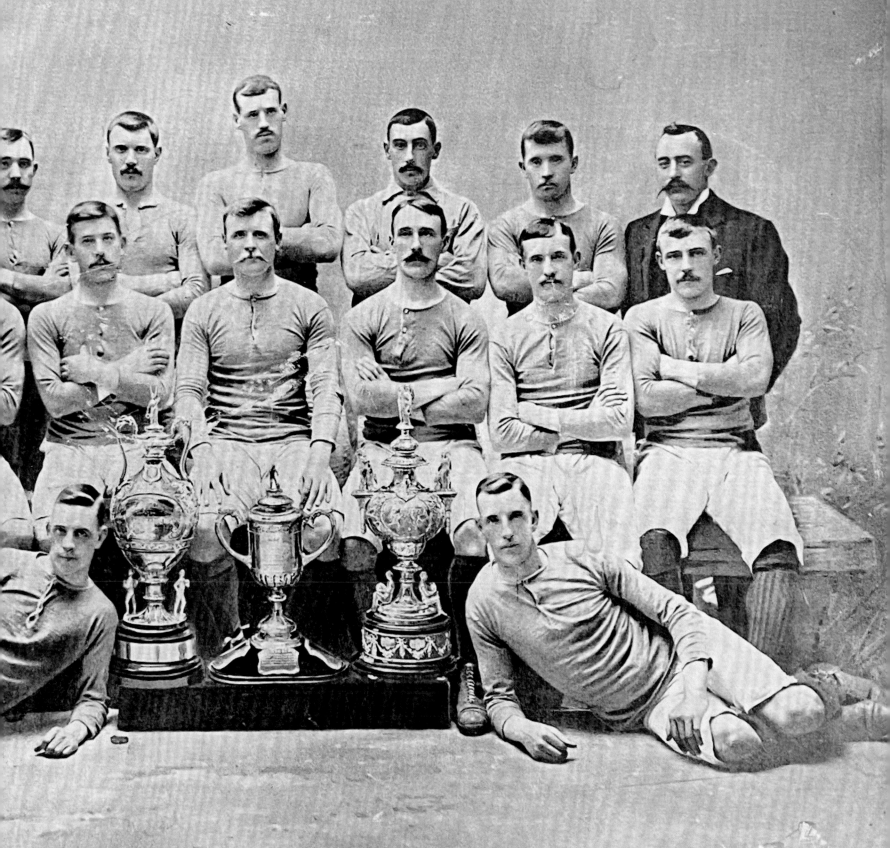

FOUR LADS HAD A DREAM

Rangers Football Club grew from the dreams and aspirations of four teenage friends into a sporting powerhouse that would touch the lives of millions, in the process creating countless traditions that can be traced back to the club's earliest days – not least the famous blue home shirt.

Just as the words of the famous song that resounds around the Ibrox stands explain – "Four lads had a dream, To start a football team, They had no money, no kit, not even a ball..." – when the team that would go on to be the most successful club side in world football was formed in the spring of 1872 they didn't have a ball to play with, let alone a set of kit. Fast-forward 150 years and the blue of Rangers is one of the most famous football shirts in the world.

As they discussed the idea of starting a football team while walking through West End Park in Glasgow, little did the four young friends – William McBeath (15), Peter Campbell (15) and brothers Moses (16) and Peter McNeil (17) – realise the impact that their club would go on to have in the lives of so many others.

Many details of those fledgling days have been lost to the mists of time, but it was Moses who decided that the club would be called Rangers, named after an English rugby club with the same name he had spotted in Charles William Alcock's *Football Annual* book.

In an article for the *Scottish Football Association Annual* of 1880/81, an early member called William Dunlop, under the pen name of 'True Blue', wrote about the club's first match in May 1872. The game was against another recently put together side, Callander Football Club, and took place at Flesher's Haugh area of Glasgow Green with Rangers having to enlist four experienced footballers to help make up the numbers for a full team, including Harry McNeil – the brother of Moses and Peter – who was a regular at Queen's Park, at the time the most successful club in Scotland.

While the four experienced players are believed to have worn their club colours for the goalless draw, the seven inexperienced Rangers played in an assortment of ordinary clothes, discarding as much as they could to keep cool. Following that first match, the club held a meeting, whereupon it was decided that they required a 'uniform' of their own and it was agreed that, from that day onwards, the club would play its matches in royal blue shirts, white knickerbockers and blue/white hooped socks.

The club arranged a second match sometime in the summer of 1872 against a side named Clyde (no relation to the later club of the same name) and recorded their first victory with an 11-0 win while wearing the new royal blue shirts for the first time.

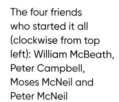

The four friends who started it all (clockwise from top left): William McBeath, Peter Campbell, Moses McNeil and Peter McNeil

Right: The 1874/75 members' book listing the officials, constitution and rules of the nascent Rangers Football Club

THE RANGERS' FOOTBALL CLUB.

1874-75.

Patron.
THE MOST NOBLE THE MARQUIS OF LORNE.

President.
MR. W. D. M'BEATH.

Captain.
MR. PETER M'NEIL.

Vice-Captain.
MR. P. CAMPBELL.

Second-Eleven Captain.
MR. W. J. RALSTON.

Hon. Treasurer.
MR. HENRY ANDERSON.

Hon. Secretary
MR. W. J. RALSTON (pro tem.),
109 KENT ROAD.

Committee.

MR. MOSES M'NEIL.	MR. JAMES WATSON.
MR. JOHN YUIL.	MR. THOS. VALLANCE.
MR. JOHN RYBURN.	

MEMBERS CHANGING EITHER HOUSE OR BUSINESS ADDRESS
WILL PLEASE INTIMATE CHANGE TO SECRETARY.

CONSTITUTION AND RULES.

I.—That this Club be called the "RANGERS' FOOTBALL CLUB."

II.—That the Committee consist of the President, Captain, Vice-Captain, Second-Eleven Captain, Treasurer, Secretary, and Five other Members—Five a quorum. The Committee shall retire annually, but shall be eligible for re-election.

III.—That the Yearly General Meeting be held in the last week in April, when the Treasurer and Secretary shall read Annual Reports, and the Committee be elected, by ballot, after nomination; and that a General Meeting be held in November.

IV.—That the Secretary be authorised to call a Meeting of Committee at any time.

V.—That a Meeting of Committee be held on the last Wednesday of every month.

VI.—That applicants for Membership, duly proposed and seconded, shall be admitted, provided a majority of the Committee agree.

VII.—That the Subscription be Five Shillings per annum, payable in April. The Committee may erase from the roll the names of Members whose Subscriptions are unpaid on the 31st August, the same having been applied for by the Treasurer. Members leaving the Club shall give notice in writing to the Secretary at or before the Yearly General Meeting, at which meeting the roll shall be read, and all on the list held liable for their Subscriptions.

VIII.—That any Member joining, or playing matches for, any other Club, shall be immediately expelled on the fact becoming known.

IX.—That the Committee shall have power to make, alter, or annul Bye-Laws.

X.—That in the event of any of the Offices of the Club becoming vacant during the year, the Committee shall have full power to fill up the same till the next Annual Meeting.

XI.—That the Captain and Secretary have the power of taking on, or refusing matches.

XII.—That no alteration be made on these Rules, except at the Yearly General Meeting, and unless supported by two-thirds of the Members present. Notice of proposed alterations must be given to the Secretary on or before the 15th March.

BYE-LAWS.

I.—That *any dispute* arising on the field shall be decided by the Captain, or in his absence, by the Vice-Captain, or in the absence of both, by the Captains of Sides, when there are no Umpires. But should any Member consider himself aggrieved by such decision, appeal in writing can be made to the Secretary, to be laid before the first Meeting of Committee, whose decision shall be final.

II.—That those choosing the sides at practice shall be Captain of their respective sides, which shall not exceed eleven in number.

III.—That the Club Uniform be White Knickerbockers and Royal Blue Jersey.

IV.—That each Member is expected to be in possession of the Club Uniform; and that no Member can take part in a match unless in Uniform.

V.—That any Member infringing upon the Laws of the Game and persisting in such violation, will be subject to expulsion from the Club by the Committee.

LAWS OF THE GAME.

I.—The maximum *length of ground* shall be 200 yards; the maximum *breadth* shall be 100 yards; the length and breadth shall be marked off with flags, and the goals shall be upright posts, 8 yards apart, with a tape across them, 8 feet from the ground.

II.—The winners of the toss shall have the option of kick-off or choice of goals. The game shall be commenced by a place-kick from the centre of the ground; the other side shall not approach within ten yards of the ball until it is kicked off, nor shall any player on either side pass the centre of the ground in the direction of his opponent's goal until the ball is kicked off.

III.—After the ball is kicked off, ends shall not be changed until half time. After the change of ends at half time, the same side as originally kicked off shall kick off as provided in the second part of Rule II.

IV.—A goal shall be won when the ball passes between the goal posts under the tape, not being thrown, knocked on, or carried. The ball hitting one or other of the goal or boundary posts, and rebounding into play, is considered in play.

V.—When the ball is in touch, a player of the opposite side to that which kicked it out shall throw it from the point on the boundary line where it left the ground, in a direction at right angles with the boundary lines, at least six yards, and it shall not be in play until it has touched the ground, and the player throwing it in shall not play it until it has been played by another player.

VI.—When a player kicks the ball, any one of the same side who, at such moment of kicking, is nearer to the opponents' goal-line, is out of play, and may not touch the ball himself, nor in any way whatever prevent any other player from doing so,

In these early days of the game, there were no football kits as such, with teams playing in everyday dress shirts purchased from regular gentlemen's outfitters. Players would usually purchase their own kit, meaning that the team would play in a variety of thrown-together styles and combinations of knickerbockers and socks.

But with football clubs springing up here, there and everywhere, it wasn't long before the outfitting shops realised that there was a growing market for football-specific shirts. One of these was Glasgow-based firm RW Forsyth, who from their premises at 5 and 7 Renfield Street were the first known supplier of match shirts to Rangers. The name of the club appeared on the company's list of teams supplied in September 1877.

RW Forsyth had set up in Glasgow city centre in September 1873 as 'hosier, glover and shirtmaker' and by the following month were supplying at least 15 Scottish football clubs with shirts, including Callander FC, Rangers' first-ever opponents. Within five years, Forsyth's had gained the monopoly in the sports outfitting business, supplying 300 football clubs throughout Scotland.

However, on 9th June 1877 competition arrived when Rangers founder Peter McNeil and his brother Harry opened their own outfitting business at 91 Union Street, Glasgow, offering items such as umbrellas, travelling bags and hosiery, as well as football uniforms. By 1879 H&P McNeil had moved to new premises at 21 and 23 Renfield Street, just along the street from Forsyth's, and by the early 1880s they were proudly declaring themselves as "outfitters to all the principal clubs in Scotland", with Rangers foremost amongst them, as well as supplying the Scottish, Welsh, Sheffield and Ayrshire football associations.

As one of the founding fathers of the club, it was only natural that Rangers would utilise the services of Peter McNeil's (and his brother Harry's) outfitting company. The club continued to play in their now traditional royal blue shirts, except in the 1882/83 season. The season before had seen the club suffer many poor results and club secretary Angus Campbell suggested that maybe a change of shirt colours would help get the team playing well again. The decision was therefore taken to switch to blue-and-white-striped shirts, with the stripes running horizontally.

The *Scottish Athletic Journal* welcomed the decision with open arms, commenting on 1st September 1882: "The Rangers have decided to change their colours from a shabby blue jersey, to one with white and blue stripes, the former to be half an inch and the latter an inch. I am exceedingly pleased to hear of this change, for on several occasions last year, I thought the Rangers looked for all the world like a parcel of fleshers [butchers]."

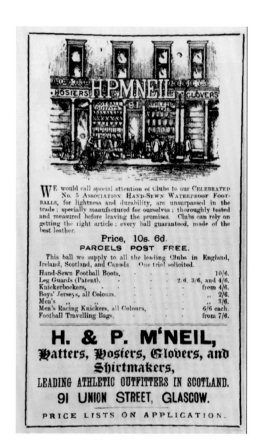

An advert for H&P McNeil, who describe themselves as the "leading athletic outfitters in Scotland"

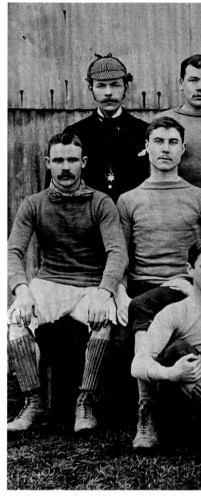

Above: The 1885/86 Rangers team, pictured at Kinning Park

Right: The four teams assemble for a photo as Rangers say farewell to Kinning Park – their first home – in February 1887 with a pair of exhibition matches

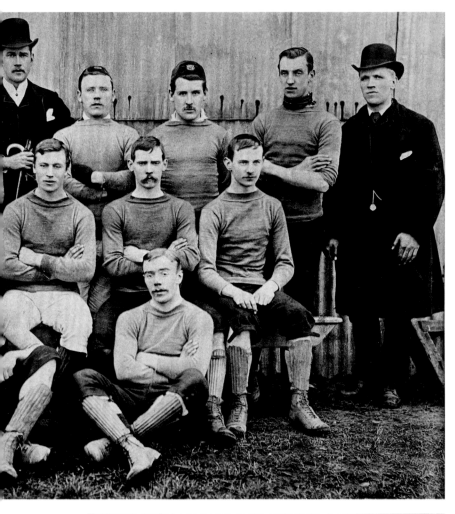

With the days of professionalism still some years away, the players had to pay for their own kit, and the club took the decision to purchase three sets of shirts – for the first, second and third XIs – but to offer them to the players for half the retail price.

The new shirts, however, were not ready for the start of the season and the team won just one of its first six matches wearing the old kit. Further frustration followed when the new shirts finally made their debut on 14th October 1882, with the new style clashing horribly with the black-and-white-striped shirts of Queen's Park.

One periodical summed up the confusion, commenting: "Which were the Rangers and which were the Queen's Park on Saturday last? The Rangers appeared for the first time arrayed in their new jerseys, which are a colourful imitation of those worn by the Queen's Park; and when there were so many men in both teams unknown to fame, the spectators got pretty well mystified before it was all over."

Clearly changing the shirt was not the answer to the team's disappointing performances. The new style had not been well received by the players or supporters, and at a club committee meeting in the Athole Arms in Glasgow on 11th June 1883 – after an appeal from ex-player Sam Ricketts, supported by the club's inside-forward of that season, James Gossland – it was agreed that the club would return to its traditional colours of royal blue. The home shirt colours have remained the same ever since.

There is obviously no photographic evidence showing the team's colours from these initial years. However, one of the earliest surviving photographs of a Rangers home shirt shows the team of 1885/86, most likely at their first real home of Kinning Park, and the shirts that the players are wearing in this picture would not have changed much from the early days of the club.

Another photograph was taken on 26th February 1887, on the occasion of the closing of Kinning Park. As Rangers prepared to move to the first Ibrox Park, they said goodbye to their home of the last 11 years with two exhibition matches. The first featured the first team against a team of ex-players (dubbed The Moderns versus The Ancients). This was followed by a match between Rangers Swifts and Shields XI, who were in effect the second and third XIs of the club. The commemorative photograph, taken before the matches got underway by photographer George Bell, features all four teams kitted out and ready to go. The image shows the teams wearing a variety of home shirts, with the players wearing a mixture of the old-style version as seen in the 1885/86 photo and newer shirts featuring a buttoned grandad-style collar.

With the closing of Kinning Park, Rangers announced that they would begin the 1887/88 season at their new Ibrox Park home wearing a new kit. Samples were obtained from Harry and Peter McNeil's outfitting shop

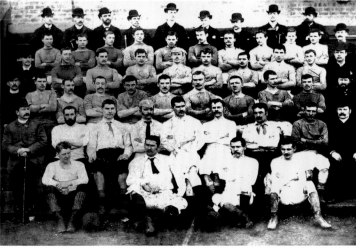

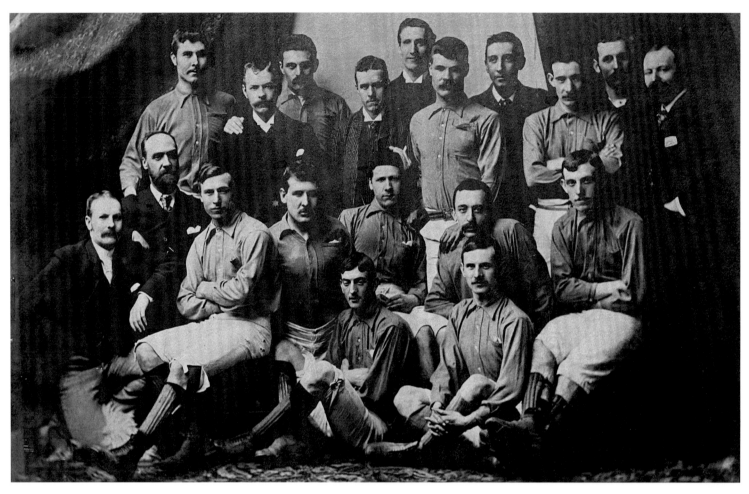

Above: A team photograph thought to date from 1888, with the Rangers players wearing dress-style shirts from H&P McNeil. Club founder Peter McNeil is on the far left

Right: The 1896/97 Rangers team, holders of the Scottish, Glasgow and Charity cups

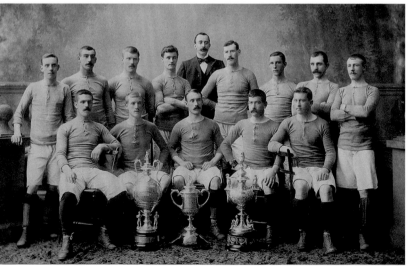

Top: Fred Lumley's Athletic Store, which took over supplying Rangers following the demise of H&P McNeil

Above: The 1908/09 Rangers team – the socks worn here would have been red and black

less than two weeks before the first match and it was agreed to go with a new style of shirt for the club, described as "royal blue, self-coloured flannel with side pocket and collar". In an arrangement that is a million miles from today's multi-million-pound kit deals, Rangers ordered 12 shirts for the season, with one being kept as a spare.

The new shirts were considered long overdue, as this quote from the *Umpire* periodical confirms: "The Rangers will open their new season with a new uniform. Glad to hear it, for the present togs are... well, not very respectable."

When the new shirts made their first appearance on 20th August 1887 against Preston North End, during the celebrated opening of the new Ibrox Park, the same journal described the new shirts as looking "smart and clean, a point too often neglected by teams". The white knickerbockers were secured by means of a belt, giving a whole new look compared with the previous style of shirts worn by the club.

Photographs of Rangers sides of this period can often give the impression that the shirt is lighter in shade than the actual royal blue which was worn, but this is believed to be due to the limitations of early photographic film and paper quality than the actual shirt colour. Even as late as the 1970s, photographs of the same shirts appear in different shades depending on which publication they feature in. This has also led to some confusion as to the origins of the club's early nickname of 'The Light Blues', which actually originated around the time of the Scottish Cup Final of 1877 when Rangers faced Vale of Leven. With both teams playing in blue, Vale's darker shirts saw them referred to as 'The Dark Blues', with Rangers picking up the nickname of 'The Light Blues'. It was a title that stuck and one that the press would refer to for many years to come when reporting on the club.

In the early 1890s Rangers made a return to shirts with the old-style grandad collars, with the goalkeeper distinguished from his team-mates only by continuing to wear the collared version. Over the years the outfield players' collarless shirts were seen either with three buttons to the front or occasionally with a lace-up opening at the neck, but apart from this difference the home shirt remained pretty much unchanged for the next 30 years.

At the end of February 1896, H&P McNeil stopped advertising in the sporting press and it is believed that it went out of business soon after. Peter had taken on full ownership of the shop in early 1895 and it proved to be too much as his fortunes and ultimately his mental health deteriorated. By now, many other sports outfitters had sprung up throughout the city and it was time for a new company to step in.

Fred Lumley was a remarkable all-round athlete who enjoyed notable success at rugby, athletics, cricket and boxing. He set up in business as a sporting outfitter in Edinburgh in 1892 before later

expanding his empire through to Glasgow, ultimately establishing himself as Scotland's foremost sports outfitter of the period. By March 1896, Lumley's had taken over H&P McNeil's prominent advertising position in the sporting press, and it was to this company that the club turned to as their next kit supplier.

Lumley was no stranger to the club, having attended Rangers Sports meetings in the past. The club had been holding pre-season athletic events at Ibrox from as early as August 1881 and these were seen as one of the premier athletic meets within the UK, often attracting the cream of world athletics. The early Rangers Sports events would also often receive entries from current Rangers players, with Tom Vallance in particular enjoying remarkable success. The first Rangers Sports saw Vallance jump more than 21 feet in the 'broad jump', as well as triumph in the hurdles, the tug-of-war and even the obstacle race. Tom was also a keen rower, like many of the early members of the club, and in July of 1881 had even set up a competitive rowing race – to be held in the Gareloch – between four of the top football clubs, namely Rangers, Dumbarton, Vale of Leven and Queen's Park.

The Rangers Sports were much-loved and well-attended events which continued up until the 1960s, with Ibrox considered the premier athletics facility in Scotland and Lumley's remaining one of the main ticketing agencies for the annual occasion.

In 1899 – with Fred Lumley's Athletic Store in Glasgow supplying the club with kit – shirt materials and styles began to change significantly. In an early pre-season advert, Lumley suggested "[Dress] Shirts for football are a thing of the past and have been superseded by the comfortable and well-fitting jersey", with worsted wool becoming the new material of choice.

Worsted wool is a combed wool which is then spun, producing a material which is strong, fine and smooth. These new 'jerseys' also offered the wearer the advantage of moisture-wicking through perspiration being drawn through the wool, far more comfortable than the old-style flannelette shirts.

The year 1899 also saw a huge period of transition for the club itself. Twenty-seven years after its inception, the decision was taken to become a limited liability company, with members being offered the opportunity to become full shareholders in the club. At the same time, Rangers decided to invest in the team's first official manager, William Wilton.

Wilton had joined the club in 1883, first as a player for the second XI before becoming an administrator, and finally match secretary of the first team in 1890. Having looked after the affairs of the team for the last nine years, Wilton was the obvious candidate for the role and accepted the position following a season where Rangers had become

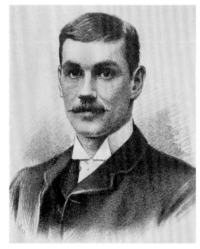

Tom Vallance, early Ranger, all-round sportsman extraordinaire and star of the Rangers Sports meetings

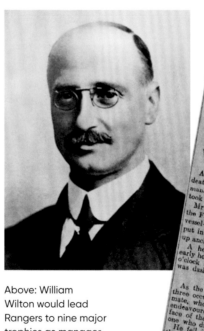

Above: William Wilton would lead Rangers to nine major trophies as manager

Right: The Dundee Courier, dated 3rd May 1920, detailing Wilton's tragic accident

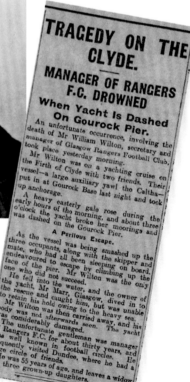

TRAGEDY ON THE CLYDE.

MANAGER OF RANGERS F.C. DROWNED

When Yacht Is Dashed On Gourock Pier.

An unfortunate occurrence, involving the death of Mr William Wilton, secretary and manager of Glasgow Rangers Football Club, took place yesterday morning.

Mr Wilton was on a yachting cruise on the Firth of Clyde with two friends. Their vessel—a large auxiliary yawl the Caltha—put in at Gourock Base last night and took up anchorage.

A heavy easterly gale rose during the early hours of the morning, and about three o'clock the yacht broke her moorings and was dashed on the Gourock Pier.

A Perilous Escape.

As the vessel was being smashed up the three occupants were sleeping on board. mate, who had all been sleeping on board. endeavoured to escape by climbing up the face of the pier. Mr Wilton was the only one who did not succeed.

He fell into the water, and the owner of the yacht, Mr Marr, Glasgow, dived in to the rescue and caught him, but was unable to retain his hold owing to the heavy sea.

Mr Wilton was then carried away, and his body was not afterwards seen. The yacht was considerably damaged.

The unfortunate gentleman was manager of Rangers F.C. for about thirty years, and was well known in football circles. He frequently visited Dundee, where he had a large circle of friends.

He was 55 years of age, and leaves a widow and three grown-up daughters.

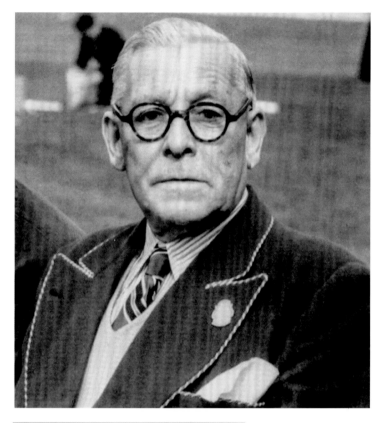

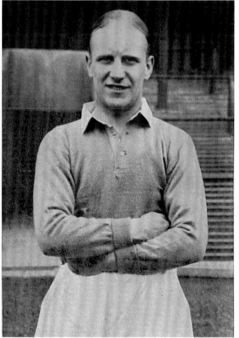

Above: The inspirational and iconic Bill Struth, who gave the club decades of unstinting service

Left: The Rangers shirt barely changed between 1919 and the mid-1950s, and thanks to Struth's insistence was always worn tucked into the players' shorts

champions by winning all 18 matches of their league campaign to become the club's first 'Invincibles'.

Wilton was the man who set the standards for the club, standards that would be upheld and strengthened by his successor, William Struth. During Wilton's 21 years in charge as the club's first manager, Rangers would claim eight league titles, one Scottish Cup, nine Glasgow Cups and seven Glasgow Merchants' Charity Cups.

His final season in charge had seen the team win the title, wrapping up the season with a 3-1 win over Morton at Ibrox on 1st May 1920. As he left Ibrox that night to begin the first day of his holiday, he headed for Gourock, where he was to embark upon a yachting cruise with friends. During the night, the boat broke free of its moorings during a storm and was dashed against Gourock Pier. Of the five people on board, four managed to climb the mast onto the pier but Wilton lost his grip and fell into the water. Despite attempts to rescue him, he slipped under and his body was not recovered until one month later.

During the 1919/20 campaign, Wilton's last season in charge, the club had begun to introduce a new style of home shirt which was adopted gradually from April 1919 onwards, but then remained pretty much unchanged for the next 37 years.

The new home shirts kept with the tradition of a plain royal blue with no club crest applied, unlike the change shirt of the era. In keeping with the changing fashions in football shirts at the time, a white fold-down collar was introduced with four buttons to the front to close. Curiously, this style was only ever ever produced in long sleeves until 1954.

The oldest known match worn Rangers home shirt in existence is in this style. It was worn by Dr Adam Little, who had signed for the club from Blantyre Victoria in the summer of 1937, making his debut at the age of 18 in a Benefit match against Stoke City just a few months later. He was one of a 14-man Rangers squad which travelled to play in the match, held in aid of the Holditch Colliery Disaster Relief Fund and which saw Rangers presented with a Loving Cup from Sir Francis Joseph, president of Stoke City, in appreciation of their efforts. The Loving Cup had previously been gifted to all the leading English clubs in commemoration of the Coronation of the King and Queen and sits proudly to this day in the Ibrox trophy room, from where it is brought out on the occasion of the first home match every New Year to toast the health of the reigning monarch.

Little went on to play more than 200 times for Rangers, winning 17 medals, predominantly during wartime football, and featured in the club's biggest victory over Celtic, the 8-1 demolition on New Year's Day 1943. Despite fading somewhat over the years, the shirt is a classic example of the home design worn from 1919 until well into the 1950s. It was an iconic shirt design in the history of Rangers and one

that saw most success under the man who succeeded Wilton and who became arguably the greatest manager ever to serve the club – William 'Bill' Struth.

Struth, or 'The Boss' as he was affectionately known by his staff, joined Rangers in May 1914 as the club's trainer, replacing James Wilson, who had sadly passed away following 17 years of service to Rangers. Six years later, in June 1920, he became the club's second full-time manager, stepping into role sadly vacated by Wilton. He easily made the transition and drove the club on to dominate the Scottish game. He was the first manager to lead the club to both a domestic double (in 1927/28) and treble (in 1948/49).

Although Wilton had set the standards expected by those who played for Rangers, Struth continued to cultivate those ideals and mould the club into the institution it is today. He was a superb psychologist and motivator who instilled a sense of discipline and pride into the work of both players and staff.

As a man with high standards both on and off the pitch, his players were expected to turn up for training wearing a collar and tie, and during their free time away from the club were only to be seen eating at the best restaurants and sitting in the best seats in the theatre. They were representing Rangers at all times and were required to remember that.

On the pitch, shirts would be tucked into shorts and the shirt collar would always be turned down. In the dressing room before a match, shorts were always to be put on last to prevent taking the field with creases or marks on them. Just before leaving the dressing room, Struth would give the team one final kit inspection before instructing his captain to lead them out and taking his place in the stand. Struth felt that if the players looked their best, they would take to the field already feeling that they had an advantage over the opposition. A freshen-up at half-time, with dirty legs washed down, boots cleaned of mud and a new set of strips, would see the standards maintained, with the players reappearing clean and dry for the second half.

Any player who fell short of what Struth expected of a Ranger would be given the message that he didn't want to hear – that the boss wanted to see him in his office. Often Struth would allow the player to stew for a couple of days before calling him up the marble staircase at Ibrox to the manager's room, where he would be reminded of his responsibilities as a player for Rangers.

Struth became a director of the club in 1947 and was appointed vice-chairman on his retirement as manager in the summer of 1954. He died two years later, aged 81, having served Rangers for 40 years and established ideals and traditions that those who love the club still cherish to this day.

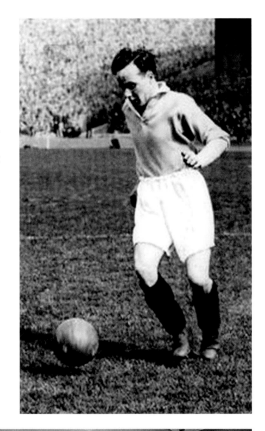

Opposite: The oldest known Rangers home shirt – dated to 1938 – was worn by Dr Adam Little (right), who went on to become one of the country's star footballers during the wartime years

Below: A picture of Bill Struth's office, taken in 1928. The office was situated in the Main Stand at Ibrox, which was designed by famed architect Archibald Leitch

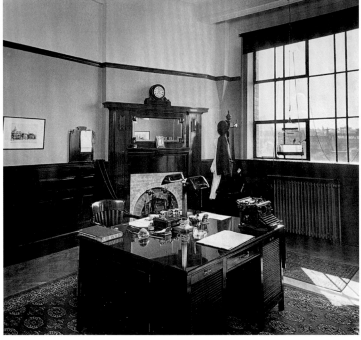

THE CHANGE SHIRT
THE FIRST 100 YEARS

While the blue of Rangers' iconic home shirt is recognised the world over, the history of the club's various change shirts is equally storied and impressive.

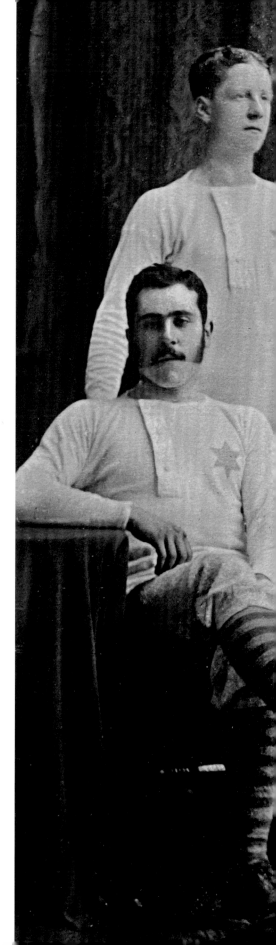

The oldest known surviving photograph of Rangers is believed to have been taken around the time of the Scottish Cup Final matches against Vale of Leven in March 1877. Within five years of the club's formation Rangers had reached their first major final and would do battle with a Vale of Leven side who were then one of the giants of Scottish football. The final – played at West of Scotland Cricket Ground, Hamilton Crescent, Glasgow – and the two subsequent replays were watched by record-breaking crowds of around 10,000 people, with huge numbers of non-paying supporters watching from every vantage point outside the arena. Vale ultimately proved too strong for their youthful opponents – defeating them 3-2 in the final match – but Rangers had made their mark.

The photograph in question shows the Rangers team – indeed, all the players who played in the final and two accompanying replays – wearing a white shirt with a six-pointed star along with their usual white knickers and blue-and-white-hooped socks. No documented evidence has been found at this time to say whether Rangers ever wore this style of shirt during any match. There was certainly a colour clash between the traditional royal blue of Rangers and dark blue of Vale of Leven for the 1877 final, but the Vale side are now known to have played in red and blue shirts for the final and wore white shirts for both replays. Periodical reports of the time have shown that Rangers stuck with their usual royal blue shirts in each match.

Although ongoing debate remains regarding the origin of the white shirt worn in the photograph, it is widely believed that the significance came through Rangers' early connections to Clyde Rowing Club, with captain Tom Vallance being a member of both clubs. Coincidentally, the Swindon rugby club that spawned the name 'Rangers' were mentioned in Charles Alcock's 1870 book *The Football Annual* as being kitted out in a "white jersey with blue star on breast".

Interestingly, instead of a star the shirt of captain Tom Vallance featured the lion rampant of the Scotland national team, Tom having made his international debut two weeks before the final on 3rd March 1877, against England at The Oval in south London – the wearing of the international badge on a club shirt being a common occurrence for those who had been capped by their country in those early days.

Was this white shirt the club's first change kit? Probably not. Was it a shirt borrowed from Clyde Rowing Club for photography purposes? It seems more than likely this was the case. Perhaps the well-worn blue shirts were deemed to be looking a little tatty around the edges ahead of the photograph, but whatever the reason white was certainly the colour chosen by the club over the next 30 years as Rangers' choice of change kit.

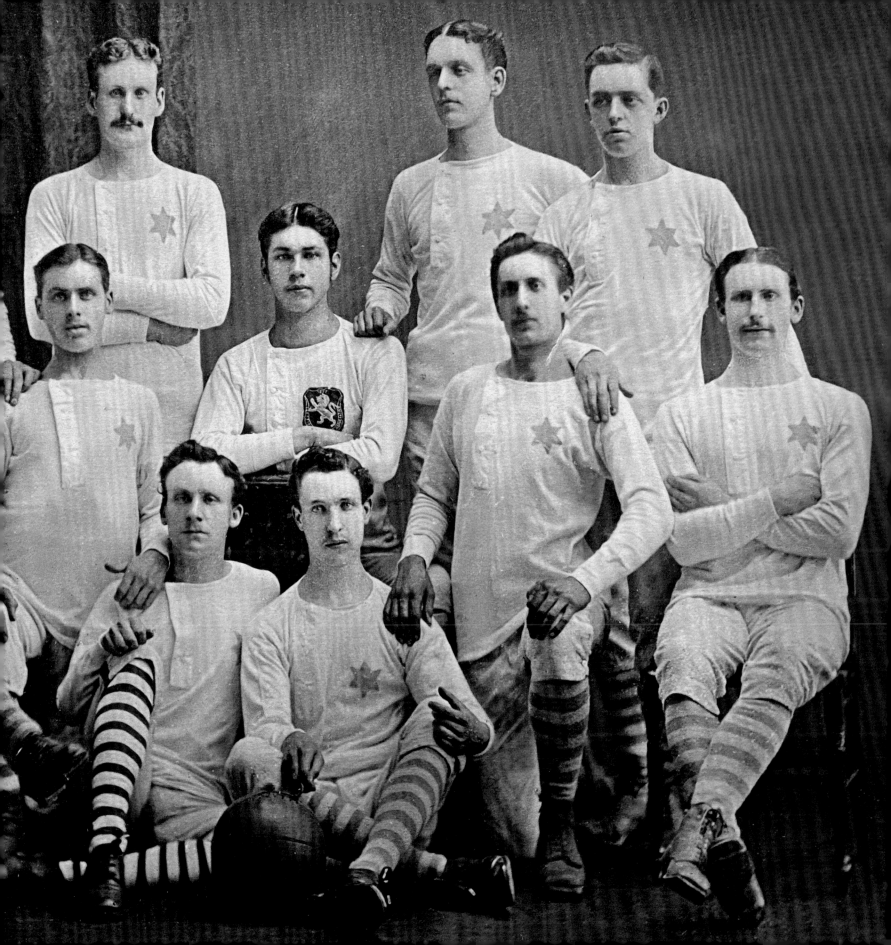

During that early period of Scottish football, it was not uncommon to see matches featuring both clubs playing in almost identical colours. Thankfully, common sense prevailed and clubs began to recognise the importance of a second kit as back-up.

Although not much documentation pertaining to early Rangers shirt colours is known to exist, it is documented that white shirts were worn by the club during a match against a blue-shirted Dumbarton in the Glasgow Merchants' Charity Cup semi-final replay on 2nd May 1885 at Hampden Park, with Rangers losing 2-0 on the day. The use of white as the club's preferred change shirt colour is further evidenced via a club board meeting in April 1887, which saw the club's treasurer instructed to purchase white shirts for the upcoming Charity Cup ties versus the dark-blue-shirted Renton FC.

The wearing of white shirts continued with a July 1893 pre-season public trial match, which also featured players from the club, in a Blues versus Whites match, and those same shirts were used when Everton ventured north to play at Ibrox Park in a match on 28th September 1893. Everton visited Ibrox for another fixture on 4th January 1897 and Rangers wore white again to avoid a clash. As change shirts were worn far less frequently in those early days such a switch could catch fans and reporters unawares – one report from the 1897 match claimed that the Rangers supporters occasionally cheered for the wrong team due to Everton playing in blue.

Edinburgh side St Bernard's were another team whose shirts caused a colour clash, so Rangers donned white once again during a 4-3 victory against the Edinburgh side – in one of the last matches to be played at the first Ibrox Park – on 25th November 1899. That particular game had seen Rangers needing a late strike to take the points, with one periodical of the time dissecting Rangers' poor performance by suggesting that "some had it that Rangers never do well in white and quoted precedent in proof thereof. Others made out that they couldn't play against their own colours – that they were mistaking foe for friend".

In the 1907/08 season Rangers introduced a new change shirt featuring horizontal stripes, similar to the home shirt of the 1882/83 season. The shirt would feature two-inch stripes of white and royal blue with a grandad-style collar and would remain as the club's change shirt until the end of the 1910/11 season. Blue and white stripes would be a recurring theme of Rangers change kits in years to come, often referred to in the press as Rangers' 'butcher's apron' shirts, and it would be many years before the club used anything other than those two colours on a shirt.

The 1911/12 season saw Rangers unveil a new-style change shirt in white with a single thick horizontal blue band around the midriff. The grandad-style collar and cuffs were also in blue, although towards the end of its use in 1914 it was occasionally seen with a plain white collar and cuffs. As well as the usual league teams who played in blue, such as Dundee and Raith Rovers, Rangers would also face colour clashes during that period from teams such as Motherwell and Partick Thistle – who used blue as their main kit – and even Hibs, who played in a green that was felt to be quite similar to the hue of the Rangers shirt, especially in poor daylight conditions, this being pre-floodlighting days.

Rangers' next change shirt would see a return to a traditional plain white shirt, one which made its first appearance during the league match against Dundee at Ibrox on 6th March 1915. In order to maintain a high

Previous pages: The oldest photograph of a Rangers team currently known to exist, believed to date from around March 1877 and showing the team wearing white shirts and shorts with blue-and-white-hooped socks

Below: The 1893/94 Rangers team, the first Rangers side to win the Scottish Cup. Note the early change shirt on the left of the front row, worn by Robert Marshall, who played for the club between 1889 and 1896

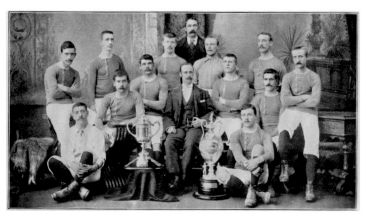

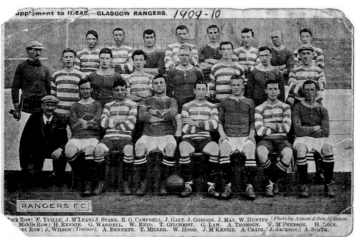

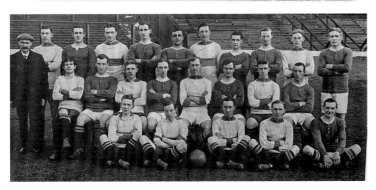

standard of appearance, Rangers would always change into new shirts at half-time. On this day Rangers changed from white back into their usual blue home shirts, having trialled the new white shirt during the first half. This white shirt, complete with a new style of fold-down collar and buttoned neck, would also break new ground for Rangers in another way.

In a move ahead of its time, the shirt was often adorned by a black cloth patch featuring the white intertwined letters 'RFC'. Although crested badges had long been seen on international shirts, they were seldom used during that period on domestic club shirts.

During this shirt's time in use, three variations of the club crest and shield would be worn. Strangely, the use of a crested badge would only be seen on this change shirt and not on any of the club's other shirts for many years to come. The club were concerned that the heavy washing the shirts were subjected to would see black dye from the shield run onto the white material, so to get around this the crested shield was tacked onto the shirt by thread and removed after each match, a job carried out by the ladies

Above: The Rangers team of 1907/08, with some players wearing the new horizontally striped change shirt

Left: A colourised version of the 1910/11 squad photo, showing the blue and white change shirt introduced in 1907/08

Below left: This 1911/12 picture shows Rangers' new change shirt, complete with a thick horizontal band across the torso

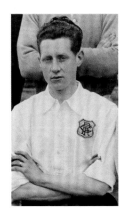

A 1930s 'dress shirt'-style change jersey, worn here by Archie Macaulay, who would go on to play for West Ham, Brentford and Arsenal. Note the large, elaborate club crest

of the laundry. This way the shirts would remain in pristine white condition throughout their use, continuing as the regular change shirt up until 1934.

The plain white shirt even made an appearance in the Scottish Cup Final of 16th April 1921 against a blue-shirted Partick Thistle side at Celtic Park in what is believed to be the first time the club wore anything other than their home shirt during a domestic final.

This shirt (pictured opposite) is the oldest known Rangers change shirt discovered so far and is believed to be from around the 1920-1922 period. Unfortunately missing its crested badge, although a faint outline remains, the shirt was worn by Alan Morton. Joining the club in June 1920, he enjoyed 13 successful years before retiring in 1933 to join the Rangers board, where he served the club until his death at the age of 78.

As well as Morton, this style of shirt would be worn by some of the finest players to ever feature for the club, such as forward Bob McPhail, Sandy Archibald and captain Davie Meiklejohn. McPhail would claim in his autobiography that it was a shirt which the players detested. By the time he joined the club in May 1927, the shirt was very much a loose-fitting, cotton-feel shirt, which he felt let the cold air in too easily. When he complained to manager Bill Struth about this fact, Struth opened a bottle of methylated spirits and made sure the players' bodies were rubbed front and back with the liquid, telling them: "That'll keep the cold out."

It has been widely reported that Rangers wore a red change shirt during the 1920/21 season, but research has proven that not to be the case. Rangers' change kit for the season was actually the same standard white shirt worn before and after that season. The myth of the red shirt stems from a squad photograph taken at the beginning of the campaign which was altered at some point before publication. Extra players were in effect 'photoshopped' in (Andy Cunningham and Tommy Cairns don't feature in the original photograph) and the colour of the shirts darkened, perhaps to show up better

in early newsprint of the period. The original photograph actually shows the squad wearing the older style of royal blue home shirts, with grandad collar, and the white change shirts with fold-down collar. In fact red wouldn't make an appearance into Rangers' colour scheme until 1950.

During the summer of 1923, Rangers toured France and Switzerland, taking with them an alternative to the plain white change shirt. The original idea behind having the third shirt is unknown but it was an idea that the club would revisit for many years. This alternative change shirt saw a return to blue and white horizontal stripes. Featuring a fold-down collar, which had replaced the grandad-style collar of earlier incarnations, a version of the shirt with one-inch royal blue stripes was taken on tour and was used against CAP Olympique in Paris during a 6-1 victory.

Another version of the blue-and-white-striped shirt, this time with thicker stripes, made an appearance in a match away to Raith Rovers in February 1929 and was also used for the 1930 Scottish Cup Final against Partick Thistle as the sides fought out a 0-0 draw. With Thistle playing the final in blue and Rangers in blue and white stripes, both clubs felt that the shirts had not been distinctive enough in the first match and agreed a further change for the replay. For the replay match on 16th April 1930, Rangers reverted to their well-known plain white shirt and black shorts, with Thistle playing in brown and gold hoops with white shorts. This time the white shirt was successful, with Rangers winning back the Scottish Cup 2-1 in front of 103,000 fans.

The plain white change shirt would make sporadic appearances between 1935 and 1939, usually featuring in the pre-season public trial match and thus the official team photograph. It was even brought out for a couple of cameo appearances in September and November of 1951 and used in the official squad photograph of that year, but in reality by late 1933 Rangers were rarely using the plain white shirt, and by 1934 they had introduced a new regular change shirt.

The oldest known Rangers change shirt, worn by Alan Morton, is thought to date from the early 1920s

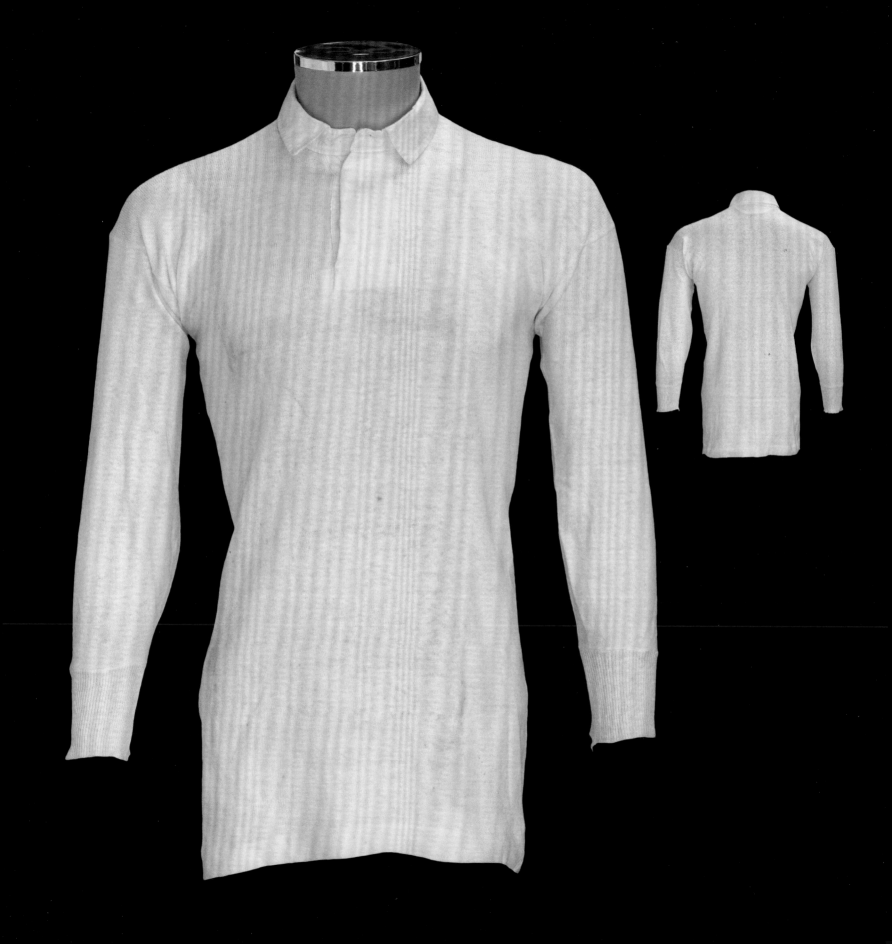

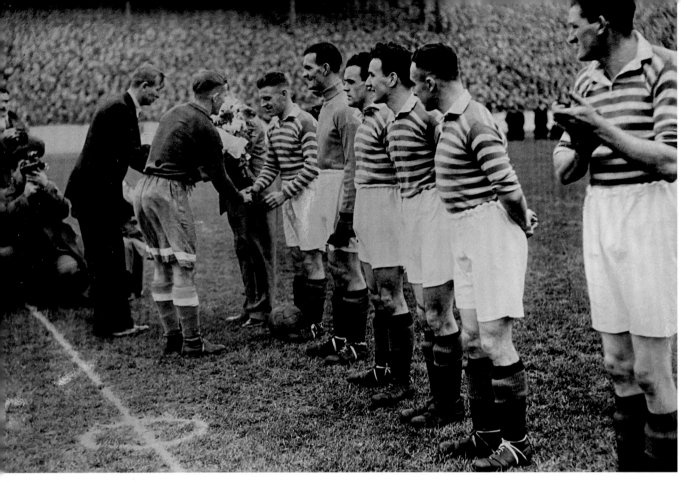

The captains shake hands prior to the famous 1945 match between Rangers and Moscow Dynamo, which saw Rangers – playing in blue-and-white-hooped shirts – earn a 2-2 draw against the star-studded tourists

Used between 1934 and 1936, the shirt still made use of horizontal stripes but this time it was primarily white with three thick horizontal bands of royal blue around the torso and arms, with a buttoned neck and a fold-down collar in white. The shirt debuted on 31st March 1934 during a 1-0 victory in the Scottish Cup semi-final against St Johnstone at Hampden.

Rangers unveiled an updated version of the blue and white horizontal stripes once again for use between 1937 and 1950. This time the shirt featured narrower stripes, which sat closer together than on the previous version and featured a fold-down collar and buttoned neck. It was a shirt that was to feature in one of the most historic matches in the club's history when the Russian maestros of Moscow Dynamo came calling on 28th November 1945 during their UK exhibition tour. The build-up to the match was unlike anything that had been experienced before as thousands queued overnight at various Glasgow sports shops in order to try to pick up a ticket for what in effect was a touring

national side. More than 90,000 lucky spectators made it into Ibrox, including many children of school age who had suddenly been 'too unwell' to attend school that day. Rangers fought out a 2-2 draw with the Russians, who went home undefeated after their four-game tour of the UK.

These same shirts would also see use for the League Cup semi-final against Falkirk on 11th October 1947. In only its second season as a competition, and with Rangers the defending champions, Falkirk claimed victory with three minutes of the match remaining.

Rangers had worn numbers on the back of this change shirt for the first time one month earlier, against Dundee at Dens Park on 13th September 1947, with black numbers hand-stitched onto a large white square cloth panel. The club had first discussed the use of shirt numbers at a board meeting in November 1946 and the decision had been made to adopt their use, with their first appearance on a Rangers home shirt coming in the match against Celtic at Ibrox on 1st January 1947.

Cup success was finally claimed in this iconic change shirt during one of its last outings. The League Cup Final on 12th March 1949 saw Rangers beat Raith Rovers 2-0, with both teams wearing their respective change shirts on the day.

Rangers' next change shirt was unusual in that it was predominantly the same colour as the home shirt, although it did see the first introduction of red into the club's colour scheme. Only worn around half a dozen times throughout the 1950/51 season, the shirt featured a royal blue body with three bands – ordered red, white and red – around the torso and sleeves. The collar was the regular white fold-down type, with a buttoned neck. The shirt was first worn against Raith Rovers on 11th March 1950 during the Scottish Cup quarter-final as Rangers needed three attempts to get past their resolute opponents, eventually defeating Rovers 2-0 at Ibrox en route towards an eventual Scottish Cup Final victory against East Fife on 22nd April 1950.

Apart from one away league match against Dundee and a Scottish Cup semi-final replay against Queen of the South, both in April 1950, the only other appearance of the shirt was during the Scottish League Cup Final at Hampden on 27th October 1951, once more versus Dundee. At that time, the Scottish Football League rules dictated that in the event of a colour clash both teams would change. Dundee suggested that they were happy for Rangers to wear their traditional home shirts of royal blue as they would be playing in white but with rules being rules, Rangers had to change and ironically changed into a shirt that was still predominantly blue. Dundee ran out 3-2 winners and the shirt was consigned to the history books, never to be used again. With no colour photographs of the shirt and with its short period of use, some have suspected throughout the years that the shirt must have been red, but this was not the case.

Having a royal blue home and change shirt was never going to be practical, however, and with that in mind Rangers went with a new change shirt for the start of the 1952/53 season. Described by the press as scarlet, the shirt was a mirror image of the style of that period's home shirt, only differing in colour. The seeds of the idea for a red change shirt may have been sown in February 1951 when Rangers travelled to Kirkcaldy to play a league match against Raith Rovers. With Rangers' change shirt of the time also being predominantly blue, they borrowed the red change shirts of Raith Rovers, who played in their normal dark blue shirts.

This wasn't the first occasion that Rangers had borrowed shirts to play against Rovers. A problem regarding the kit had occurred against the men from Kirkcaldy in the league match of March 1939, which resulted in Rangers

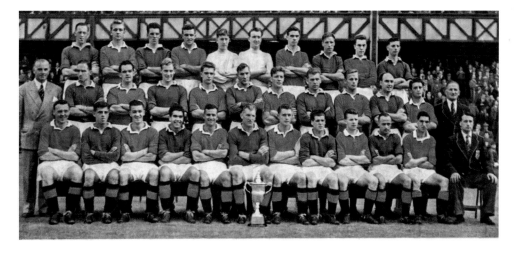

A squad photo from the 1950s showing the red change shirt introduced for the 1952/53 season

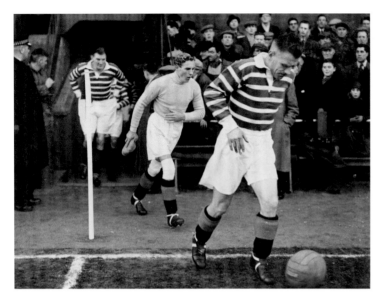

Jock Shaw leads Rangers out at Brockville Park as they prepare to take on Falkirk in November 1950

playing in the white change kit of Raith Rovers, complete with a large Raith Rovers club crest.

From the beginning of the 1952/53 season, up until its last competitive outing during the Scottish Cup match against Dundee on 11th February 1961, the plain red shirt would be the club's main change shirt, although during what was a period of massive change in Scottish football with the introduction of European competition and evening floodlit matches the club elected to also introduce some alternative change shirts for use in these events.

As early as the late 1870s, Rangers had experimented with matches played under floodlights, or electric light as it was known in those days. A match against Third Lanark RV had taken place at the first Hampden Park on 4th November 1878, illuminated by three lights powered by Siemens Dynamo Engines provided by Edward Paterson of London, albeit with disappointing results. Ten years later, on 3rd March 1888, the club trialled its own 'electric light match', when a charity match was arranged against the Scottish Corinthians (who were actually a Scottish International Select) and held at Ibrox Park – the new home of the club. Powered by 30,000 'candle power' lights supplied by Messrs Braby & Co – the company responsible for

the building of the new stadium the previous year – the match saw Rangers triumph 4-1 and was more of a success than previous attempts, but in general early floodlight experiments were deemed a failure and not worth pursuing.

It wasn't until the 1950s that thoughts once again turned to the use of floodlighting in order to make playing matches in the evenings a possibility. With the advent of European competition, midweek matches would be common, and with the majority of spectators being working-class males, it made sense to have matches played under floodlights in the evening, thus allowing the working man to attend.

In September 1951 Rangers requested permission from the Scottish Football Association to play matches at Ibrox using artificial lights. The SFA replied that they were happy for the club to play private friendly matches, although at that time they did not approve of any competitive matches being played in that way – a stance that would continue until 1956.

With this in mind, October 1952 saw the club begin to experiment with installing floodlights, originally just 12, which beamed down from the top of the Main Stand. During a series of trial matches – at first kept in-house and later against guests such as Dumbarton – various options were considered, such as using fluorescent paint on the match ball, the touchlines, the goalposts and even the playing kit. By the end of November 1952, four pylons had been erected, one at each corner of the ground, with each one containing 25 bulbs ranging from 1,000 to 1,500 watts. The club claimed the floodlighting system had been modelled on that of Yankee Stadium, where floodlighting had been used in baseball matches for some time.

After further trial matches and with the floodlighting system fully completed, the club welcomed old friends Arsenal to Ibrox on 8th December 1953 to officially open the stadium's new lighting system, and for that one match only the club would play in a white shirt with blue satin shorts. Arsenal were

invited as guests in recognition of the two clubs' long-standing friendship. Two years earlier, in October 1951, Rangers had travelled to London for a match under Arsenal's new floodlight system at Highbury, and with Rangers playing in their normal home kit of royal blue shirts that night Arsenal players had complained that it was difficult to pick out the Rangers players under the lights.

Ironically, Rangers and Arsenal had actually first discussed playing a floodlit match against each other as early as 1930, with plans to play at Wembley Stadium under what they called 'arc lights'. Advanced plans had seen the match scheduled for December 1930 but objections were raised by the English FA, who saw it as going against its rules and accused both clubs of 'commercialism' – essentially benefitting financially from a match not played under its auspices. Much to the displeasure of both clubs, the match didn't go ahead.

To fully embrace the new floodlight era of the 1950s, the club decided that a new kit would be required in order to make the most of the new lighting system, and 1954 would see Rangers debut a new change shirt which would become known as the first of the 'floodlight shirts'.

Worn between 1954 and 1958, usually with blue satin shorts, this shirt was white with two royal blue bands around the torso and sleeves, plus a white fold-down collar with a button-neck. The shirt would see use in the many floodlit friendly matches at Ibrox during these four years, played against teams such as Manchester City, Arsenal and a British Army Select, amongst others. This style would also be worn in the 1957/58 season during European matches against Saint-Étienne at Ibrox and Italian giants AC Milan, both at Ibrox and in the return leg at the Arena Civica in Milan (the match having been moved from the San Siro due to adverse weather). The shirt would also see use in a successful final as Rangers defeated Third Lanark after a replay to win the Glasgow Cup under the Ibrox floodlights on 31st March 1958.

Midway through the 1958/59 season Rangers replaced the 'floodlight shirt' with a new version, bringing together the colours red, white and blue again on a shirt for the first time since 1950/51. The predominantly white shirt would still feature two bands

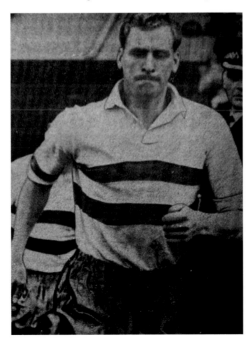

Right: The first 'floodlight shirt', worn here by Sammy Baird, who joined Rangers in 1955 from Preston North End

Far right: The second 'floodlight' shirt was introduced for the 1958/59 season

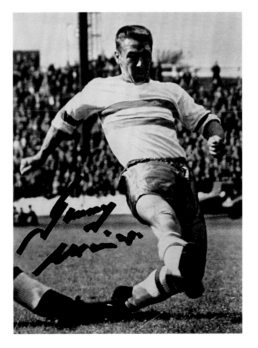

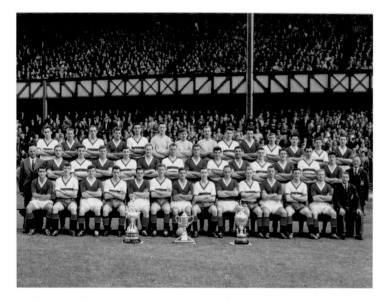

The 1960/61 Rangers squad – with half the players in the new change shirt launched for that season – pose with the Glasgow Merchants' Charity Cup, the Scottish Cup and the Glasgow Cup

around the middle, but this time instead of two blue bands it would feature a blue band above a red band. A blue crew-neck collar and cuffs completed the iconic new look. Although used predominantly in league matches, it was very much a continental style of shirt and would feature in the European Cup Winners' Cup match at home against Borussia Mönchengladbach in November 1960 and the first leg of the same competition's semi-final against Wolverhampton Wanderers in March 1961 as Rangers strived to become the first British team to make it to a European final.

The shirt was revised for the start of the 1960/61 season and a new version was unveiled during the club's pre-season public trial match on 8th August 1960. Still featuring the blue and red bands on a white body, the revised shirt would feature a v-neck collar as opposed to the crew-neck design of its predecessor. Only used sparingly during the 1960/61 season, it was often interchanged with the crew-neck version when a switch was required, and in April 1961 Rangers launched a new-style change shirt.

Described in further detail elsewhere in this book, Rangers' new shirt featured vertical blue and white stripes with a sewn cloth number in red. It was worn for the first

time away to Wolverhampton Wanderers in the return leg of the 1960/61 European Cup Winners' Cup semi-final and was also used the following month both home and away as Rangers made their first European final appearance, a two-legged affair against all-conquering Fiorentina.

Even though the blue-and-white-striped shirt was the club's main change shirt from 1961 to 1968, in 1965 Rangers decided to throw another alternative shirt into the mix. A plain, brilliant white crew-neck shirt, which was always accompanied by white shorts and socks, gave Rangers the look of Real Madrid, whom they had met the previous season in the European Cup. Whether the idea behind this shirt originated from those matches against the Spaniards is not known but it seemed to have inspired the players wearing it as the club only suffered one defeat in more than 20 matches wearing this shirt during its seven-year lifespan, including a 1-0 victory on its first appearance in a match against Inter Milan at Ibrox on 3rd March 1965, with the crucial goal scored by the great forward Jim Forrest.

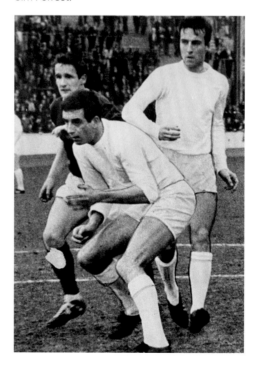

The 'lucky' all-white kit, which inevitably reminded onlookers of Real Madrid. Rangers would only suffer defeat once while wearing it

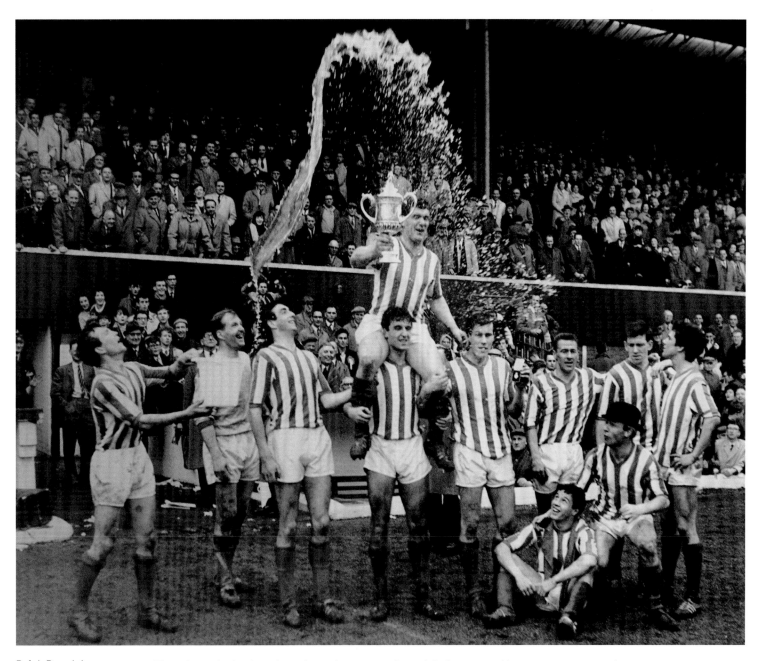

Ralph Brand douses his team-mates while captain Bobby Shearer holds on to the trophy following Rangers' Scottish Cup win in 1964

There is no doubt that throughout the years there has often been an eclectic range of change shirts worn by the club as Rangers often chose to mix and match, regularly appearing in shirts which hadn't been seen for a few seasons. Unfortunately, with the shirts generally being worn to destruction through being re-used by reserve teams and for training, virtually nothing has survived in respect of these early change shirts – but period photos and research have helped shine a light on the early history of these kits, which remain as important a part of the story of the club as the historic home shirts.

CHAPTER TWO
SCOTLAND'S GALLANT FEW

1945-1978 UMBRO & BUKTA

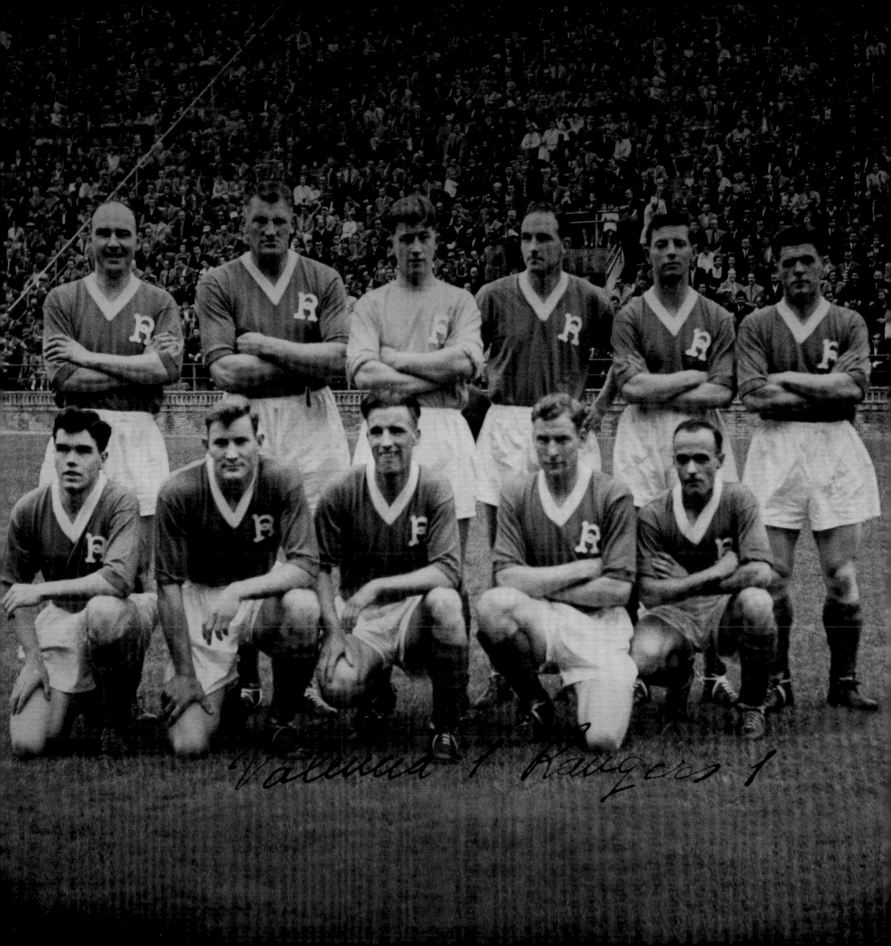

Valencia 1 Rangers 1

HOME 1940s

Match worn by **GEORGE YOUNG**

The home shirt used during Bill Struth's legendary reign as manager would remain virtually unchanged during its 37 years of use between 1919 and 1956. However, there were several variations in the material used over that time and numbers were added in 1947.

Originally produced in a heavy, knitted wool by an unknown manufacturer, the design featured a white fold-down collar, while the neck was fastened by three or sometimes four buttons – although most players preferred to play with these undone. Only ever available in long sleeves, it would have been uncomfortably hot to play in on warm days and heavy when soaked through on a wet Scottish winter's afternoon.

The decision to permanently include numbers on the back of the team shirts was taken at a board meeting in November 1946 and came into effect on 1st January 1947 for the annual New Year match versus Celtic. However, this wasn't the first time Rangers players had worn numbers. They had been first used when the club toured the United States and Canada in 1928, as was the custom in North America long before it became accepted practice in Europe.

Numbers were also used when Rangers returned to the US and Canada two years later, playing 14 matches in the space of one month – winning them all and scoring 68 goals in the process. Footage from the first match of the 1939 tour, against Ulster United, shows the Rangers players' shirts featuring large white panels on the back with black numbers, which were often hanging off having come loose from the shirt.

The shirt featured here was worn by club legend George Young, known to all as 'Corky' due to the lucky cork which he always carried. Having signed for the club in 1941, Corky enjoyed 16 years at Rangers, where he captained both club and country, earning six league titles, four Scottish Cups and two League Cups.

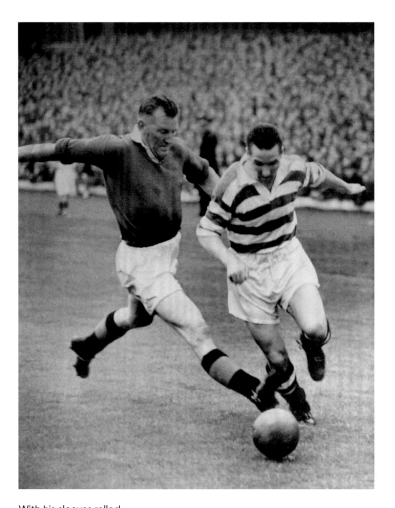

With his sleeves rolled up, George Young gets a foot in on Celtic's Neilly Mochan, typifying his no-nonsense approach to defending

HOME EARLY 1950s

Match worn by **SAMMY COX**

By the 1940s, Rangers were using a combination of their classic, woollen jerseys and the very latest Umbro-manufactured shirts.

The Umbro shirts – like the one featured here, which was worn by Sammy Cox – were far lighter than their woollen counterparts and became the favoured style in the early 1950s, by which time the older, heavier style had been phased out.

In 1924, 22-year-old retail trader Harold Humphreys had invited his brother Wallace to join him in his fledgling Manchester business venture. Quickly rebranding from 'Humphreys Brothers' to 'Umbro', they set about building an empire based on producing sporting garments, predominantly for football teams. By the mid 1930s, Umbro were established as the UK's leading football shirt manufacturer and were making much marketing mileage out of the fact that they had supplied the kits of both Manchester City and Portsmouth for the 1934 FA Cup Final.

Umbro would revolutionise the football shirt market as the heavy, thick woollen shirts of the past were superseded by the release of shirts made from a new lighter fabric based on Peruvian cotton, which they called 'Tangeru'. In their promotional material, Umbro described Tangeru as an "all-new knit-weave fabric" which was "chill-resisting, absorbent and always retaining its velvety smoothness".

Umbro, however, was not a kit supplier to teams in the modern sense. Clubs would purchase their team strips through a local supplier and by the 1940s – as well as Lumley's in Sauchiehall Street – Rangers were using The Sportsman's Emporium at 103 St Vincent Street, Glasgow. This arrangement continued over the next 30 years and, ironically, for a period in the 1990s, some years after the demise of The Sportsman's Emporium, the same shop space became a branch of The Rangers Shop.

Like George Young, Sammy Cox was another member of the famous Rangers defence of the period, famously dubbed the 'Iron Curtain', and was part of the Rangers side which won Scottish football's first domestic treble in the 1948/49 season.

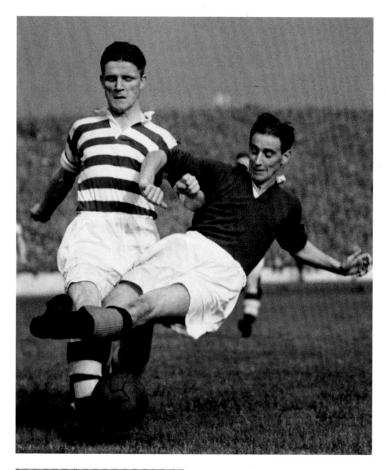

Above: Hall of fame member and part of Rangers' 'Iron Curtain' defence, Sammy Cox enjoyed a 10-year spell at the club

Left: Umbro's 'Tangeru' cotton was a gamechanger in terms of shirt design

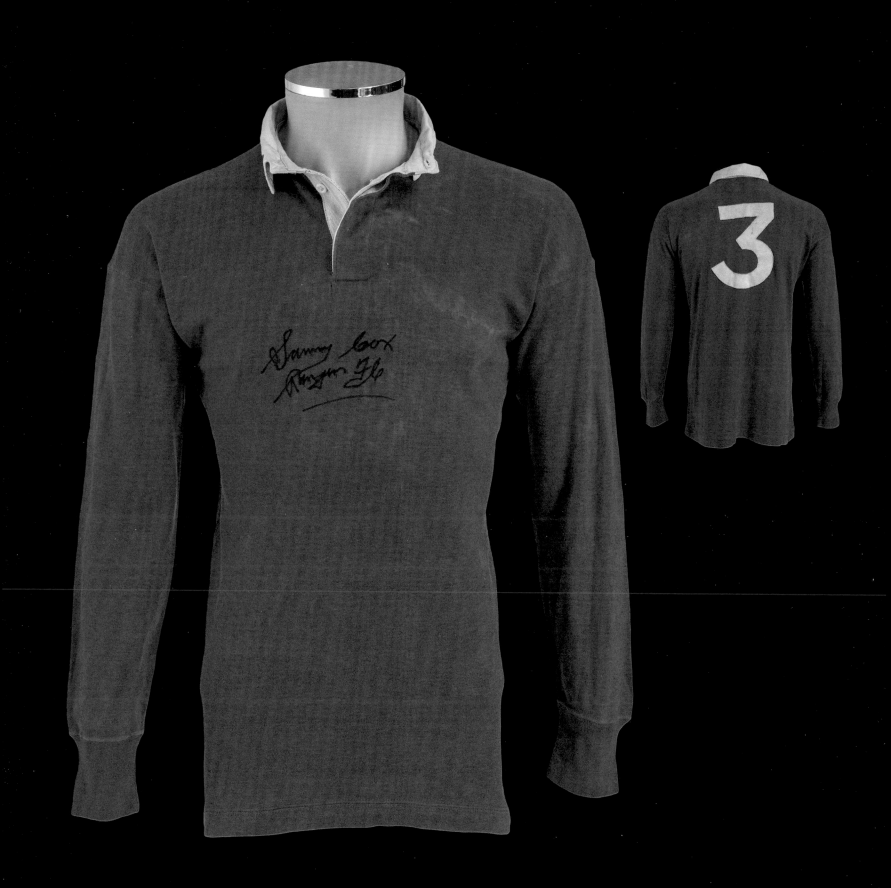

HOME MID TO LATE 1950s

Match worn by **SAMMY BAIRD**

Rangers wore Umbro's 'Tangeru' shirts throughout the 1950s. Even after the introduction of a new short-sleeved design in 1956, assistant trainer Joe Craven continued to select this style for the team – predominantly during the winter months – until the end of the decade.

Umbro were now using the marketing slogan 'The Choice of Champions', which was included on the collar label, with Rangers amongst many of the top British and international sides using the Wilmslow-based company's products.

This is another iconic Rangers shirt, particularly since it was worn during a highly successful period in the club's history. While wearing this design between 1919 and 1956, and with legendary manager Bill Struth at the helm for the majority of that time, the club won 20 league championships, 10 Scottish Cups and two League Cups, as well as multiple Glasgow Cups and Glasgow Merchants' Charity Cups.

Even during the Second World War, the club continued to play matches, despite many of their players being on active service. Although not officially included in the honours roll by Scottish football's governing body, the club would also win seven wartime Southern League Championships, four Southern League Cups, the Summer Cup, the Emergency War Cup and the Victory Cup.

The shirt featured here was worn by inside-forward Sammy Baird. Having joined the club from Preston North End in 1955, Baird won three league titles and one Scottish Cup during a five-year spell at Ibrox. And following the introduction of European competition in 1956, Baird played in all of the club's first 16 European matches, scoring five times in the 1959/60 European Cup campaign, when the club reached the semi-final.

He moved to Hibs in the summer of 1960 for the sum of £5,000. On retiring from the game he became a publican, like many ex-footballers of the period, running his own 'Baird's Bar' in Bo'ness, where this shirt was proudly displayed before being gifted to a local man – who still owns the jersey to this day.

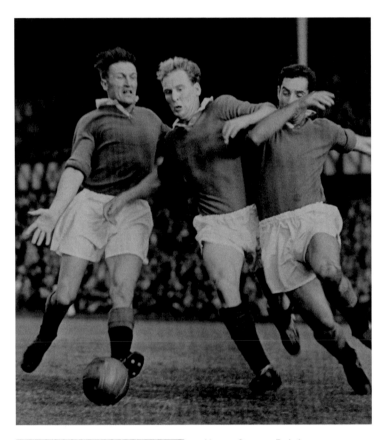

Above: Sammy Baird takes on Harold Davis at the club's annual pre-season trials at Ibrox in August 1959

Left: Umbro's iconic 'The Choice of Champions' label

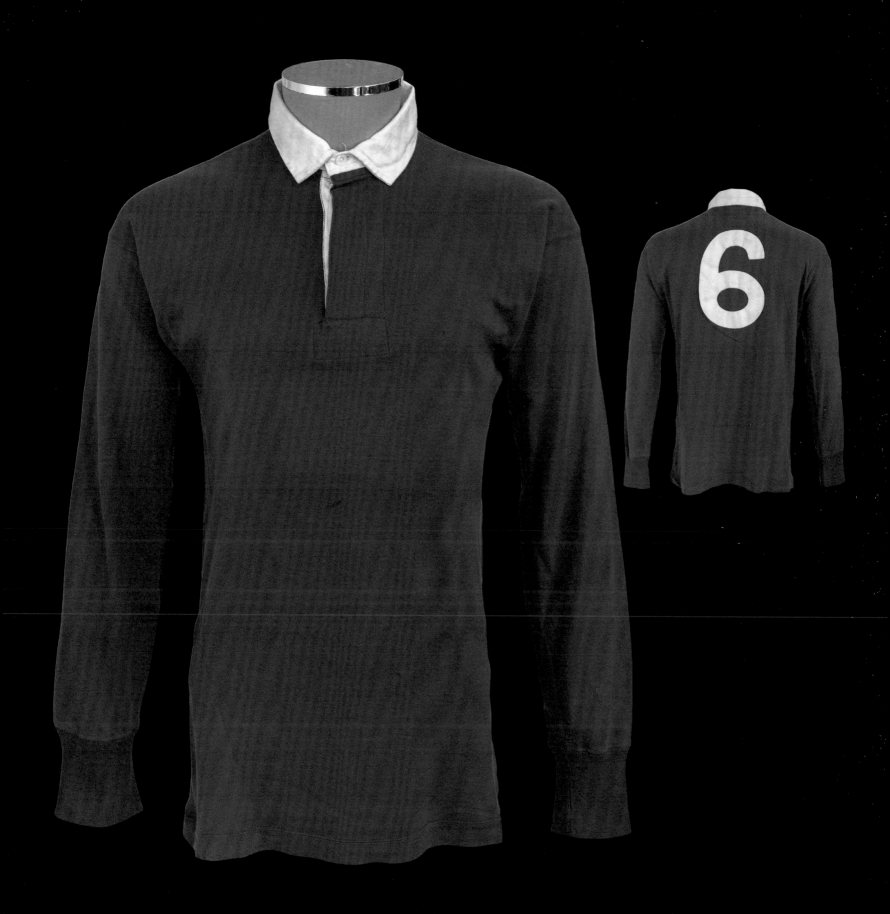

HOME 1956-68

Match worn by **RALPH BRAND**

The mid 1950s saw a revolution in football shirt design when Umbro introduced their short-sleeved, v-necked 'Continental' shirt template and – like many clubs – Rangers were quick to adopt the new style.

First worn by a Rangers team on the club's post-season tour of Spain in the summer of 1956, a shirt which featured a prominent 'R' crest (as shown on page 37), the lightweight royal blue shirts featured a large v-neck collar in white, giving the team a sleek, modern look inspired by the continental opposition they would soon be facing in European competition.

The shirt style was gradually introduced into use domestically, initially being worn in warmer weather at the beginning and end of the 1956/57 and 1957/58 seasons, with the previous long-sleeved design being worn during the colder months. Initially only available in short sleeves, later versions of the Continental design were produced with long sleeves and the old-style shirts were phased out.

Unfortunately, very few of these shirts have survived. In those significantly less commercial times, kit was purchased by the club every season, and once past their best the first-team shirts would be handed down to the reserve team before ending up as training shirts. Indeed, photographs show this style of shirt still being used by Rangers players in training up until the late 1970s.

The Rangers players were certainly not allowed to keep or swap shirts during this era, with former striker Jim Forrest recalling: "If I had attempted to take a shirt, I would have been chased up and down the Paisley Road by Davie Kinnear [the club's trainer, who was entrusted with looking after the kit]."

The shirt pictured opposite was worn in numerous matches by legendary number 10, Ralph Brand, who scored 206 goals in 317 games between 1954 and 1966.

"I loved the number 10 jersey," Brand would say many years later. "In fact when I left Ibrox, when it was my turn to move on, it was one of the requests I had for manager Scot Symon – that I could have my number 10 jersey."

For such a legend, who had served the club so well, Rangers made an exception, which explains how this magnificent and extremely rare shirt has survived.

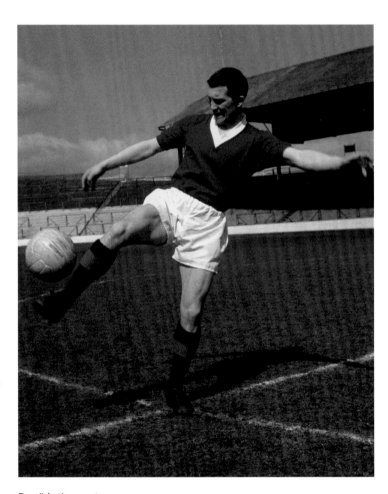

Possibly the most iconic Rangers home shirt in the eyes of many supporters, here put through its paces by striker Ralph Brand

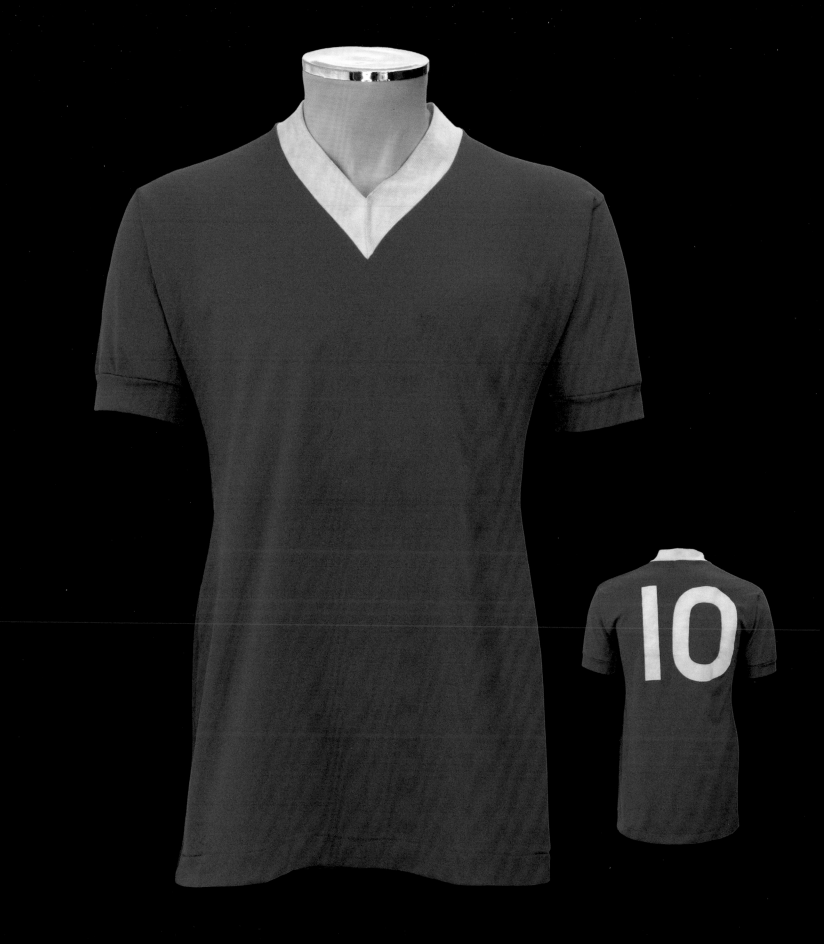

ALTERNATIVE HOME 1956-59

Rangers' first venture into the newly formed European club competitions for the 1956/57 season saw them drawn against OGC Nice. For the home match at Ibrox, under the glare of the floodlights, Rangers launched a new shirt, one which would only ever see occasional use and thus making it one of the most sought-after shirts for Rangers collectors. Unfortunately, to this day none have turned up – likely as it was eventually discarded by the club and not even used as a training shirt.

Manager Scot Symon announced its arrival in *The Evening Times* before the second round first leg match clash with Nice on 24th October 1956. He said: "We will be wearing this new type shirt for the very first time and we are sure that the crowd will like it. We have a feeling that our normal jersey does not show up too well under the lights, but this one should be a winner, we hope, in more senses than one. It is made of an entirely different material. It has a nice sheen to it and we expect it to sparkle on the field."

Made of Rayon, and presumably manufactured by Umbro, who made similar versions for other UK clubs, this long-sleeved blue shirt was similar in style to the previous home shirt of 1919-1956 – with a fold-down collar in white – and made a winning debut, with Rangers claiming a 2-1 victory at Ibrox. It also also featured in the play-off match in Paris on 28th November 1956, which saw Rangers ultimately lose 3-1 in what had been a bad-tempered trio of matches against the French side.

Over the next three years the shirt would make sporadic appearances in matches home and away to Anderlecht in the European Cup, as well as away matches against Arsenal and Hibernian. Although Rayon was a lightweight material, it tended to hold in heat and sweat in warm weather but be too lightweight for a Scottish winter, and thus use of this shirt eventually fizzled out.

Above: Referee Luc Van Nuffel addresses Sammy Baird (10) and Alex Scott (7) ahead of the play-off match in Paris in November 1956

Right: The Rangers team in the players' tunnel prior to the game in Paris

Opposite: This distinctive shirt would only ever see occasional use over its short lifespan

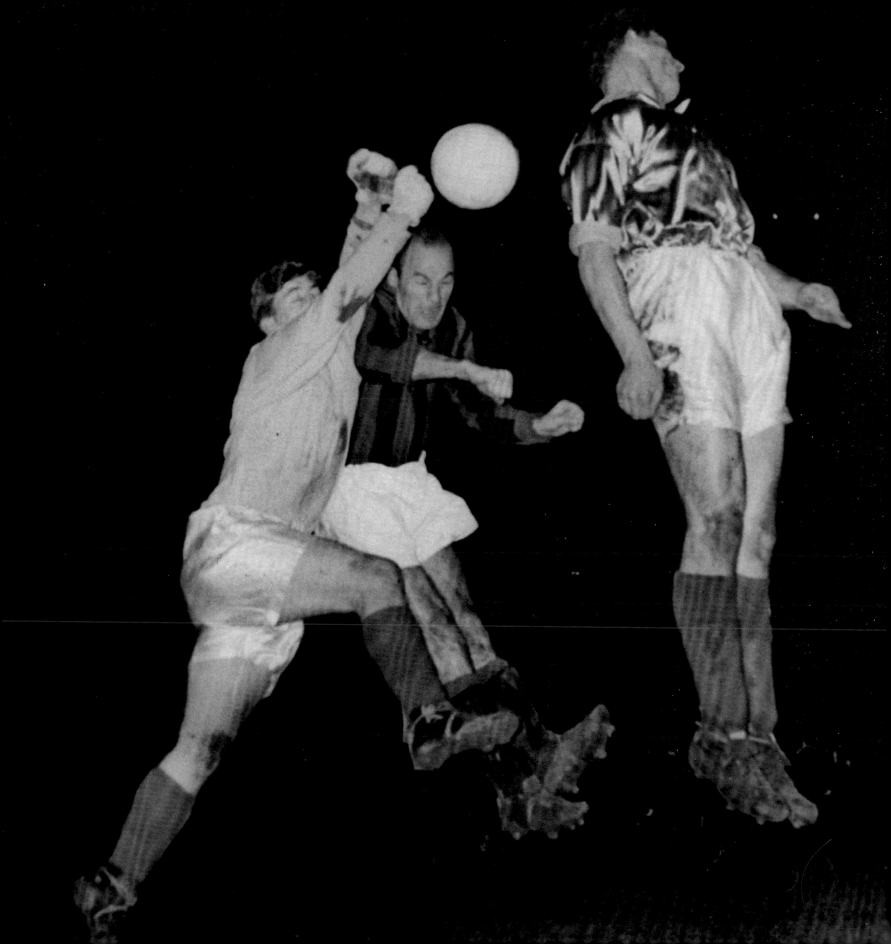

CHANGE 1961-68

On 19th April 1961, Rangers headed south to England to play the second leg of their European Cup Winners' Cup semi-final match against Wolverhampton Wanderers with a two-goal advantage. A crowd of 45,000 saw Rangers progress to the final of the competition with a 1-1 draw, a feat achieved whilst wearing a striking new blue-and-white-striped change shirt.

Unlike the club's previous blue-and-white-striped shirts, the stripes were now vertical instead of horizontal, with the collar remaining as a v-neck in royal blue. Despite Rangers' long association with Umbro, this shirt was manufactured by Bukta. It is not known why Rangers went with a Bukta 'Zeebux' shirt, perhaps Umbro were unable to supply this particular choice of change shirt at that time.

Defeating Wolves meant that Rangers became the first-ever British club to reach a European final. In those days the European Cup Winners' Cup Final was a two-legged affair, and the new striped change shirt was used in both the home and away legs of the final against Fiorentina of Italy – who wore their famous violet shirts and proved to be just too strong for Rangers over the two matches.

This shirt style continued to be worn between 1961 and 1968. One of its most memorable appearances came during the Scottish Cup Final on 28th April 1964, when Rangers defeated Dundee 3-1 in what has been described as one of the greatest cup finals ever witnessed at Hampden. Two goals from Jimmy Millar and one from Ralph Brand saw Rangers triumph against a strong Dundee side, which featured big names such as Alan Gilzean and Bert Slater.

The shirt was brought out of retirement for two matches in 1970, when a crew necked variant was worn, and continued to feature in the annual official squad photograph until the beginning of the 1972/73 season. They were also worn by the players as training shirts during the 1972 European Cup Winners' Cup run in both v-neck and round-neck configurations.

Unfortunately, no surviving match worn examples have surfaced but this unnumbered spare was obtained by an ex-player of the period and kept as a memento of his time at the club.

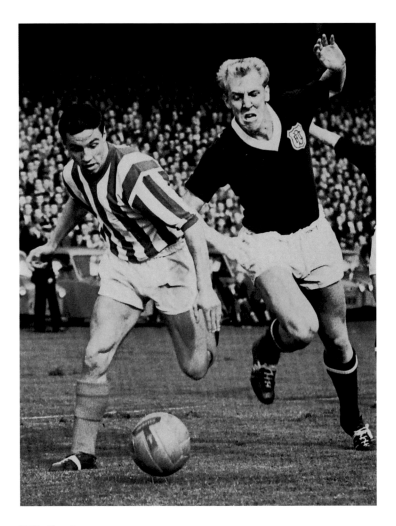

Willie Henderson
skilfully evades
the challenge of
Dundee's John Ure

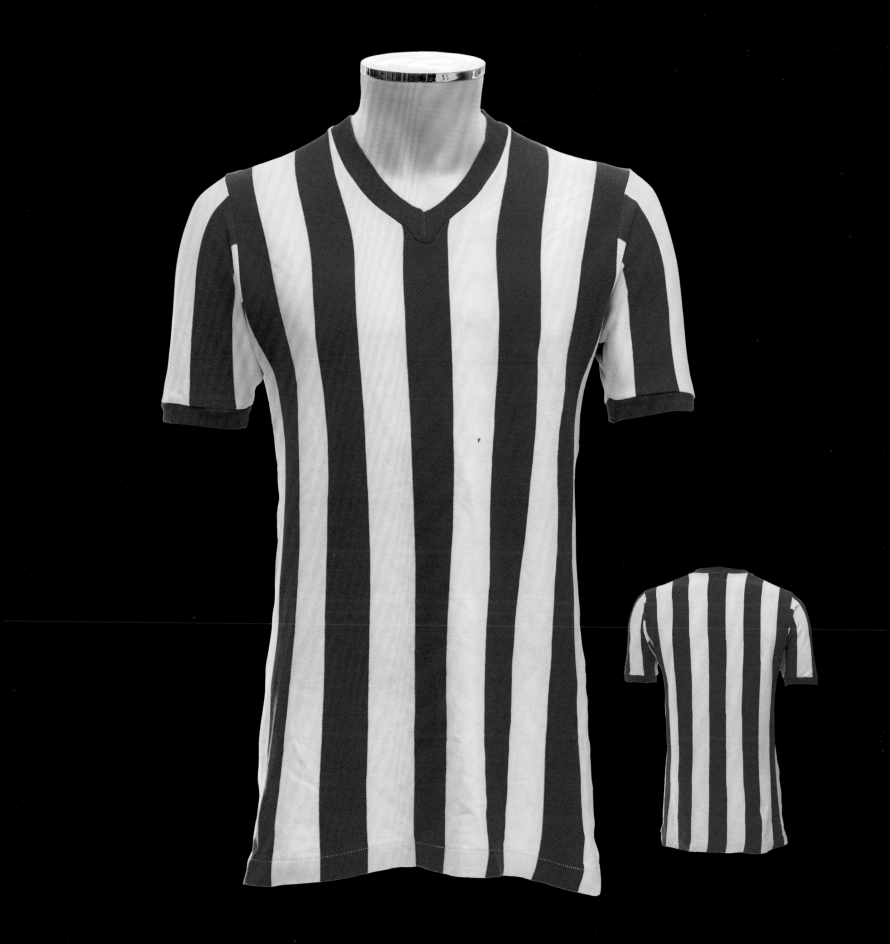

HOME 1968-78

Match worn by **WILLIE HENDERSON**

On the 10th August 1968, Rangers ran out of the Ibrox tunnel for a Scottish League Cup match against Celtic wearing a brand-new all-blue home shirt which would become the home choice for the next 10 years and is considered by many to be THE iconic Rangers shirt.

Unveiled the previous day at the club's pre-season photocall, the new Umbro shirts were self-coloured in royal blue, including the new round-neck collar (as opposed to the previous white) to match the main body of the shirt. Most striking of all, however, was the permanent addition of a large, embroidered club crest over the left breast.

The shirt design was classically simplistic and is remembered fondly by supporters and players alike. Striker Derek Parlane was one who felt that the shirt typified what the Rangers were all about, calling it "clean and classic". "I felt like a giant every time I pulled it over my head," he said.

One of the reasons the shirt is so fondly remembered is because it was worn during another highly successful period in the club's history, with Rangers winning domestic trebles in both 1975/76 and 1977/78 along with the European Cup Winners' Cup in 1972 and the Scottish Cup in 1973. The league title had also been secured in 1974/75 and the League Cup in 1970, with 16-year-old Derek Johnstone famously scoring the winner versus Celtic.

This fine example from that period was worn by Willie Henderson between 1968 and 1972. Having joined the club in 1959 from Caldercruix School, Henderson made his first-team debut as a 17-year-old in March 1961 before enjoying a successful 12-year period at Rangers, scoring 62 times before a dispute with manager Willie Waddle saw him released by the club in early May 1972, just three weeks before the European Cup Winners' Cup Final versus Moscow Dynamo.

An illustration of how shirts were made to last by clubs during this period, Henderson's number 7 on the back of the shirt has been torn and stitched back together, ensuring the shirt could remain in use.

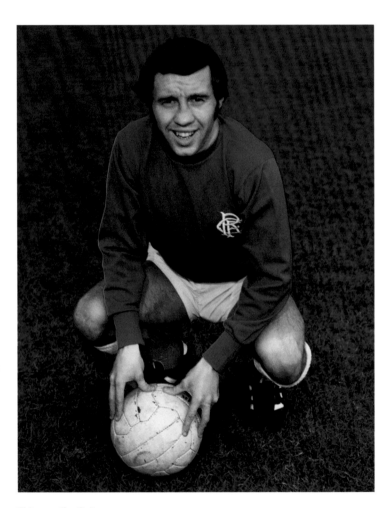

This was the first home shirt to feature an embroidered club crest, worn here by winger Willie Henderson

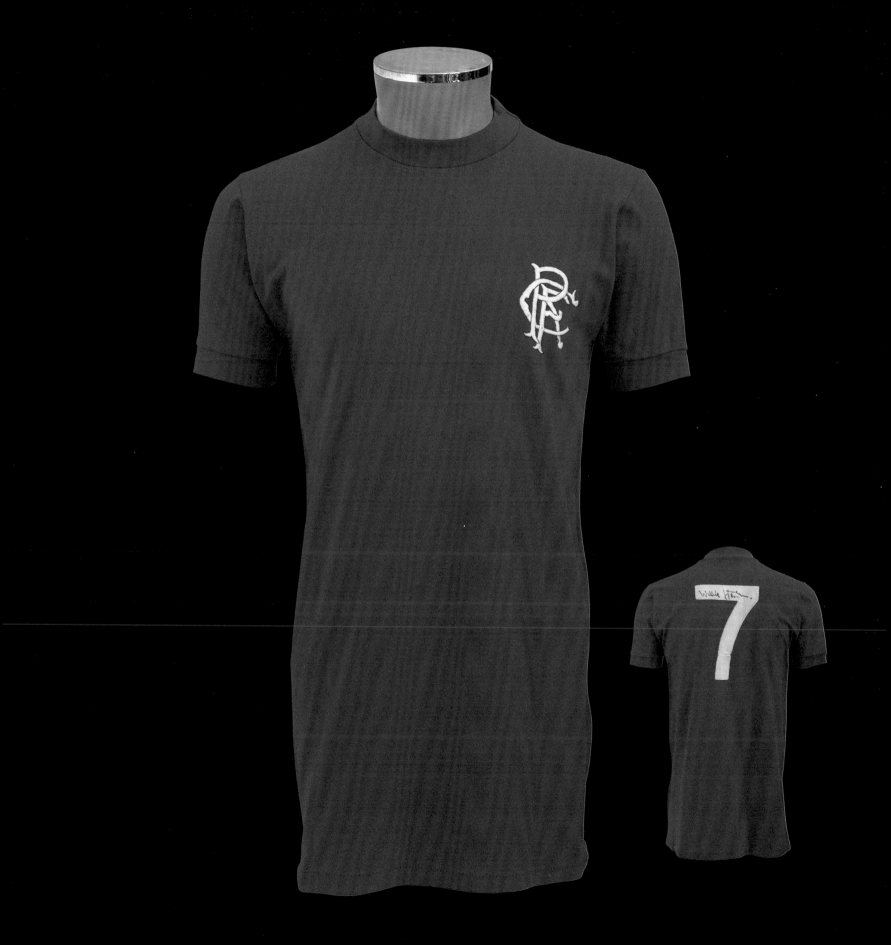

CHANGE 1968-78

August 1968 saw a new style of change shirt launched to coincide with the release of the club's smart new home kit. Manufactured by Umbro, the change shirt was identical in design to the home version, albeit now seeing a return to a scarlet red colourway last seen in the early 1950s.

Like the new home shirt, a club crest sat over the left breast but – unlike the previous crested shirts of the 1920s and '30s – it was now embroidered into the shirt as opposed to being sewn on as a patch. Traditionally the shirt would be worn with white shorts and blue socks, although through time it would also be seen with a red sock variation.

With the league rules of the period having the home team change in the event of a colour clash, this shirt would almost exclusively see use in matches at Ibrox during its 10-year lifespan, bar one lone outing at Hampden for a League Cup semi-final against Forfar in early 1978 – a match Rangers won 5-2 after extra time.

It did however travel with the team to European away matches, where it would see use either as training kit or, in the case of the European Cup Winners' Cup Final in Barcelona 1972, as leisure wear.

Unfortunately, very few of these shirts have survived, with none being available for the purpose of inclusion in the book.

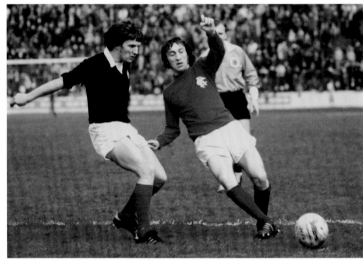

Above: Graham Fyfe and Dundee's Gordon Wallace tussle for the ball

Right: John Greig plays a game of dominos ahead of the 1972 European Cup Winners' Cup Final against Moscow Dynamo

Opposite (clockwise from top left): Ron McKinnon, Colin Stein, John Greig, Andy Penman and Willie Johnston pose for a 1968/69 pre-season photograph, with Stein sporting the new red change shirt

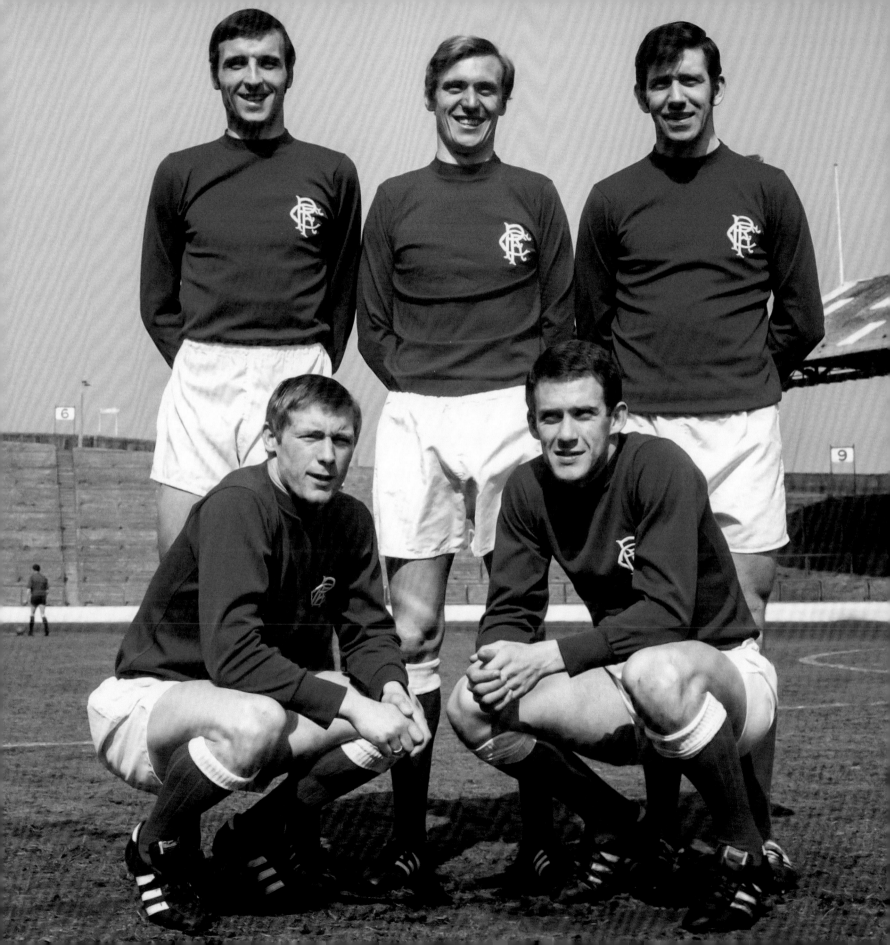

ECWC FINAL 1972

Match worn by **COLIN STEIN**

This shirt was worn during what was undoubtedly Rangers' greatest-ever triumph, when on 24th May 1972 they defeated Moscow Dynamo in the final of the European Cup Winners' Cup in Barcelona.

Having reached two European finals in 1961 and 1967 without success, it was to be third time lucky as the club finally cemented their place amongst the elite of European football.

On this famous occasion, the Rangers shirt featured commemorative match detail embroidery for the first time. However, only one set of the Umbro-manufactured shirts was embroidered with the game details, and because of the sweltering conditions in Barcelona many of the players changed into fresh shirts without the commemorative details at half-time. This meant that several of the players were able to swap shirts at the end of the match and still keep the unique cup final shirts they had worn in the first half.

Even if he wanted to swap shirts at full-time, Colin Stein never had the chance. Thousands of Rangers fans broke ranks and invaded the pitch to congratulate their heroes, with Stein even out-running his super-quick team-mate Willie Johnston in his haste to get back to the dressing room.

Despite the expected heat, Rangers had not brought any short-sleeved shirts to Barcelona, unlike their opponents who had come prepared with lightweight short-sleeved shirts. Indeed, unaccustomed to the early summer Spanish conditions, before the match Rangers had even instructed the players to wear their tracksuits whilst relaxing beside the hotel pool, less any of them succumb to sunstroke.

Stein was the man who set the club on their way to a famous victory with his 23rd-minute strike. The iconic picture of 'Steiny' turning away to celebrate, arms aloft and with his sleeves rolled up to the elbow, is one of the most famous photographs from that balmy night as the 'Barca Bears' attained legendary status, becoming the first team in Rangers history to win a European trophy.

Stein had joined the club in late October 1968 for a then Scottish record fee of £100,000 and made his debut on the 2nd November, scoring a four-minute hat-trick against Arbroath. He would become a fan's favourite during his two spells at the club, writing his name into the history books as one of the club's best-ever centre-forwards.

Colin Stein takes the acclaim of the Nou Camp after putting Rangers on their way to victory in the 1972 European Cup Winners' Cup Final

HOME 'CENTENARY' 1973

Match shirt of **COLIN JACKSON**

For the 1973 Scottish Cup Final against Celtic, Rangers wore a set of shirts carrying embroidery that commemorated the club's 100-year anniversary with the text 'Centenary 1873-1973'.

In fact, subsequent research has discovered that Rangers were not formed in 1873, but actually a year earlier in 1872. The error is thought to originate from an early history book, *The Story of the Rangers: Fifty Years' Football 1873-1923: A Jubilee History*, published in 1923. It is now believed that the author, John Allan, may have been flexible with the facts to ensure that the publication of his book coincided with the club's '50th anniversary'.

Despite this slight – although at the time unknown – inaccuracy on their shirts, Rangers rose to the occasion, defeating Celtic 3-2 with big defender Tom Forsyth poking home the winner with his studs from around six inches out after Derek Johnstone's header had come off both posts. Big Tam was an unlikely scorer, and he told the *Glasgow Herald* after the match: "I was so excited I nearly missed it." He wasn't joking!

The 'Centenary' shirts would make another appearance later that same year during a 100-year anniversary celebration friendly at Ibrox versus old friends Arsenal on 20th August 1973. More than 200 former Rangers players were paraded in front of 60,000 fans before the match was kicked off in style by 97-year-old Alex Newbigging – then the oldest living Rangers player – who had been signed as a goalkeeper by the club's first manager, William Wilton, in May 1906.

This shirt featured here was prepared for the 1973 final against Celtic. It was not worn and was later presented to defender Colin Jackson, who missed the match through injury, as a memento of another triumphant cup final occasion.

Midfielder Quintin 'Cutty' Young sporting the famous 'Centenary' shirt during Rangers' 3-2 victory over Celtic in the 1973 Scottish Cup Final

ALTERNATIVE CHANGE 1973-78

Match worn by **ALEX MacDONALD**

For the beginning of the 1973/74 season, the club unveiled a new version of the all-white alternative change shirt which had been in use from 1965 onwards.

Using the same round-neck, self-coloured Umbro template as the classic blue home and red change shirts from the period, this new white shirt incorporated an embroidered club crest – in blue – over the left breast. Unlike the previous all-white kit, blue shorts were worn with this shirt, with white socks and blue numbers.

One slight difference between this shirt and the home versions seen earlier in this book was that this style was manufactured in 100 per cent polyester, making it much lighter than those earlier shirts of the same style.

First used during a European Cup Winners' Cup first-round match away to Turkish side Ankaragücü on 19th September 1973 – which ended in a 2-0 victory for the visitors – this white design was only used on a handful of other occasions, primarily in matches against Dundee and St Johnstone. It was, however, a successful shirt during its five years in use – Rangers never lost a match while wearing it.

The shirt featured here was worn by midfield dynamo Alex MacDonald in almost every match when it was worn. Having signed for the club in November 1968 from St Johnstone, 'Wee Doddie' was a dyed-in-the-wool Rangers who gave everything for the cause and was a firm favourite with the supporters, who saw him as living their dream by playing for the club. In more than 500 appearances during his time with Rangers, MacDonald scored 94 goals and claimed a haul of three league titles, four Scottish Cups, four League Cups as well as the European Cup Winners' Cup.

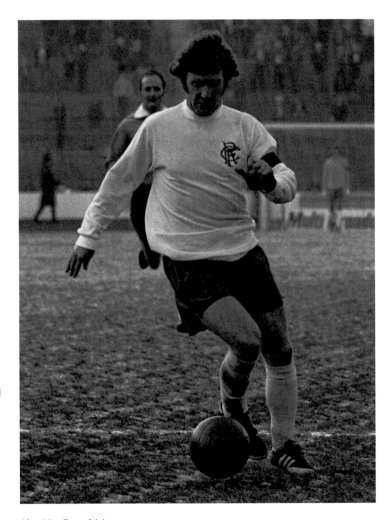

Alex MacDonald, in the rarely seen white Umbro alternative change kit, navigates icy conditions at Ibrox in January 1977

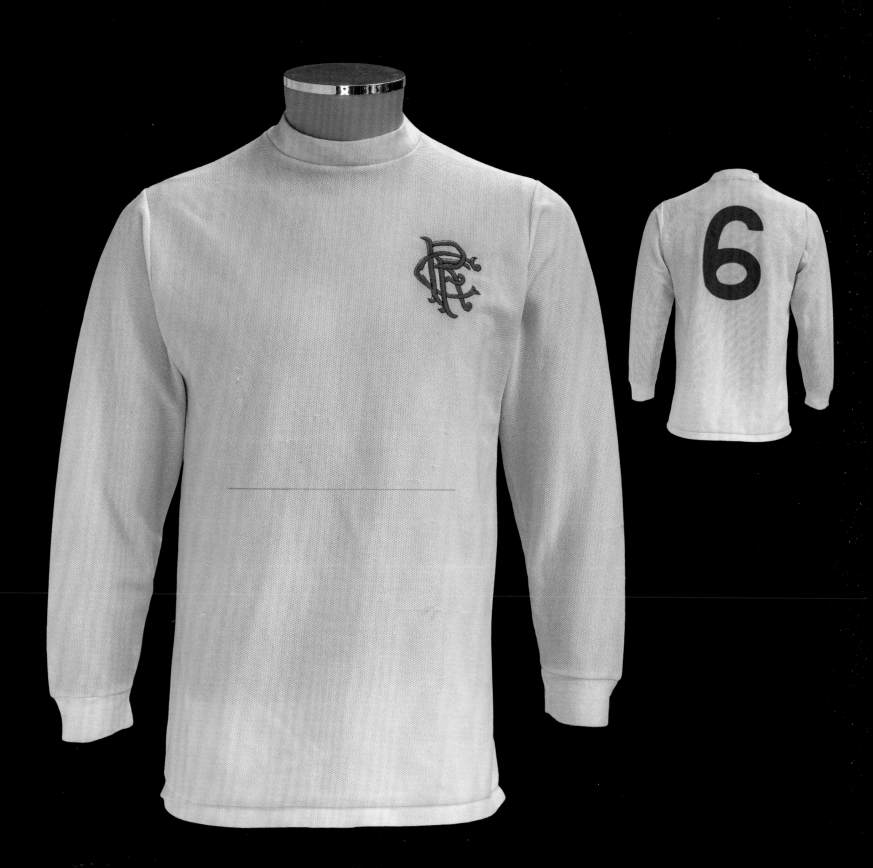

SCOTTISH CUP FINAL 1976

Match worn by **MARTIN HENDERSON**

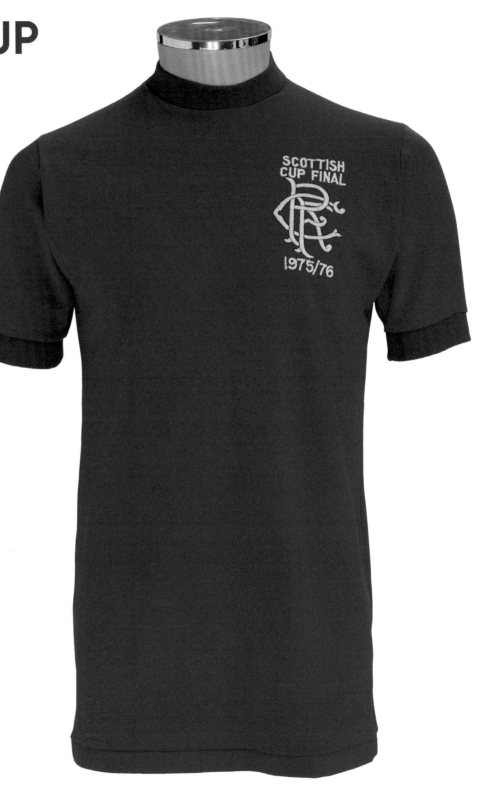

Rangers secured the domestic treble in the 1975/76 season by defeating Hearts 3-1 at Hampden on 1st May 1976. Two goals from Derek Johnstone, the first after only 41 seconds, and one from Alex MacDonald saw the Scottish Cup return to Ibrox for the first time since 1973.

This number 9 shirt was worn on the day by Martin Henderson, with the 19-year-old leading the line in front of 85,000 spectators in what was his only Scottish Cup Final appearance. Henderson had assumed the role in November 1975 after a drop in form by Derek Parlane and would retain the shirt until the end of the 1975/76 season – scoring 13 times in the process – before moving on from the club in 1978.

SCOTTISH CUP FINAL 1977

Match worn by **CHRIS ROBERTSON**

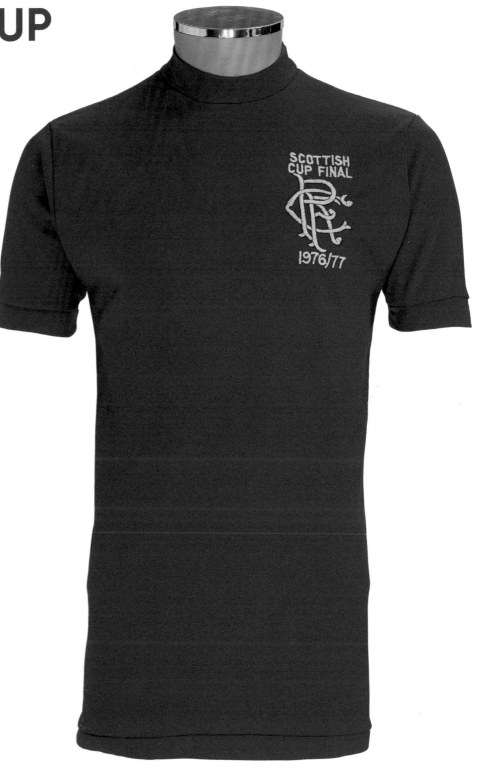

Rangers were unable to retain the Scottish Cup in 1977, going down 1-0 to Celtic, whose goal was scored with a disputed penalty. Derek Johnstone was the man penalised for handball, with 'DJ' maintaining his innocence to this day.

This number 12 shirt was worn by Chris Robertson, the youngster coming off the bench with 20 minutes remaining and almost equalising with a header which cannoned off the crossbar.

Robertson – the older brother of Hearts striker John Robertson – had been scoring freely in the club's reserve side, with a tally of more than 20 goals leading to him earning his place in the cup final squad. Chris departed the club in 1980 for Hearts, where he teamed up briefly with his younger brother.

TREBLE WINNERS

LEAGUE CUP
FINAL 1978

Match worn by **SANDY JARDINE**

Celtic were beaten 2-1 in the 1978 League Cup
Final with Gordon Smith scoring the winner
with two minutes of extra-time remaining.

Rangers had demonstrated their higher
levels of stamina and fitness, with manger
Jock Wallace's famously demanding training
sessions paying off once again. The players
had also showed their resilience and strength
of character during the game, which fell just
three days after the death of their popular
team-mate Bobby McKean. Wallace had

THE FIRST SHIRT DEAL

Like its counterparts at other clubs, the world-famous Rangers shirt was utterly transformed in the late 20th century as football's embrace of sponsorship and commercialisation turned the game into big business.

The mid-1970s and early 1980s were a momentous period of change in the world of football, with a dramatic revolution in the design of club shirts – which had remained virtually unaltered for a century – that saw them become logo-plastered, shadow-striped symbols of the increased commercialisation of the game.

For their entire history, like other clubs Rangers had purchased their kit every season via sports retailers, predominantly Lumley's Sports and Sportsman's Emporium in Glasgow.

The likes of Umbro and Bukta produced catalogues every year from which clubs – from those at the top of the professional

Willie Waddle played an instrumental role in securing Rangers' first kit deal with Umbro

game to lowly Sunday League amateurs – could purchase their kit. Naturally Umbro would offer incentives to clubs like Rangers since it was in their interest to be supplying the best teams around, but with no manufacturer logos on the shirts there was no obvious way for anyone to determine which manufacturer was supplying which club.

With the manufacturers focusing on selling adult-size team kits, there was no replica kit market as such. The idea of an adult wearing a team shirt to the match was unheard of, and if parents wanted to buy the club colours for a football-mad son or daughter, they would have to purchase a plain shirt (which could have been made by any manufacturer) from their local sports store and a badge to stitch onto it from the club shop.

It was English company Admiral who turned this traditional state of affairs upside down when they signed the first-ever modern kit deal with 1973/74 English league champions Leeds United. Admiral founder Bert Patrick recognised the market potential of selling replica kits, initially to children, and was prepared to pay clubs for the right to supply them. By the mid 1970s, Admiral were supplying the likes of Manchester United, Coventry, Aberdeen, Dundee and Clydebank, and in 1974 they signed a sensational deal to supply the England national team – the FA agreeing a contract that would earn them a £150,000 annual advance on its 10 per cent royalty on shirt sales.

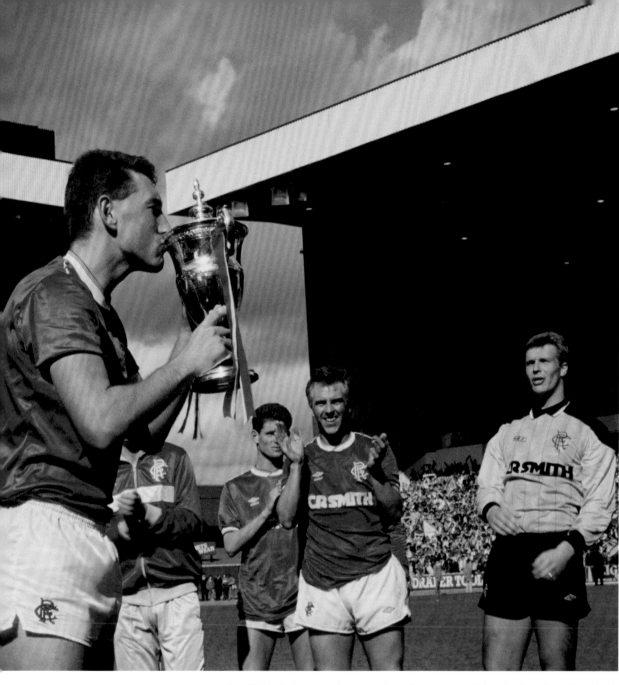

Club captain Terry
Butcher kisses the
Premiership trophy
after Rangers'
1986/87 title triumph.
Note the different
sizes of the CR
Smith logo on Dave
McPherson's (far left)
and Graham Roberts'
(far right) shirts

But if Admiral were to invest so heavily in
these deals then they needed to ensure that
other manufacturers could not copy their
designs, and this fact sparked a revolution
in football shirt design. Club shirts that had
barely changed for decades were suddenly
adorned with all manner of new colours,
logos, stripes, details and trims.

While dipping their toes more gently into
the water in terms of design aesthetics, other
manufacturers – primarily Umbro but also

adidas, Le Coq Sportif and others – were
quick to follow. If they were going to pay for
the privilege, at the very least they wanted
their logo on the shirt to prevent any other
company selling similar-looking replicas.

With a deeply ingrained respect for
tradition, Rangers were relatively late to
the party, with the board first exploring the
possibility of a commercial deal with a shirt
manufacturer in 1976. Then, on 23rd February
1977, an initial meeting took place between

Umbro marked the
signing of their new
four-year deal with
Rangers with adverts
such as this one,
which appeared in
the Rangers News
in early May 1978

Umbro and Rangers renewed their partnership for a further two years after their initial deal concluded in 1982 – the club's passionate and loyal fan base had attracted the attention of Le Coq Sportif but Umbro's offer won the day

Rangers vice-chairman Willie Waddle and Umbro International.

After negotiations, an initial four-year deal was agreed and the new partnership began on 1st May 1978. This deal would see an embroidered Umbro 'double diamond' logo appear on the club's shirts, beginning with the Scottish Cup Final on 6th May 1978, while on 3rd May the *Rangers News* ran an Umbro ad with the strapline: "Like Rangers, choose Umbro sports and leisure wear."

The Umbro deal marked a watershed moment in the club's history, with a kit manufacturer now paying to have their logo on the shirt as well as the right to manufacture and market replicas alongside a new range of associated merchandise – tracksuits, training tops, t-shirts and so on – for supporters.

Interestingly, Rangers goalkeeper shirts had been seen with an Umbro logo from the 1972 European Cup Winners' Cup Final onwards – for some reason brand advertising on goalkeeper shirts had gone under the radar in the early 1970s, with many sides featuring branded shirts between the sticks.

For the first time, officially branded, mass-produced replica shirts – in both the home and change designs – were available in the club shop. These were different from the player-specification shirts in terms of the material used and in that the replica shirts had the Umbro logo and club crest heat-pressed on, as opposed to being embroidered as they were on the player-specification versions.

In March 1982, as the first Umbro deal was concluding, Rangers considered offers from both Umbro and Le Coq Sportif for the right to become the official kit supplier from the 1982/83 season onwards. Already supplying the likes of Tottenham Hotspur, Aston Villa and Everton, the French sportswear company were not able to match the Umbro deal and Rangers renewed for a further two years, with

Campbell Ogilvie was appointed as Rangers' general secretary in 1978

CR Smith's groundbreaking sponsorship deal with both Celtic and Rangers ensured that neither side of Glasgow felt alienated

the proviso that the club kept copyright of the Rangers crest.

At the same time as the relationship between football clubs and kit manufacturers was changing, another knock-on effect of the commercialisation of the game was the sudden appearance of shirt sponsorship.

In September 1982 Rangers first discussed the idea of shirt sponsorship, with the then general secretary Campbell Ogilvie stating in the *Rangers News*: "Tradition is something this club will always have, but times change. Five years ago, we didn't have the Umbro motifs on our jerseys. We have to move with the times and a jersey sponsorship deal is something we cannot overlook."

Although it was discussed at board level, official approval was required from the footballing authorities before the idea could progress. Fortunately, midway through the 1983/84 season, the Scottish Football Association gave the go-ahead and – after weighing up various options – Rangers made history by signing their first-ever shirt sponsorship deal in September 1984. The famous royal blue jersey would carry the logo of Scottish double glazing firm CR Smith, who

had secured the rights in a deal worth around £250,000. In fact it was a joint deal, with Celtic signing up on the same terms and both clubs agreeing to wear the CR Smith logo on the front of their shirts for the next three seasons. It was a shrewd move by the firm in that it avoided alienating either side of the famous West of Scotland divide – a tactic revisited by other companies up until 2013.

The first match shirt to feature the new sponsor's logo was worn on 29th September 1984 during a 1-0 win at Ibrox over Dundee United. In line with UEFA guidelines, a smaller version of the sponsor logo was required for European use and TV matches, and for the 1985/86 and 1986/87 seasons the shirts were produced with this smaller logo only, although the team were seen wearing a mix of larger and smaller logo shirts in domestic matches.

On completion of the CR Smith deal in 1987, Rangers came to an agreement with Scottish Brewers to have McEwan's Lager on the front of the club's shirts in an initial three-year deal worth £1 million. With the arrival of David Holmes as chairman and Graeme Souness as player-manager, Rangers were big business and the commercial side of the club, for so long neglected, was driven forward by a more financially minded board.

Rangers' kit deal with Umbro concluded at the end of the 1989/90 season and Admiral were awarded the contract from the start of the 1990/91 campaign. Scottish Brewers remained as the main shirt sponsor until 1999 during what was an enormously successful period in the club's history, with McEwan's Lager being very much front and centre on the Rangers shirt throughout the whole 'nine-in-a-row' campaign.

In the space of just a handful of years, the Rangers shirt had transformed forever.

An Admiral advert featuring Rangers kits – the Leicester-based manufacturer took over from Umbro for the 1990/91 season

THE KIT ROOM

The Rangers shirt is known wherever football is played, so it is unsurprising that the select few to be entrusted with its care have become part of the very fabric of the club and ensure its traditions remain cherished.

Rangers are a club who pride themselves on looking their best on the football field. In a tradition going back to the days of manager William Struth, the club would have two sets of kit prepared for each match so the players could change at half-time into a clean, dry outfit. Struth felt that this would provide a psychological advantage over the opposition, who would often reappear in wet, dirty clothing while Rangers would take to the field looking immaculate and ready to go.

Nowadays it's very much the choice of the individual player whether to change at half-time, with some choosing not to do so, but the option is still available with two sets of kit always prepared for use.

In the early days of Rangers' existence, as with most clubs of the period, players would be responsible for paying for and maintaining their own kit. A surviving club handbook from the 1874/75 season stated the rule that "each Member is expected to be in possession of the Club Uniform; and that no Member can take part in a match unless in Uniform". Shirts in this early period would often be purchased by the club and sold back to the player to ensure uniformity in appearance. As the early years progressed it became the responsibility of the club to supply the playing staff, usually with a 'one size fits all' shirt, which would remain the property of the club and as such would need to be looked after and maintained throughout the season.

By the 1880s the role of looking after the kit at Rangers was under the auspices of the Ground Committee, who concluded that the day-to-day responsibility for the kit should fall under the remit of the club's trainer. Rangers' first 'professional' trainer was Johnny Taylor, who took on the full-time role of looking after the players from 1888 until his untimely death from pneumonia in 1897 at the age of just 45. During his time he helped guide the club to its first league title victory in the 1890/91 season and its first Scottish Cup Final win in 1894, and was often praised for how immaculately he had the Rangers players turned out.

The Scottish Sport, reporting on that 1894 Scottish Cup Final, described the arrival at the stadium of the kit of both Rangers

Ibrox's home changing room as it was during the 1965/66 season

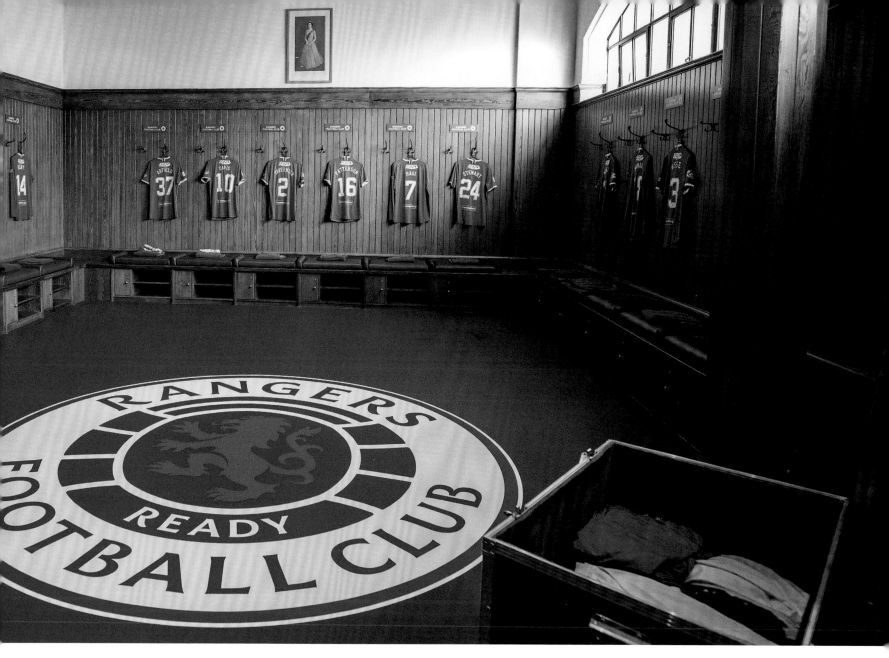

Jimmy Bell lays out the players' kit in the immaculate home changing room at Ibrox

and Celtic, highlighting the standards set by Taylor in the process: "A slight flutter was caused when the first cab drew up. The idlers made way for the 'nobility and gentry', who proved to be Johnny Taylor and his man Geordie, with a gigantic hamper. What that hamper contained gave rise to a keen discussion and the remark by a bystander that 'the Rangers would get a big dram at half-time'. Some minutes later the Celtic paraphernalia appeared. No cab for them. Tommy Bonar drove up the club pony, harnessed to an antiquated cart in regular

'knocked them in the Old Kent Road'-style, and another big hamper was unloaded."

Taylor was followed by James Wilson, who held the role from 1897 to 1914 and was responsible for preparing and coaching the team through the remarkable and record-breaking first 'Invincible' season of 1898/99, which saw Rangers winning all 18 of their league matches.

When James Wilson too died at a relatively young age, Rangers secured the services of another young trainer by the name of William Struth, who held the post from 1914 until 1920

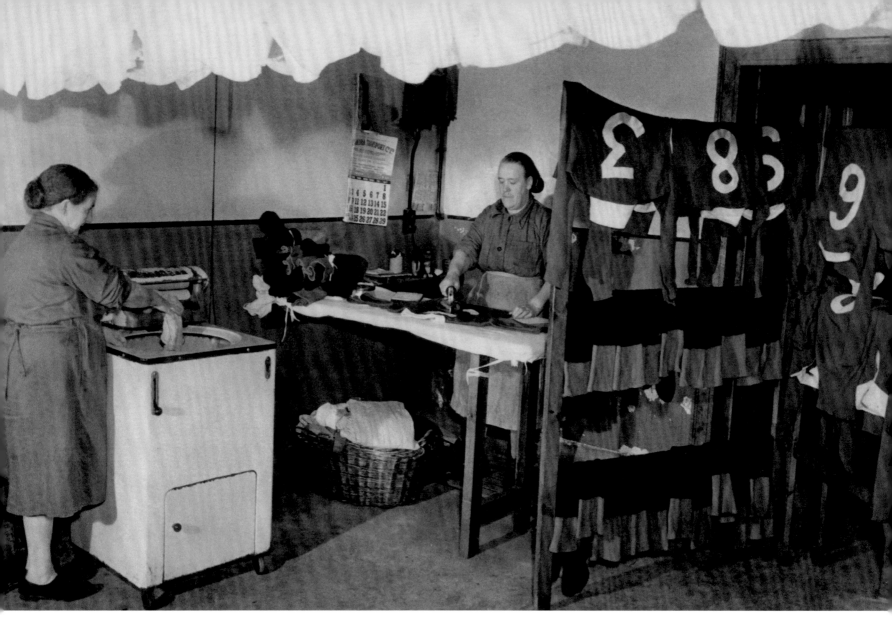

The Rangers laundry operation, here pictured in action during the 1950s

before taking over the role as manager following the passing of William Wilton. A series of ex-players followed him in the role as trainer, including:

George Livingstone: 1920-1927
James Kerr: 1927-1932
Arthur Dixon: 1932-1947
Jimmy Smith: 1947-1956
Davie Kinnear: 1956-1970

As important as the trainer was to the role of overseeing the kit, the real heroes of preparing and maintaining the kit at the time were the backroom ladies. As early

as August 1896, Rangers had employed a washerwoman at a rate of 10 shillings a week, who was tasked with washing and mending the players' kits and was requested to be present at the ground on Saturdays as a term of her employment.

In the late 1930s, the washerwoman role was taken on by Maggie Lindsay, who would go on to serve the club for 35 years in various capacities. At the time she joined the club, Rangers were sending kits outside the stadium to be laundered, but Maggie – along with her colleague, Jeannie Patterson – would soon assume complete responsibility for the laundering of the playing kit with the

Maggie Lindsay (left) and Jim Baxter are all smiles in the Rangers laundry room during the 1960s

• *America here we come . . . Rangers physiotherapist Tommy Craig was a busy man last week making sure that all the equipment was in order for the Light Blues' North American tour.*

Tommy Craig shows off the kit boxes required for one of the club's tours to North America during the 1970s

introduction of Rangers' own 'steamie', or wash house, within the stadium. The room contained washing tubs, washing boards and a mangle to wring out the clothes, and the ladies would not only ensure the cleanliness of the kit but would also be responsible for the mending, darning and ironing of the kit. Unlike today's modern versions, the earlier sets of shirts would be expected to last a full season at least. Even into the 1970s the shirts would be scrubbed clean on an old scrubbing board, and the Ibrox wash house would continue to see use until the opening of the Rangers Training Centre in 2001, which included new, purpose-built laundry facilities.

This was the beginning of a family dynasty, as Maggie was joined in the wash house for a spell by her daughter-in-law, Lizzie Love, who would take on various roles during her almost 50 years of service with the club. Lizzie's daughters, Mary (better known as 'Tiny') and Irene Gallagher, would also become long-standing servants of the club, alongside many other members of the extended Love/Gallagher family.

From 1947 until the early 1970s, the Rangers trainers were assisted by another former player in Joe Craven, who guarded the kit room "like a bank vault" according to ex-player Derek Johnstone. Players were not permitted to keep a Rangers shirt as a souvenir unless expressly gifted one by the club, and swapping shirts with an opponent was never even considered, unlike today where some players have gained impressive collections of jerseys. Only when shirts began to feature commemorative embroidery in the 1970s for cup finals and Testimonial matches did it become acceptable for the players to be allowed to keep their own match shirt.

Joining Rangers as a physio in 1970, Tommy Craig would serve 12 years with the club, where he continued the dual role of looking after the fitness of the players as well as kit duties. He was followed by Stan Anderson, Bob Stewart and Bob Findlay, before everything changed with the arrival of David Holmes, who became chairman of Rangers in 1986.

Mr Holmes could see the need for redevelopment in all areas of the club and set about fashioning Rangers into a modern business. Setting up a commercial department, he attracted investment and

sponsorship which had previously been sadly lacking and was instrumental in the high-profile appointment of Graeme Souness as player-manager in April 1986.

As a part of the reorganisation of the club, 1986 also saw the chairman invite an ex-employee of his from the John Lawrence Group to help look after the players. George Soutar, known to the players as 'Doddie', was assigned the role of looking after the playing kit. Doddie would modestly claim his role was really to make the tea but it was obvious that, as a Rangers supporter all his days, he thrived in his new role.

Within a short period, however, it became obvious that the burden was too heavy for Doddie to manage alone as a man in his later years. It was for this reason that Graeme Souness and Walter Smith would ask a gentleman by the name of Jimmy Bell to become the club's first official kitman.

A lifelong supporter first and foremost, Bell's association with the club began in 1981 as a driver with Parks of Hamilton, who supplied the club with the official coach for transport to matches. His first big job for

George 'Doddie' Soutar (back row, far left) and Jimmy Bell (front row, far right) formed a formidable backroom partnership

the club was taking the players' wives and families to Hampden for the 1981 Scottish Cup Final before driving a supporters' club bus to the same venue a few days later for the replay. Jimmy would work as a full-time mechanic for Parks during the week and drive for the club on Wednesdays and Saturdays, and happily recalls the prestige of driving the side to the Scottish League Cup Final in 1984 under Jock Wallace's watchful guidance.

Bell's role evolved to helping to load and unload the kit, and working under the new management team of Souness and Smith it was noticeable that – despite Doddie's enthusiasm – the heavy role really required a younger man to manage the kit. Jimmy was the ideal candidate for the job, known and respected by the playing and coaching staff and with a basic knowledge of kit organisation. With Doddie available to provide assistance, Bell was offered the role on a Saturday and started full-time on the Monday. Parks of Hamilton were happy for Bell to take on the extra responsibilities, which he would combine with continuing to drive the team coach. The dual role continued until Mark Warburton's reign as manager in 2015, when Jimmy was requested to step down from his role as driver.

It was a steep learning curve but a challenge that Bell relished, although maybe not initially. "Driving the bus was the easy bit," he recalls, as he began to develop an improved process for managing the club's kit. "It definitely needed better organising, and I did wonder at times what I had let myself in for. As a mechanic, I always had my tools with me. If something went wrong, I could fix it." Feeling at times that he was out of his comfort zone, those early days made Bell realise the importance of being prepared for any eventuality.

Keen to adhere to the standards of the club, those early days working under Souness

David Holmes (left) ushered in a new regime behind the scenes as well as a world-famous manager and star players

This was much to the anguish of the club laundry ladies of the period, Cathy and Betty, who jokingly described Souness as "the bastard that gave us all the extra work".

Within the laundry room at Ibrox, the washed shirts were hung up to dry on traditional wooden pulleys, and this method is still in use to this day. With the building of the Rangers Training Centre in 2001, the laundry room at Ibrox was no longer required, but Bell ensured the wooden pulleys were removed and installed in the new purpose-built laundry room at Auchenhowie.

The role of the modern kitman involves working closely with the laundry staff, especially with the mountain of kit required to be cleaned on a daily basis. Not only is the first team catered for, but the role now includes laundering and organising the Rangers Women's kit as well as that of the B team and youth academy.

Today the laundry room operation is run by Karen Steel and Mary Murray. Still a two-person job, shirts no longer require hand washing but instead are fed into four large industrial washing machines to ensure their cleanliness. Once washed, they are hung up

and Smith would see Bell drive the coach while wearing his club suit, which he would continue to wear in the dugout, leading Walter Smith to recall that "Jimmy was the only person that I ever saw changing a set of studs while wearing a Versace suit". Nowadays, Bell can be seen in a more relaxed set of training gear pitchside.

The arrival of the Souness era quickly forced Rangers to take a more modern and professional approach, with the new boss determined to bring much-needed changes to a sleeping giant of a club. Until the Rangers revolution in 1986, the players would re-use one set of training kit. The dirty kit would be hung up to dry overnight before being used again the following day, still dirty from the previous exploits and only washed once per week. Having experienced top-flight football in both England and Italy, Souness would give the club the shake-up it needed. He saw to it that new kit was purchased, and Jimmy was given the job of ensuring kits were washed daily and fresh kit was available for training at any given time.

The laundry room at the Rangers Training Centre in Auchenhowie is certainly a far cry from the old facilities at Ibrox

to dry and returned folded two days later for Bell to organise. It's a complex task, a fact Bell appreciates having had to do it all over the world by himself during trips away from home.

Souness' time in charge would also see Bell act as an occasional personal driver for his new boss. If Souness wanted to travel to watch a prospective signing, Bell would often take him there, and he happily recalls driving to Leeds for Souness to play in Don Revie's Benefit match before driving him home again straight after the game. Bell knew he was in a privileged position given the fact that Souness famously only places his trust in a select bunch of people. That sense of trust is something that Jimmy has maintained throughout his time at Rangers, enjoying a close working relationship with nine full-time managers as well as the hundreds of players whose confidence he has kept during a 40-year association with the club.

Players past and present have nothing but good words for Bell, as they know that

nothing is too much trouble for him – but only once they have earned his respect. Dutch legend Ronald de Boer has played all over the world and describes Bell as the best kitman he's ever worked with. Likewise Paul Gascoigne, who returned to the Rangers Training Centre for a visit in 2019 to see Steven Gerrard's side's match preparation and simply couldn't wait to search out Bell for a reunion – more than 20 years after leaving the club.

Although he has a reputation outside the club of presenting a dour exterior, those who have had the privilege of witnessing Bell operate inside the bubble of the team environment know nothing could be further from the truth.

Make no mistake, however – Bell has no qualms about keeping players humble and mindful of the traditions and expectations that come with a club like Rangers. Josh Windass tells jokingly of how Jimmy is only too happy to keep players grounded, telling the *Open Goal* podcast: "I would walk in in

No one knows the standards and expectations that come with the Rangers shirt better than Jimmy Bell

1971 INVENTORY
Match Hamper
Two sets of royal blue jerseys plus an extra goalkeeper jersey; three sets of white shorts; one set of red and white stockings plus six spare pairs; tie-ups, cotton wool and soap; Vaseline and talcum powder

Training Hamper
19 tracksuits (including a dark blue one for manager Willie Waddell, a red one for trainer Jock Wallace and a light blue one for Tommy Craig); 19 red jerseys; 19 sets of white stockings; 19 sets of black shorts; tie-ups, medical bag and 16 pairs of shinguards

Small Hamper
38 towels; four pennants; five boxes of club ties

Boot Hamper
16 pairs of leather studded boots; 16 pairs of rubber studded boots; 19 pairs of training shoes; studs and laces

the morning and he'd look at me in disgust and say: 'Brian Laudrup, now he was a proper number 11. You're shite. Get home.'"

Bell takes defeat as badly as any other Rangers supporter. One day he was watching two young players laughing and joking while having a darts competition a day or two after a defeat. "Yeah, ask them what skip the dartboard ended up in," Bell laughs. Accepting defeat is not the Rangers way – nor is it Bell's.

One thing Jimmy is not a fan of – like kitmen all over the world – is the swapping and giving away of shirts, citing the extra work it creates in terms of having to print up new shirts. He understands that everyone wants a Rangers shirt when they play against them, but nowadays a lot of teams don't swap shirts as they are instructed not to by their club, yet it doesn't stop them asking for a Rangers shirt. Bell recalls a match from a few years ago where he advised the players not to swap due to shortages. By half-time seven players had agreed to give their shirts to the opposition after the final whistle, much to his frustration. As the players sat on the bus following the match an opposition player knocked on the bus door to complain that he hadn't been given a shirt. "Aye, and you are still not getting one!" said a less-than-impressed Bell before closing the bus door.

Kit requirements have changed dramatically through the years, with the professional game seeing many more items added to a kitman's inventory. Those early days of the Rangers kit hamper arriving by horse-drawn cab soon moved on with the introduction of motorised transport and by the 1940s, a club employee by the name of Tom Petrie would drive the Rangers supplies to away matches, filling his taxi with two wicker baskets full of kit. His vehicle would later be superseded by the introduction of

the team bus, which allowed the players and kit to travel together.

When Rangers travelled to Rennes on 15th September 1971 for the first round of the successful European Cup Winners' Cup campaign, the kit requirements had doubled again to four hampers, and the inventory from that trip (left) demonstrates just how much the kit had expanded.

Today, the four hampers of 1971 have expanded to 10 hampers of kit and equipment, with that increasing to 18 hampers for European trips. As the club now train at a custom-built facility on the outskirts of Glasgow, even matches at Ibrox require detailed preparation, but fortunately Bell's philosophy of "every match is an away match" ensures nothing is left to chance. Although now working with an assistant, Jimmy still arranges the match kit by himself, working to a system in his head as he has done for many years. "I don't write things down," he explains. "If you need to write it down, you just confuse yourself. It's just all about being prepared for every eventuality."

A Rangers kit box dating from the 1970s – a far cry from its enormous modern counterparts

The only thing that he does insist on is that players are responsible for ensuring that their boots are left out, ready to be packed in the match hampers. This has been the way since the days of Dick Advocaat's time as manager. On asking Advocaat what should happen if the players forget them, Bell was told: "It's simple, they don't play and they get fined. It's their tools. A joiner wouldn't go to work without his tools."

As part of his match preparation, Bell prefers to put out the kit the night before the match. That way, if any late adjustments need to be done, they can be taken care of in the morning. He will take kits for all players in case of last-minute injuries or inclusions. The day before the match Bell will be given a list of players for the squad and he ensures that kit is put out for all members, whether playing or not, so as not to give the opposition any chance of knowing the team line-up. He recalls captain Lorenzo Amoruso quizzing him before a match a few years ago, "But Jimmy, he's not playing and he's not playing," and replying, "Yeah, you know that but the opposition don't."

Two sets of kit are laid out for the team, with Bell knowing who has a preference for long or short sleeves and who will likely change at half-time. A spare set is also left out for the goalkeepers, although they very rarely change their kit at the interval.

Although Bell claims not to be a superstitious man, he prefers not to change winning habits. As an example, Rangers will often wear a change kit away to teams such as Aberdeen and Hibs, despite there being no colour clash. If the team had a good result on their previous visit, then Bell will stick with the same colour of kit.

Likewise, the captain will always be given an unwashed armband to wear if it was worn in a victorious previous match. During the 2020/21 season, captain James Tavernier requested a new armband to be worn with Castore's 'retro' kit which would see use in the League Cup match away to St Mirren. Despite Bell's protestations, Tavernier preferred a new one to be worn with the new kit. Unfortunately, Rangers went on to lose the match; 'Tav' has never again requested a new armband following a victory.

Rangers is a club steeped in tradition and standards. Bell, who is especially proud of their heritage, installed a photograph of HM The Queen in the home dressing room before a match against Celtic in 1988. Rangers went on to demolish their arch-rivals 5-1 that day and the photograph has remained in place ever since, with the captain changing beneath it. Bell would also be responsible for the club wearing a poppy on their shirt from as early as 2003. Before the days of having a specially embroidered shirt, he would buy a box of poppies and these would be stuck onto the shirts, with the opposition sometimes also making use of Bell's supply – 2008 would see the end of this method as the club began to produce their own embroidered commemorative poppy shirts.

Sometimes you just have to improvise! Rangers shirts are hung out to dry at Buckie Thistle's Victoria Park ground in 2014

Jimmy Bell, meticulous as ever, applies lettering to a shirt in the Rangers kit room

The responsibilities of the modern-day kit manager have expanded massively from the days of simply mending and washing the kit after a match. Today the job is a full-time position, involving preparation and maintenance of kit and equipment on an industrial scale throughout the season, and requires loyalty, commitment and empathy – the professional athletes of today have far more requirements than just kit, and the kitman's room is often a place where they feel able to open up on any issues requiring a sympathetic ear.

It's a role that Bell takes great pride in, and he has never forgotten that he is a Rangers supporter who works for the club that he loves. He may not be a Meiklejohn or a Struth or a Gerrard, but there is no doubting the huge influence that Bell has had during his 40 years at Rangers, and through people like him the standards and traditions set from the early days of the club continue to be respected.

THE BLUE SEA OF IBROX

1978-1990 UMBRO

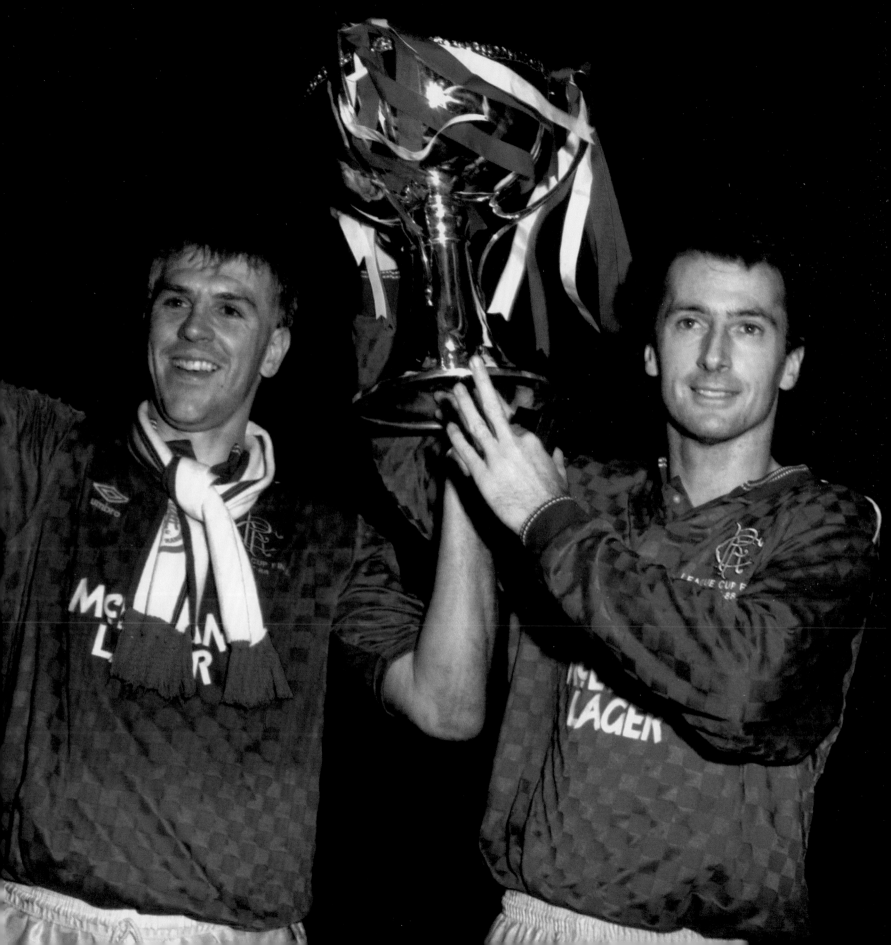

HOME 1978-82

Match worn by **DEREK JOHNSTONE**

A new era dawned for Rangers at the beginning of the 1978/79 season, with the club turning to legendary long-time captain John Greig to replace Jock Wallace as manager. Along with the new management team came a brand-new playing kit.

This was the dawn of a new era as far as football kits were concerned. The replica kit industry had taken off – although kits were initially only made for children – and Umbro were playing catch-up after their Leicester-based rivals, Admiral, had turned the football world upside down with their daring, modern designs and team kits plastered with their logo.

But it wasn't just the shirts that changed at this time; Admiral changed the whole relationship between football teams and their kit manufacturers. Gone now were the days of clubs selecting their kit from a catalogue and purchasing it every season. Now the manufacturers would have to pay for the privilege of having teams wear their shirts as well as – crucially – the right to sell replicas to the fans. In return they would be able to change the designs regularly and – of course – place their logos in prominent positions on their clubs' famous shirts.

Long-term supplier Umbro, therefore, became Rangers' official kit partner in 1978, producing a royal blue home shirt with a new style v-neck and fold-down collar. Both collar and cuffs were trimmed in red, white and blue. The shirt was unveiled during a pre-season friendly match away to Inverness Caledonian Thistle on 29th July 1978, was subsequently worn for four years and remains a popular and fondly remembered Rangers jersey.

The shirt featured here was worn by legendary striker Derek Johnstone, who scored more than 200 goals in 546 appearances for the club, winning three league titles, five Scottish Cups and five Scottish League Cups, as well as claiming a European Cup Winners' Cup winners' medal.

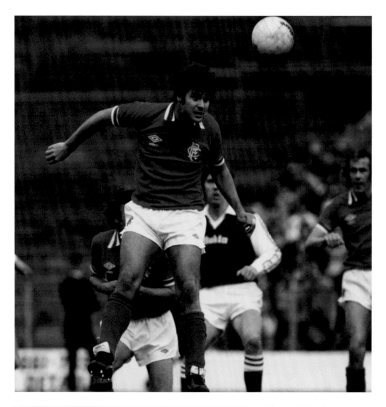

Above: Derek Johnstone, sporting the first-ever Rangers home shirt to feature the colours red, white and blue together

Left: The club crest was a dominant presence on this much-loved jersey

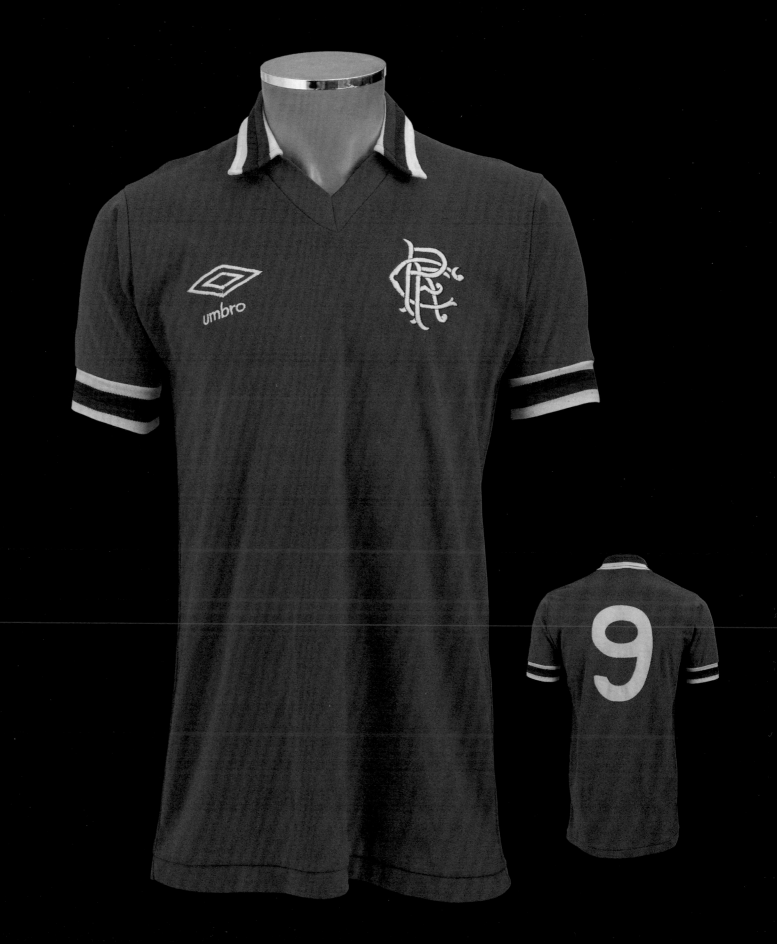

CHANGE 1978-82

Match worn by **SANDY JARDINE**

The first Rangers change shirt under the new official relationship with Umbro was a stunning red version of the home jersey.

Red had been the first-choice change colour since 1968, but as well as the addition of the large fold-down collar and cuffs trimmed in red, white and blue, this was the first Rangers alternative shirt to carry a manufacturer logo – Umbro's 'double diamond' mark appearing over the right breast.

Over the course of its four-year lifetime, the shirt was worn on fewer than half-dozen occasions, both at home and away. But whenever it was used the number 2 shirt was invariably worn by club legend Sandy Jardine.

Christened William Jardine, he was nicknamed 'Sandy' because of his hair colour, and the name stuck throughout his long career at Rangers. During his career at the club, he made over 650 appearances, a record only bettered by John Greig and Dougie Gray. He would amass a total of three league titles, five Scottish Cups and five Scottish League Cup with the club, as well as a European Cup Winners' Cup winners' medal before departing in 1982 to end his career at Hearts.

After retiring from football he returned to Rangers in a PR capacity, and in 2012 he fronted the 'Rangers Fans Fighting Fund' campaign, including leading a fans' march to the headquarters of the SFA to deliver a letter protesting about sanctions that had been applied to the club.

Jardine sadly passed away after a short illness at the age of 65 in 2014 but is remembered fondly by all associated with the club, with the Govan Stand having been renamed The Sandy Jardine Stand in recognition of his services to the club.

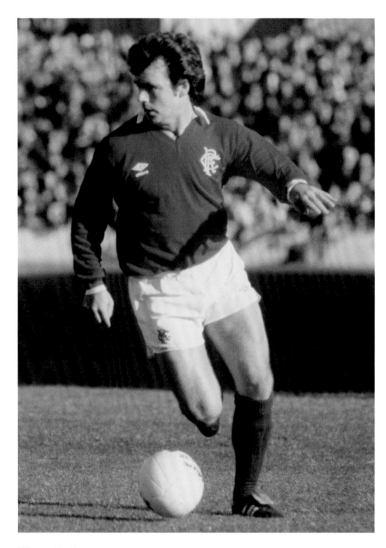

Winger Davie Cooper on the ball against Dundee in 1981 and wearing the long-sleeved version of this iconic shirt

CUP DOUBLE

LEAGUE CUP FINAL 1979

Match shirt of **ALEX MILLER**

For the 1979 Scottish League Cup Final against Aberdeen, Rangers had long- and short-sleeved shirts prepared for the match, with unusually bold match embroidery arranged in a circular pattern around the club crest.

With the final played on a beautiful spring day in March, all the Rangers players started in short sleeves. Then at half-time they changed into a new set of short-sleeved shirts, but these were standard league shirts without embroidery.

When substitute Alex Miller came on in the second half, he too wore a plain short-sleeved shirt and the shirt pictured here was never worn.

A late header from Colin Jackson gave Rangers a 2-1 win in the final.

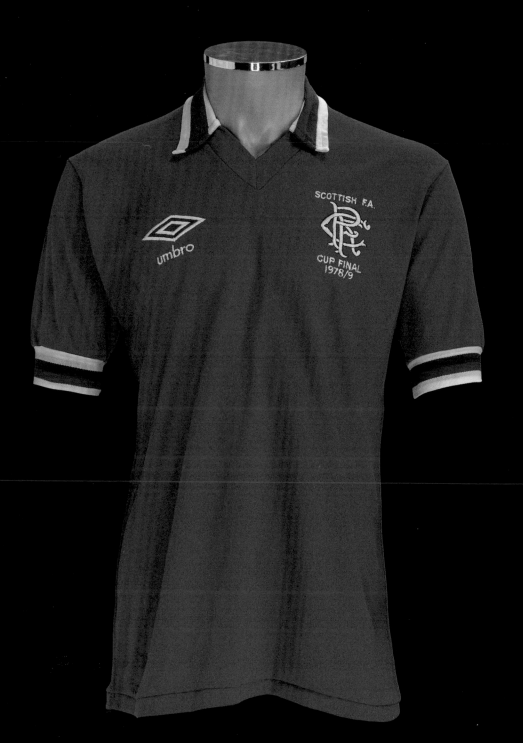

SCOTTISH CUP FINAL 1979

Match shirt of **ALEX MILLER**

The shirts prepared for the 1979 Scottish Cup Final against Hibernian are unusual in that they were actually required for three matches – the tie eventually being settled after a second replay.

In the end more than five-and-a-half hours of football were played, with Rangers winning the third game 3-2.

Despite finding himself on the bench for all three matches, Alex Miller came on as a substitute in each, even missing a penalty in the second replay.

Well-respected by supporters, Miller was a utility player who always gave everything for the cause. A clash with Celtic's Jim Brogan during the 1971 Scottish Cup Final had even seen him play the second half with a jaw broken in three places.

SCOTTISH CUP FINAL 1980

Match worn by **JOHN MacDONALD**

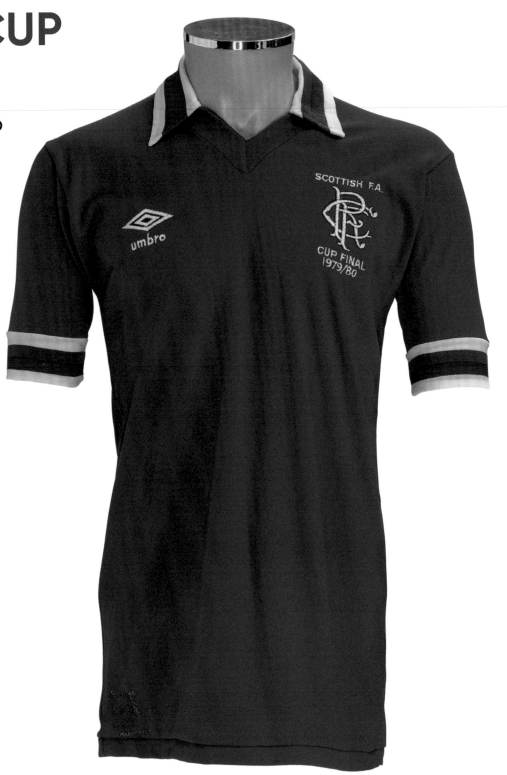

The 1980 Scottish Cup Final against Celtic would go down in Scottish footballing history – not for the football played but for the trouble that occurred after the match, with both sets of supporters battling it out on the pitch. It was a watershed moment, one which led to the banning of alcohol at Scottish football grounds.

The match itself saw a deflected goal during extra-time earn Celtic the trophy, but that scarcely seems to matter given the events that followed the final whistle.

This shirt was worn by John MacDonald, a lifelong Rangers fan, who said: "I can't begin to tell you how proud I was when I signed for Rangers. To be able to pull on the light blue jersey was every schoolboy's dream." Despite the disappointment of losing his first Scottish Cup Final, he would make up for it in style the following year.

SCOTTISH CUP FINAL 1981

Match worn by **JIM BETT**

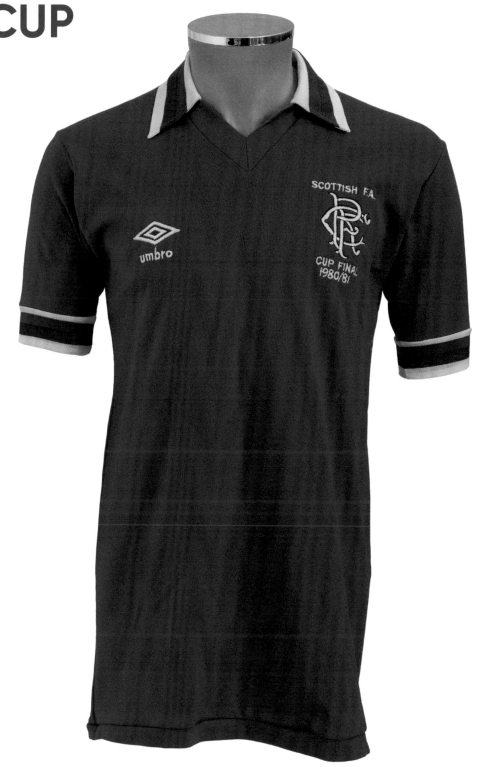

This shirt was worn by Jim Bett during the 1981 Scottish Cup Final and subsequent replay against Dundee United three days later.

With the first game finishing goalless after midfielder Ian Redford had a last-minute penalty saved, Rangers produced a fantastic performance in the replay. Goals from Bobby Russell, Davie Cooper and two from John MacDonald secured a 4-1 win and clinched the trophy for the 24th time in the club's history.

A silky midfielder, Bett was signed in 1980 from Belgian club Lokeren and would win one Scottish Cup and one Scottish League Cup during his three years with Rangers. His final match for the club was the 1983 Scottish Cup Final against Aberdeen, a club he later played for with distinction following another two-year spell in Belgium.

HOME 1982-84

Match worn by **SANDY CLARK**

Unveiled to the press on Friday 6th August 1982, Umbro's brand-new home kit was the first major departure from a plain blue shirt, with the addition of white pinstripes being the stand-out feature.

Advances in fabric manufacturing had allowed manufacturers to experiment with material containing man-made fibres, and this design is made from a 70 per cent nylon fabric, which meant that it shimmered and shined like no Rangers shirt before it.

The shirt is also notable for the return of a v-neck collar style, reminiscent of the 1960s home shirt, albeit complimented by a neat blue and red trim that also appeared in the cuffs.

Rangers first wore this shirt during a pre-season friendly against the new FA Cup holders, Tottenham Hotspur, at Ibrox on 8th August 1982. Spurs ran out 1-0 winners on the day against a new-look Rangers side. It went on to be worn over the next two seasons during a period that saw the end of John Greig's reign as manager and the return of Jock Wallace, who took up the mantle in November 1983 for a second stint in charge.

The shirt pictured here was worn by striker Sandy Clark during a European Cup Winners' Cup second round second leg match away to Porto on 2nd November 1983 at the Estádio das Antas. Losing the match 1-0, Rangers exited the competition on the away goals rule despite having recorded a 2-1 victory in the first leg at Ibrox.

Clark had moved to Rangers from West Ham in March 1983 but left the club in October 1984 after struggling to command a regular starting place under Wallace's stewardship.

Sandy Clark, wearing the last Rangers home shirt to not feature a sponsor, on the ball against Celtic

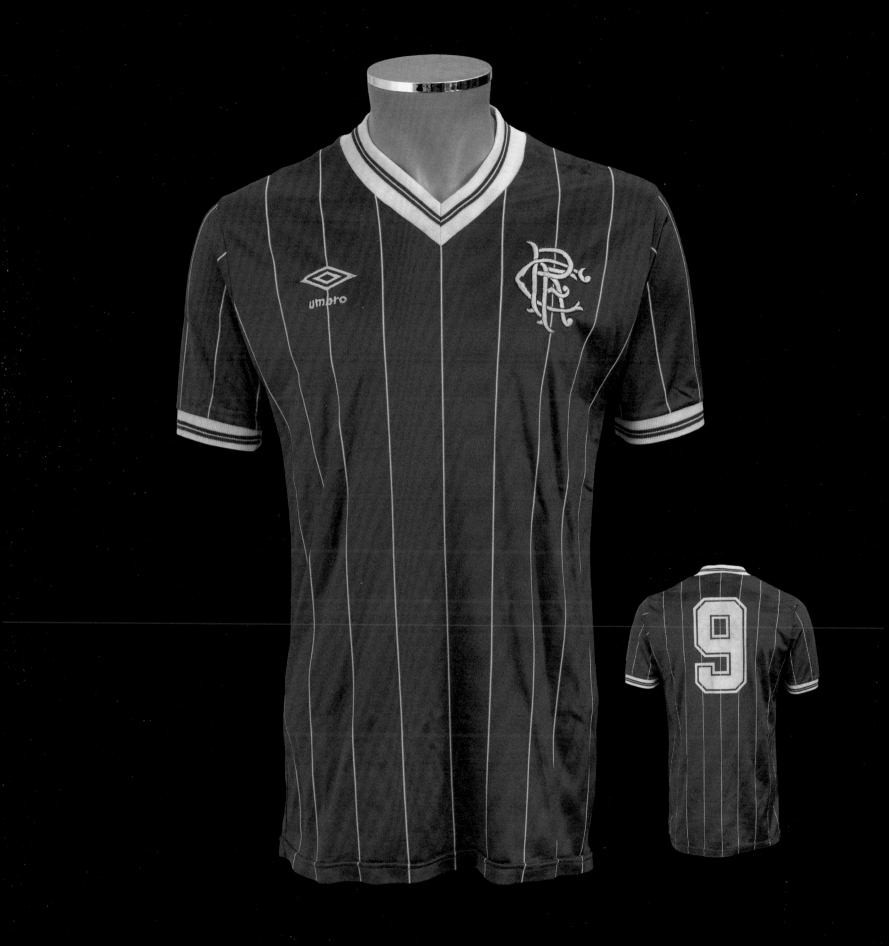

CHANGE 1982-85

Match worn by **IAN REDFORD**

Rangers' first white change shirt since 1973-78 was worn for three seasons between 1982 and 1985. Like the home shirt from the same period, it was notable for the incorporation of pinstripes – this time a neat double-lined red and blue design – that were very much 'of the time'.

An even more notable feature on the shirt pictured opposite is the addition of a sponsor logo. The name of double glazing company CR Smith had first appeared on the Rangers home jersey in late September 1984, and the same company logo was also added to the existing change design in blue.

The shirt pictured opposite was worn at home to Inter Milan in the UEFA Cup in November 1984 on a famous night at Ibrox. Having lost 3-0 in the first leg in the San Siro wearing their home kit (UEFA regulations at this time meant that in the event of a clash the home team changed), Rangers wore their white change shirt for the second leg and proceeded to tear into their illustrious Italian opponents, who included Karl-Heinz Rummenigge and Liam Brady in their line-up.

In a tactical masterstroke, manager Jock Wallace had moved defender John McClelland up front, a formation tweak which caused havoc in the Inter defence. Rangers scored three times but went out 4-3 on aggregate after a goal scored by Inter's Alessandro Altobelli sealed their fate. Despite the aggregate defeat it was one of the club's great European club performances as the all-star Italian team was humbled by a spirited performance from a Rangers team encouraged by the noisy Ibrox support.

The shirt pictured opposite was worn by midfielder Ian Redford, who swapped with Inter goalscorer Altobelli at the final whistle. The Italian striker would later describe the night at Ibrox as an extremely tough match.

Keen-eyed observers will notice that the CR Smith logo is smaller on this shirt than on the shirts worn in the league. This is because of UEFA regulations, which stipulated that sponsor logos had to be smaller than was allowed in Scottish domestic competition.

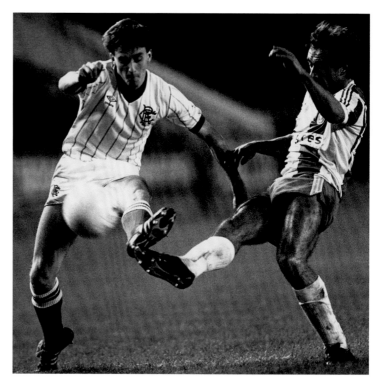

Above: Bobby Russell – in the short-sleeved, unsponsored version of this shirt – and Porto's Jaime Pacheco clash during the European Cup Winners' Cup match at Ibrox in October 1983

Right: The sizeable and ornate club crest was a prominent feature of this jersey

SCOTTISH CUP FINAL 1983

Match worn by **GORDON DALZIEL**

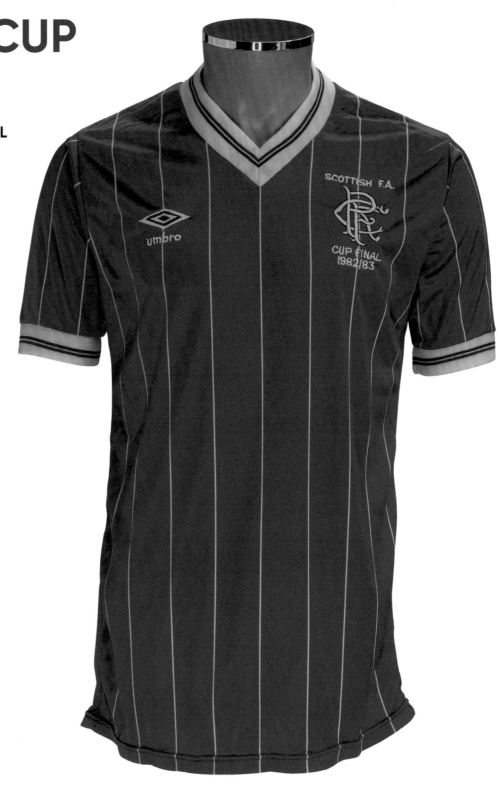

Rangers were at Hampden again on 21st May 1983 for what was a club record eighth consecutive Scottish Cup Final appearance. Sadly, it wasn't to be another trophy-winning occasion as a late Eric Black goal settled the match for Aberdeen during extra time.

This number 12 shirt was worn by 21-year-old striker Gordon Dalziel, who came off the bench to play the 30 minutes of extra time, favouring the short-sleeved version of the shirt – as all the Rangers outfield players did that day. A product of Rangers' youth system, Dalziel had made his full debut for the club in 1979 but would only feature intermittently over the next four years before moving on to Manchester City in December 1983.

Despite making it to both domestic finals, the 1982/83 season was a disappointing one for the club, with Rangers finishing fourth in the league.

LEAGUE CUP FINAL 1984

Match worn by **JIMMY NICHOLL**

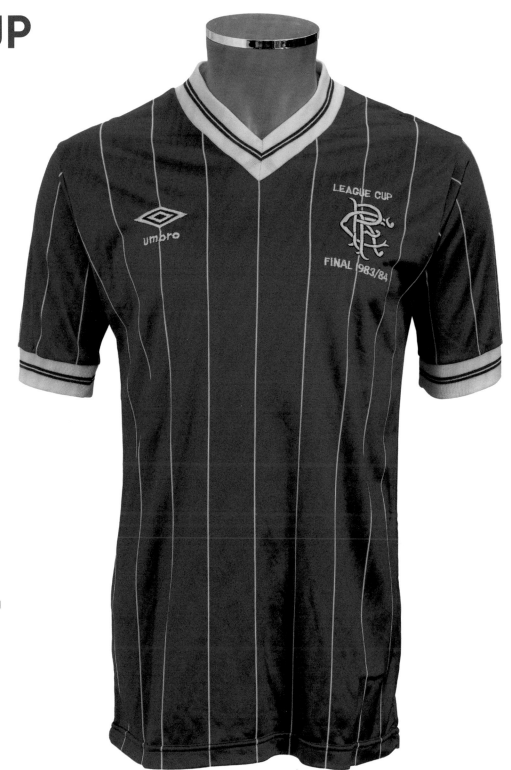

Rangers won the League Cup Final in March 1984 with a 3-2 victory over Celtic, with all three goals scored by striker Ally McCoist.

This shirt was worn by Ulsterman Jimmy Nicholl who was on loan from Canadian side Toronto Blizzard, the arrangement being that he would play for Blizzard in the summer and Rangers in the winter.

A few weeks after winning the League Cup, Nicholl was given the captain's armband for his last match of the loan spell, a home game against Celtic. Rangers won 1-0, but Nicholl was sent off in the 55th minute. He later recalled: "After the game, Jock Wallace said to me, 'Nicholl, you are going back to North America on Monday, but if we hadn't won that game you wouldn't have needed a plane as I would have booted your backside so hard you would have landed in Toronto'."

HOME 1984-87

Match worn by **IAIN FERGUSON**

Rangers unveiled a brand-new home shirt at the pre-season photocall at Ibrox on 7th August 1984, and the shirt made its debut the following day in a friendly against Leicester City.

Manager Jock Wallace was not a fan of the modern style of kits and had wanted to see a return to a more traditional Rangers shirt. Fittingly, therefore, the new Umbro design saw a return to a plain royal blue body, with the previous jersey's pinstripes conspicuous in their absence. The new crossover collar in white with blue piping gave this shirt a contemporary twist and was matched in the colour of the cuffs – although short-sleeved shirts were occasionally seen minus the cuffs.

A few weeks after the start of the season, double glazing company CR Smith announced that it had signed a three-year shirt sponsorship deal with both Rangers and Celtic – worth £250,000 to each club – and on 29th September the new home shirt was adorned with a sponsor's logo for the first time as Rangers took to the field to face Dundee United.

During its time on the Rangers shirt, the CR Smith sponsor logo would appear in different sizes. Some shirts were prepared to meet UEFA guidelines requiring smaller sponsor logos than used domestically. Rangers would often mix and match, occasionally using both styles of shirt during the same match.

This particular shirt style is synonymous with the arrival of Graeme Souness as player-manager in April 1986 to replace Wallace, whose second stint at the club hadn't reached the heights of his previous spell in charge. Souness was joined by Walter Smith as assistant manager, and these appointments marked the start of a Rangers revival.

Souness and Smith were winners and brought that mentality with them into the Ibrox dressing room. Signings such as the England captain Terry Butcher, goalkeeper Chris Woods and defender Graham Roberts gave Rangers a solid defence to build from, and the Premier League title was won on a dramatic day at Pittodrie on 2nd May 1987, as Rangers secured the title for the first time since 1978.

This particular shirt was worn by striker Iain Ferguson as Rangers won the Skol League Cup Final at Hampden on 28th October 1984. It was Rangers' 13th Scottish League Cup Final victory, and Ferguson – who had joined the club in the summer of 1984 – scored the only goal of the game in a 1-0 victory over Dundee United. It would be the only honour he won during a two-year period with the club.

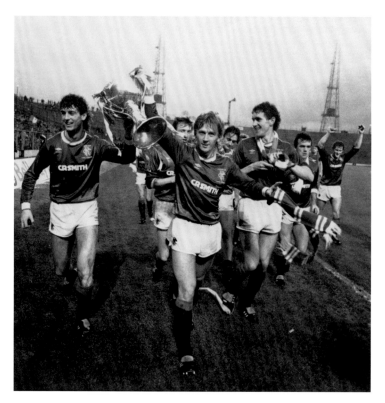

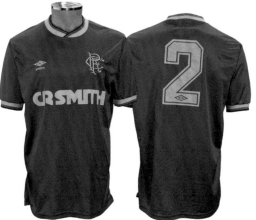

Top: Rangers celebrate with the League Cup trophy after Iain Ferguson's superb strike clinched a 1-0 victory over Dundee United

Right: Note the different-sized CR Smith logos on this shirt and the one opposite – a result of UEFA regulations on TV advertising

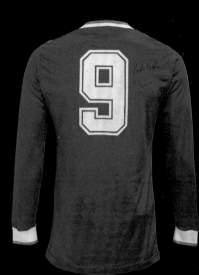

CHANGE 1985-88

Match worn by **SUBSTITUTE** and **DAVIE COOPER**

Although a new home shirt had been unveiled at the start of the 1984/85 season, it wasn't until the start of the following season that a new change shirt was released.

Rather than mirroring the style of the home shirt, as had become the custom, this stylish new Umbro design was white with a smart horizontal band of blue and red across the chest and an open-neck fold-down collar, also in royal blue.

This shirt was worn over a period of three seasons, and for its first two seasons would feature CR Smith as shirt sponsor before McEwan's Lager came on board for its final season in 1987/88.

Used on numerous occasions during its three-season lifetime – including an outing in the popular Tennent's Sixes indoor tournament – the shirt would make its final appearances during pre-season matches against Raith Rovers and Kilmarnock in July and August 1988, even though a new change shirt had already been unveiled to the press for the 1988/89 season. Both sponsors are featured on these pages.

With squad numbers not yet in use, it is not always possible to say for certain which players wore which shirt, but the number 14 shirt (opposite) was the second allocated substitute number (along with 12 since 13 was never used) and so would have been worn by a number of players during its lifespan. However, during the 1987/88 season – when the McEwan's Lager version was worn – the number 7 shirt (right) was used by Davie Cooper, Kevin Drinkell and Derek Ferguson.

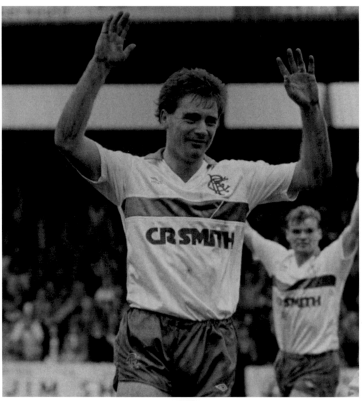

CR Smith were the first sponsors to appear on this popular change shirt, with the switch to McEwan's Lager (right) coming in the 1987/88 season

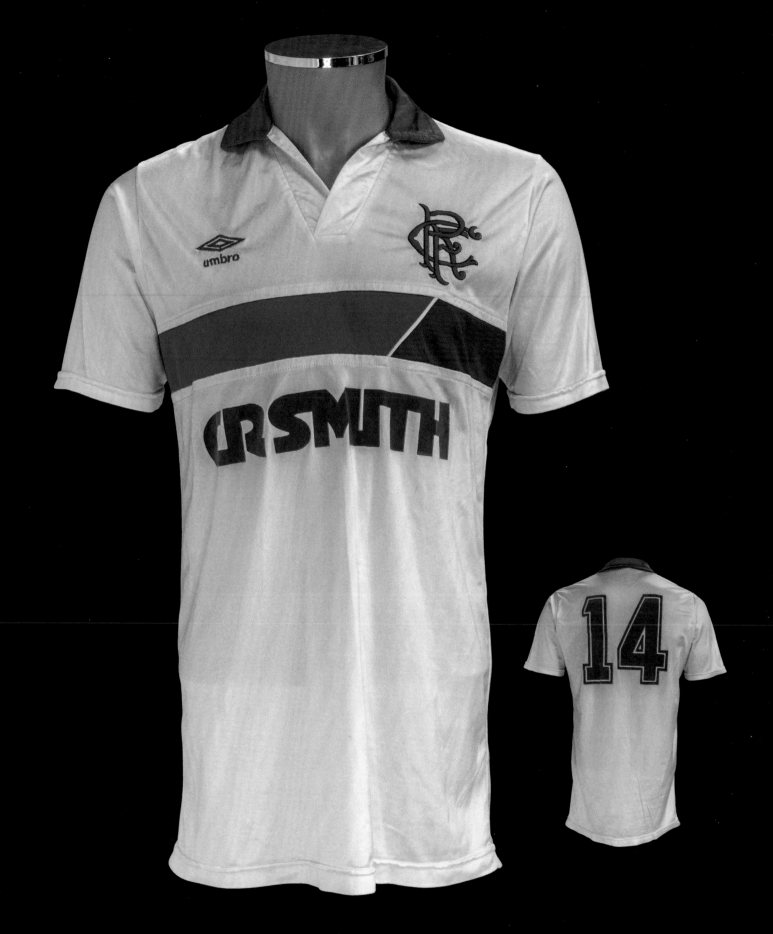

HOME 1987-90

Match worn by **KEVIN DRINKELL**

Rangers launched a new home shirt as Scottish Premier League champions in July 1987, and along with the new design came a new sponsorship deal. A three-year deal with Scottish Brewers would see the club carry the McEwan's Lager logo on its shirts.

The deal initially attracted some criticisms as health campaigners argued that it might encourage young fans to try out the product advertised by their idols. This was refuted by Rangers chairman David Holmes, who explained to the *Rangers News*: "We considered offers from seven or eight different companies who wanted to be our sponsors and thought long and hard before giving the nod to Scottish Brewers. A young person buying a Rangers strip identifies with their heroes in the team, not the name on the front of the jersey."

The new shirt was the last produced for the club by Umbro until the company returned for the 2005/06 season. Made of 100 per cent 'Tactel' nylon, the plain blue shirt featured a chequerboard shadow pattern throughout and a retro grandad-style collar in blue with red piping and incorporating a border of small white squares. A single press-stud button allowed the collar to open at the front, although this nearly always remained closed when worn by the players. During its first two seasons, shirts with the standard, larger-sized club crest were used but for the 1989/90 campaign the badge was reduced in size.

Two league titles were secured wearing this style of shirt, first in 1988/89 and then 1989/90, kicking off the famous 'nine-in-a-row' league title-winning period.

This particular shirt was worn by Kevin Drinkell on 23rd October 1988 during the Scottish League Cup Final against Aberdeen at Hampden. Drinkell was brought down by Aberdeen keeper Theo Snelders in the 14th minute of the match for a penalty, which was converted by Ally McCoist as Rangers defeated the Dons 3-2. Drinkell had signed for the club from Norwich City in July 1988 and made 36 appearances during his 15 months at the club, before losing his place to Mo Johnston and signing for Coventry City in October 1989.

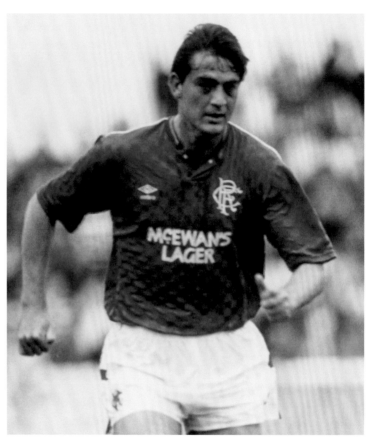

Above: Kevin Drinkell was a powerful presence in the Rangers line-up but the arrival of Mo Johnstone put paid to his time at Ibrox

Right: Loved by fans, the last home shirt of Umbro's tenure was an instant classic

CHANGE 1988–90

Match worn by **STUART MUNRO**

On 1st June 1988, Rangers unveiled a brand-new and very striking Umbro change shirt. With its red and white diagonal halves and opposing red and white sleeves, it was very similar to the famous shirt design of French side Monaco.

The collar and long-sleeved cuffs were in white with red and blue piping, and like on the home version the grandad-style collar was secured at the front with a press-stud button. The McEwan's Lager logo and the shirt numbers were applied in flock, and the club crest was embroidered in blue along with Umbro's 'double diamond' motif.

Appropriately enough considering the seeming French influence on the design, the shirt was first worn against Bordeaux on 14th August 1988 during Davie Cooper's Testimonial match, which was its only appearance at Ibrox. Such was the high esteem that Cooper was held in that a full house attended the match, with thousands locked outside unable to get in. As well as the Cooper Testimonial match, the shirt was used a further nine times between 1988 and 1990, including three Testimonial matches – all played away from home.

This particular shirt was worn by defender Stuart Munro, who signed from Alloa Athletic in early February 1984 and made his debut a few weeks later against Dundee. With the arrival of Graeme Souness and the start of the Rangers revolution, many felt Munro would be replaced by a big money signing as Souness and Smith rebuilt the team, but to his great credit his performances saw him remain as first-choice left-back for the club until his departure to Blackburn Rovers in 1991, having more than played his part in the early titles of the 'nine-in-a-row' period.

Worn for two seasons, this was the final Umbro release before Admiral took over the reins as the club's kit supplier for the start of the 1990/91 season.

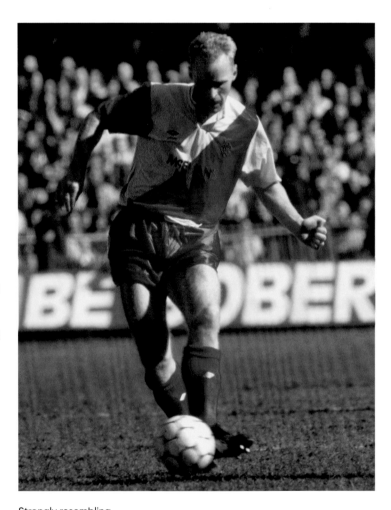

Strongly resembling the Monaco shirt of the period, this jersey – worn here by defender John Brown – was something of a radical departure for Rangers

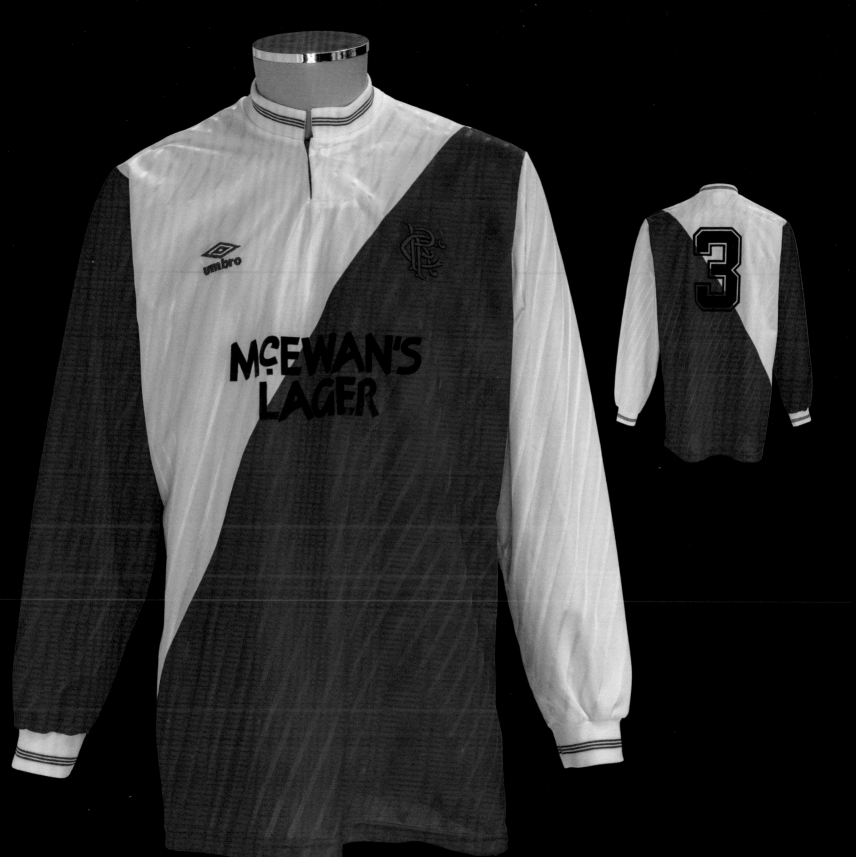

SCOTTISH CUP FINAL 1989

Match worn by **RICHARD GOUGH**

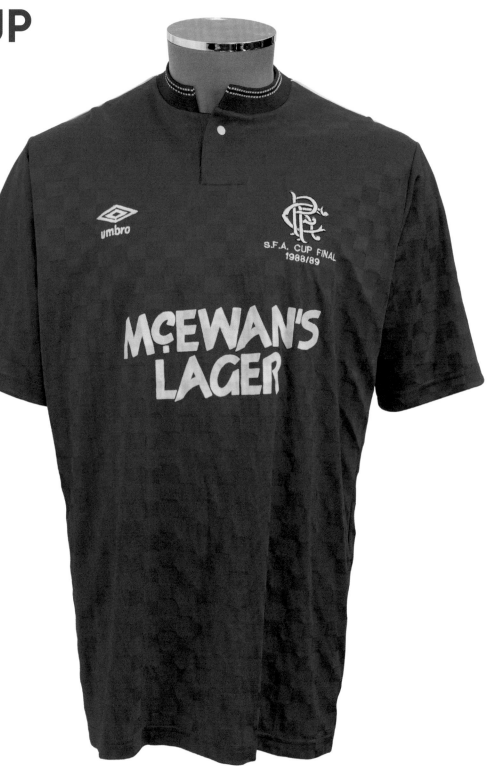

The 104th Scottish Cup Final took place between Rangers and Celtic on 20th May 1989. Having wrapped up the league title the week before, Rangers were denied a domestic treble when they lost 1-0 to Celtic at Hampden, having felt certain they were on the end of some dubious decisions from the match officials.

Rangers' player-manager Graeme Souness was subject to a touchline ban at that time, but was able to take his place on the bench by naming himself as a substitute for the match.

This shirt was worn by Richard Gough, one half of a formidable central defensive partnership alongside Terry Butcher, in the future club captain's first-ever Scottish Cup Final with Rangers. Gough had signed in October 1987, with the club paying Tottenham Hotspur £1.1 million to secure his services.

LEAGUE CUP FINAL 1989

Match shirt of **IAN FERGUSON**

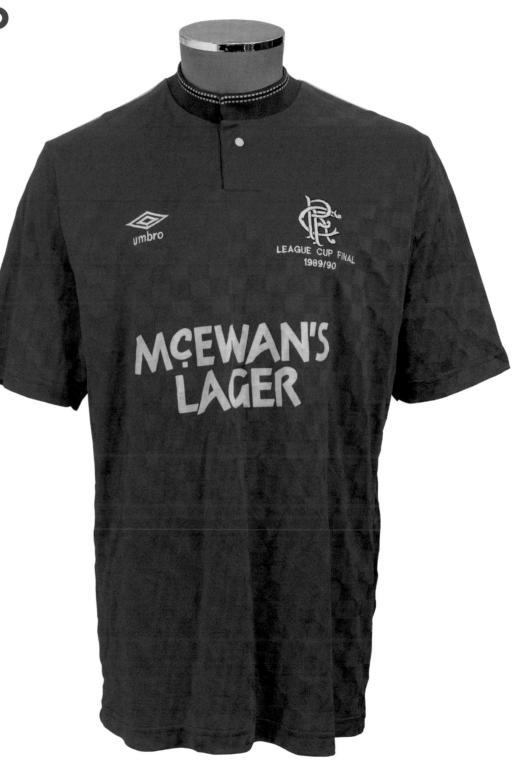

This shirt was prepared for Ian Ferguson when Rangers faced Aberdeen in the final of the Scottish League Cup for the third year in a row.

A boyhood Rangers fan who grew up in the shadow of Celtic Park, Ferguson joined Rangers in February 1988 from St Mirren. Going on to win his first league title a few months later, Ferguson was one of only three Rangers players to complete the 'nine-in-a-row' journey, along with team-mates Richard Gough and Ally McCoist.

The previous two finals at Hampden had seen Rangers take the spoils, but Aberdeen won this match 2-1. With the majority of the Rangers team favouring the short-sleeved version of the shirt for the final, only Ferguson – whose alternative shirt is pictured here – and Ray Wilkins wore the long-sleeved version during the game.

BETWEEN THE STICKS

Originally identical to the shirts worn by their outfield colleagues, the Rangers goalkeeper jersey has become as distinctive as the numerous club favourites who have worn it over the years.

This section pays tribute to the men between the sticks, a position that can make you a hero or a villain with supporters in the blink of an eye. Thankfully, Rangers have had many more heroes than villains when it comes to goalkeepers, and the jerseys they have worn have been just as storied as those of their outfield counterparts.

During the early years of football, clubs saw no need to differentiate between outfield players and goalkeepers, and Rangers were no different. Up until the 1890s it was commonplace for all 11 members of the team to wear the same colour jerseys, which no doubt led to some confusion for both spectators and officials. Rangers had actually filed a protest with the Scottish Football Association in November 1875 after a 2-1 loss to Third Lanark RV which insinuated Rangers' loss had been as a result of a failure to recognise the Third Lanark goalkeeper. The complaint was not upheld.

Those early keepers for Rangers included James Watt and George Gillespie, a man who had started his career as an outfield player and played full-back for the club during the famous 1877 Scottish Cup Final matches against Vale of Leven.

In the early days of Rangers' existence it wasn't unusual for goalkeepers and outfield players to occasionally swap positions, and on 27th October 1877 Gillespie started in goal for the Scottish Cup clash with Alexandra Athletic, replacing Watt for that one match. One year later he returned to goalkeeping, possibly due to fitness issues as some years later his obituary in the *Scottish Referee* of February 1900 – following his death from pneumonia at the young age of 40 – suggested that "terrible struggles told upon his rather tender tendons... he was forced to give up playing back and retire into goal". Although he made the goalkeeper position his own, Gillespie remained open to the odd game as an outfield player if and when required. He would also feature for the club during the 1879 Scottish Cup Final, once again versus Vale of Leven, but this time as the club's goalkeeper.

Towards the turn of the century it became apparent that at least some distinction would have to be made between goalkeepers and outfield players, and photographic evidence from the early to

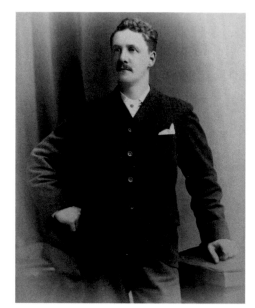

George Gillespie was an especially versatile Ranger, beginning his playing career at full-back before largely switching to goalkeeping duties

mid-1890s shows Rangers keeper David Haddow wearing a different style of shirt (although, interestingly, not a different colour) from his team-mates – an old-style H&P McNeil shirt with collar and pocket while his colleagues sported the pocketless, grandad-style shirt.

Haddow's approach to goalkeeping back then was typical of the no-nonsense temperament required at the time, and he was described in a periodical in 1893 as "a very reliable man who fears nothing. He resents the too kind, attentions of rushing, charging forwards and is inclined to punch them out as well as the ball". Haddow would go on to become the first Rangers goalkeeper to win a Scottish Cup Final after the club's 3-1 triumph over Celtic in 1894.

Such a distinction remained the exception rather than the rule and it was only during the first decade of the new century that contrasting goalkeeper jerseys would start to be worn regularly. Team photographs of the late 1890s and early 1900s show Rangers beginning to move away from the regular blue shirt to woollen jumpers for their keepers. Then came the International Football Association Board's 1909 decree that goalkeepers must wear colours that distinguished them from outfield players. Initially only three colours were permitted: scarlet, white or royal blue, although other colours such as yellow and green were later to follow, with Rangers primarily favouring yellow.

However, Herbert Lock, who was at the club from 1909 until 1921, did not favour the jumper. Born in England, 'Harry' arrived at the club from Southampton and was known for his daring approach to goalkeeping, routinely throwing himself into the path of onrushing attackers, often at great risk of serious injury to himself. Lock also adopted an unusual method when facing penalties. Knowing that he couldn't advance beyond his line, he would often stand off-centre and behind the goal line and then rush forwards, thus adding momentum to his dive as the kick was taken.

Above: David Haddow was a formidable presence in the Rangers goal, and the latter stages of his career would see him also play for – amongst others – both Burnley and Tottenham Hotspur

Right: Herbert Lock's seeming disregard for his own safety swiftly became the stuff of Rangers legend

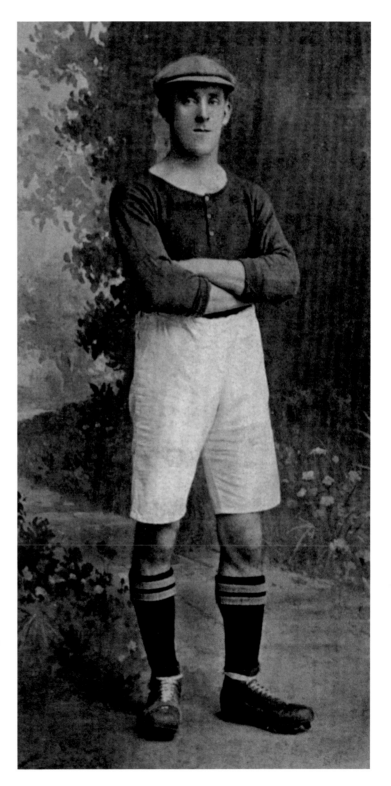

By 1911 Lock preferred wearing the club's change shirt as his choice of goalkeeper shirt when the outfield players were playing in the blue home kit. The shirt was white with a thick blue band around the midriff and a blue round-neck collar and cuffs. Although this change shirt was only used by the club's outfield players between 1911 and 1914, the style was retained in a thick woollen version as one of the goalkeeper kits throughout the 1920s.

At this point honourable mention must go to Lock's successor, Willie Robb, who played 257 consecutive matches for the club during a five-year period as first-choice goalkeeper between 1920 and 1925. This fact is all the more remarkable considering that goalkeepers weren't as well protected by the referee as they are today and injuries were commonplace, with charging the goalkeeper while he held the ball still deemed acceptable practice. Typical of the type of injuries sustained by keepers of this period – who played without gloves and faced a heavier ball than is used in modern times – Robb once told of how he attempted to stop a powerful shot from Dundee's Davie McLean. "I looked at my hand. One of my fingers had gone. I called the referee, who stopped the play, whereupon everyone started the hunt for my finger. It couldn't be found. Only then did I look in the palm of my hand. The shot I had stopped was so fierce my finger was completely dislocated and there it was lying in the palm of my hand."

After Robb's departure in 1926, roll-neck jumpers were favoured as they were the style of choice of his successor, Tom Hamilton, who was the club's goalkeeper when Rangers reclaimed the Scottish Cup in 1928 by defeating Celtic 4-0, breaking a hoodoo that had hung over the club since 1903. However, things did not go as well for Hamilton the following year during the 1929 Scottish Cup Final against Kilmarnock. After the teams

WILL'S CIGARETTES

J. DAWSON (RANGERS)

Jerry Dawson, nicknamed 'The Prince of Goalkeepers', immortalised in a Wills's Cigarettes card

had taken the field, some Rangers fans had encroached onto the pitch and handed the players horseshoes and other lucky mascots, which the players placed beside the Rangers goal while they warmed up. With Rangers winning the toss and choosing which end to attack first, both teams had to change ends and Hamilton carried the mascots to the opposite end of the pitch. Unfortunately, as he reached the penalty box he dropped some of the mascots, causing groans from the Rangers fans, who considered it an unlucky omen. Perhaps they were right as

Rangers struggled on the day and even missed a penalty as Kilmarnock won 2-0.

Roll-neck jumpers continued as the main style throughout the 1930s and into the 1940s and were favoured by 'The Prince of Goalkeepers', Jerry Dawson, who was first choice between the posts from 1931 to 1946. Jerry had signed for the club in November 1929, originally as understudy to Tom Hamilton, but by the early 1930s had made the jersey his own, and he would continue in that role until May 1944, when he was to suffer a double leg-break during the Southern League Cup Final against Hibernian while wearing his bright 'canary yellow' jersey. With no substitutes allowed at that time, it was his team-mate and future club manager Scot Symon who took his place in goal. After regaining full fitness and with it still being wartime, Dawson would subsequently mostly feature in matches for a second side, which Rangers had entered into the North-Eastern League.

However, he did manage to return to play for the main side during the early part of the 1945/46 season, including the famous match against Moscow Dynamo in November 1945, but his time at Ibrox was coming to an end and six months later he would leave the club for Falkirk. Ironically, his first match for his new club was at Ibrox against a Rangers side featuring his replacement, 23-year-old Bobby Brown, recently signed from Queen's Park.

Brown would serve the club from 1946 until 1955, never missing a single league match in his first five seasons with the club. Similarly to those immediately preceding him, he continued with the heavy woollen roll-neck jumper, usually in yellow. Brown was another keeper who worked under Bill Struth during his time at Rangers, and he recalled Struth's insistence that his team was immaculately turned out for every match. White shorts would always be the last item of kit to go on to ensure they were clean and without creases. Socks were pulled up, collars folded down and if sleeves were rolled up they had to be equal in length, with a final inspection from Struth before the team was permitted to take the field. At half-time dirty legs would be washed and a clean set of kit changed into for the second half. Brown would go a step further in his preparation by inserting a new set of laces into his boots before every match. This was inspired by witnessing team-mate Willie Woodburn being given a half-time rollicking by Struth after his lace snapped during a match. While Woodburn was off the pitch having a new lace inserted, the team lost a goal and Woodburn's supposed 'lack of preparation' was deemed accountable.

Signed as an 18-year-old by the club in 1947, George Niven would take over the number 1 spot from Brown from 1954 until 1961. Like others before him, he favoured a yellow roll-neck jersey, although now

Norrie Martin signed for the club in 1958 and was Rangers' goalkeeper for the narrow defeat against Bayern Munich in the 1967 European Cup Winners' Cup Final

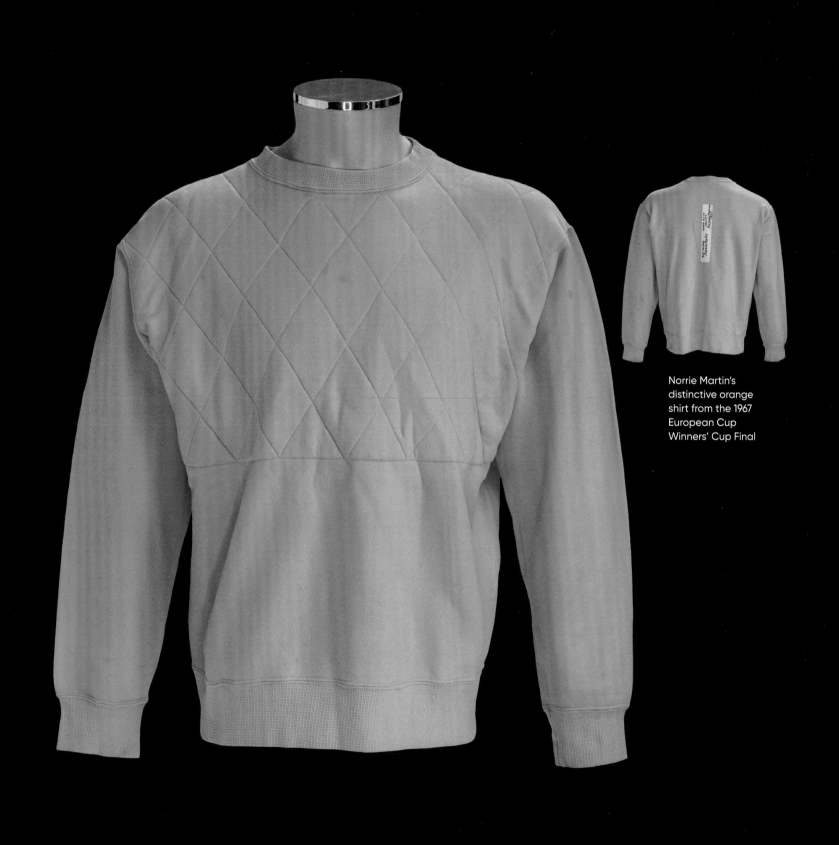

Norrie Martin's distinctive orange shirt from the 1967 European Cup Winners' Cup Final

in a lighter material. The late 1950s saw a big period of change in kit design and manufacture, and it was finally recognised that goalkeeping kits would also need to be revamped. A 1956 end-of-season tour of Spain saw Niven wearing a new lightweight round-neck shirt for the first time. Adding to its uniqueness was the addition of a large white letter 'R' over the left breast and the number one applied to the rear. Although Rangers had embraced the idea of shirt numbering in 1947/48, this was only seen as necessary for outfield players. Despite sowing the seeds of the idea during that tour, it was to be another 15 years before the club would regularly add a number to a goalkeeper shirt.

Into the 1960s, Rangers continued with the lightweight round-neck goalkeeper shirt, predominantly in yellow. Billy Ritchie would command the number 1 spot throughout the first two thirds of the decade, with Norrie Martin, Erik Sorensen and Gerry Neef seeing out the end of that period between the posts. Signed from Morton in July 1967, Sorensen was known for favouring playing in an all-black kit but that changed when he signed for Rangers, with yellow still being the preferred option for the club.

Martin was Rangers' keeper for the 1967 European Cup Winners' Cup Final, and his shirt for the match (which was almost orange in appearance) was manufactured in England by Copdale, with the outfield players sporting Umbro-manufactured shirts. Martin was another keeper who featured for the club as an outfield player. During a 1965 Glasgow Cup match with Celtic at Parkhead, Rangers saw defender Roger Hynd carried off with an ankle injury and striker George McLean injured with a badly gashed leg. Norrie completed a trio of first-half injuries by breaking a finger while saving a shot. With no replacement keeper available in those days, Rangers started the second half with nine

men, with Martin playing as centre-forward and Davie Provan filling in as goalkeeper. Although Rangers did take the lead against a strong Celtic side, they were unable to hang on, losing the match 2-1.

UMBRO 1970-1990

The arrival of the 1970s saw Rangers sign a goalkeeper who would go on to attain legendary status on 24th May 1972 when the club made it third time lucky in a European final by defeating Moscow Dynamo 3-2 at the Camp Nou. Peter McCloy had made his way to Ibrox in March 1970 from Motherwell and immediately assumed the number 1 position, usually wearing a yellow shirt, or occasionally red, manufactured by Umbro and usually featuring a fold-down collar, with some occasional dips back into the previous round-neck version.

The 1972 European Cup Winners' Cup Final would see McCloy wearing a yellow shirt featuring an embroidered Umbro logo, the first time any manufacturer's logo had been

Peter McCloy is congratulated by fans after Rangers' 3-2 victory over Moscow Dynamo in the 1972 European Cup Winners' Cup Final

displayed on a Rangers shirt. Interestingly, this logo did not appear on the outfield players' shirts. Umbro had begun to add their logo to garments such as tracksuits and goalkeeper shirts in the early 1970s but it would be 1978 before it would officially appear on a Rangers outfield player's shirt. This match would also mark the first time a Rangers shirt would feature commemorative match details surrounding the club crest.

Like most of the team on that warm night in Spain, McCloy changed into a fresh, unadorned league shirt at half-time, and like his team-mates he was determined to hang on to his specially embroidered shirt and recalls stuffing it straight into his bag after the match.

McCloy made his debut for the club in March 1970 away to Dunfermline and was quick to learn a lesson in getting the fans behind him. During that period, he would choose a pair of his favourite Peter Bonetti gloves to wear in wet conditions.

Unfortunately, those gloves were only manufactured in green and as he went to take to the field, his gloves were nowhere to be found. Trainer Joe Craven, who acted as kitman during that period, revealed he had hidden them, telling him "you can't wear anything green at this club". A swift appeal to the manufacturer saw McCloy receive a box of gloves, dyed blue specially for him, which saw him through a few seasons until his own connections as a sports shop owner saw him source a new style of padded gloves from Switzerland, one which became popular with his fellow goalkeepers throughout the country.

However, McCloy's connection with the sports industry almost caused him to fall foul of the club in 1984. Since 1978, Umbro had been Rangers' official kit supplier, but for the 1984 League Cup Final match against Celtic, Peter preferred to wear a yellow and black shirt obtained through his shop from goalkeeping specialists uhlsport. Thanks to widespread TV coverage, this change of shirt

Jim Stewart would share goalkeeping duties with Peter McCloy during his time at Ibrox and would go on to win two caps for Scotland

McCloy and Alex MacDonald celebrate Rangers securing the treble in 1978

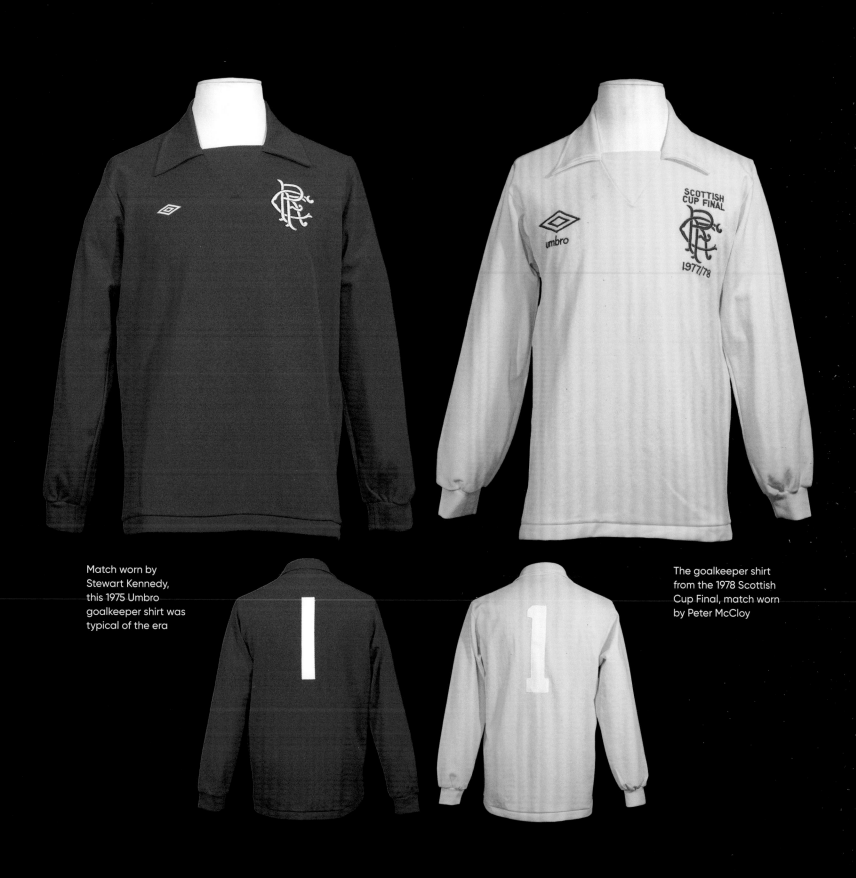

Match worn by
Stewart Kennedy,
this 1975 Umbro
goalkeeper shirt was
typical of the era

The goalkeeper shirt
from the 1978 Scottish
Cup Final, match worn
by Peter McCloy

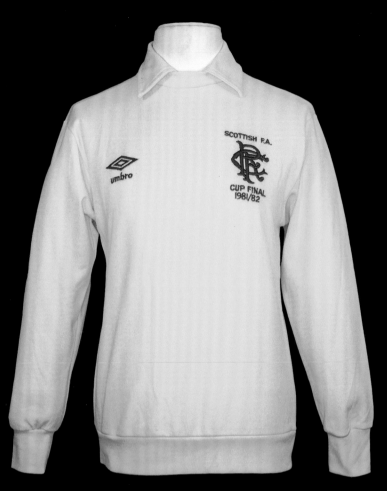

Jim Stewart's
match worn shirt
from the 1982
Scottish Cup Final

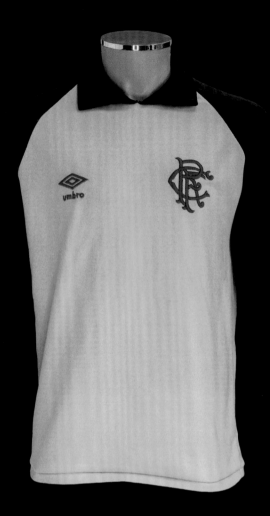

A 1983/84 season
shirt match worn
by Peter McCloy

A 1986 jersey, match worn by England international Chris Woods

A 1988 jersey, similarly match worn by Woods. Note the smaller crest size on the left breast

was picked up on by an unhappy Umbro, who complained to Rangers, and McCloy was hauled into manager Jock Wallace's office, who demanded to know whether McCloy was being paid money by uhlsport to wear their kit. He wasn't, but it was an example of how sponsorship was becoming more important to the finances of football clubs throughout the 1980s.

McCloy would face stiff competition for the number 1 jersey during the 1970s from Stewart Kennedy, as well as in the early 1980s from Jim Stewart, before stepping down from a playing role with the club in 1986 to join the coaching staff, ending a 16-year spell as the club's main keeper.

During the 1970s only two shirt colours were ever used. The favoured shirt of the club was yellow with the occasional red alternative for a colour clash, but by the early 1980s fashions were changing again and Umbro introduced a new yellow and black design which was joined by a red and black alternative and even a grey and black

version, as used by Nicky Walker during the 4-4 match with Celtic in March 1986. This style of shirt was used until a revolution swept Rangers in the summer of 1986 with the arrival of Graeme Souness as player-manager.

Souness, alongside his assistant, Walter Smith, rebuilt Rangers into a club capable of reaching the highs of domestic and European football once again, with one of his most astute signings being England goalkeeper Chris Woods. During Woods' first season at the club he would wear both the red and yellow versions of the new Umbro No.1 template shirt. A version in grey was also supplied to the club and Woods would wear this for his Ibrox debut in a friendly match against Bayern Munich on 5th August 1986. From then on, the grey colourway shirt was only occasionally seen, predominantly in reserve matches. After his first season, Woods would favour a yellow shirt for the majority of his five-year spell at the club, during which time he set a British record of 1,196 minutes of consecutive football without conceding a goal.

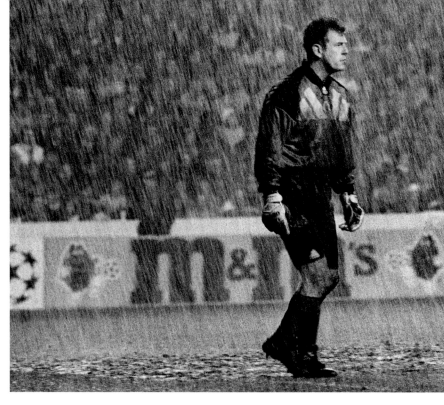

ADMIRAL 1990-1992

The 1990/91 season saw the introduction of a new kit supplier in Admiral. Originally a five-year deal, the partnership was terminated by the club after only two years due to disappointment with some of the kit supplied.

Admiral's goalkeeping shirts utilised the club's favoured choice of colours in red, yellow and grey, with both the red and yellow featuring a 'flame-pattern' design throughout and the grey featuring a pattern of faint vertical and diagonal lines which created a subtle diamond effect.

The beginning of Admiral's second season as the club's kit supplier saw Rangers with a new manager in place in the form of Walter Smith, following the departure of Graeme Souness to Liverpool. Smith's first piece of transfer business was to tie up the signing of a new goalkeeper in Andy Goram, who joined from Hibs in June 1991 as the replacement for the departing Woods, who was returning south to England to join Sheffield Wednesday.

Unlike his predecessor, Goram did not favour one shirt over the other and would be seen wearing all three versions throughout his first season. After a slightly shaky start to his time at the club, he would go from strength to strength, remaining the first-choice goalkeeper for the club between 1991 and 1998, becoming a firm fan favourite and earning his nickname of 'The Goalie'.

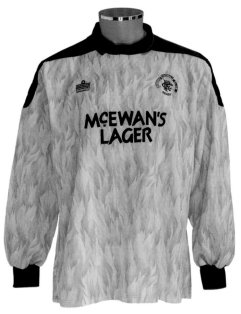

Rangers' goalkeeper shirts took a turn for the outlandish with this 1990-92 Admiral shirt, match worn by Andy Goram

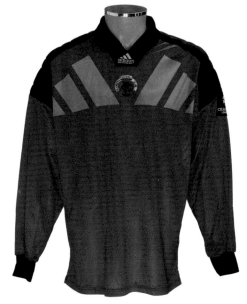

A 1992/93-vintage match worn shirt of Goram's, who considers this particular style one of his favourites

Andy Goram shrugs off the rain during Rangers' 2-2 draw with Olympique Marseille in the Champions League in November 1992

ADIDAS 1992-97

With Admiral falling out of favour with the club, adidas were quickly secured as an alternative, sealing a five-year deal for the period 1992-1997. The first couple of seasons would see the usual goalkeeper colourways of yellow, red and grey used by the club, with the goalkeeper shirts not being too dissimilar in style from the template used for the outfield players. Summer 1992 promo shots had actually seen the keepers dressed in adidas 'Taifun' template shirts. These shirts had the McEwan's Lager sponsor applied but no club crest. Both Goram and Ally Maxwell wore them during matches in August 1992, but they swiftly gave way to the standard red, yellow or grey template used for the next two seasons, including the club's run in the inaugural Champions League campaign in 1992/93.

The start of the 1994/95 season saw the introduction of a new style of shirt, believed to be known as the 'Predator' template, which moved away from the plain colourways seen previously. The club were presented with three new shirts to choose from, and once again Goram would utilise all three from the range, with the two main shirts featuring in red/yellow/black or alternatively purple/grey/black. The third version of this design featured an orange/grey/black colourway but this style only saw use in a couple of matches during its time – Maxwell wearing it during the Ibrox International Tournament match against Manchester United in August 1994.

The purple/grey/black shirt would be worn as Goram made one of the most impressive saves of his career during the 3-3 Old Firm match on 19th November 1995 at Ibrox – a point-blank volley from Celtic's Pierre van Hooijdonk that Goram somehow turned away one-handed.

The mid-1990s saw shirt designers given free rein to go for bold designs and adidas were no different. Featuring an explosion of shapes and patterns, the 1995/96 season saw the club's goalkeeper shirt available in two colourways, orange/yellow/white/black and blue/grey/white/black.

The last of the adidas goalkeeper kits made their debut during the 1996/97 season. The first featured an ombré effect, with colour blending down the body of the shirt from yellow to red, and featured a printed image of the Ibrox Main Stand across the shirt. A large club crest sat on the centre of the chest, encased within a black shield. It was a shirt which split opinion, with people either loving or hating it. Back-up goalkeeper Theo Snelders was one who would happily wear it, often with his trademark tracksuit bottoms. Goram, however, fell into the latter category, much preferring to wear the white alternative shirt – this popular jersey was an example of classic adidas styling, plain white with the company's trademark three-stripe piping in red and blue down both sleeves, plus a black round-neck collar. Goram would go on to wear this shirt in two victorious cup finals, the Scottish Cup Final in May 1996 and the Coca-Cola Cup Final in November of the same year.

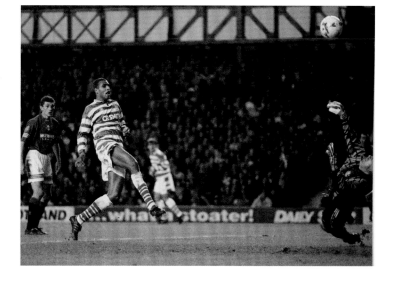

What a save! Goram somehow palms away a point-blank volley from Celtic's Pierre van Hooijdonk

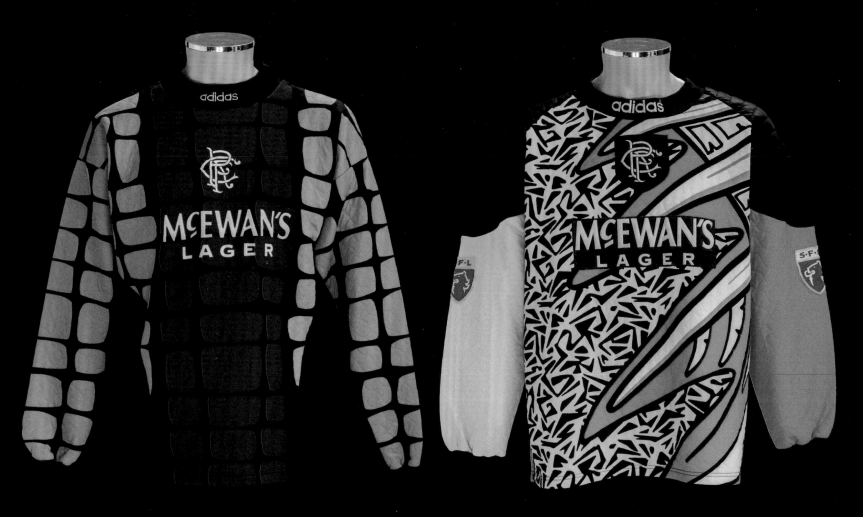

Andy Goram's match worn 1994/95 season shirt – arguably one of the most iconic Rangers goalkeeper shirt designs

Dating from 1995/96, this Andy Goram match worn shirt was certainly easy to pick out in a crowded penalty area...

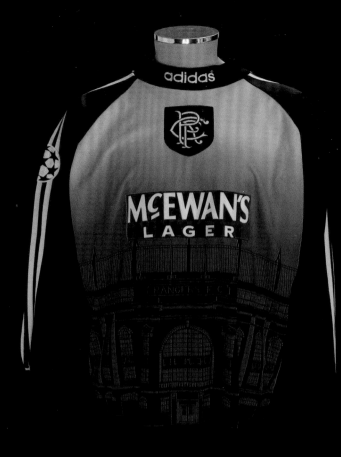

This Andy Goram
match worn jersey
from 1996/97 featured
a detailed print of
Ibrox's Main Stand

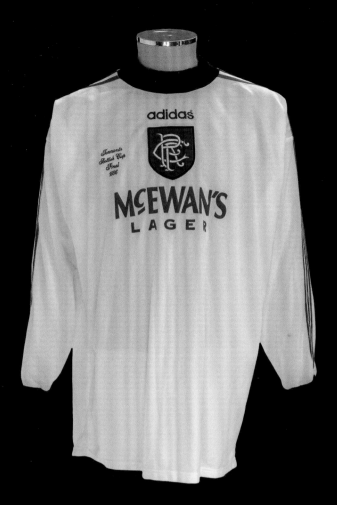

1

Andy Goram's shirt
from Rangers' 5-1
victory over Hearts in
the 1996 Scottish Cup
Final, complete with
match embroidery

The yellow 1997/98 season shirt, match worn by Finland international Antti Niemi

NIKE 1997–2002

Between 1997 and 2002, Nike became kit suppliers to the club and they continued with the fashion of loose-fitting goalkeeper kits. Goram's final season at the club in 1997/98 saw himself and his goalkeeping colleagues provided with a choice of two shirts from the same template: one in yellow and one in grey, with both trimmed in black.

These shirts would continue to see use during the following season of 1998/99, but with two new goalkeepers in position. French World Cup winner Lionel Charbonnier was signed in the summer of 1998, and he would be joined later in the season by Stefan Klos, who signed from Borussia Dortmund. Charbonnier tended to favour the grey shirt with Klos opting for the yellow, although a red version was later thrown into the mix and this colour would be chosen by Klos for the 1999 Scottish Cup Final victory over Celtic.

Three goalkeeper shirts were produced for the 1999/2000 season, similar in all but colour. Released in black, orange and a silvery white,

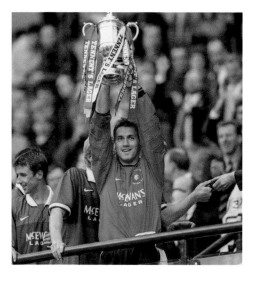

German goalkeeper Stefan Klos lifts the Scottish Cup after Rangers' 1-0 victory over Celtic at Hampden in May 1999, and the spare match shirt he was issued for the game (above)

Nike's orange 1999/2000 shirt, match worn by Mark Brown

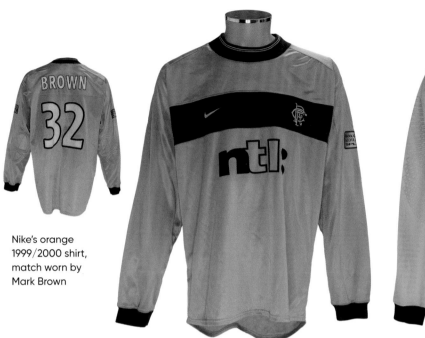

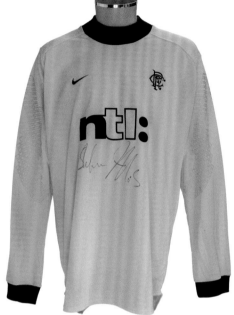

The 2002/03 Nike shirt, match worn by Stefan Klos

each featured round-neck collars, a thick band across the chest and padding to the shoulders and elbows. One of the orange shirts would be worn by Parma's Gigi Buffon during a Champions League qualifier at Ibrox in August 1999. With Parma playing in a yellow and blue kit and Rangers in blue, the UEFA delegate felt that Buffon's dark shirt wasn't acceptable and Rangers supplied Parma with one of their own orange keeper shirts. Adjustments were made, with Parma's sponsor, crest and manufacturer label cut out from a Parma kit and stitched into place over the Rangers, Nike and NTL logos. Buffon's name and number set were supplied through the club shop and he was good to go.

On 27th December 1999 during a league match away to Celtic, Charbonnier was seen wearing the club's third-choice outfield kit as a goalkeeper shirt. It's believed that this was the first time in recent history that a Rangers outfield player's shirt was used for this purpose, but it was something that the club's keepers would revisit from time to time

from that day onwards. Charbonnier later claimed his red shirt, white socks and blue shorts were chosen to represent the colours of his country's flag.

By the early 2000s, goalkeeper shirts in general were no longer as loose-fitting and largely eschewed padded shoulders and elbows, giving them a more dynamic appearance, and Rangers' shirts were no different. Nike's final two seasons as kit supplier would see four shirts to choose from in 2000/01 and three for 2001/02. Available in light blue, grey, black or yellow, the shirts for Nike's penultimate season all featured a black round-neck collar and embossed rubberised dots to the front of the shirt to aid grip.

Klos would go on to reuse the light blue and black shirts during the 2001/02 season, with Nike also supplying the club with an additional three new shirts. These shirts came in yellow, sky blue and red designs, with Klos choosing the red shirt for the victorious League and Scottish Cup finals of 2002.

IN-HOUSE/DIADORA 2002-05

The 2002/03 season saw Rangers producing their own kit 'in-house', which was released with Diadora branding. Three goalkeeper shirts were produced for that initial campaign in red, sky blue and plain black designs. As Rangers' home and change shirts for the season featured two different sponsor logos, kit man Jimmy Bell had to be on his toes to ensure that the goalkeeper shirt used featured the correct sponsor.

The following season was easier in that respect with Carling taking on the role as shirt sponsor for both home and change shirts. Three shirts once again were produced, in sky blue, navy blue and red, and all featured round-neck collars with two triangular-shaped panels in contrasting colours pointing outwards from the collar towards the armpits.

The last of the Diadora-branded shirts came in the 2004/05 season. Similar in appearance to the previous season, three

kits were produced: a sky blue and a red variant, but this time black replaced the previous navy blue colourway. The black and sky blue versions both had matching dark blue collars and cuffs, trimmed with red, while the red version had black trimmed with blue.

Although Klos was still seen as the club's first-choice goalkeeper, a serious knee injury in January 2005 saw him ruled out for the remainder of the season and Dutchman Ronald Waterreus was signed as a replacement, earning himself a CIS Insurance Cup Final winners' medal against Motherwell on 20th March 2005, a match in which he wore the previous season's red shirt. Waterreus was also in goal for 'Helicopter Sunday' as the club claimed the league title on the dramatic last day of the 2004/05 season, when again he would choose the previous season's kit – this time in sky blue.

IN-HOUSE/UMBRO 2005-13

Umbro's name returned to the Rangers shirt for the beginning of the 2005/06 season, although the club continued to produce kits in-house for that campaign. It was noticeable that Umbro's name appeared in letter form only on these shirts as opposed to via their trademark 'double diamond', which wouldn't be re-introduced until the following season, when they did become official kit supplier. Not including those in-house shirts, Umbro would go on to produce a total of 19 goalkeeper shirts during a seven-year partnership.

The last season of the in-house period saw three colourways of red/black, sky blue/black and black/yellow made available to the club's goalkeepers. Waterreus continued on from where he left off the previous season, playing the majority of the club's matches, with a fit-again Klos backing him up and with third-choice goalkeeper Allan McGregor getting game time through a loan deal to Dunfermline Athletic.

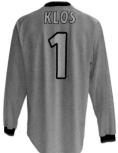

The sky blue goalkeeper shirt from 2002/03, Rangers' first season of 'in-house' design, match worn by Stefan Klos

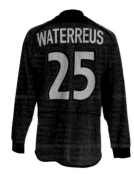

The red 2005/06 'Umbro/in-house' goalkeeper shirt, match worn by Dutch international Ronald Waterreus

The 2006/07 season saw three goalkeeper shirts released. It was the season where Allan McGregor took his chance to become the club's number 1 after Frenchman Lionel Letizi, who had started the season as the main keeper, made a number of unfortunate errors. With Klos still struggling for fitness, McGregor's performances saw him make the position his own.

Umbro's shirts for this season were black, red/black and sky blue/black. McGregor tended to stick predominantly with the red/black version, with Klos playing his final match for the club in the black/red version in March 2007 versus Osasuna. Klos would depart the club at the end of the 2006/07 season, retiring at the age of 36 after a fantastic career.

The club's habit of re-using goalkeeper kits saw the black shirt from the previous season return during 2007/08. Umbro also supplied two new templates in red and in yellow/black, this being the first time a predominantly yellow shirt had featured in the past seven years. All of these shirts would make appearances in massive games for the

club during the campaign, where a domestic cup double was completed and the final of the UEFA Cup was reached.

McGregor remained the club's first-choice keeper, with back-up being secured in January 2008 through the signing of Neil Alexander from Ipswich. It was a dream move for Alexander, who – following an injury to McGregor in mid-April – would find himself ending his first season for the club winning the Scottish Cup, playing in both UEFA Cup semi-final legs against Fiorentina and becoming only the fourth goalkeeper in Rangers' history to keep goal during a European final.

Alexander had worn the black shirt for the UEFA Cup semi-final first leg as Fiorentina played in their red change kit. The second leg in Florence saw him choose his favoured all-red kit as Fiorentina returned to their violet-coloured home kit. On that historic night in Florence he became the hero of the hour as his part in the penalty shoot-out propelled Rangers into the final against the Russians of Zenit Saint Petersburg. Alexander stuck with the red kit for the final – in which Zenit sadly proved too strong – although the club had

Above left: Allan McGregor's red 2009/10 shirt

Above: Neil Alexander's white 2010-12 shirt. While McGregor was largely the club's first-choice goalkeeper during this period, Alexander was a more than able deputy

Neil Alexander's spare shirt from the 2008 UEFA Cup semi-final victory over Fiorentina, which saw Rangers win 4-2 on penalties to book their place in the final

Alexander lets out a celebratory roar after 10-man Rangers overcome Fiorentina in the UEFA Cup

a yellow version on standby should he have chosen that instead.

The season would end on a high, however, with victory in the Scottish Cup Final over Queen of the South, where Alexander would choose to break with recent tradition and go with the season's yellow template on a gloriously warm day at Hampden.

Similarly to the previous season, Umbro's shirts for 2008/09 would be orange, black and red. The design was identical to the template of the home outfield shirt of that season. The 2009/10 campaign saw the first of Umbro's yellow neon-style shirts released, along with two other templates in red and grey. All three would see use at some point during the season with red once again being the preferred colour worn during the League Cup Final, as it had been over most of the recent finals. An agreement with the goalkeepers at the club saw Alexander be given the League Cup matches to play in and he kept up his winning habit by earning another domestic winners' medal, as the club defeated St Mirren 1-0 on 21st March 2010

despite finishing the match with nine men following two red cards. Towards the end of the season, both McGregor and Alexander would be seen wearing the club's white outfield third shirt, perhaps as a hint towards the following season where Umbro would introduce white as one of the three shirt templates provided to the club.

The 2010/11 season would feature three goalkeeping kits – yellow/black, red/black and white. Once again, goalkeeping duties were shared between Alexander and McGregor. Alexander's good fortune was to favour him again as he was once more assigned the League Cup matches, and he would pick up yet another winners' medal after Rangers defeated Celtic 2-1 in the final. As was the case the previous season, an outfield shirt would make an appearance as a goalkeeper shirt, with the black third-choice kit being worn on several occasions, most notably by McGregor in the match against Celtic at Ibrox in April 2011, when his penalty save from Georgios Samaras was instrumental in helping to keep Rangers on target for their 54th league title.

Allan McGregor was the goalkeeper of choice for Rangers' league fixtures when they clinched the title in 2011

The purple variant of Umbro's 2012/13 goalkeeper shirt, match worn by Neil Alexander

Umbro's penultimate set of shirts would see only two new goalkeeper colourways produced as the club continued with the all-white shirt from the previous season. Joining that white shirt was a similar all-black affair, featuring a new collar style, and a yellow/black shirt also featuring the new collar. Again, all three kits would be worn throughout the season, with McGregor also wearing the Rangers outfield red change shirt for a single league match at Ibrox versus St Mirren in April 2012.

The 2012/13 campaign would be Umbro's last as kit supplier as well as a season of rebuilding for the club as it faced life in the Scottish Third Division post-administration. McGregor moved to Besiktas in the summer of 2012, while Alexander stayed to claim the number 1 position – one of only a handful of senior professionals who remained for the start of the new campaign. Umbro's last three goalkeeping kits were in yellow, purple and black.

The yellow kit had been unveiled at the end of the previous season in commemoration of the 40th anniversary of the 1972 European Cup Winners' Cup victory, and to increase the similarity to the shirt worn on that night in Barcelona, a plain, oversized club crest – minus the five stars – was embroidered onto the shirt. Sponsors Tennent's also agreed to a smaller size logo, placed unobtrusively below the crest.

The purple and the black versions had vertical lines in a shadow pattern and would feature a smaller club crest which would include the five stars above it, although the smaller sponsor's logo remained. It would be a season where Alexander would wear all three shirts, along with three other shirts from previous seasons, as well as having kitman Jimmy Bell provide him with a white outfield player's change shirt from the season to wear as a goalkeeper shirt.

PUMA 2013–18

PUMA took over as kit supplier from the start of 2013/14 and the club also began the period with a new first-choice goalkeeper in Cammy Bell, recently signed from Kilmarnock, replacing the departing Neil Alexander.

Three kits were provided to the club in that first season, with two of them using the same template. A yellow shirt with a dark grey chest panel was replicated with a similar red and grey shirt from the same template. The chest panel was dissected by a yellow and white or red and white vertical strip respectively.

The third shirt of PUMA's first season would see an orange and black shirt, different in style from the other two and based loosely on the orange Nike kit from 1999. In contrast to the round-neck shirts of the first two, this shirt would feature a fold-down collar in black which added to the retro feel of the shirt.

Only two kits were released for 2014/15, while goalkeeping duties were shared

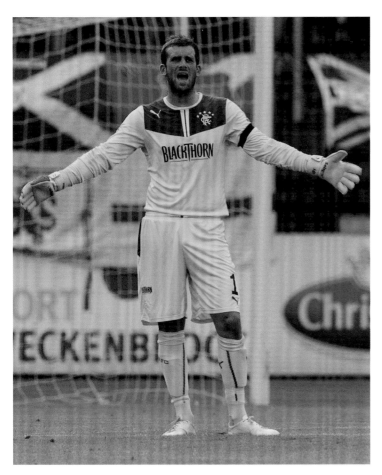

Cammy Bell joined Rangers from Kilmarnock in April 2013 and helped them secure the League One title during his first season with the club

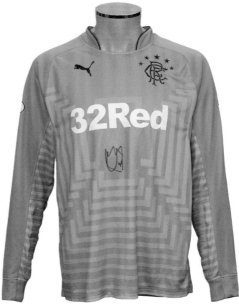

PUMA's light blue 2014/15 goalkeeper shirt, match worn by Cammy Bell

between Cammy Bell and Steve Simonsen. Once again both shirts were identical in style, being taken from the World Cup 2014 template and only differing in the colourway used. Similar kits were given to Arsenal and Borussia Dortmund for that season, with Rangers kits being provided in a luminous yellow and in light blue. Both shirts would feature a shadowed geometric square pattern to the front.

The 2015/16 season saw three new kits to choose from. Known as the PUMA 'Stadium' template, all three kits featured the same three colours – red, white and black – with each shirt's main colour broken up with chest and sleeve panels in the alternate colours. Wes Foderingham had been signed from Swindon in the summer of 2015 and was deemed first choice, with Cammy Bell dropping to the

back-up position. Similarly to the previous season, the keepers chose to wear the full matching kits without the interchanging that had been done in the past, something that was no doubt appreciated by Jimmy Bell. Foderingham would wear the red kit as he picked up a winners' medal from the Petrofac Training Cup in April 2016, although it wasn't to bring the same success in that season's Scottish Cup Final.

Rangers began the 2016/17 season with four new goalkeeper kits available to the club. All four would feature throughout the season, with Foderingham remaining as first choice and fellow Englishman Matt Gilks serving as his deputy and playing in all five of the club's League Cup matches during a six-month spell at the club. Once again, PUMA had released kits that were largely identical except in the colourways used – the main body of the shirt being either black, light blue, luminous yellow or red, with black arm bars down each sleeve containing a four-colour panel of cyan, magenta, yellow and black.

Cammy Bell's shirt from the 2016 Petrofac Training Cup Final, where he was an unused substitute, and the competition sleeve badge (above)

Allan McGregor's match worn 2019/20 hummel shirt

The round-neck collared shirts would feature the club crest, PUMA logo and the 32Red sponsor logo in white except for the luminous yellow kit, which had the details in black for maximum effect.

Both the red and black PUMA shirts from the 2016/17 season continued to make the odd appearance during the early part of 2017/18, with Foderingham using them during Rangers' two Europa League qualifiers against Progrès Niederkorn of Luxembourg. Unusually for him, Foderingham would wear both shirts without their matching shorts, going with a black shirt/red shorts combo during the home leg and red shirt/white shorts for the return. The black shirt would also see a few outings in matches against Motherwell during the season, but it was the new orange kit which would see use during the majority of matches. Always worn with matching shorts and socks, the stunning orange shirt would be the only new addition to the goalkeeper range for the 2017/18 season. Never available to buy as a replica, this shirt featured black sleeve bars down both arms which were dissected by a black band halfway down each sleeve which circumvented the arm. This was to be the last shirt of the PUMA deal, with Rangers lining up a new kit supplier for the start of an exciting new era at the club.

HUMMEL 2018-20

Pre-season 2018/19 had seen not just the introduction of Steven Gerrard as the club's new manager but also the announcement of a new kit supplier, with Danish company hummel taking over. Three kits were made available for the returning Allan McGregor – who had rejoined the club after an absence of six years – coming in black, yellow or orange (or 'firecracker' as it was branded by hummel). The shirts were classically clean and uncluttered, with the only addition

being the manufacturer's trademark chevrons across both shoulders and the standard club logos. All three kits would be worn during the season by McGregor, always in full matching kit – something of a rarity for him during his Rangers career.

Early Europa League qualifying matches in July and August 2018 would see the yellow kit worn without the club sponsor logo in matches away to Osijek, Maribor and Ufa due to advertising restrictions. This was also the case in November as Rangers returned to Russia for the Europa League group match against Spartak Moscow.

The club's short deal with hummel would come to an end in the summer of 2020 and its final season in partnership with Rangers saw 2019/20 kick off with a further three new goalkeeping shirts. Incorporating hummel's new ZEROH2O technology, these shirts once again came in yellow, black and orange and were superficially similar in appearance to the previous season's shirts, but on closer inspection featured a honeycomb design, tying in with hummel's trademark bee logo. The Danish company had designated the yellow shirt as the home version, the black as the change and the orange as the third shirt, but in the end the decision was taken to use whichever shirt McGregor and Jimmy Bell selected for each match.

The season's Europa League campaign would once again throw up a need for a change of sponsor, with matches against Young Boys of Switzerland and Feyenoord seeing the Rangers Charity Foundation logo appearing instead of that of 32Red. UEFA had preferred a charity logo to feature in matches where 32Red's logo couldn't be used, so who better than the club's own charity foundation? McGregor would favour the orange shirt versus Young Boys and the yellow version against Feyenoord in October and November 2019 respectively.

CASTORE 2020-

Castore's first season as kit provider saw the Rangers goalkeepers supplied with four choices, the first three being yellow, white and orange, each of which had its own bespoke design woven into the fabric. All three of these kits were worn at some stage during the historic 2020/21 title-winning season by Allan McGregor and Jon McLaughlin. A retro fourth shirt in purple was also produced but never featured.

The club's 150th anniversary season kicked off with three goalkeeping kits released by Castore. The shirts now featured the new anniversary scroll design beneath the club crest, with yellow being designated as the home shirt, while the other two shirts were orange or a white and gold combination. A fourth kit – produced in blue – was also released in October 2021 alongside the special 150th celebration 'Gallant Pioneers' outfield kit.

Allan McGregor – here wearing Castore's orange 2020/21 shirt – rejoined Rangers from Hull in May 2018

BETTER THAN ALL THE REST

ADMIRAL, ADIDAS & NIKE

HOME 1990-92

Match worn by **GARY STEVENS**

At the start of the 1990/91 season, Admiral became Rangers' new kit supplier, ending the club's long-standing association with Umbro. The Admiral arrangement – which had been signed a year before in June 1989 – was a five-year deal worth around £4 million.

Admiral had revolutionised the design and marketing of football kit in the late 1970s and early 1980s before going bust in 1982. The classic brand had subsequently been acquired in 1988 by a consortium including The John Lawrence Group, who owned Rangers until they sold the club to Murray International Holdings in November 1988.

Admiral's PR department claimed that the new Rangers home shirt had been designed in collaboration with manager Graeme Souness. "Between us we agreed a jersey which kept the club's tradition but will be used as a leisure shirt by fans," said the company's sales and marketing manager.

The home shirt featured a slightly raised 'wood-effect' pattern and a new-style club crest sat on the left breast. An additional club crest also featured on the back of the shirt, sitting just below the neckline. To comply with UEFA's strict guidelines regarding only allowing one club crest on a shirt, a set of jerseys were manufactured for use in European competition which lacked the second crest.

Prior to the start of the season, it had also been announced that McEwan's Lager would continue as Rangers' shirt sponsor for at least the next six campaigns.

The shirt made its debut during a pre-season friendly against Dundee at Dens Park on 4th August 1990, a match notable for a one-off appearance by Souness following his retirement from playing the previous season. Souness was listed as 'trialist' and even capped his run-out with a goal.

Despite it being a popular shirt with fans, within a few months of the deal commencing concerns were raised regarding the manufacturing quality of the replica kits sold to supporters. These concerns were enough to force Rangers to part ways with Admiral after just two years.

This shirt was worn by defender Gary Stevens during the League Cup Final victory over Celtic on 28th October 1990.

Above: Gary Stevens challenges for the ball during the 1990 League Cup Final victory over Celtic – this shirt's only cup final appearance

Left: The bespoke match embroidery from the final

CHANGE 1990-92

Match worn by **ALEXEI MIKHAILICHENKO**

The change shirt produced by Admiral during their short-lived tenure as Rangers' kit supplier was a popular design worn on nine occasions, more than half of those coming against St Johnstone.

Made in the UK from 100 per cent polyester, the change shirt material featured a shiny, shadow pattern design, which almost gave the shirt a two-tone effect. The McEwan's Lager logo was applied in a raised flock, with the Admiral logo and new club crest and scroll being embroidered into the shirt. Like the home shirt of the period, an embroidered 'RFC' logo was also positioned on the back of the shirt, below the collar, although this detail was absent on shirts prepared for European competition.

Although the Admiral deal didn't turn out the way that either the club or manufacturer had hoped, both the home and away shirts were well-received by fans and are still popular to this day.

This short-sleeved number 10 shirt was worn by Ukrainian midfield maestro Alexei Mikhailichenko on his Rangers league debut, away to Falkirk on 7th September 1991. Known around the club as 'Chenks', Mikhailichenko almost marked the occasion with a wonder goal. Seeing the keeper off his line he tried an audacious shot from the halfway line, which only just cleared the crossbar. Five years later David Beckham would hit the headlines for scoring with a similarly audacious long-range effort for Manchester United. Beckham netted his famous goal wearing a pair of adidas Predator boots, which had actually been produced for Rangers midfielder Charlie Miller. With Beckham requesting a set of boots from adidas for the match versus Wimbledon, the only boots available for him to try out was a pair waiting to be shipped to Scotland for Miller, complete with 'Charlie' embroidered on the tongue.

During his five-year Rangers career, Mikhailichenko amassed five league titles and three Scottish Cup winners' medals before retiring from football in the summer of 1996.

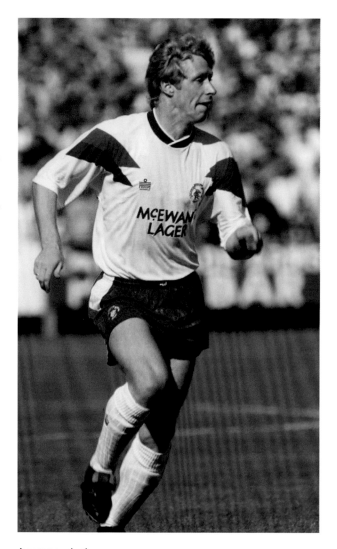

A summer signing from Sampdoria, Alexei Mikhailichenko made his debut in the match against Falkirk in September 1991

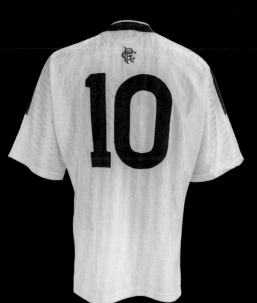

LEAGUE TITLE DECIDER 1991

Match worn by **TOM COWAN**

Despite their kit deal being terminated early after just two years, Admiral still played a significant part in the history of the club when Rangers clinched the league title in dramatic fashion on the last day of the 1990/91 season.

A month earlier, manager Graeme Souness had left the club to join Liverpool and his assistant, Walter Smith, took over the reins at the start of a hugely successful period for the club.

Before the final match of the season, Rangers were two points clear of opponents Aberdeen at the top of the table, although the visitors were the form team having been seven points behind with 10 games to go. Those in the raucous Ibrox crowd were well aware that this was a winner-takes-all situation, and the Rangers players rose to the occasion to record a famous 2-0 triumph.

The shirt featured here was worn in this famous match by defender Tom Cowan, who fractured his leg in a challenge but incredibly managed to play on for another 10 minutes before being substituted. Tom recalled: "I knew I was playing from the Thursday as we went through some set-pieces and I was told I would be left-back. I was excited and a little bit nervous but nothing that would upset me.

"After the tackle I didn't realise straight away I'd injured myself but after trying to run around on it for five minutes and feeling a clicking from my lower leg I suppose I knew I couldn't continue. I was devastated as I really wanted to finish the game and help the team win the league. Playing for the biggest team in the world, that's what it felt like when you were a Rangers player. I loved playing for Rangers."

The fierce commitment of the players to win the league that day was further epitomised by defender John Brown, who had agreed to have a pain-killing injection into his damaged Achilles tendon before the match knowing that there was a danger it could snap during the game. Unfortunately, this is exactly what happened during the second half and Rangers finished the match with many players hobbling through the pain barrier.

When the final whistle blew, however, Rangers were league champions for the third season in succession and on their way to the amazing nine league titles in a row achievement.

Top: Tom Cowan received treatment and attempted to play on despite his injury

Above: Cowan and John Brown celebrate Rangers' hard-earned victory

HOME 1992-94

Match shirt of **PAUL RIDEOUT**

In the autumn of 1991, Rangers agreed a new kit deal with global sports brand adidas. The fans were delighted with the five-year deal, the most lucrative kit contract the club had ever had, and although it was due to take effect at the start of the 1992/93 season, the first Rangers adidas shirt was worn for the Scottish Cup Final at the end of the 1991/92 campaign.

The first adidas home shirt was a bold design from a template born out of their new 'Equipment' range, which was notable for an absence of the brand's traditional 'three-stripe' motif in favour of sets of three bold blocks of colour on the shoulders. These shirts also incorporated the company's new 'Equipment' logo, which replaced the famous trefoil logo – ironically at a time when 'old skool' adidas clothing had very much come back into fashion.

Like the previous Admiral shirts, the new-style embroidered crest and scroll was used, which now sat in the centre of the shirt, with the embroidered 'Equipment' logo appearing above it, within the collar of the intentionally loose-fitting shirts.

Rangers were domestically dominant in this shirt, winning the treble in the 1992/93 season and almost repeating the feat during the following campaign.

Although a set of Admiral shirts, complete with match embroidery, was prepared for the Scottish Cup Final against Airdrie on 9th May 1992, Rangers elected to debut the following season's new kit for the end of season finale. That decision was taken on the basis that with the league season officially over, the Admiral deal was concluded, leaving Rangers free to switch to the new adidas shirts for the final.

A professional performance saw goals from Ally McCoist and Mark Hateley help Rangers lift the Scottish Cup for the first time since 1981 and got the new deal with adidas off to a successful start.

This shirt was made ready for Paul Rideout, although the big Englishman was an unused substitute on the day.

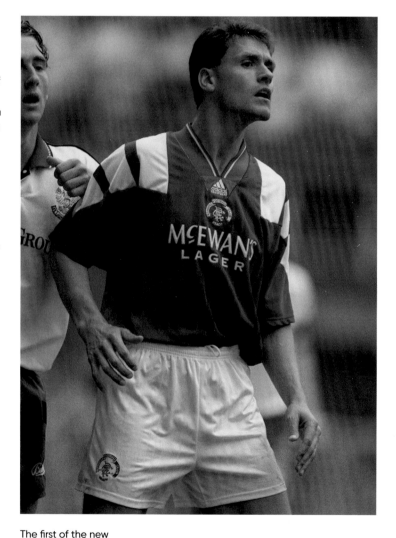

The first of the new adidas home shirts, worn by striker Paul Rideout, who joined Rangers for £500,000 from Notts County in January 1992

CHANGE 1992/93

Match shirt of **NEIL MURRAY**

Rangers' first adidas change shirt was an exact reverse of the home design, although the white version with red shoulder panels was only worn for a single season.

Like the home shirt, the fabric incorporated a repeated pattern of three vertical strips, with no McEwan's Lager sponsorship logo appearing on shirts worn in the Champions League.

First worn during a league match away to Dundee on 15th August 1992, it would be used on 10 occasions during the 1992/93 season – including two matches at Ibrox, against Lyngby Boldklub and Club Brugge during the inaugural Champions League campaign. At this time, UEFA regulations stipulated that in the event of a kit clash the home team should change.

The Group A match against Belgium's Club Brugge on 17th March 1993 produced one of the most bizarre but celebrated goals ever seen at Ibrox. Scott Nisbet's deflected effort spun wildly and bounced over Brugge keeper Dany Verlinden – it turned out to be the winner.

This shirt was prepared for midfielder Neil Murray for that match but was an unused spare on the night, with Murray preferring to play in short sleeves.

The shirt features the rectangular patch of the original Champions League design, complete with the year of the competition. Two sets of patches were produced by UEFA for the tournament, one black and one white, to cover all eventualities regarding colour clashes. For the first two seasons of the competition these patches were worn on the left sleeve, before moving to the right from 1994/95 onwards.

Like the Admiral shirts of the preceding period, these first adidas kits were popular with supporters. This is no doubt partly explained by the great performances and trophy successes that were recorded while they were in use.

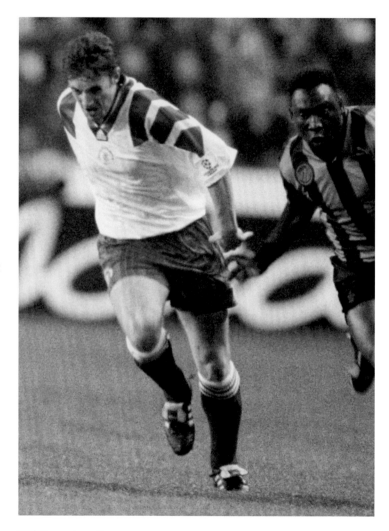

Neil Murray in action against Club Brugge in the short-sleeved, unsponsored version of this shirt

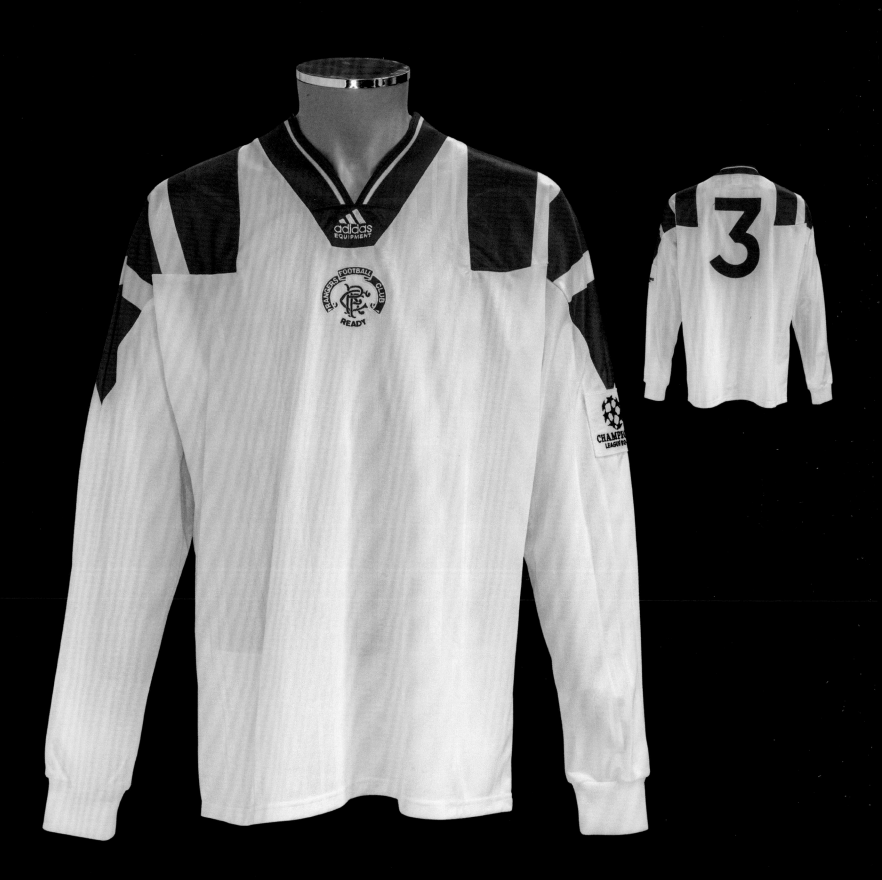

CHAMPIONS LEAGUE 1992/93

Match worn by **NEIL MURRAY**

The 1992/93 season saw Rangers produce a monumental run in the UEFA Champions League, going through the tournament – which featured a preliminary round, two further rounds and a group stage, where the eight remaining teams were divided into two groups of four, with the top team in each group contesting the final – undefeated and only narrowly missing out on the final to a Marseille side who were later found guilty of financial irregularities.

Rangers had been the driving force behind the idea of a Champions League tournament to replace the European Cup. In December 1990, club secretary Campbell Ogilvie had taken his proposals to UEFA, and 1992/93 was the inaugural season of the new competition.

The shirts worn during this Champions League campaign are notable for the absence of the McEwan's Lager logo, since at this time sponsor logos were not allowed in UEFA competitions. It was also, of course, the first appearance on the Rangers shirt of the Champions League 'Starball' logo.

The 'Starball', now an icon of the game, was devised in honour of the eight teams who would go on to contest the group stage of that first tournament – hence the eight stars – with Rangers being the only representative from the UK to qualify, having beaten Leeds United in the 'Battle of Britain' in the second round.

This shirt was worn by Neil Murray during the Group A away match against Marseille on 7th April 1993 and swapped at full-time with Marseille's Alen Bokšić.

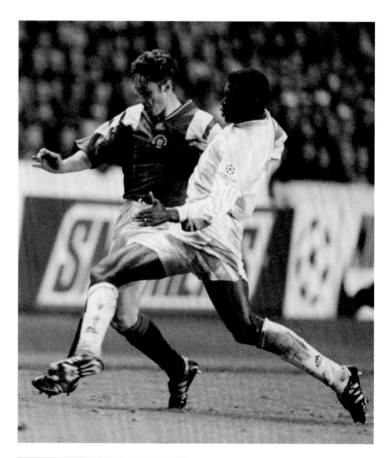

Above: Neil Murray and Marseille's Marcel Desailly tussle for the ball

Left: The first variation of the Champions League sleeve patch, which would later change to a round design

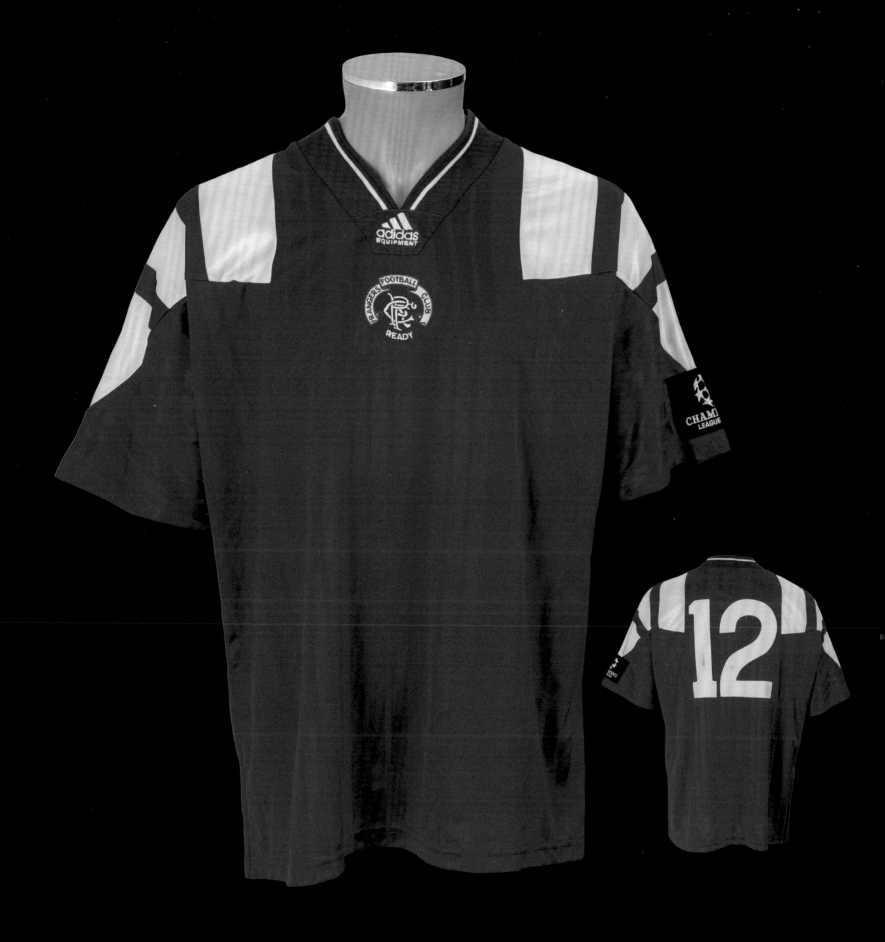

TREBLE WINNERS

LEAGUE CUP
FINAL 1992

Match shirt of **MARK HATELEY**

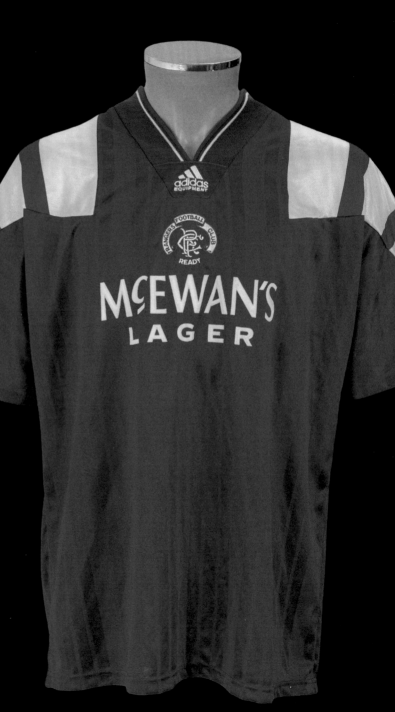

Rangers had faced Leeds United in the epic 'Battle of Britain' Champions League match at Ibrox in the week before the League Cup Final in October 1992, and the 11 players who had beaten the English champions were selected for the showpiece final against Aberdeen.

The shirts prepared for the match were unusual in that the match embroidery was positioned on both sleeves, rather than the front of the shirt.

This short-sleeved jersey was prepared for Mark Hateley but remained unworn as the big striker wore long sleeves on the day. With his team-mates all in short sleeves, Hateley rolled his sleeves up and got on with helping Rangers win 2-1 in extra time to lift the League Cup for the 18th time.

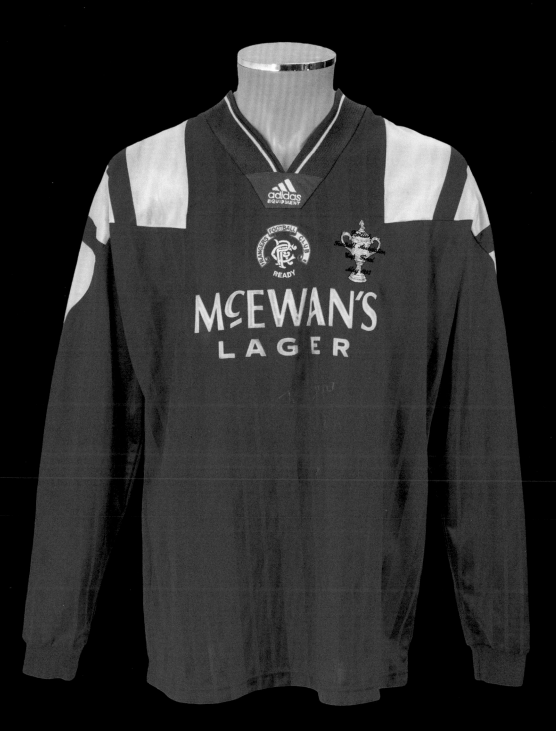

SCOTTISH CUP FINAL 1992

Match shirt of **IAN DURRANT**

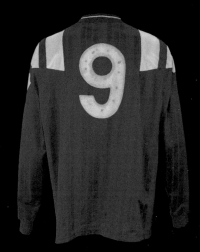

With the national stadium undergoing reconstruction, the Scottish Cup Final match was moved to Celtic Park and it was Rangers who were in paradise as the treble was secured – for the first time since 1978 – with a 2-1 victory over Aberdeen.

With Ally McCoist out of the final with a broken leg, Ian Durrant wore the number 9 shirt, although he opted for short sleeves so this long-sleeved jersey was not worn. Durrant said he would have preferred the number 10 shirt but joked that Hateley had got to it first!

With both teams being supplied by adidas, the commemorative match embroidery matched the style used by Arsenal in the corresponding English FA Cup Final played on the same day.

CHANGE 1993/94

Match worn by **DAVE McPHERSON**

Unveiled in late May 1993, the new change shirt from adidas made its debut appearance during a 2-1 victory on 14th August 1993 against St Johnstone at McDiarmid Park.

The design saw a radical move away from the white change shirts of recent seasons and instead incorporated thick vertical stripes in orange and navy blue – the first time either of these colours had been used in a Rangers kit.

Close inspection revealed that the new club crest with scroll was imprinted in a shadow pattern throughout the material, and there was a return to the tradition of having the embroidered club crest on the left breast with the manufacturer logo on the right.

The fold-down collar, in navy with orange piping, closed at the front with a single button – polo-style – which gave a more traditional look and feel.

Made from 100 per cent polyester, the shirt wasn't without teething problems as the initial batch of replica shirts had issues with quality control, with the material often appearing to have 'pulls and catches' after a few wears.

Having experienced similar problems with Admiral, Rangers complained strongly to adidas, feeling that the credibility of the club was at stake. Following a meeting between the club and their kit manufacturer, assurances were given that the issue would be resolved in future production and fans were urged to return faulty items for a replacement.

On the field, the shirt was worn on seven occasions during its single season in use, including a Champions League qualifying fixture away to Levski Sofia on 29th September 1993.

This shirt was worn by Dave McPherson during the first half of a soggy 2-1 victory away to Raith Rovers in February 1994. The club had numbered some shirts with plain white numbers, which could be used in European competition, and a set with adidas trefoil logos. The team had started the game with the adidas numbered set, but most – including McPherson – changed into the European set with plain white numbers at half-time.

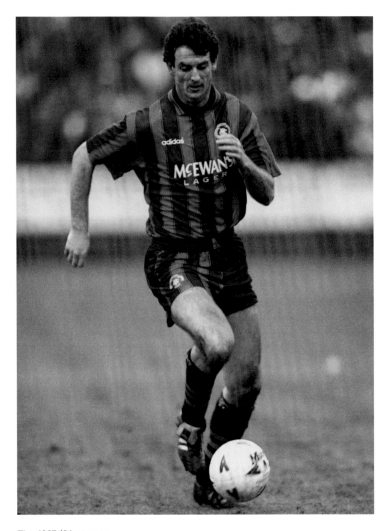

The 1993/94 season would see orange feature on a Rangers shirt for the first time – a colour that would be revisited in seasons to come

SCOTTISH LEAGUE
CUP FINAL 1993

Match worn by **IAN DURRANT**

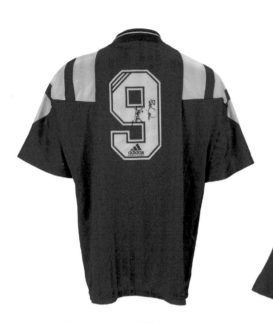

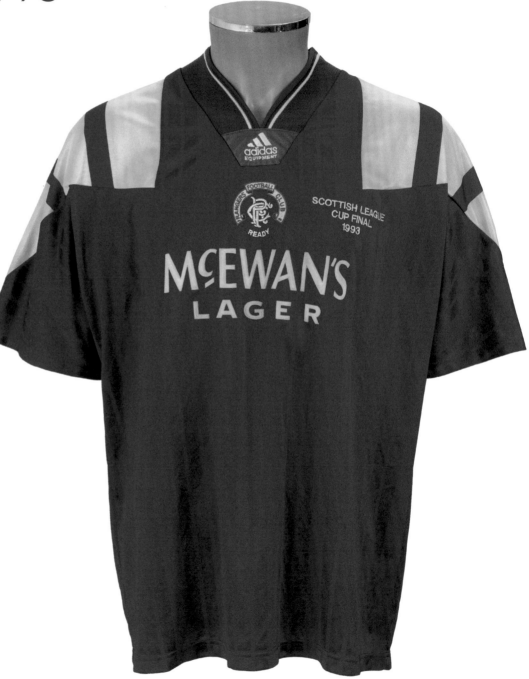

The last of the adidas 1992-94 shirts to feature in a cup final was worn during the Scottish League Cup Final on 24th October 1993, when Rangers took on a Hibernian side – with Ally McCoist named on the bench as he made his comeback from a leg break.

Coming on as a 67th-minute substitute, McCoist scored the winner in true 'Roy of The Rovers' style with an overhead kick in the 81st-minute to claim his eighth Scottish League Cup winners' medal in 10 years.

Despite the heroics of McCoist, the man of the match was Ian Durrant, who ran the show and also scored the opening goal. This short-sleeved shirt was worn by Durrant and features the adidas 'Equipment' heat-pressed numbers as opposed to the previous season's plain stitched numbers.

SCOTTISH CUP FINAL 1994

Match shirt of **MARK HATELEY**

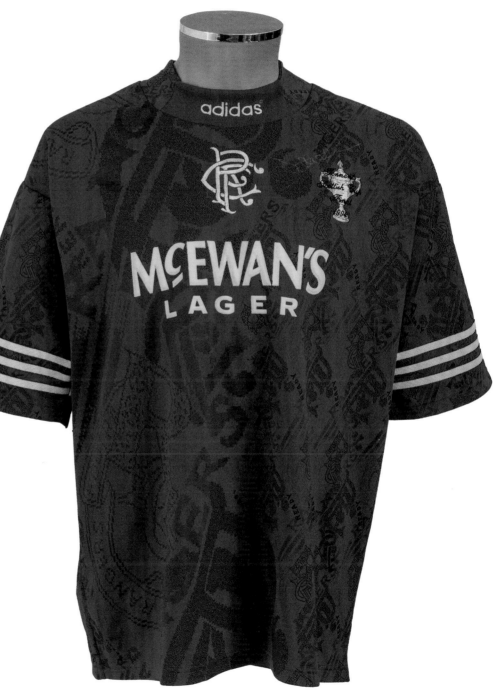

Rangers' attempt to win back-to-back domestic trebles saw them face Dundee United at Hampden in the 1994 Scottish Cup Final on 21st May 1994.

Like the final of 1992, Rangers took the field wearing a new-style adidas home shirt. But it wasn't to be a successful introduction as Dundee United spoiled the party by inflicting a 1-0 defeat on them at Hampden.

This short-sleeved shirt was prepared for the match for Mark Hateley but as usual the English striker went with his favoured long sleeves, albeit with the arms – as ever – rolled up.

HOME 1994-96

Match worn by **IAN FERGUSON**

With the custom for most football clubs now being to change their home shirt style every two years, Rangers unveiled a new adidas kit for the start of the 1994/95 season.

Pictures of the shirt were first seen in the *Rangers News* on 6th April 1994 and the club then elected to wear the new style for the Scottish Cup Final against Dundee United on 21st May 1994, although a 1-0 loss was not the launch pad the club had hoped for the shirt. Despite that sales were high, with Rangers fans snapping up the new style in large numbers.

A return to a more traditional, larger crest without a scroll was a welcome addition. It sat proudly on the centre of the chest, as well as being incorporated in the shadow pattern throughout the royal blue material. The adidas logo was built into the crew-neck collar and the company's trademark three stripes featured horizontally around the sleeves.

For the 1995/96 season, the Scottish Football League implemented sleeve patches for the first time. The heat-pressed patches came in flock and featured the SFL crest in blue with a yellow border.

Despite the initial cup final setback, the shirt was worn during two title-winning seasons and was worn by many outstanding players, including Brian Laudrup, Paul Gascoigne and inspirational captain Richard Gough. Gascoigne in particular was instrumental in ensuring Rangers wrapped up their eighth consecutive league title in 1995/96, with a highlight being his hat-trick against Aberdeen at Ibrox on 28th April 1996 which sealed the title in front of an adoring full house.

This shirt was worn by midfielder Ian Ferguson during the Champions League Group C match against Borussia Dortmund at Ibrox on 27th September 1995. Ferguson scored with a header in the 73rd minute to earn the club a 2-2 draw, with the Germans having taken the lead twice in a hard-fought match.

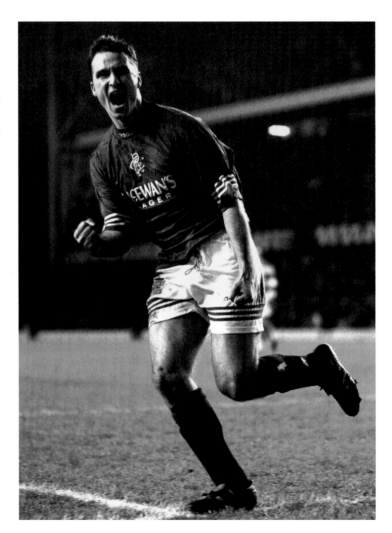

A pumped-up Ian Ferguson celebrates his strike against Celtic in the New Year derby in January 1995

CHANGE 1994/95

Match worn by **CHARLIE MILLER** and **IAN DURRANT**

The 1994/95 season was the first in which Rangers unveiled three new kits for the campaign.

The change shirt was a dynamic red-and-black-striped design which incorporated the club crest both as an oversized graphic on the front and within a shadow pattern throughout the material. The right sleeve also saw the addition of a small square patch featuring the club crest.

The design also incorporated a grandad-style collar in black with red and white piping, which was secured at the front with a button. McEwan's Lager continued as sponsor and was applied to its usual position in a white flock.

First unveiled alongside the new home shirt in April 1994, the red and black design was worn four times during the 1994/95 season in away league matches against Falkirk and Kilmarnock, with Rangers victorious on all four occasions. However, with UEFA guidelines stipulating that clubs could not display more than one standard-sized club crest per shirt, it was deemed unacceptable for European use and Rangers had to go back to adidas to request an additional jersey for non-domestic matches.

This number 9 shirt was prepared for use throughout the season and was worn three times in a short-sleeved configuration by both Ian Durrant and Charlie Miller.

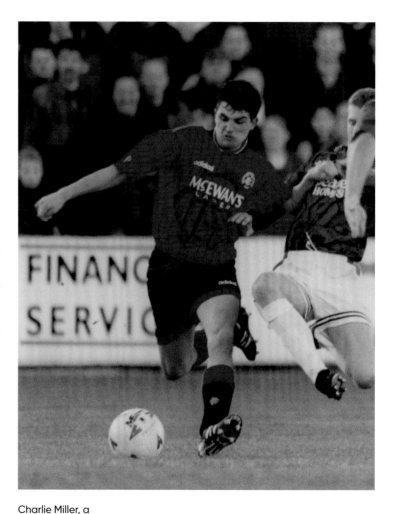

Charlie Miller, a skilful playmaker who also relished the physical side of the game, battles his way through the Falkirk defence

THIRD 1994/95

Match worn by **BRIAN LAUDRUP**

The new third shirt was launched in August 1994, and despite only making the briefest of appearances at the start of that campaign it would go on to become considered a cult classic Rangers shirt.

With the season's red and black change shirt not earning approval from UEFA, Rangers had been forced to go back to adidas for an alternative, who came up with a lightweight shirt in two-tone lilac. It featured a polo shirt-style collar in black with lilac and white piping, giving the design a fresh and stylish look unlike any other Rangers shirt before it.

Although designed for European competition, the club's early exit at the hands of AEK Athens in the Champions League qualifying round meant that it never saw action as intended. In fact, it made only two competitive appearances in its lifetime: against Sampdoria in the August 1994 pre-season Ibrox International Tournament and against Motherwell at Fir Park during a league match in October 1994.

It wasn't a popular shirt with the management team and defeats in both of these matches saw kitman Jimmy Bell given strict instruction to consign it to the kit room. However, it did see action on one final occasion when it was worn in Scott Nisbet's Testimonial between a Rangers Select team and a Rangers International Select side in May 1995.

This shirt was worn by Brian Laudrup during his Ibrox debut against Sampdoria in the Ibrox International Tournament. Laudrup quickly became a fan favourite and is regarded by all who saw him as one of the club's most skilful players. Signed from Fiorentina in the summer of 1994, he quickly fell in love with the club and played probably the best football of his distinguished career at Ibrox before moving on to Chelsea some four years later.

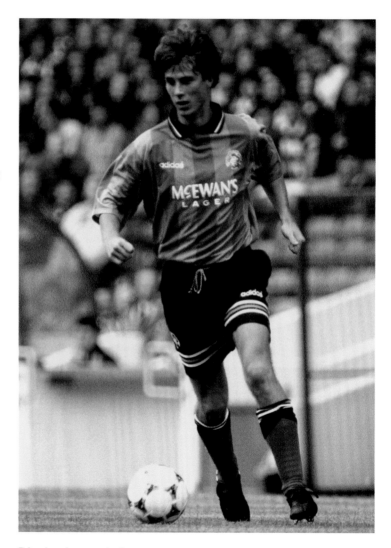

Brian Laudrup sported this iconic lilac shirt while making his home debut during the Ibrox International Tournament

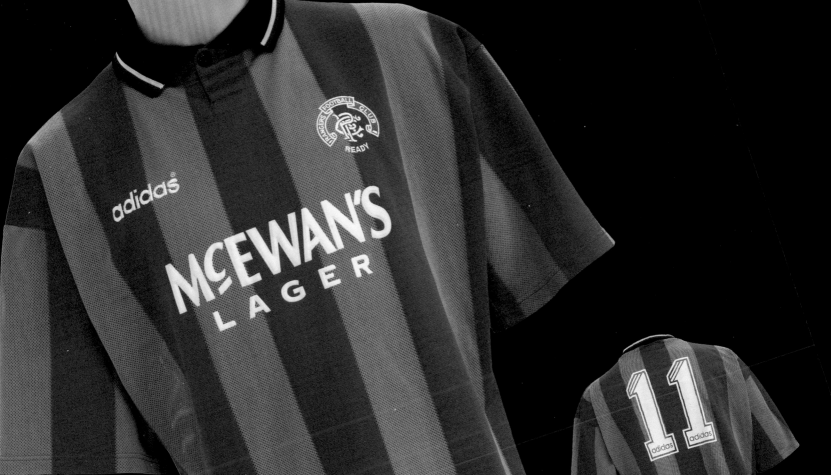

CHANGE 1995/96

Match worn by **SUBSTITUTE**

The fifth change shirt design in four seasons, the alternative to the home jersey for the 1995/96 season was definitely another bold statement from adidas.

Featuring a red-and-white-quartered design with black trim, including an oversized v-neck and 'three stripe' mark on the sleeves, the shirt was worn eight times during the season.

The style is synonymous with the sensational arrival at Rangers of England star Paul Gascoigne following his signing from Italian side Lazio. Indeed, when Rangers played Anorthosis Famagusta during a Champions League qualifying match at Ibrox on 9th August 1995 in this shirt style, it was actually Gazza's first-ever match in European competition, at the age of 28.

One other notable feature is the placement of the club crest within a large black shield, reflecting the fashion for retro features in football shirt design common at the time and very much reminiscent of the style used on the 1920s and 1930s change shirt.

To ensure that the sponsor logo was clearly visible, the McEwan's Lager branding was placed within a white rectangle, and on the bottom right there was the addition of a small rectangular patch featuring three registered trademark club crests.

The shirt pictured here was prepared for a domestic league match in which the numbers 1-11 were still used, meaning that this was a substitute jersey. The number on the back incorporated adidas logos and three stripe detailing, although they were plain black for the Champions League qualifier when the shirt made its debut.

Another popular and fondly remembered design, it was worn during the season when Rangers claimed their eighth league title in a row.

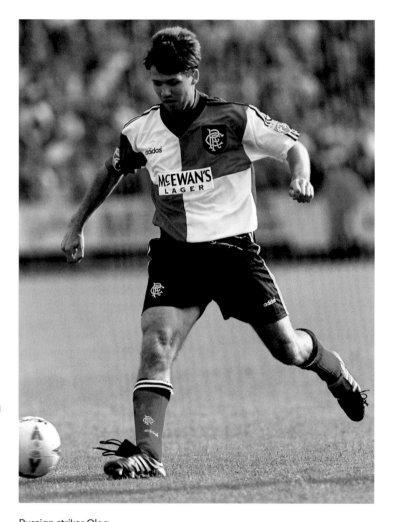

Russian striker Oleg Salenko would have been one of the players to have worn this popular shirt during the 1995/96 season

HOME 1996/97

Match worn by **DEREK McINNES**

The final Rangers home shirt of the adidas era was, according to the manufacturer, designed to reflect "the heritage of this great club with a refreshing new look" and will forever be remembered as the 'nine-in-a-row' jersey.

In fact the shirt was virtually identical to the France shirt worn by Zidane and co at the recent Euro 96 tournament in England, the only major difference being the collar, which was open with a v-insert compared to the lace-up version on the French kit. Shadow patterns featuring the club crest also ran throughout the fabric of the shirt and the embroidered 'RFC' crest moved back to its traditional position above the right breast.

The bottom right front of the shirt included a different version of the trademark patch first seen on the previous season's change shirt, and although this was technically against UEFA rules it slipped under their radar and was not removed for Champions League matches.

Although only worn for a single season, this shirt remains another firm favourite with supporters. It made its debut in the Scottish Cup Final on 18th May 1996 and would also see action in an epic 4-3 Scottish League Cup Final victory over Hearts on 24th November 1996. However, it is of course most famously known as the shirt in which Rangers sealed their historic ninth league title in a row on 7th May 1997 with victory over Dundee United at Tannadice Park.

This shirt was worn by Derek McInnes during the Champions League Group A match against Ajax on 16th October 1996, with the plain white numbers used to comply with UEFA's strict regulations on the number of club and sponsor logos allowed on a shirt.

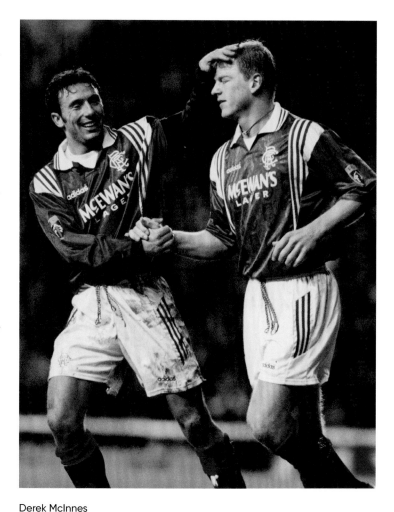

Derek McInnes celebrates with Jörg Albertz whilst wearing the last of adidas' Rangers home shirts, seen here in the league configuration

CHANGE 1996/97

Match shirt of **JOACHIM BJÖRKLUND**

The 1996/97 season was the last campaign with adidas as Rangers' kit supplier, and the global sports brand signed off the partnership with one final slice of classic three stripe styling.

The last adidas change shirt saw the return to a predominantly white design, but the contrasting sleeves of red and white and the three stripes in blue and red running vertically down the right front of the shirt gave a modern yet classic twist to this traditional change colour.

Like all shirts during the 1990s, it was a loose fit and designed to look best when worn outside the shorts (or a pair of jeans in the Ibrox stands). The collar had reverted to a grandad-style, in red, with three buttons at the neck. Like the previous season's change shirt, the large club crest sat within a shield design, although the shield was now red with a blue border and the embroidered crest was white with the McEwan's Lager sponsor logo changed to a blue flock style.

Launched in May 1996, the shirt made its first outing during the pre-season friendly match on tour against Danish side Fremad Amager on 27th July 1996, with the Gers coasting to a 9-1 victory.

Back home, the shirt would only see use on a further four occasions, coming in the two matches away to both Kilmarnock and Raith Rovers during that season's league campaign.

This shirt was prepared for Swedish defender Joachim Björklund for one of those league campaign matches during the 1996/97 season. Björklund would go on to lift both league and Scottish League Cup trophies during the campaign, having arrived at Rangers from Italian side Vicenza in the summer of 1996.

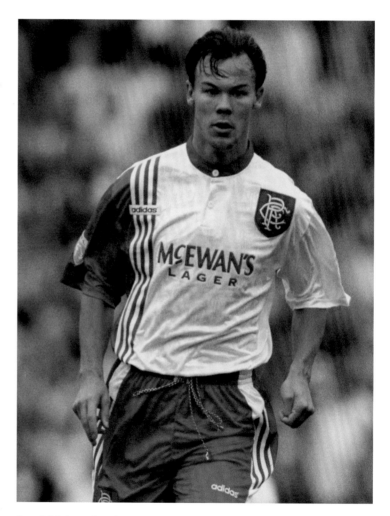

Swedish international centre-back Joachim Björklund was a composed presence in the Rangers defence during the 1996/97 campaign

SCOTTISH CUP FINAL 1996

Match worn by **PAUL GASCOIGNE**

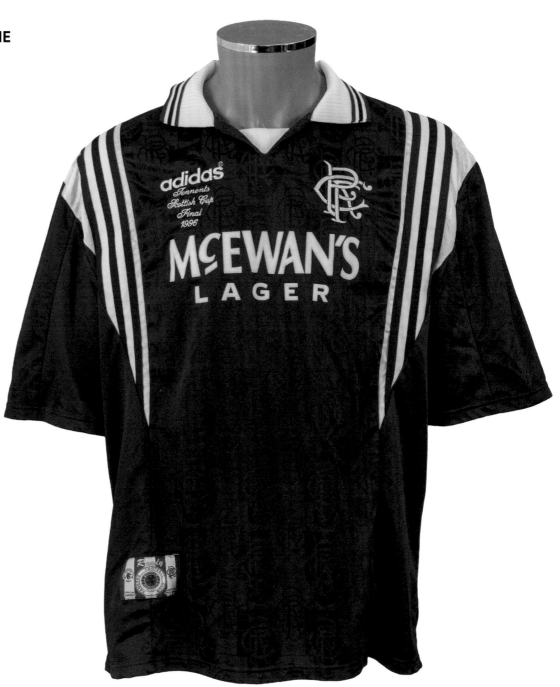

Following in the tradition of the previous two kit releases, Rangers had launched the 1996/97 season shirt at the end of the previous campaign, and it was worn in the Scottish Cup Final against Hearts on 18th May 1996. This proved to be a good omen for the glory to come as Rangers destroyed the men from Edinburgh 5-1, with Brian Laudrup running the show and helping to set up a hat-trick for striker Gordon Durie.

This shirt was worn by Paul Gascoigne during this, his one and only Scottish Cup Final appearance. Gazza and Rangers were a perfect match and he undoubtedly played the best football of his career during his near three-year spell at Ibrox. Reflecting on his time at Rangers, Gazza would later say: "I'd do it all over again. I'd do those two years for the rest of my life."

LEAGUE CUP FINAL 1996

Match shirt of **CRAIG MOORE**

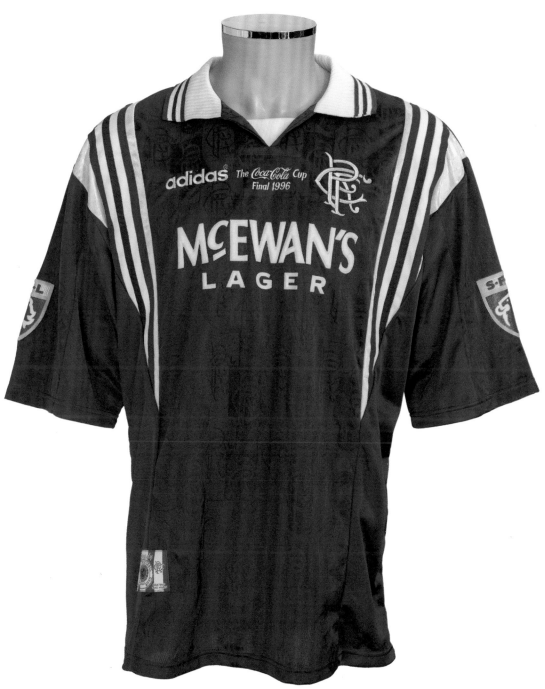

Rangers had reached the Scottish League Cup Final by scoring 16 goals along the way, and would add another four to that total as they defeated Hearts 4-3 at Celtic Park, with two goals apiece from Ally McCoist and Paul Gascoigne.

Gazza had an outstanding match, despite needing a half-time whisky to settle his nerves after an on-field argument with McCoist continued on into the dressing room. In front of surprised guests, he had marched into the Celtic Park boardroom in full kit, ordered his drink and downed it in one before heading back out to the pitch for the second half, where he tore Hearts apart.

This shirt was prepared for defender Craig Moore, but the big Australian opted to play in a long-sleeved shirt on what was a bitterly cold afternoon in Glasgow.

HOME 1997–99

Match worn by **MARCO NEGRI**

In April 1997, it was announced that American sportswear giants Nike would be the club's new kit supplier, having signed a five-year deal to take effect from the start of the 1997/98 season.

The first Nike shirts were worn during a pre-season 'Nike Fun Day' at Ibrox on 13th July 1997, which included a 'Blues v Whites' match between teams made up from current squad players that was reminiscent of the old public trial matches the club used to hold.

The new home shirt was a darker blue than previous recent designs with a small, embroidered club crest sitting within a red piped shield over the left breast. McEwan's Lager continued as the shirt sponsor, but their logo was incorporated into the shirt fabric rather than being printed onto it in flock. It was also positioned within a darker blue band, which went around the body of the shirt, broken at the rear to create a clean space for the shirt number.

Both the white collar and cuffs were a thicker fabric than on previous recent shirts, incorporating grey and black piping – colours that also appeared more prominently on the new Nike change shirt.

The new style was worn during a huge transitional period at Ibrox, with manager Walter Smith stepping down at the end of the 1997/98 season. It was the end of a golden era, with many experienced players such as Andy Goram, Ally McCoist, Ian Durrant, Brian Laudrup and Richard Gough all leaving the club.

With the departure of Smith, Dutch supremo Dick Advocaat took over the managerial reins. Advocaat was the first non-Scot to manage Rangers and quickly set about rebuilding the squad, landing the club their first domestic treble since 1992/93. The league title was wrapped up at Celtic Park on 2nd May 1999 with a famous 3-0 victory.

This shirt was worn by Italian striker Marco Negri during the 1997/98 season. Negri had burst onto the scene, scoring 33 times in 26 appearances, before an eye injury unfortunately stopped him in his tracks.

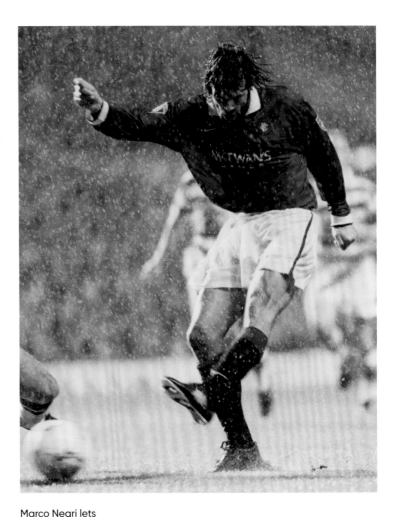

Marco Negri lets fly against Celtic during the 1997/98 season. Sadly, Negri's career would be cut short due to injury

CHANGE 1997/98

Match worn by **ALEX CLELAND**

While the first Nike change shirt maintained the tradition of being white in colour, the design incorporated an unusual two-tone design. The white top section of the shirt gradually merged from grey into black at the bottom, with four vertical grey stripes running down the front shirt and splitting the dark section into panels.

The fold-down collar was in black with red and white piping, and this matched the sleeve cuffs. Like the home style, a small club crest sat within a blue shield design, while the blue McEwan's Lager logo was no longer printed in flock but was an integral part of the printed material itself.

At the beginning of the 1997/98 season, Rangers had become one of the first football clubs to commission a television commercial urging supporters to purchase the new Nike shirts directly through the club shop. Using Paul Gascoigne as the star of the advertising campaign, it helped bring in huge sales as fans snapped up the new designs. Approximately 20,000 shirts were sold in the first week alone.

Together with the home shirt, the new change jersey made its debut during the 'Blues v Whites' pre-season match at Ibrox before being worn during a Testimonial match for Everton defender Dave Watson at Goodison Park three days later.

The 1997/98 season was the last campaign before player names and squad numbers were introduced in the Scottish League. However, this change had already come into effect in European competition, which meant that for Champions League qualifying and UEFA Cup matches Nike supplied sets of shirts with names and numbers in their own block-style font.

This shirt was prepared for the 1997/98 league campaign, with Alex Cleland and Stuart McCall both wearing number 2 during their final season as Rangers players.

Defender Alex Cleland in the first of the new change kits from Nike, which debuted during the Nike Ibrox Fun Day Blues v Whites match in July 1997

SCOTTISH CUP FINAL 1998

Match worn by **BRIAN LAUDRUP**

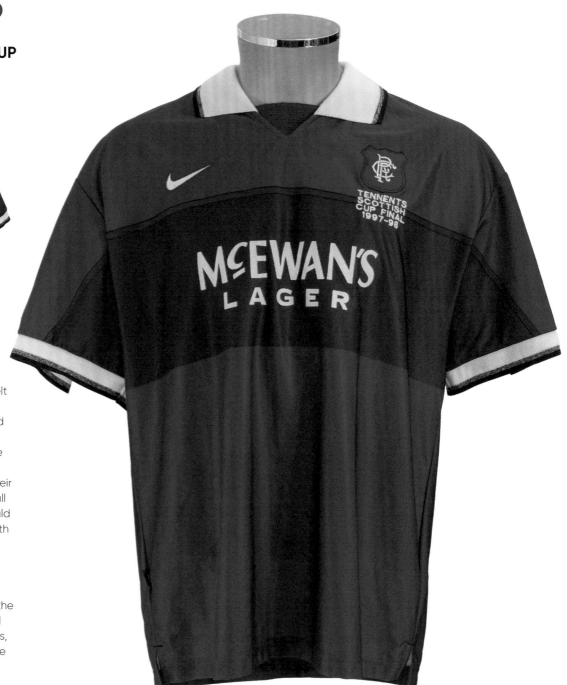

The Scottish Cup Final on 16th May 1998 felt very much the end of an era for Rangers.

Winning a 10th league title in a row had proved to be a step too far and manager Walter Smith had announced he would be stepping down after the final. Many of his senior players had also decided to end their time at the club and unfortunately, after all the recent triumphs, the Scottish Cup would elude them on their final appearances, with Hearts gaining the spoils on the day.

This shirt was worn during the final by Danish superstar Brian Laudrup – his last match for the club he had grown to love. One of the greatest players to ever wear the Rangers shirt, he ended his four-year spell with three Scottish League Championships, one Scottish Cup and one Scottish League Cup winners' medal, as well as countless individual accolades.

SCOTTISH CUP FINAL 1999

Match worn by **ANDREI KANCHELSKIS**

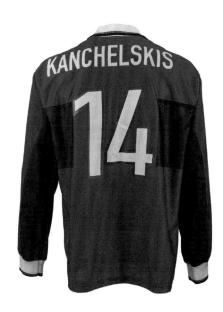

Rangers took on Celtic in the final of the Scottish Cup on 29th May 1999, looking to win their first domestic treble since 1993.

Dick Advocaat's team had hit the ground running, winning the Scottish League Cup and League Championship, and Celtic were swept aside too as a 49th-minute goal from Rod Wallace saw the treble completed in style.

These shirts saw a return to having the embroidered match details surrounding the crest in a circular pattern. Like the Scottish League Cup Final shirts some six months earlier, the 1999 final was the first time a Rangers Scottish Cup Final shirt featured player names.

This shirt was worn by flying Ukrainian winger Andrei Kanchelskis who came off the bench in the 76th minute to replace Sergio Porrini.

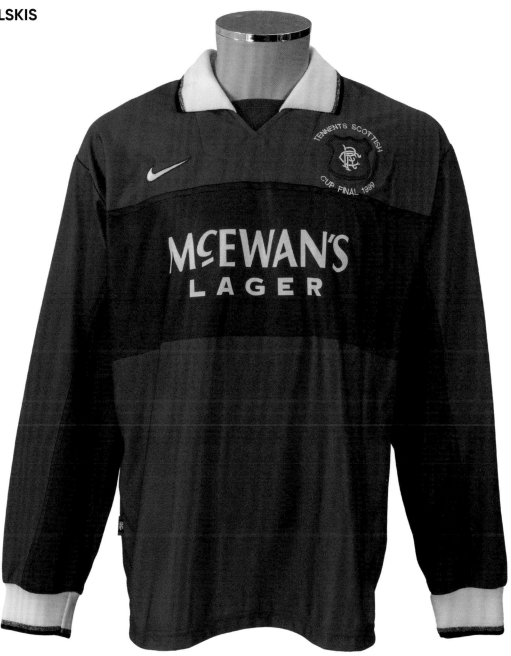

CHANGE 1998/99

Match worn by **IAN FERGUSON**

Nike produced a new shirt in the summer of 1998, restoring the club's away colours to the ever-popular red.

The plain red body of the shirt was broken up by a band of navy blue which ran down both arms and sides of the shirt, and the v-neck collar incorporated the same shade of blue along with a band of white. The club crest appeared minus the shield that Nike had used on its first two shirts, and this was also the last shirt to feature the McEwan's Lager logo.

Used 11 times during the 1998/99 league season, the shirt was also chosen for the Scottish League Cup Final at Celtic Park in November 1998, with St Johnstone having been drawn as the 'home' team.

The 2-1 cup final triumph set the scene for the rest of the season, with Rangers going on to complete the domestic treble under manager Dick Advocaat in his first season in charge.

The 1998 Scottish League Cup Final was the first time a change shirt had been used by the club during a domestic major final since the Scottish Cup Final victory over Dundee in 1964. Rangers had also worn change shirts during the 1921 Scottish Cup Final against Partick Thistle, the 1930 Scottish Cup Final and replay (also against Partick Thistle), and the Scottish League Cup Finals of 1949 and 1951 against Raith Rovers and Dundee respectively.

This shirt was worn during the final by midfielder Ian Ferguson. 'Fergie' had come on as a 64th-minute substitute, replacing Jörg Albertz, as Rangers lifted the trophy for the 21st time, with Rangers' goals coming from Albertz and Stephane Guivarc'h.

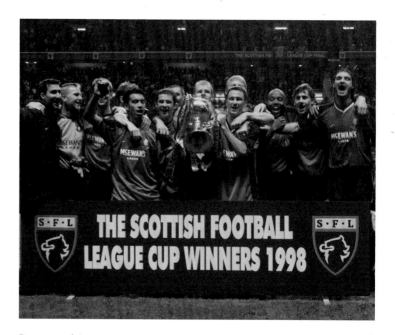

Rangers celebrate their League Cup Final victory over St Johnstone, the 21st time the club had lifted the trophy

NIKE

RC

SCOTTISH LEAGUE
CUP FINAL
1998

McEWAN'S
LAGER

I FERGUSON
14

HOME 1999-2001

Match worn by **GABRIEL AMATO**

On 1st July 1999 Rangers and Nike launched a new home kit with another television advertising campaign, this time starring Rod Wallace and Giovanni van Bronckhorst.

The shirt was royal blue with white piping, with mesh underarm panels for ventilation. The return to a v-neck collar was at the request of manager Dick Advocaat, whose reasoning was that round-neck collars restricted airflow and made shirts uncomfortable, and he ensured that every Rangers shirt designed during his time at the club featured an open neck.

The new home shirt also saw a change of main sponsor, with cable TV company NTL having signed a three-year deal to replace McEwan's Lager in February 1999.

The previous Nike shirts had been manufactured in the UK, but production had been relocated to Portugal and the new style felt significantly lighter to wear than its predecessor.

First worn during a pre-season friendly match away to Stirling Albion on 3rd July 1999, this style saw action for two seasons, with Rangers winning the league title and Scottish Cup during the first of those campaigns.

This shirt was worn by Argentinian striker Gabriel Amato during the league match against Celtic at Ibrox on 7th November 1999. It was a glorious occasion that saw Rangers defeat their Old Firm rivals 4-2, with Amato scoring the fourth goal in one of his last matches for the club. 'Gabby' had joined the Gers during the summer of 1998 and had a short but successful period before moving on in January 2000.

The shirt carried the new-style Bank of Scotland SPL sleeve patches in gold, which were reserved for the defending champions and were worn for both seasons of this shirt's lifetime.

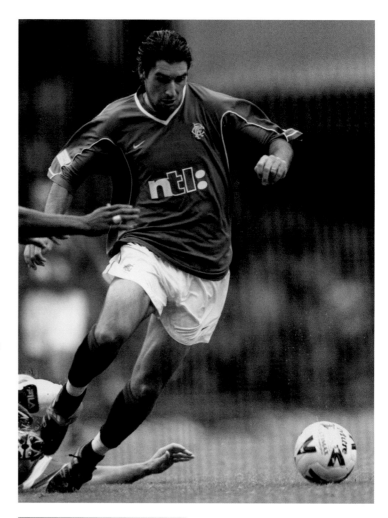

Above: Gabriel Amato leaves the Celtic defence for dead at Ibrox in November 1999

Left: The SPL competition badge

CHANGE 1999/2000

Match shirt of **COLIN HENDRY**

The change shirt for the 1999/2000 season was unusual in that it was predominantly blue, and consequently was only worn on two occasions – both times away to Aberdeen.

Many supporters were annoyed that they had purchased a shirt which saw very little use, with the club generally preferring to use the previous season's shirt in the event of a kit clash. Rangers acknowledged this in the club newspaper, explaining that the shirt had been designed by Nike a full 18 months earlier when they had no idea what designs other SPL teams would be using.

This shirt was prepared for defender Colin Hendry, who on signing for Rangers in August 1998 had been disappointed at not being able to claim his favoured number 5 shirt which had been allocated to Arthur Numan. Hendry took the number 35 jersey before moving to number 16 for this season.

THIRD 1999/2000

Match shirt of **COLIN HENDRY**

The 1998/99 change shirt design was thrown back into service for the 1999/2000 season – this time as the club's third kit after the realisation that the varying tones of blue in the new change shirt didn't really help avoid the majority of kit clashes.

Now with a new sponsor in NTL, the red and navy shirt was worn on nine occasions during the season as Rangers cruised to a domestic league and cup double.

Prepared for use by Colin Hendry, this shirt was never worn as he faced long periods out through injury and dropped down the pecking order, with manager Advocaat preferring to go with a partnership of Craig Moore and Lorenzo Amoruso. Hendry eventually departed Ibrox for Coventry City in February 2000.

CHAMPIONS LEAGUE
1999

Match worn by **JÖRG ALBERTZ**

Jörg Albertz wore this shirt when he returned to his homeland with Rangers to face Bayern Munich in the Champions League Group F match in November 1999.

Despite suffering a 1–0 defeat at the Olympic Stadium, Rangers were outstanding in front of a huge contingent of away fans, hitting the woodwork three times and dominating the Germans for long periods of the match.

The Champions League version of this shirt differed from its domestic configuration through the addition of the 'Starball' patch on the right sleeve and the use of plain, unbranded numbers.

Albertz, known as 'The Hammer' because of his ferocious left–foot shoot, had scored in the earlier match against the German giants at Ibrox during a 1–1 draw, before Rangers agonisingly conceded a late deflected goal.

SCOTTISH CUP
FINAL 2000

Match worn by **TUGAY KERIMOĞLU**

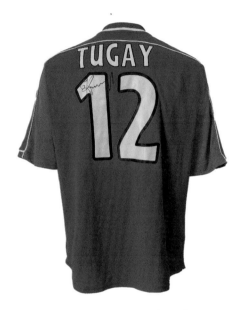

Before the Scottish Cup Final against Aberdeen in May 2000, Dick Advocaat had been keen for the players to wear orange shirts after Rangers supporters – in honour of their Dutch manager and players – had dubbed the match the 'Orange Day Final'.

The club's fans were encouraged to wear something orange on the day, although winger Andrei Kanchelskis said that the players preferred to stick to their usual kit.

In the end, the home shirt was worn during the 4-0 victory over Aberdeen. Unusually, however, the short-sleeved shirts which were prepared were replica specification stock that featured a Nike size label on the front, with the long-sleeved shirts being the normal player-issue jerseys.

This shirt was worn by Tugay Kerimoğlu, who came on as a 73rd-minute substitute, replacing Giovanni van Bronckhorst.

CHANGE 2000/01

Match worn by **BERT KONTERMAN**

Predominantly white with horizontal red and blue bands, Rangers' change shirt for the 2000/01 season was reminiscent of Rangers' famous 'floodlight shirts' of the 1950s.

This shirt was worn by Dutch centre-back Bert Konterman during the second leg of the Champions League second qualifying round match against Danish side Herfølge at Ibrox. Rangers had worn their home shirts for the 3-0 victory in the away leg, but the decision was made to play the home match in white to avoid any clash with the Danish team's yellow and blue kit.

Rangers recorded another 3-0 win in the second match and went on to the group stages to meet Sturm Graz, Monaco and Galatasaray. Being a qualifying round, there is no player name or Champions League sleeve patch on this shirt.

THIRD 2000/01

Match worn by **TORE ANDRÉ FLO**

Arriving somewhat under the radar, having not been officially announced to the public, this third kit was produced by Nike for use during the 2000/01 season.

The red shirt with black piping was manufactured using the company's Dri-FIT technology and made its debut for the league match away to Kilmarnock on 5th August 2000. It was worn twice more during the season, against Hibernian and then against Kilmarnock again on 11th April, when this shirt was worn by Tore André Flo.

At the time of writing, the big Norwegian remains the club's record signing at £12 million. In his two season at Rangers, Flo contributed with a fine return of goals before signing for Sunderland in the summer of 2002.

A limited number of replica shirts were produced, going on sale some two months after the style was first worn by the team.

HOME 2001/02

Match worn by **NEIL McCANN**

The final Rangers home shirt of the Nike era was notable for the inclusion of red side and underarm panels. It was another stylish offering from a global brand whose shirts are still fondly remembered by the Ibrox faithful today.

Using Nike's Dri-FIT technology, the royal blue shirt also featured white piping which framed the red vented side panels, while red was repeated as an insert within the collar design.

The new shirt of course also included a v-neck collar on the directions of manager Dick Advocaat, but halfway through the season the club's Dutch manager decided the time had come for him to move upstairs. Advocaat became Director of Football and Alex McLeish was chosen to replace him to become the club's 11th manager.

The shirt made its debut during a pre-season tour match against Dutch side VV DOVO, with Rangers cruising to a 7-0 victory. But the league season started poorly and only turned after McLeish arrived, with the team galvanised under his leadership. By the end of the season both the League Cup and the Scottish Cup were back in the Ibrox trophy room.

This shirt was worn by Neil McCann during the Champions League third qualifying round match against Turkish side Fenerbahçe at Ibrox on 8th August 2001. Since it was a qualifying round, there is no 'Starball' sleeve patch as these were not applied until the group stages. A larger than usual name was also applied above the plain shirt numbers – in white with a black border – as per UEFA guidelines.

The match finished 0-0, with Rangers playing a large part of the game with 10 men, Michael Mols having seen red. It would leave the club too much to do in Turkey against a side who had won all 17 of their home matches the previous season. Failure to reach the Champions League group stage saw Rangers parachute into the UEFA Cup, where they reached the Round of 16 before going out to eventual tournament winners Feyenoord.

Skilful winger Neil McCann wearing the Nike home shirt of the cup double-winning 2001/02 season

CHANGE 2001/02

Match worn by **NEIL McCANN**

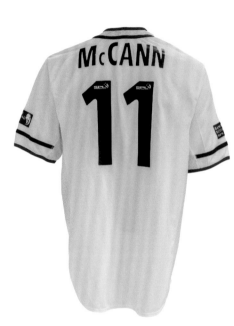

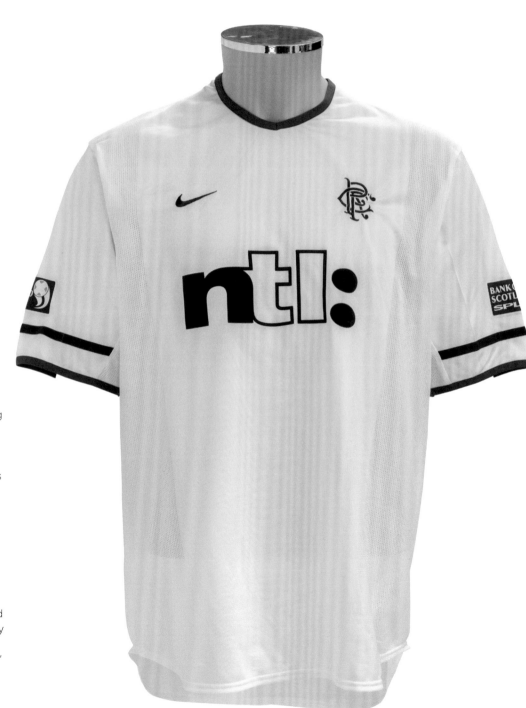

Nike's final change shirt for the club was a relatively minimalist white shirt with red piping around the front of a rounded v-neck collar.

The shirt was well-used throughout the season, with its most notable appearance coming on 6th December 2001 when Rangers defeated a very strong Paris Saint-Germain side containing star players like Ronaldinho, Nicolas Anelka and Jay-Jay Okocha as well as Mikel Arteta and Lionel Letizi – who would both go on to join Rangers in the following years – after a nail-biting penalty shoot-out in the Parc de Princes.

This shirt was worn by Neil McCann. The winger was delighted to have been allocated the squad number 11 for the season. "So many great Rangers players have worn this jersey and it has always been my favourite number," he told the *Rangers News*.

THIRD 2001/02

Match shirt of **MICHAEL MOLS**

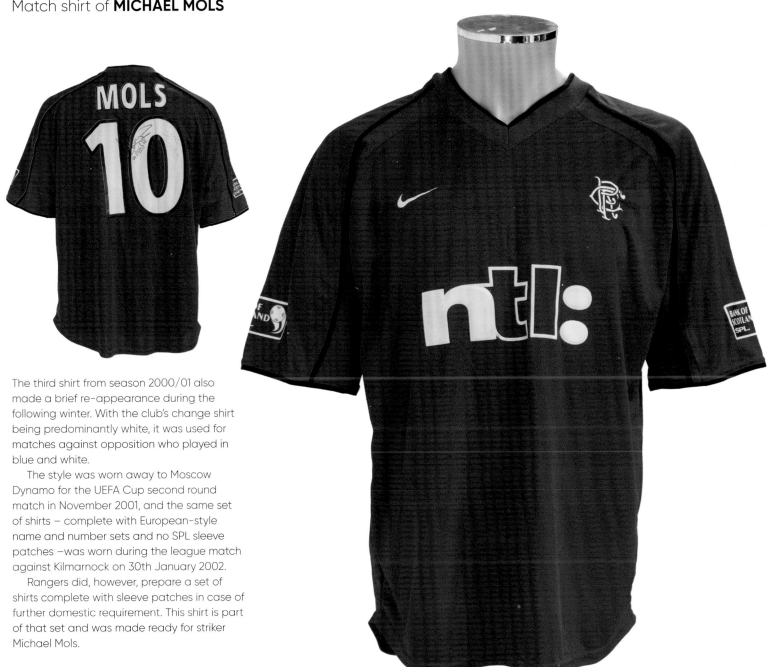

The third shirt from season 2000/01 also made a brief re-appearance during the following winter. With the club's change shirt being predominantly white, it was used for matches against opposition who played in blue and white.

The style was worn away to Moscow Dynamo for the UEFA Cup second round match in November 2001, and the same set of shirts – complete with European-style name and number sets and no SPL sleeve patches –was worn during the league match against Kilmarnock on 30th January 2002.

Rangers did, however, prepare a set of shirts complete with sleeve patches in case of further domestic requirement. This shirt is part of that set and was made ready for striker Michael Mols.

CUP DOUBLE

LEAGUE CUP
FINAL 2002

Match worn by **ARTHUR NUMAN**

Rangers faced Ayr Utd in the CIS Insurance Scottish League Cup Final at Hampden Park on 17th March 2002, having disposed of Celtic in the semi-final a month earlier.

Two goals from Claudio Caniggia and one each from Barry Ferguson and Tore André Flo saw Rangers pick apart the First Division side, who were making their first-ever national cup final appearance.

This short-sleeved shirt was worn during the final by Arthur Numan. The winners' medal he picked up after the match became the sixth that the Dutch international had won with Rangers since joining in the summer of 1998 from PSV Eindhoven.

SCOTTISH CUP FINAL 2002

Match shirt of **CLAUDIO CANIGGIA**

The 117th Scottish Cup Final was an Old Firm classic, with Rangers twice coming back from behind to win the trophy in the final seconds thanks to a Peter Lovenkrands header.

This long-sleeved shirt was prepared for Argentinian maestro Claudio Caniggia, but like all the other Rangers players he chose to wear short sleeves on a sunny Hampden afternoon.

Caniggia rolled back the years with classy forward play during his two-year spell for the club. Unfortunately, his appearance in the 2002 final was cut short when he was injured as a result of a clumsy challenge by Celtic striker Chris Sutton, which forced him to be replaced after only 20 minutes.

A MARK OF HONOUR

Special occasions that are intended to celebrate a glorious career or provide support in times of need, Testimonials have given rise to a number of Rangers shirts featuring bespoke match embroidery.

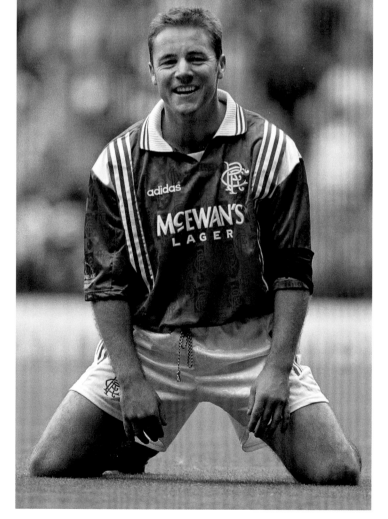

Rangers have featured in countless Testimonial and Benefit matches throughout their long history. The club has long been seen as an ideal choice of opposition for such occasions, mainly due to the large following it would inevitably bring, therefore ensuring a healthy return for the chosen cause or long-serving player.

The Rangers team for these matches would often include guest players, such as Celtic's Patsy Gallagher, who featured during his friend Andy Cunningham's Benefit match at Ibrox in late April 1922, or even the famous comedian George Robey, who played for Rangers in Jacky Robertson's Benefit match in 1904 and in Johnny May's Benefit match in 1909.

Prior to 1978, the club would play these games in their standard kit without any special details. That changed on 16th April 1978 when John Greig was recognised for his service with a Testimonial match against a Scotland International Select team at Ibrox. A crowd of 65,000 watched Rangers win 5-0, with the players' shirts featuring the embroidered inscription 'John Greig Testimonial 1978' over the right breast. With Rangers and Umbro agreeing the club's first kit sponsorship deal around the same time, these shirts are notable for being the first outfield Rangers shirts to feature a manufacturer's logo, with Umbro's 'double diamond' logo appearing below the match embroidery.

What follows are a selection of particularly notable and celebrated Testimonials and Testimonial shirts from the club's history.

Even in a Testimonial he's desperate to score! Ally McCoist rues a near miss during the Richard Gough Testimonial versus Arsenal in 1996

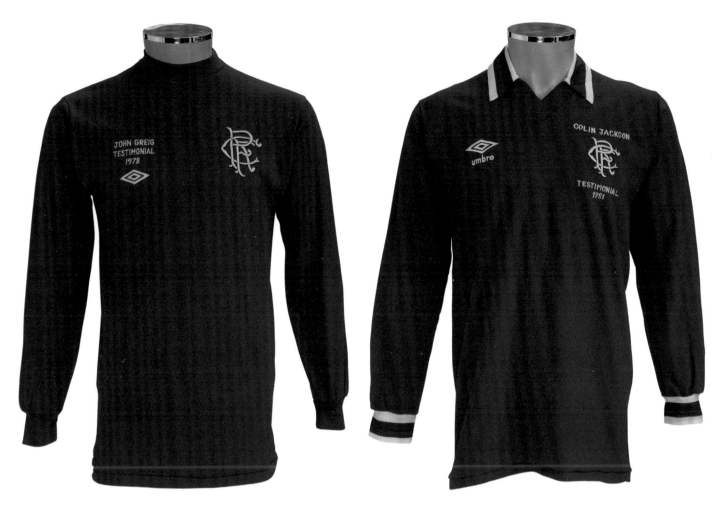

1978

JOHN GREIG TESTIMONIAL

Match worn by **Colin Jackson**
v Scotland International Select,
16th April 1978

Voted the 'Greatest Ever Ranger' by
supporters, John Greig was honoured with a
Testimonial match against a Scotland Select
at a packed Ibrox. Captain on the night
Rangers won the European Cup Winners'
Cup in Barcelona in 1972, Greig took over
as Rangers manager in the summer of 1978
following the departure of Jock Wallace.

1981

COLIN JACKSON TESTIMONIAL

Match worn by **Colin Jackson**
v Everton, 15th November 1981

Colin Jackson wore this shirt during his own
Testimonial match, which saw a crowd of
25,000 turn out to honour the big international
defender, who would leave Rangers the
following May. 'Bomber' was one of a select
few to make more than 500 appearances for
the club during a 19-year stay.

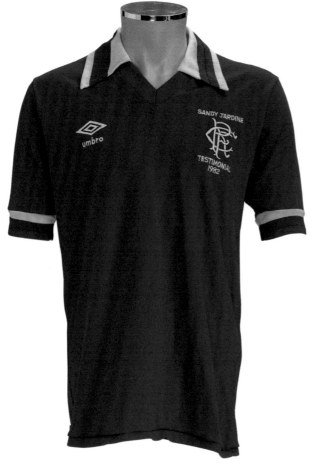

1982

SANDY JARDINE TESTIMONIAL

Match worn by **Sandy Jardine**
v Southampton, 9th May 1982

Six months after Colin Jackson's Testimonial, Rangers paid tribute to the great Sandy Jardine, whose playing career was coming to an end after 18 years at the club. Jardine was one of the most polished right-backs in world football and his importance to Rangers was recognised in 2014 when the Govan Stand was renamed the Sandy Jardine Stand.

1983

TOM FORSYTH TESTIMONIAL

v Swansea City, 27th March 1983

Tom Forsyth was honoured some 10 years after he memorably produced the winner in the 1973 Scottish Cup Final. Unfortunately, no special match shirt was produced for his Testimonial, but instead a standard league shirt was used during the match, hence no shirt could be photographed for this book.

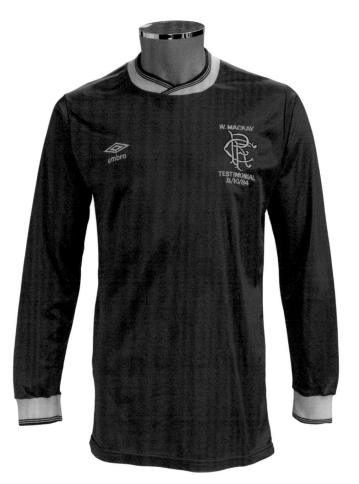

1984

BILLY McKAY TESTIMONIAL

Presentation shirt of **Craig Paterson**
v New Zealand, 31st October 1984

As well as honouring treasured servants of the club, one of the ideas behind Testimonials was to support players through troubled times. This was the case for Billy McKay, who was granted a Testimonial against New Zealand following a career-limiting knee injury. Although no special shirts were prepared for the game itself, the players were later presented with one featuring match details. This shirt was given to defender Craig Paterson, who three days earlier had captained Rangers to victory in the League Cup Final.

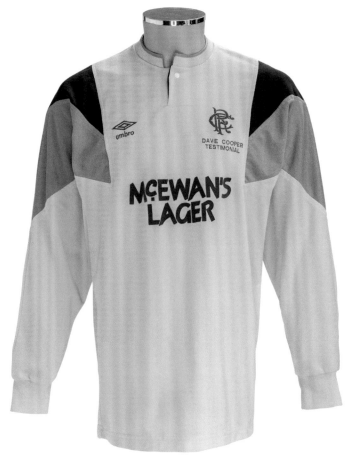

1988

DAVIE COOPER TESTIMONIAL

Match worn by **Chris Woods**
v Bordeaux, 9th August 1988

A full house of more than 43,000 fans saw Rangers win Davie Cooper's Testimonial 3-1, with this shirt being worn by goalkeeper Chris Woods. Known as the 'Hampden' template, this rare shirt style would only make a single further appearance in a league match, against St Mirren at Ibrox in late February 1989.

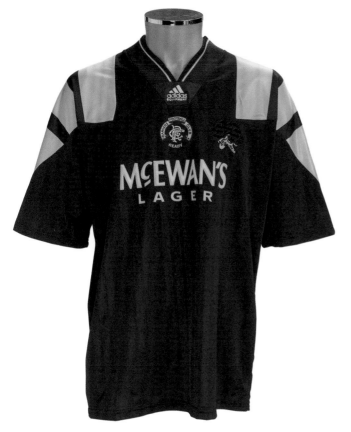

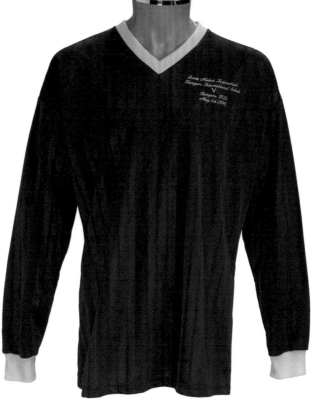

1993

ALLY McCOIST TESTIMONIAL

Match shirt of **Oleg Kuznetsov**
v Newcastle, 3rd August 1993

Ally McCoist was unable to feature in his own Testimonial against Kevin Keegan's Newcastle United as he was recovering from a broken leg picked up while playing for Scotland against Portugal. This shirt was prepared for Oleg Kuznetsov, who was an unused substitute on the night. It features a motif representing McCoist's two Golden Boot trophies, which he won as Europe's top league goalscorer in the 1991/92 and 1992/93 seasons.

1995

SCOTT NISBET TESTIMONIAL

Match worn by **Mo Johnston**
v Rangers International Select,
1st May 1995

Nisbet was a young player whose career was sadly cut short by injury. Joining the club in 1982, he made his Rangers debut in December 1985 and played more than 100 times before being forced to hang up his boots in 1993, aged just 25. His Testimonial match featured the current Rangers side versus an International Select team made up of ex-Rangers players. Rangers played in that season's third shirt but, unusually, a set of shirts was produced for the Select team by the Pasolds (Sunchild) factory in Stranraer, where Rangers' adidas shirts were manufactured.

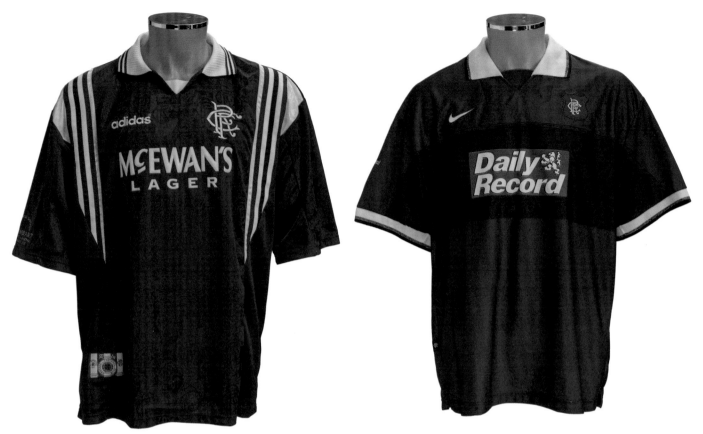

1996

RICHARD GOUGH TESTIMONIAL

Match worn by **Ally McCoist**
v Arsenal, 3rd August 1996

One of the club's greatest captains, Richard Gough was rewarded with a Testimonial against Arsenal at Ibrox. The two clubs have a long history of playing each other, going back to the 1933 'Match of Champions', when the relationship between the two clubs was fostered by the friendship between Rangers manager William Struth and his Arsenal counterpart, Herbert Chapman. This shirt was worn by Ally McCoist and swapped with Arsenal striker Ian Wright and features match embroidery on the right sleeve that reads: 'RICHARD GOUGH, LIONHEART, RANGERS v ARSENAL, 3 AUGUST 1996'.

1998

WALTER SMITH TESTIMONIAL

Match worn by **Marco Negri**
v Liverpool, 3rd March 1998

With Walter Smith stepping down as manager at the end of the 1997/98 season, Rangers took the unusual step of awarding him a Testimonial – usually reserved for players – in appreciation of all he had accomplished for the club. Having taken over as manager in May 1991 following the departure of Graeme Souness to Liverpool, Smith led Rangers to their famous 'nine-in-a-row' run of consecutive league titles. Rangers won Smith's Testimonial match, ironically against Liverpool, 1–0 thanks to an Ally McCoist strike in front of a full house of 50,000.

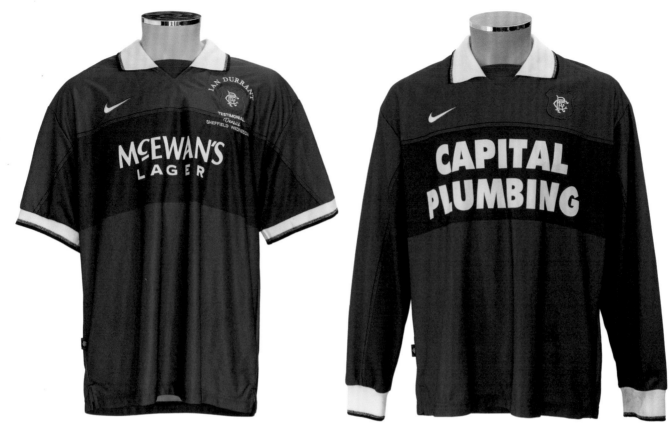

1998

IAN DURRANT TESTIMONIAL

Match worn by **Ian Durrant**
v Sheffield Wednesday, 28th April 1998

Durrant had been a product of the Rangers youth system before making his debut against Morton in April 1985. Despite losing three years of his career to a horrendous knee injury sustained in October 1988, Durrant fought back to full fitness and continued to play for the club until the end of the 1997/98 season. This shirt was worn by Durrant, who capped his big night with a goal during a 2-2 draw.

1999

ALAN McLAREN TESTIMONIAL

Match worn by **Derek McInnes**
v Middlesbrough, 2nd March 1999

Paul Gascoigne made a return to Ibrox for Alan McLaren's Testimonial. Gazza had signed for Middlesbrough from Rangers in March 1998 and he played for both sides in the match, which also featured Liverpool's Robbie Fowler playing up front for Rangers against a Boro side that included Kenny Dalglish, Bryan Robson and John Barnes. McLaren's career at Rangers had been cut short by a knee injury which forced him to retire in May 1998 at the age of 27. During his career he had the honour of being captain on the evening the club secured its ninth league title in a row at Tannadice Park on 7th May 1997.

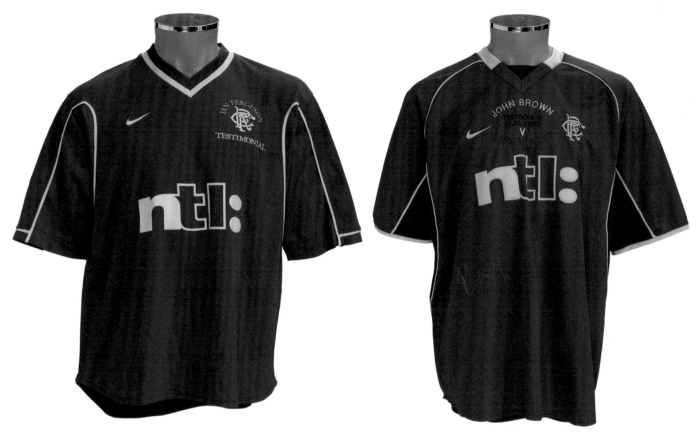

2000

IAN FERGUSON TESTIMONIAL

Match worn by **Giovanni van Bronckhorst** v Sunderland, 21st July 2000

Ian Ferguson signed for his boyhood heroes in 1988 and was one of only a few players who were at the club during the whole 'nine-in-a-row' run of league titles. He moved on in 2000 after a successful 12-year Rangers career in which he won 10 league titles, three Scottish Cups and five League Cup winners' medals. This shirt was worn by Giovanni van Bronckhorst during the Testimonial versus Sunderland when 'Gio' scored Rangers' third goal in a 3–1 win.

2002

JOHN BROWN TESTIMONIAL

Match worn by **Russell Latapy** v Anderlecht, 21st July 2002

The last of a run of Testimonials was awarded to another of the great 'nine-in-a-row' side in the form of defender John Brown. Anderlecht were the guests as 'Bomber' celebrated his 14 years at the club as both player and, by that time, youth coach. Despite retiring from the playing side in 1997, Brown made a return to the field as a late substitute against the famous Belgian team. This shirt was worn by Russell Latapy, who played the first 85 minutes before making way for Brown to take a bow in front of the 25,000 crowd.

KINGS OF SCOTLAND

2002–2013 DIADORA & UMBRO

HOME 2002/03

Match worn by **ARTHUR NUMAN**

During the Rangers Annual General Meeting in December 2001, chairman David Murray announced that from the 2002/03 season the club – rather than partnering with a kit manufacturer – would begin to produce and sell its own playing kit. Murray claimed that this would make Rangers' retail turnover in the UK second only to that of Manchester United.

When the new kit was unveiled, the new shirts did carry the logo of Italian sportswear brand Diadora, with the company paying £1 million a year for the privilege even though they did not have anything to do with the design or manufacture of the shirts. In fact the shirts were manufactured for Rangers in Morocco by British firm Dewhirst, who were Marks & Spencer's top clothing supplier at that time.

Launched in July 2002, the new shirts were promoted once again through a television commercial – this time featuring manager Alex McLeish and captain Lorenzo Amoruso – which was broadcast on both Scottish and Ulster Television.

The new home shirt was produced in 100 per cent polyester royal blue fabric, which was overprinted with a darker blue pattern that incorporated a large rampant lion motif. This pattern was unique in that every cut was from a different part of the material, ensuring that no two shirts were identical.

The shirt used double-knit 'Aquafit' fabric, which was designed to draw moisture through the shirt and allow it to quickly evaporate away, and there was a mesh panel under the arms that tapered down towards the base of the shirt.

The Diadora logo and Rangers crest were both embroidered in white thread, whilst the new ntl: home Digital TV logo was applied in embossed felt, giving it a 3D look and feel. All in all it was a popular design and supporters were certainly quick to snap up the new shirts in their droves.

This shirt was worn by Dutch defender Arthur Numan during the league campaign of 2002/03, when Rangers completed the domestic treble once again. The club's 50th league title was secured on a dramatic last day when a 6-1 victory over Dunfermline gave them the title over Celtic on goal difference.

Dutch defender Arthur Numan joined Rangers from PSV Eindhoven for £4.5 million in May 1998

DIADORA

ntl:home
Digital TV

NUMAN

5

CHANGE 2002/03

Match worn by **CRAIG MOORE**

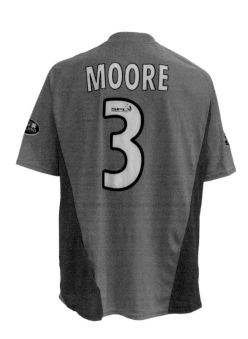

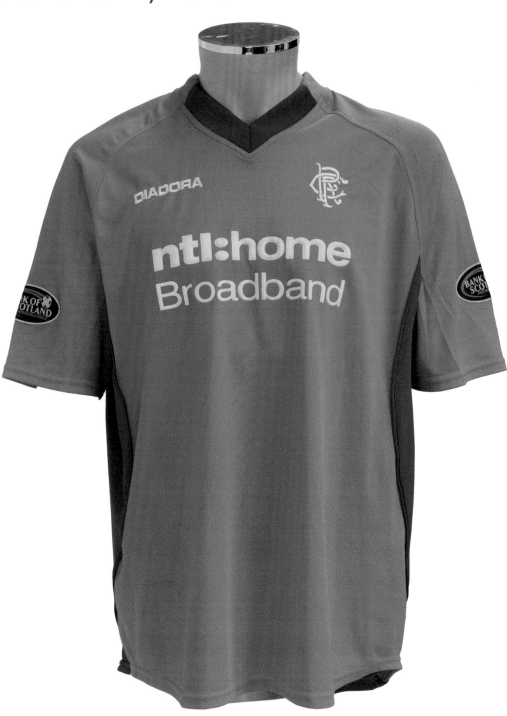

The 2002/03 season saw Rangers launch a tangerine-coloured change shirt. The colour had been suggested by fans in recognition of the large Dutch influence at the club on the back of Scottish Cup Final of 1999/2000, when thousands of Rangers supporters had donned the colours of the Dutch national side in a show of support for manager Dick Advocaat.

Like the new home shirt, it featured an 'RFC' manufacturer label and a unique production number stitched on the inside. However, the sponsor logo advertised ntl: home Broadband rather than Digital TV.

This style was only worn four times, including once at home against Dundee in August 2002. It also made a cameo appearance in the 2003 Scottish Cup Final, also against Dundee, when it was worn by goalkeeper Stefan Klos.

This shirt was worn by Craig Moore against Kilmarnock and Dundee in August 2002.

THIRD 2002/03

Match worn by **ARTHUR NUMAN**

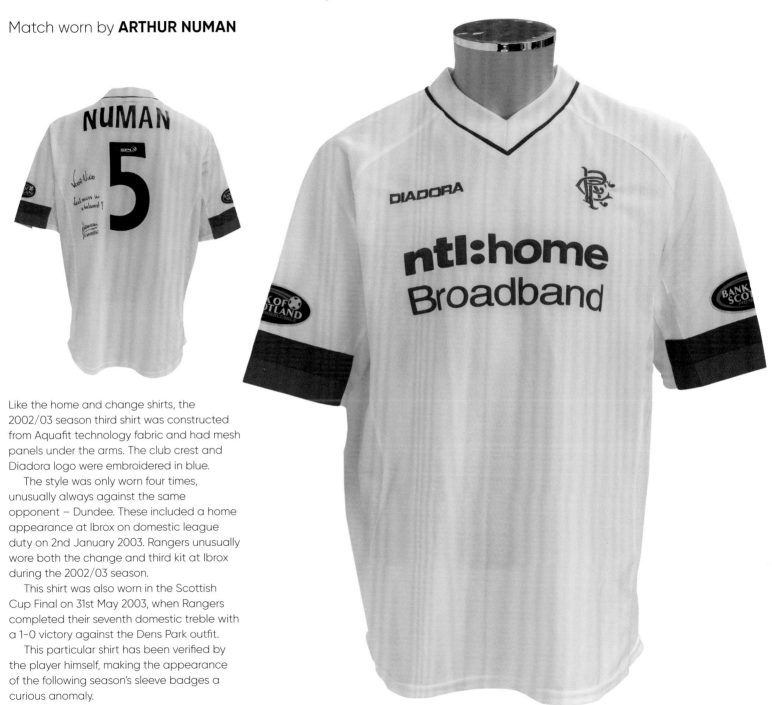

Like the home and change shirts, the 2002/03 season third shirt was constructed from Aquafit technology fabric and had mesh panels under the arms. The club crest and Diadora logo were embroidered in blue.

The style was only worn four times, unusually always against the same opponent – Dundee. These included a home appearance at Ibrox on domestic league duty on 2nd January 2003. Rangers unusually wore both the change and third kit at Ibrox during the 2002/03 season.

This shirt was also worn in the Scottish Cup Final on 31st May 2003, when Rangers completed their seventh domestic treble with a 1–0 victory against the Dens Park outfit.

This particular shirt has been verified by the player himself, making the appearance of the following season's sleeve badges a curious anomaly.

TREBLE WINNERS

LEAGUE CUP
FINAL 2003

Match shirt of **BARRY FERGUSON**

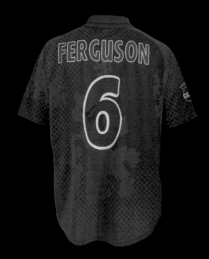

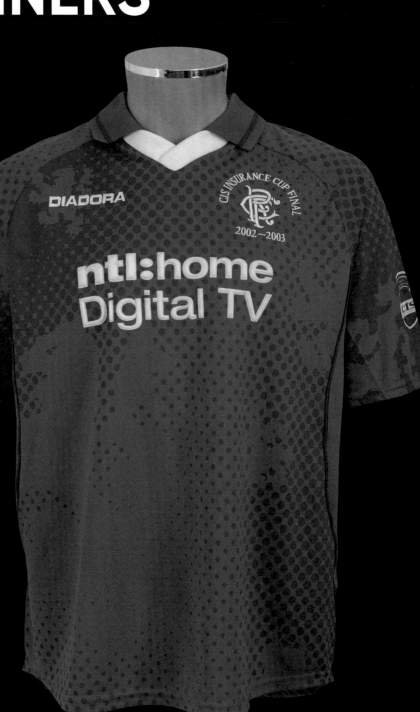

Rangers defeated Celtic 2-1 in a pulsating
CIS Insurance Cup Final on 16th March 2003,
with goals from Claudio Caniggia and Peter
Løvenkrands securing the trophy and keeping
sights set on another domestic treble.

 This shirt was prepared for Barry Ferguson,
but Rangers' talismanic skipper elected to
wear his usual long sleeves in the match and it
was not used.

 The shirts for this final were prepared using
a different name and number set to those
used in the league and previous finals, both
being red with a white border.

 Ferguson was outstanding during this
campaign, despite playing through the pain
barrier due to a pelvic injury. After the match
he picked up his third Scottish League Cup
winners' medal, part of a haul of 15 domestic
honours he won in two spells at the club.

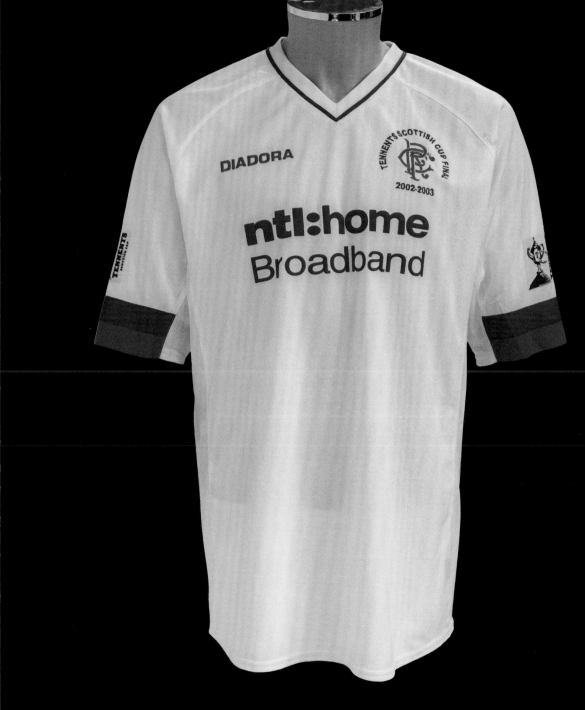

SCOTTISH CUP FINAL 2003

Match worn by **BARRY FERGUSON**

The Scottish Cup Final on 31st May 2003 saw Rangers face Dundee in the final part of the season's domestic treble campaign. Being drawn as the 'away' side for the match meant that Rangers would play the final wearing a change shirt, and they chose the white third kit to face the Dens Park side.

As well as securing another domestic treble, the match was the final appearance in a Rangers shirt for several key players, including Arthur Numan and Lorenzo Amoruso. Appropriately Amoruso signed off in style by scoring the winning goal in the 1-0 triumph.

This shirt was worn by Rangers' Player of the Year, club captain Barry Ferguson, as he lifted the Scottish Cup for the 31st time in Rangers' history. It features the competition's sleeve patches as well as embroidered match details in red thread surrounding the crest.

HOME 2003-05

Match worn by **ALEX RAE**

Rangers unveiled their second in-house produced 'Diadora' home shirt in the summer of 2003, complete with the logo of new main sponsor Carling.

The shirt was a lighter shade of blue than the previous design. It had a white v-neck collar which was flanked by red mesh chevrons which tapered down the front of the shoulders, as well as blue mesh panels on the inside of the sleeves and red piping at the cuffs.

One striking new feature was the addition of five stars above the club crest, each one denoting 10 league championship wins, with Rangers being the first club side to reach a total of 50 Scottish league titles.

When the shirt was first unveiled to the press the stars did not feature, but they appeared on the player shirts for the start of the season. By this time replica versions had already been manufactured and sold without the stars. However, the club arranged for the supporters who had purchased these shirts to visit the Rangers Shop where they could be applied for a small cost.

The new shirt made its first appearance on the pre-season tour of Germany against VfB Auerbach on 19th July 2003 and will be fondly remembered as the style worn when the club secured its 51st league title on 22nd May 2005, an occasion forever to be known as 'Helicopter Sunday'.

This unwashed shirt was worn during the CIS Insurance League Cup semi-final against Dundee Utd on 2nd February 2005 by captain for the night Alex Rae. It was a match which saw the return of Barry Ferguson following his spell at Blackburn Rovers, the former skipper coming on to replace Rae to a huge welcome in the 69th minute.

Rangers, who were wearing 1-11 instead of the usual squad numbers, hammered Dundee United 7-1 and progressed to face Motherwell in the final.

Above: Alex Rae proudly took on the role of captain on the night when Rangers demolished Dundee United on their way to another Hampden final

Left: The five stars used to celebrate Rangers' 50 league titles

CHANGE 2003/04

Match worn by **GAVIN RAE**

The new change shirt featured red and white vertical candy stripes with royal blue chevrons and trim around the collar and cuffs.

Launched on 12th July 2003, the shirt was first worn four days later in a pre-season match against German side Greuther Fürth. It was only used twice in competitive games, against Dundee and Livingstone – when this shirt was worn by Gavin Rae – and three times in friendlies.

A version of the shirt was produced for use in European competition, featuring a large square panel in red sewn onto the rear panel of the shirt to improve the visibility of the shirt numbers as per UEFA guidelines, although these were never worn.

As with the home shirt, the design was originally produced without the five stars, which were added later on.

THIRD 2003/04

Match worn by **MICHAEL BALL**

The 2002/03 third shirt design was continued for the following season, but with the addition of Carling as the main sponsor and the five embroidered stars above the club crest. All the league shirts worn during this campaign included the Bank of Scotland league sleeve patches in gold, identifying Rangers as the current league champions.

The shirt made its first appearance in the final match of the pre-season tour of Germany on 22nd July 2003 against SSV Jahn Regensburg. The Rangers team for this game included former Manchester United defender David May as a trialist, although no deal was ever agreed.

This style was only used on one other occasion during the season, a 3-2 league victory over Kilmarnock at Rugby Park on 9th November 2003. This Michael Ball shirt was worn during that match.

HELICOPTER SUNDAY 2005

Match worn by **BARRY FERGUSON**

Sunday 22nd May 2005 is a date that will forever live in the hearts and minds of Rangers supporters worldwide. It was a day where defender Marvin Andrews' mantra of 'Keep Believing' proved to be true as Rangers snatched the title from Celtic's grasp in the final two minutes of the season. With Rangers' victory over Hibernian at Easter Road and Motherwell coming from behind to stun Celtic with two last-minute goals, the helicopter carrying the trophy that had set off for Fir Park was dramatically diverted to Easter Road where Rangers were waiting to lift it as new league champions.

This shirt was worn by Barry Ferguson during the second half of the 1-0 victory over Hibs on that historic Sunday afternoon and acquired by a fan as a souvenir seconds after the full-time whistle.

Ferguson had returned to Rangers only a few months earlier from a spell in England and picked up a Scottish League Cup and league title double in that short space of time. He told the *Rangers News*: "I experienced this two years ago but I honestly didn't expect anything like it again. The gaffer just told us to go out and win at Easter Road. He said anything could happen at Motherwell and it's amazing the title has gone our way."

By the time the team bus returned to Ibrox, thousands had gathered at the stadium. Such was the size of the crowd that the club opened three of the stands for supporters to welcome home the champions in suitable style.

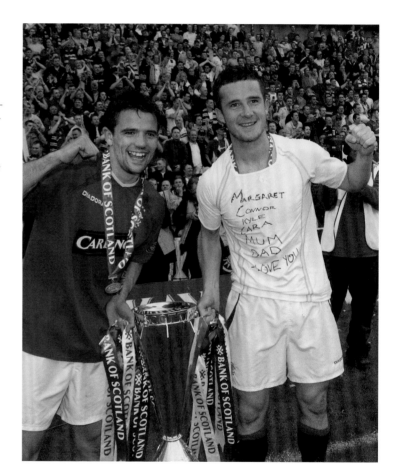

Rangers celebrate with the league trophy after their dramatic triumph on 'Helicopter Sunday'

CHANGE 2004/05

Match worn by **SOTIRIOS KYRGIAKOS**

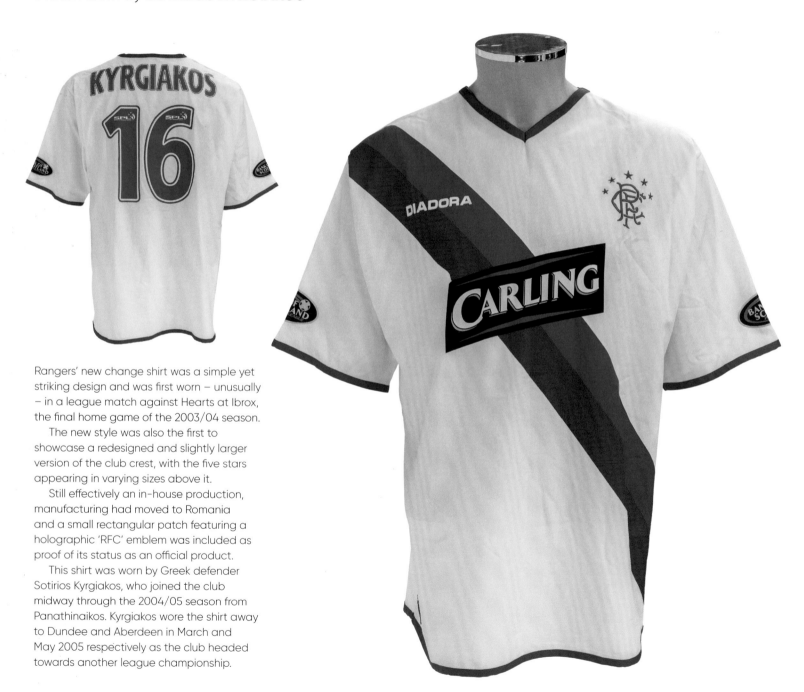

Rangers' new change shirt was a simple yet striking design and was first worn – unusually – in a league match against Hearts at Ibrox, the final home game of the 2003/04 season.

The new style was also the first to showcase a redesigned and slightly larger version of the club crest, with the five stars appearing in varying sizes above it.

Still effectively an in-house production, manufacturing had moved to Romania and a small rectangular patch featuring a holographic 'RFC' emblem was included as proof of its status as an official product.

This shirt was worn by Greek defender Sotirios Kyrgiakos, who joined the club midway through the 2004/05 season from Panathinaikos. Kyrgiakos wore the shirt away to Dundee and Aberdeen in March and May 2005 respectively as the club headed towards another league championship.

THIRD 2004/05

Match worn by **NACHO NOVO**

The third shirt for the 2004/05 season was red with a navy blue neckline, collar and cuffs and made its debut in the pre-season Walter Tull Memorial Cup match against Tottenham Hotspur.

Tull was the first black officer in the British Army, who had played football for both Tottenham Hotspur and Northampton Town before the outbreak of the First World War. It is believed that he had agreed terms to sign for Rangers after the end of hostilities, but tragically he was killed in action in late March 1918, never getting a chance to play for the club.

This shirt was worn by Nacho Novo during the 2-0 away victory against Dundee – from whom he had signed in the summer of 2004 – on 26th September 2004, when he scored his first league goals for the club during a 2-0 victory.

LEAGUE CUP FINAL 2005

Match worn by **SOTIRIOS KYRGIAKOS**

Almost 10 years to the day since the untimely passing of Davie Cooper, the 2005 CIS Insurance League Cup Final was dedicated to the legendary Rangers winger.

Played between Rangers – where he played for 12 glorious years – and Motherwell, who he signed for after leaving Ibrox in 1989, the match was unofficially labelled the 'Davie Cooper Final' in appreciation of his service to both clubs.

The Rangers shirts prepared for the 2005 final featured 'Davie Cooper 1956-1995' embroidered into the right sleeve, with Motherwell wearing similar on the left sleeve. On the front of the Rangers shirts the club crest was encircled by the match detail embroidery, which meant that for this match the five stars which normally sat above the crest were moved to the left sleeve.

Having joined the club he had supported since boyhood in July 1977 for £100,000, Davie Cooper was possibly the most naturally gifted player to ever pull on the famous blue shirt of Rangers. For all his ability, he was completely one-footed, although that famous left foot was so talented that according to his ex-Scotland manager Andy Roxburgh, he didn't need the right one.

"He was so perfectly balanced," said Roxburgh, "so technically gifted on his left, that he could do anything. He could beat people any way; right, left, double back and beat them again."

Ruud Gullit, who faced Cooper in a friendly when Feyenoord were invited to play Rangers at Ibrox in 1984, would always remember Davie's performance, and even now counts Cooper in his all-time Greatest XI opponents.

"He had incredible skill and a command of the ball," said Gullit. "There was something about his play that made him stand out. When I saw him play, I was flabbergasted. I remember thinking to myself, 'Who is this guy?' I fell completely in love with his play. Davie Cooper was one of a kind."

This shirt, still unwashed following the match, was worn by Sotirios Kyrgiakos, who scored two of the five Rangers goals as Motherwell were hammered 5-1 to bring the League Cup trophy back to Ibrox.

Above: Sotirios Kyrgiakos heads off on a celebration run after scoring in the 2005 'Davie Cooper' League Cup Final

Left: The match embroidery located on the right sleeve

HOME 2005/06

Match worn by **FERNANDO RICKSEN**

Rangers renewed their acquaintance with Umbro for the 2005/06 campaign. For the first season of the new four-year agreement, however, the club continued to design and manufacture the shirts with Umbro simply paying to have their branding on the shirts.

The final 'in-house' Rangers home shirt featured a blue body with white piping whilst the round-neck collar, cuffs and the hem of the shirt were trimmed in red. Mesh side panels extended around the lower back half of the shirt.

Umbro's name was applied in an embossed flock whilst the 'RFC' crest was embroidered in white, with the five stars above it now in red. A new addition to the shirt was a heat-pressed badge on the lower front right-hand side which featured the club name flanked by a Union flag and a Saltire, commemorating the club's Scottish and British heritage.

A disappointing season saw Rangers finish third in the league, but the undoubted bright spot of the campaign came in the Champions League where Rangers became the first Scottish club to qualify for the last 16 of the competition, only failing to progress further after Villarreal of Spain triumphed on the away goals rule.

Manager Alex McLeish stood down at the end of the season and was replaced in the summer of 2006 by Frenchman Paul Le Guen, who became the club's second foreign manager.

Dutchman Fernando Ricksen wore this shirt during the league campaign. Ricksen had joined the club in 2000 and during his time at Rangers made almost 200 appearances.

Ricksen's career at Ibrox would come to an end at the beginning of the 2006/07 season when he joined Dick Advocaat at Russian side Zenit Saint Petersburg. Tragically, illness took his life at the young age of 43 but he is fondly remembered by both the Rangers supporters and the wider public for his courage in facing up to his debilitating illness.

Whilst the deal with Umbro was initially signed for four seasons, in fact it would continue until the end of the 2012/13 campaign.

Above: Versatile Dutch defender Fernando Ricksen was elected to the Rangers Hall of Fame in 2014

Right: Francis Jeffers' Champions League shirt, demonstrating the different name and numbers required for that competition

CHANGE 2005/06

Match worn by **FERNANDO RICKSEN**

The launch of Rangers' new change shirt took place in the unlikely location of the CN Tower – at the time the world's tallest free-standing structure – in Toronto, where the club was on tour.

The shirt was white with a vertical red stripe down the front, but unlike with the home or third versions, the Carling logo was incorporated within the material rather than being printed in flock.

Well-received by the supporters, the style was worn nine times, including two appearances in the Champions League in the group matches away to Porto and Inter Milan, when this shirt was worn by Fernando Ricksen.

The match at the San Siro was played behind closed doors after crowd trouble at previous Inter matches, and despite a 1-0 defeat Rangers went on to finish second in a strong group.

THIRD 2005/06

Match worn by **DADO PRŠO**

The last of the 'in-house' shirts produced by the club, albeit with Umbro branding, was unveiled on 15th September 2005.

The third shirt was predominantly navy blue in colour with royal blue piping and trim, as well as mesh side panels which continued around the lower back half of the shirt.

Perhaps not surprisingly considering its colour scheme, this style only made three appearances. It was worn in two league matches away to Kilmarnock and once away against Dundee United, with Dado Pršo featuring in two of these three matches.

The big Croatian was an absolute warrior for Rangers, having arrived at the club in 2004. In fact he played with a bandaged head so often that replica Pršo headbands were sold in his honour. Unfortunately, recurring knee injuries forced him to retire in 2007, aged just 32.

HOME 2006/07

Match worn by **BARRY FERGUSON**

The new home shirt unveiled on 3rd May 2006 was the first that had not been designed and manufactured by the club for four seasons, with Umbro having returned as Rangers' official kit supplier. It was a period of change, with chairman David Murray also having recently announced a 10-year merchandise retail agreement with JJB Sports.

The new home shirt was based on the Umbro template used for the shirts worn by the England national team and incorporated the company's thermo-regulation technology which was designed to keep the body at the optimum temperature for best performance.

The blue body of the shirt was complemented by red piping and white trim to the back of the cuffs. There were white panels on each shoulder, with the one on the right incorporating a Saltire design, and a large 'RFC' crest with stars was built into the mesh rear of the shirt.

Red vented panels extended from the armpits down to the base of the shirt, making this one of the lightest home shirts ever used by the club. The new version of Umbro's famous 'double diamond' logo returned to the shirt while a small, rubberised label on the right lower edge continued the Union Flag/Saltire theme introduced for the previous season.

Carling continued as the club's main sponsor, but when Rangers played away to Auxerre in a UEFA Cup group stage match on 23rd November 2006 the sponsor's logo was missing. This was because France at the time had a strict policy of not permitting alcohol advertising on television.

This shirt was worn in that match by skipper Barry Ferguson, when a 2-2 draw was enough for Rangers to progress to the third round of the competition. Unfortunately, this was to be one of manager Paul Le Guen's few high points and his time with the club came to an end after just half a season in charge. Club legend Walter Smith answered the call to return to Rangers for a second spell as manager in January 2007, with Ally McCoist as his assistant.

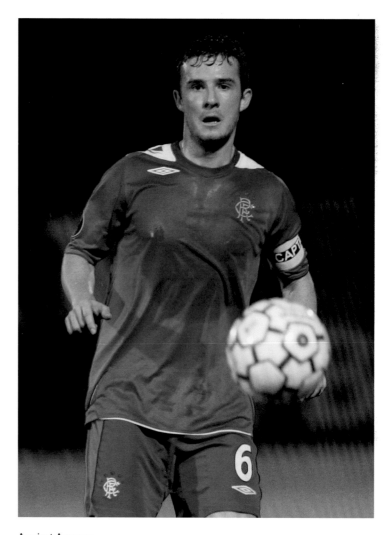

Against Auxerre Rangers utilised unsponsored shirts to comply with the advertising rules in place in France in 2006

CHANGE 2006/07

Match worn by **BARRY FERGUSON**

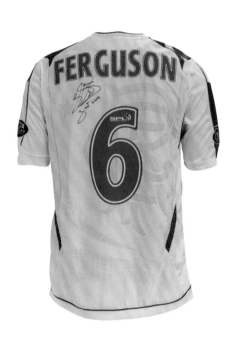

With Rangers beginning the 2006/07 season with a Frenchman in charge, Umbro supplied the club with a change shirt bearing a striking resemblance to the home shirt of French club Monaco – just as they had done in 1988.

This shirt was worn by captain Barry Ferguson during the 2006/07 campaign, with the skipper wearing the change colours away to Falkirk, Inverness Caledonian Thistle and Kilmarnock.

It was a season where the 29-year-old skipper equalled the record for most European appearances by a Scottish player, held up until that point by club legend John Greig.

Ferguson's European debut for Rangers had been nine years earlier in 1997 versus Irish side Shelbourne. Finding themselves 3-0 down with only 30 minutes remaining, Rangers were somehow galvanised into action and secured a stunning 5-3 victory.

THIRD 2006/07

Match worn by **CHARLIE ADAM**

Completing the trio of Umbro shirts for the season was the sky blue and navy third shirt, which was only worn on a single occasion during the campaign – away to Dundee United on 5th November 2006.

New signing Karl Svensson, who was enlisted to help promote the new design, said: "I have only been in Glasgow a short time but I know how passionate the Rangers supporters are about the club. I have seen thousands of fans in the new home and away kits already, so I am sure they will want this new strip as well."

This shirt was worn by Charlie Adam when he scored Rangers' only goal during the 2-1 defeat to Dundee United on the shirt's only run-out. Adam was blossoming as a player and remained at the club until 2009 before furthering his career in England with Blackpool, Liverpool, Stoke City and Reading.

HOME 2007/08

Match worn by **DANIEL COUSIN**

The 2007/08 season saw Rangers win a cup double whilst narrowly missing out on the league title and the UEFA Cup Final.

Umbro's home shirt for the season was a complex piece of shirt design and manufacturing. It was constructed from multiple separate panels, the majority of which were vented for player comfort. The back of the shirt was made from a polyester/cotton mesh for the same reason, and the sections of the shirt – most noticeably at the bottom of the side panels and cuffs – were connected via seamless heat bonding to prevent irritation.

Aesthetically, the shirt was notable for the red and white stripes following the shape of the v-neck collar, and a large 'RFC' crest imprinted into the material of the left shoulder. For domestic use the name and number sets appeared in red, whilst for European matches they were white.

Although it was produced for the 2007/08 season, Rangers wore it for the first time against Aberdeen on the final day of the previous league campaign at Pittodrie. The squad then flew out to Los Angeles and wore it again for a friendly against LA Galaxy three days later.

Because of the French ban on alcohol advertising, a version of this shirt was worn without the usual Carling logo on 2nd October 2007 as the club chalked up one of its best-ever European victories. Rangers had been expected to struggle in their Champions League group match against French Ligue 1 leaders Lyon, but produced a stunning away performance to win 3-0.

This shirt was worn during that famous match in Lyon by striker Daniel Cousin, who scored the second goal. Rangers had taken the lead with a bullet header from Lee McCulloch before Cousin blasted a second past the helpless Lyon keeper. Five minutes later, DaMarcus Beasley sealed the victory with a third.

Above: Fiery centre-forward Daniel Cousin joined Rangers from Lens in August 2007

Right: Both red and white name and number sets were used during the 2007/08 campaign – blue numbers were used on the club's change shirt

CHANGE 2007/08

Match worn by **JEAN-CLAUDE DARCHEVILLE**

The away shirt for the 2007/08 season was produced from a similar template to the home shirt. It featured a white body with what Umbro described as 'aubergine' sleeves.

Captain Barry Ferguson said: "The design and colours of the new kit are a departure from previous strip designs but I am sure we will love it. The supporters have already snapped up the new home kit for 2007/08 and will undoubtedly do the same for the away strip."

The shirt was often used during the season, including the UEFA Cup semi-final second leg away to Fiorentina, when Rangers claimed a place in the final after a dramatic penalty shoot-out.

This shirt was worn by Jean-Claude Darcheville in the league match away to Inverness Caledonian Thistle on 19th January 2008, when he scored an 89th-minute winner.

THIRD 2007/08

Match worn by **LEE McCULLOCH**

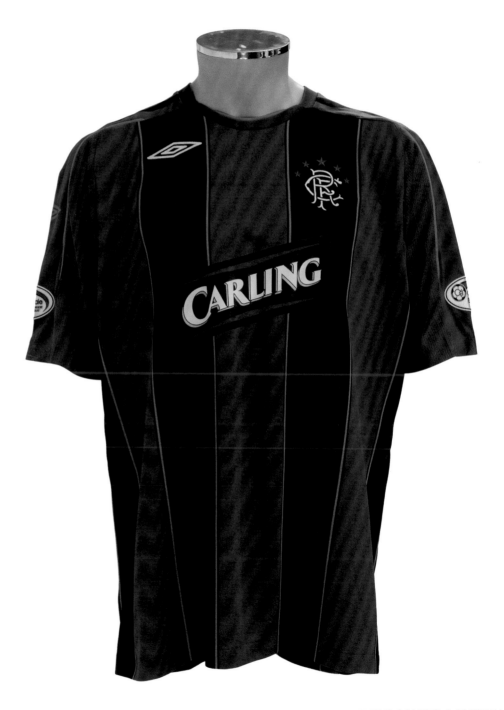

The third design for the 2007/08 season only saw action twice – both times in victories away to Kilmarnock – with this shirt being worn by Lee McCulloch in the second of those games in February 2008. It was swapped with Kilmarnock's Gary Locke following Rangers' 2-0 victory.

The win was part of an 11-match winning run, but a draw and a defeat in the last two matches of the season meant that Rangers finished a close second in the league, having been forced to play six matches in 14 days – including the UEFA and Scottish Cup finals.

Lee McCulloch was signed in the summer of 2007 and remained at Ibrox until 2015. Proudly assuming the role of club captain in 2012, Lee was inducted into the Rangers Hall of Fame two years later in 2014.

CUP DOUBLE

LEAGUE CUP FINAL 2008

Match shirt of KRIS BOYD

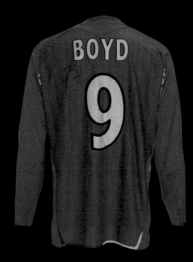

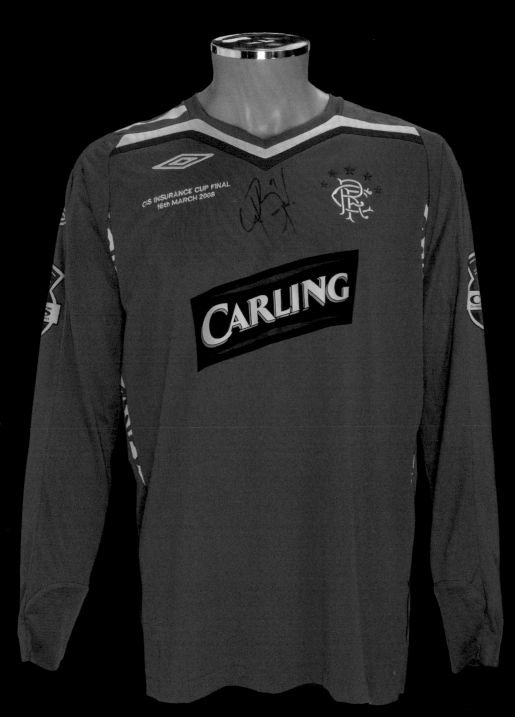

Rangers' preparations for the Scottish League Cup Final against Dundee United were not ideal, with the players having arrived home from Germany following the UEFA Cup tie against Werder Bremen just two days earlier.

This is the spare shirt of striker Kris Boyd, who had an eventful afternoon despite starting on the bench. With Rangers struggling and 1-0 down against a resolute United defence, he was given the nod for the last 30 minutes. He scored an equaliser with five minutes remaining to take the match to extra time, only for Dundee United to go 2-1 up through Mark de Vries. Boyd then fired Rangers level seven minutes from the end before scoring the winning spot-kick in the shoot-out.

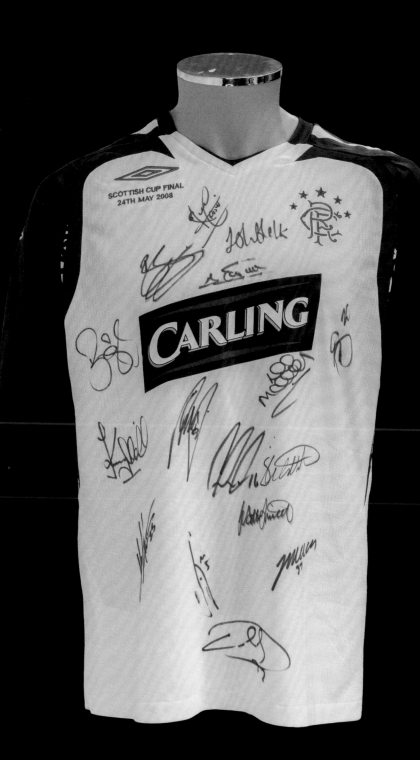

SCOTTISH CUP FINAL 2008

Match shirt of **KRIS BOYD**

Rangers were running on empty when they faced Queen of the South at Hampden thanks to a demanding end-of-season schedule. Playing in the change kit, which had also been worn in the semi-final against St Johnstone, the players called on all their reserves to beat a spirited Queens side who were level with 20 minutes remaining.

This shirt was prepared for goalscorer Kris Boyd, who once more rescued the situation with a 72nd-minute header to seal a 3-2 victory. Despite the heat, Boyd played the whole match in long sleeves whilst insulated by some unwanted facial hair. He had planned to shave his newly grown moustache off before kick-off but his team-mates hid his shaving kit!

UEFA CUP FINAL 2008

Match worn by **DAVIE WEIR**

Despite a famous victory away to Lyon, Rangers did not make it through to the group stages of the Champions League in the 2007/08 season and instead moved into the UEFA Cup. Following tough matches against Panathinaikos, Werder Bremen, Sporting Lisbon and Fiorentina, the club made it to its fourth European final since 1961. Unfortunately, however, the Russians of Zenit Saint Petersburg – under the stewardship of ex-Rangers manager Dick Advocaat – proved too strong on the day.

For Rangers boss Walter Smith, getting to the final of a European competition had been an immense achievement. "I can't speak highly enough about the group of players we have at the club," he said after the game. "We've had 18 matches against a lot of very good sides and still managed to get to the final, which is testimony to the way they have handled themselves. They have been fantastic."

This shirt was worn during the first half of the final by Davie Weir, one of Smith's first acquisitions after returning as manager. Having signed for Rangers as defensive cover on a short-term deal at the age of 36 in January 2007, Weir's performances towards the end of the 2006/07 season saw him secure a one-year contract for the following campaign. A consummate professional who kept himself in top physical condition, Weir's deal with the club was extended by another season every year before he finally left the club in January 2012 at the age of 41. In the five years after his stopgap signing, Weir had captained the club and earned himself three league titles, three Scottish League Cup and two Scottish Cup winners' medals, as well as being a runner-up in a European final.

The shirts produced for the occasion in Manchester featured match embroidery detailing on the right of the chest and a new style of lower case name and number, as instructed by UEFA.

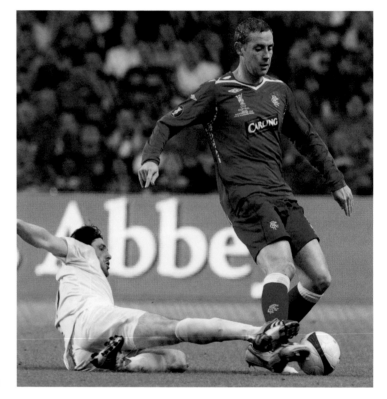

Above: Davie Weir evades the challenge of Zenith's Fatih Tekke during the 2008 UEFA Cup Final

Left: A close-up of the match embroidery

HOME 2008/09

Match worn by **SAŠA PAPAC**

Rangers kicked off the 2008/09 season with a new set of three kits released by Umbro, who were now under the umbrella of parent company Nike having been sold to the American global brand the previous year.

The traditional royal blue home shirt featured white piping and a heat-pressed Saltire to the rear of the neck.

Player shirts still hadn't reached the stage of being figure-hugging, but performance technology was becoming more and more advanced with manufacturers designing shirts aimed at maximising player comfort on the field. The shirt utilised Umbro's lightweight and breathable Climate Control technology, which incorporated a twill mesh design at the back. The design featured a hybrid neckline with no exposed seams for added comfort, and Umbro claimed that the shirt was anatomically cut to emphasise the athleticism of the modern player.

This shirt style made its debut on 13th July 2008 during the pre-season tour match against SC Preussen Munster. Six days later Rangers played a blue-shirted Schalke side, but they did not have a set of the new change shirts so had to play in the televised friendly wearing a training shirt, which had been made ready by kitman Jimmy Bell's application of blue squad numbers.

Despite the delayed kit, it turned out to be another successful season under Walter Smith as he guided Rangers to a league and Scottish Cup double, as well as finishing as runners-up in the League Cup Final. The shirt featured here was worn by Bosnian international Saša Papac during the SPL match against Hibernian at Ibrox on 20th December 2008, when a 1-0 victory kept Rangers on track for the title.

Papac was a reliable and consistent performer who joined Rangers as a Paul Le Guen signing in August 2006 and would go on to become left-back of choice under Walter Smith. He retired from football after leaving Rangers in the summer of 2012.

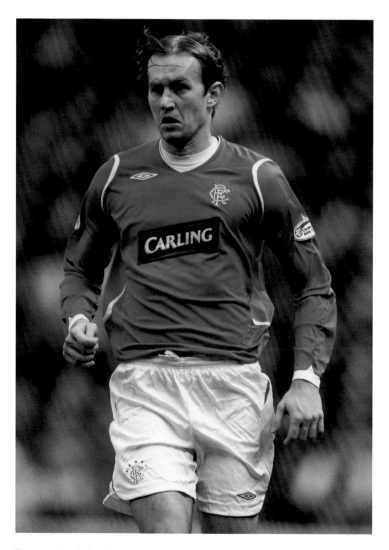

The much-admired Saša Papac in action versus Hibs during a league encounter at Ibrox in December 2008

CHANGE 2008/09

Match worn by **KIRK BROADFOOT**

Having not been available in pre-season, the new white change shirt – with its horizontal red and blue band across the chest – was similar in construction to the home shirt but without the mesh underneath the armpits.

The style was debuted during the league match away to Falkirk on 9th August 2008 and was worn eight times over the course of the season domestically in both league and Scottish Cup matches. It also featured in a mid-season friendly match against the Italian giants of AC Milan.

This shirt was worn by Kirk Broadfoot during that glamour friendly at Ibrox on 4th February 2009. Milan had brought a strong squad to Glasgow, including Kaka, Beckham, Ronaldinho and Pirlo, but a fighting performance from Rangers saw the match end in a 2-2 draw with Rangers' goals coming from DaMarcus Beasley and defender Saša Papac.

THIRD 2008/09

Match shirt of **STEVEN NAISMITH**

For the league match against Kilmarnock at Rugby Park on 9th November 2008, the match shirts featured an embroidered poppy design on the right breast along with the inscription 'Lest We Forget'. Rangers had worn the poppy on shirts in the past but these were the first to be embroidered onto the shirt. The match worn shirts were later signed by the players and donated to charities such as Poppy Scotland and Help for Heroes to auction – a tradition which the club has carried on ever since.

This shirt was prepared for striker Steven Naismith for the style's only other outing, the League Cup semi-final against Falkirk at Hampden Park – complete with competition sleeve patches and 1-11 numbering rather than squad numbers – although he favoured the short-sleeved version for the 1-0 win despite the cold January conditions.

LEAGUE CUP FINAL 2009

Match worn by **STEVEN DAVIS**

Despite almost 10 years' experience in his two spells as manager, the 2009 League Cup Final was the first time Walter Smith had overseen Rangers for a domestic final against Celtic. The shirts prepared for the game had match detail embroidery and competition sleeve patches.

This shirt was worn during the first half of the final by one of Northern Ireland's finest exports, Steven Davis. Originally signed on a six-month loan in January 2008, Davis made the move permanent the following August. He left the club in 2012 but returned for a second spell in 2019 having been signed from Southampton by Steven Gerrard.

SCOTTISH CUP FINAL 2009

Match worn by **KYLE LAFFERTY**

This shirt, with its lavish, circular match embroidery complete with trophy – unusually placed on the right breast below the Umbro logo – was worn by striker Kyle Lafferty during the Scottish Cup Final victory over Falkirk at Hampden Park on 30th May 2009 as Rangers completed the league and Scottish Cup double.

The double was secured by a stunning long-range effort from Nacho Novo, just 30 seconds after he had come on as a substitute. Describing his goal as "one of the best I've scored for the club", Novo later admitted he hadn't even seen the ball go in as it dipped and swerved away from the Falkirk keeper.

Ulsterman Lafferty is one of a long list of famous names who have crossed the Irish Sea to play for Rangers, including Bert Manderson, Sam English and Billy Simpson.

HOME 2009/10

Match worn by **DAVIE WEIR**

Rangers' home shirt for the 2009/10 season featured a checkerboard pattern within the body fabric, reminiscent of the Umbro home shirt worn between 1987 and 1990. It was a commercial masterstroke from Umbro as the shirt of that period had been one of the most popular in recent times, being worn by the likes of Graeme Souness, Ally McCoist, Terry Butcher and Ray Wilkins at the start of the 'nine-in-a-row' run of league title wins.

The red, white and blue overlapping v-neck collar and cuffs added to the retro feel of the design, whilst the inside collar featured a Rangers crest which sat above a 'Football Shirt by Umbro' mark. The heat-pressed Saltire remained on the rear of the shirt, with Carling continuing as the main shirt sponsor. The jersey also featured the new Clydesdale Bank SPL sleeve patches in gold to identify Rangers as the current league champions.

At the launch of the new shirt in July 2009, midfielder Kevin Thomson said: "I really like the design of the new strip and I am sure it will be a hit with our supporters. I knew Rangers were a big club when I joined but when you see thousands of fans in Scotland and abroad wearing the kit with pride you realise how massive the club really is. Hopefully we can be as successful in the new strip as we were last season."

The style was first worn against FC Nürnberg during a tour match in Germany prior to the start of the season in which Rangers would wrap up their 53rd league title, remaining unbeaten at home in all domestic competitions.

This shirt was worn by captain Davie Weir on the final day of the season against Motherwell at Ibrox when the Rangers players wore shirts which featured a heat-pressed 'Scottish League Champions 2010' inscription on the right breast, which had been added by kitman Jimmy Bell especially for the occasion.

Captain Davie Weir celebrates with the league trophy after Rangers' triumphant 2009/10 campaign

CHANGE 2009/10

Match worn by **SAŠA PAPAC**

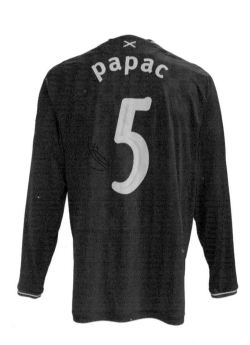

Featuring the same checkerboard effect as the home design, the 2009/10 change shirt was usually worn with blue shorts and socks, although occasionally white socks were selected to prevent a clash.

It was first worn during a pre-season friendly against Portsmouth at Fratton Park, one of seven occasions that it was worn during the 2009/10 campaign.

This shirt was worn by Saša Papac in the Champions League group match away to Unirea Urziceni on 4th November 2009. The club's European campaign had started poorly and the match against the Romanian champions had looked like getting it back on track as Rangers led 1-0, only for the hosts to score a stunning 88th-minute equaliser.

The shirt features a 'European' Umbro name and number font which differed from that used for domestic matches.

THIRD 2009/10

Match worn by **STEVEN DAVIS**

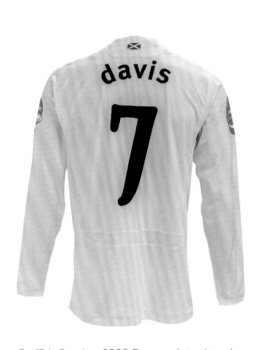

On 17th October 2009, Rangers introduced a new third shirt – like the other shirts of the period incorporating Umbro's Climate Control technology – for the match away to St Johnstone.

The off-white colour used was described as 'Polar White' by Umbro and the design had a brighter white stripe running diagonally across the front.

Worn with matching shorts and socks, the style was used four times – three times in the league against St Johnstone and once versus Dundee United.

This shirt was worn by Steven Davis in the League Cup semi-final against St Johnstone at Hampden Park. Davis opened the scoring on a cold, snowy night as Rangers progressed into the final, where they would complete a league and cup double by defeating St Mirren.

HOME 2010/11

Match worn by **MADJID BOUGHERRA**

Having recently invited supporters to suggest key features they would like to see in a home shirt and received numerous requests for a return to a more traditional design, Rangers unveiled a new home shirt reminiscent of the classic style worn between 1919 and 1956 under legendary manager Bill Struth.

The plain blue colour, classically styled fold-down collar and the heavier, cotton-like feel of the jersey were unmistakably retro, although Umbro's 'double diamond' motif and the logo of new shirt sponsor Tennent's – who had replaced Carling after signing a three-year deal – brought the design right up to date.

The 2010/11 season saw Rangers win a 54th league title as well as lifting the League Cup. This shirt was worn by Madjid Bougherra during the league match against Dundee United on 10th May 2011 when Rangers' fans bade an emotional Ibrox farewell to outgoing manager Walter Smith, seeing him off with a 2-0 victory.

During the course of the season, the player shirts appeared with a number of variations. On 2nd January 2011 it featured an 'Always Remembered' logo to mark the 40th anniversary of the 1971 Ibrox disaster, when 66 supporters lost their lives on stairway 13 following the New Year match against Celtic. Following that fateful day, Rangers – led by manager Willie Waddell and his board – set out to ensure that such an incident could never happen again and over the next 10 years the stadium was transformed into a safe, modern arena with stands based on the design and construction of the Westfalenstadion in Dortmund.

For the match against Motherwell on 30th April 2011, captain Davie Weir's shirt featured an embroidered message to the newlyweds of the previous day's Royal Wedding with the words 'Congratulations William and Catherine, 29th April 2011'.

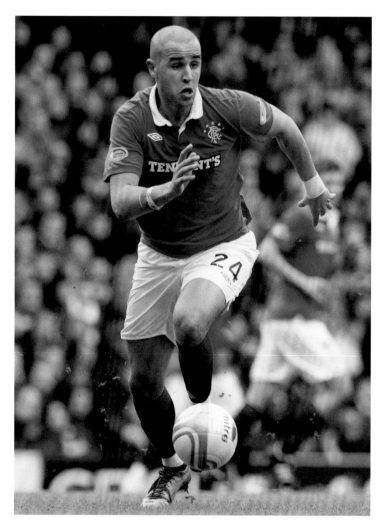

Above: Madjid Bougherra formed a fine partnership with Davie Weir

Left: The SPL sleeve patch

CHANGE 2010/11

Match worn by **MADJID BOUGHERRA**

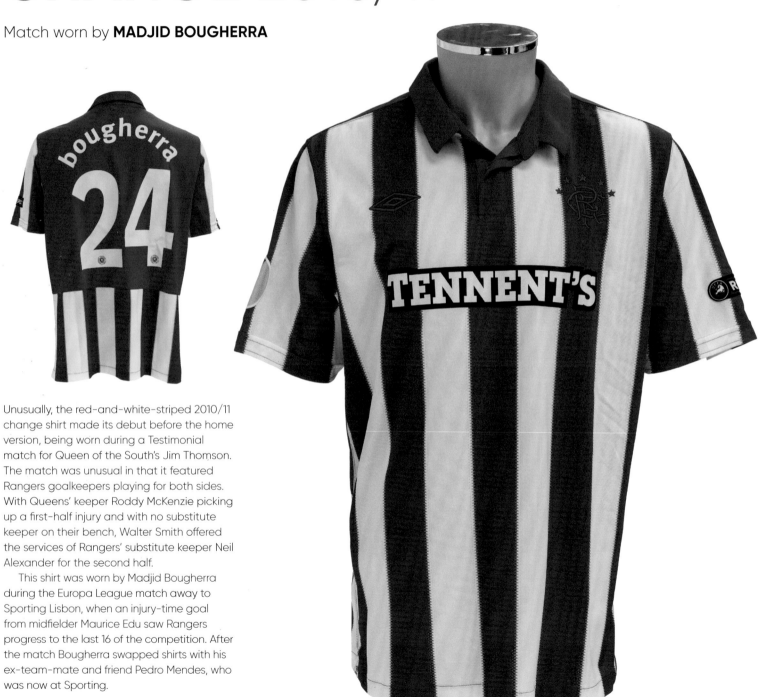

Unusually, the red-and-white-striped 2010/11 change shirt made its debut before the home version, being worn during a Testimonial match for Queen of the South's Jim Thomson. The match was unusual in that it featured Rangers goalkeepers playing for both sides. With Queens' keeper Roddy McKenzie picking up a first-half injury and with no substitute keeper on their bench, Walter Smith offered the services of Rangers' substitute keeper Neil Alexander for the second half.

This shirt was worn by Madjid Bougherra during the Europa League match away to Sporting Lisbon, when an injury-time goal from midfielder Maurice Edu saw Rangers progress to the last 16 of the competition. After the match Bougherra swapped shirts with his ex-team-mate and friend Pedro Mendes, who was now at Sporting.

THIRD 2010/11

Match shirt of **KYLE HUTTON**

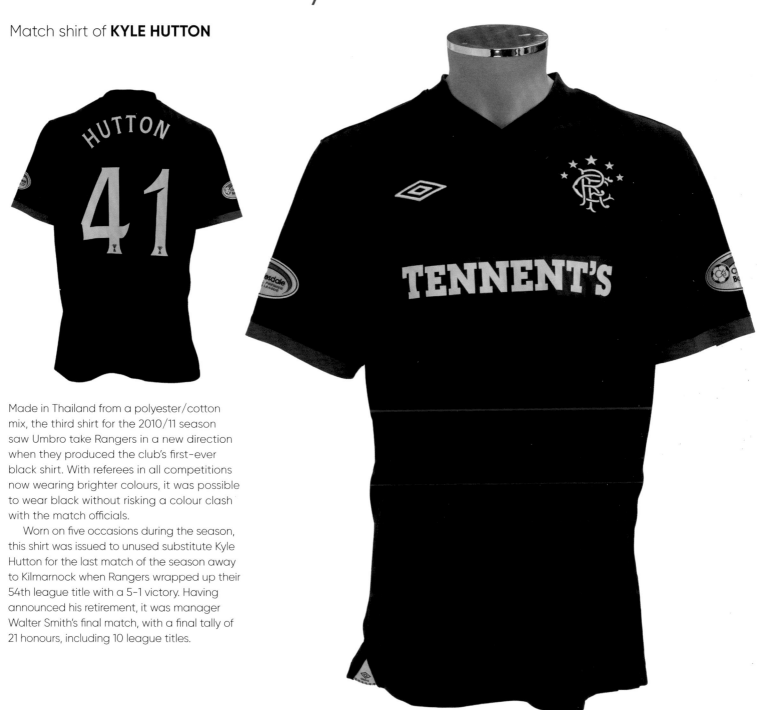

Made in Thailand from a polyester/cotton mix, the third shirt for the 2010/11 season saw Umbro take Rangers in a new direction when they produced the club's first-ever black shirt. With referees in all competitions now wearing brighter colours, it was possible to wear black without risking a colour clash with the match officials.

Worn on five occasions during the season, this shirt was issued to unused substitute Kyle Hutton for the last match of the season away to Kilmarnock when Rangers wrapped up their 54th league title with a 5-1 victory. Having announced his retirement, it was manager Walter Smith's final match, with a final tally of 21 honours, including 10 league titles.

LEAGUE CUP FINAL 2010

Match worn by **DAVIE WEIR**

Rangers recorded a stunning Scottish League Cup Final victory against St Mirren at Hampden Park on 21st March 2010.

Struggling to hit top form, Rangers found themselves down to nine men after both Danny Wilson and Kevin Thomson were ordered off during the second half. But with seven minutes remaining, Kenny Miller powered home a header from a Steven Naismith cross to give a resilient Rangers one of their bravest cup final victories in modern times.

This shirt was worn by captain Davie Weir as he led the club to their 26th Scottish League Cup title.

After the game, Weir told the *Rangers News*: "I don't think you could have written the script for that one. We know we were poor, but at the final whistle you realise you've won a cup and to do it with nine men is a real achievement."

SCOTTISH LEAGUE CUP FINAL 2011

Match worn by **EL HADJI DIOUF**

Forward El Hadji Diouf had a short but eventful period at the club, picking up league and Scottish League Cup winners' medals.

Diouf wore this number 17 shirt during the League Cup Final against Celtic, the Senegalese star having come on as a substitute in extra time, during which a Nikica Jelavić goal gave Rangers a 2–1 victory.

Like the League Cup Final shirt from the previous season, the match details were placed around the club crest, although heat-pressed rather than embroidered.

Having completed his loan, Diouf returned to training at Blackburn Rovers and was pictured wearing one of his Rangers shirts and with a winners' medal around his neck.

HOME 2011/12

Match worn by **MAURICE EDU**

First unveiled in promotional photos in April 2011 and released the following month, the new home shirt from Umbro's 'Tailored by Umbro' range was worn during one of the most turbulent seasons in the club's history.

A popular kit with supporters, this shirt featured a return to the classic white v-neck collar of the 1960s and had red and white piping to both shoulders.

With Walter Smith having stepped aside after another league title win, his protégé Ally McCoist assumed the mantle of manager alongside his assistants Kenny McDowall and former 'nine-in-a-row' team-mate Ian Durrant. It was to be a baptism of fire for the new management team as ongoing financial constraints saw the club enter administration on 14th February 2012 and deducted 10 points in the league as a result.

During the period of administration, a 'Rangers Fans Fighting Fund' was launched to raise money to help protect the future of the club, and for the final home league match of the season against Motherwell the club shirt featured the group's logo. The shirts were later auctioned off to help raise funds for the campaign.

This shirt was worn by American midfielder Maurice Edu during the first half of that match on 5th May 2012. Edu joined the club in August 2008, playing more than 100 matches and picking up three league winners' medals, one Scottish Cup and two League Cup winners' medals during his time in Glasgow before moving on in August 2012.

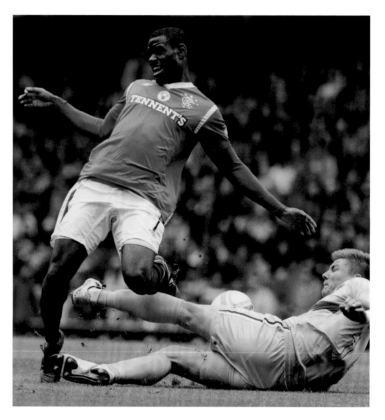

Above: Maurice Edu takes a painful blow from Motherwell's Shaun Hutchinson

Left: The Rangers Fans Fighting Fund badge would feature for this solitary match at the end of the 2011/12 season

CHANGE 2011/12

Match worn by **DORIN GOIAN**

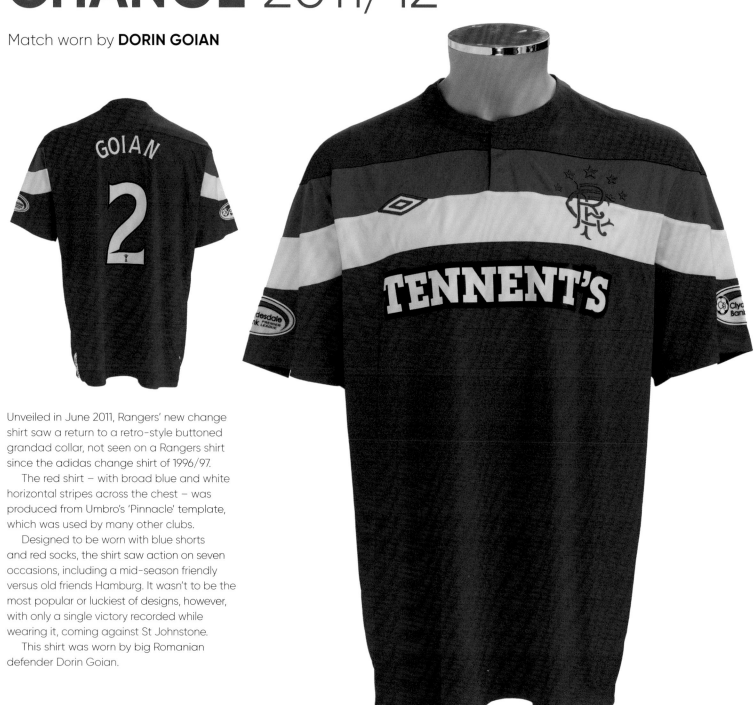

Unveiled in June 2011, Rangers' new change shirt saw a return to a retro-style buttoned grandad collar, not seen on a Rangers shirt since the adidas change shirt of 1996/97.

The red shirt – with broad blue and white horizontal stripes across the chest – was produced from Umbro's 'Pinnacle' template, which was used by many other clubs.

Designed to be worn with blue shorts and red socks, the shirt saw action on seven occasions, including a mid-season friendly versus old friends Hamburg. It wasn't to be the most popular or luckiest of designs, however, with only a single victory recorded while wearing it, coming against St Johnstone.

This shirt was worn by big Romanian defender Dorin Goian.

THIRD 2011/12

Match worn by **KIRK BROADFOOT**

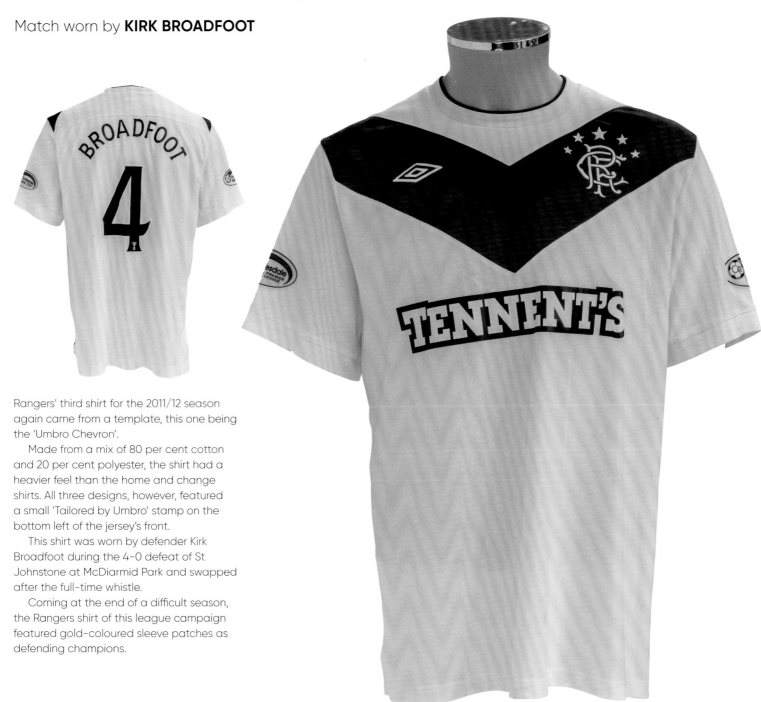

Rangers' third shirt for the 2011/12 season again came from a template, this one being the 'Umbro Chevron'.

Made from a mix of 80 per cent cotton and 20 per cent polyester, the shirt had a heavier feel than the home and change shirts. All three designs, however, featured a small 'Tailored by Umbro' stamp on the bottom left of the jersey's front.

This shirt was worn by defender Kirk Broadfoot during the 4-0 defeat of St Johnstone at McDiarmid Park and swapped after the full-time whistle.

Coming at the end of a difficult season, the Rangers shirt of this league campaign featured gold-coloured sleeve patches as defending champions.

HOME 2012/13

Match worn by **LEE McCULLOCH**

The 2012/13 season would see the conclusion of the kit deal with Umbro and they would go out in style with a stunningly simplistic shirt which helped celebrate the 140th anniversary of Rangers whilst also paying homage to the side who won the European Cup Winners' Cup Final some 40 years previously.

To emphasise the connection between past glory and future success, the shirt was launched at the Rangers Training Centre in late April 2012 by young player Rhys McCabe and club legend Sandy Jardine, who played in the famous European campaign of 1972.

"The new kit is designed to commemorate the 40th anniversary of Barcelona 1972, which is one of the club's greatest-ever achievements," said Jardine.

"It was an honour and privilege to be part of the team that won the Cup Winners' Cup in 1972 and the strip worn at the Nou Camp has become the most iconic in the club's history. The strip for 2012/13 will undoubtedly capture the imagination of our supporters as we celebrate Barcelona '72 and our 140th anniversary."

Royal blue in colour, the shirt featured a round-neck collar with 1972 stitched on the inside and a welcome return to a large club crest (minus the five stars which were moved to the bottom rear of the shirt). Shirt sponsor Tennent's even agreed to reduce its branding to a smaller, less obtrusive logo.

The new shirt made its debut in an end of season fundraising friendly against old friends Linfield in Belfast on the 7th May 2012 and was worn as Rangers easily won the Third Division title as the journey back to the top flight began.

This shirt was worn by club captain Lee McCulloch during the match against Elgin City at Ibrox on 5th January 2013.

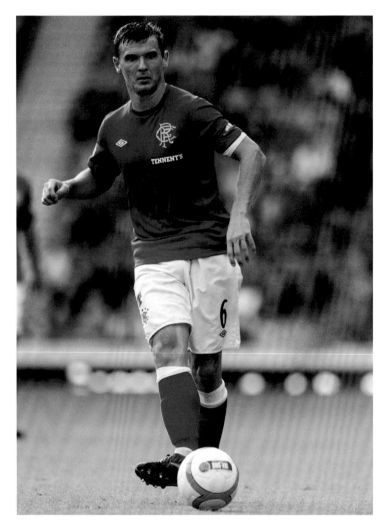

Above: Lee McCulloch brought vital nous to a young Rangers side

Left: This shirt introduced a new sleeve sponsor – Barr's Irn Bru

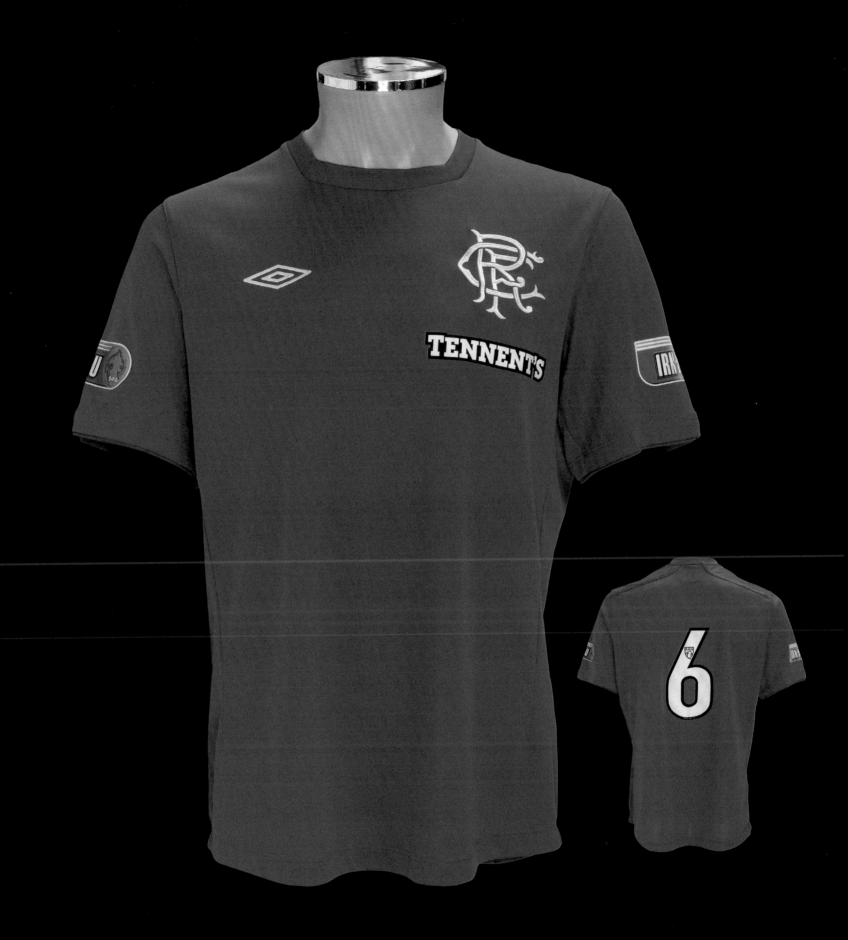

CHANGE 2012/13

Match worn by **KAL NAISMITH**

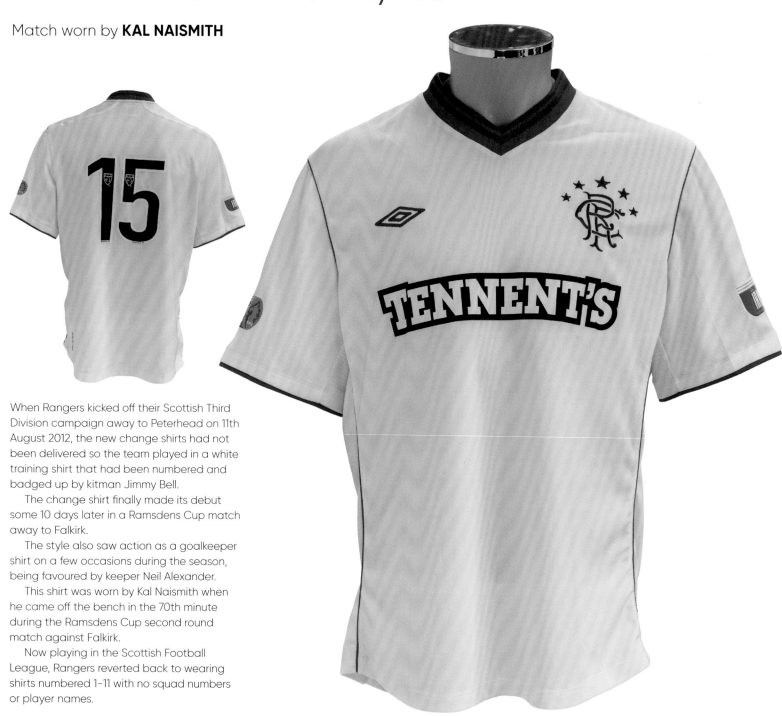

When Rangers kicked off their Scottish Third Division campaign away to Peterhead on 11th August 2012, the new change shirts had not been delivered so the team played in a white training shirt that had been numbered and badged up by kitman Jimmy Bell.

The change shirt finally made its debut some 10 days later in a Ramsdens Cup match away to Falkirk.

The style also saw action as a goalkeeper shirt on a few occasions during the season, being favoured by keeper Neil Alexander.

This shirt was worn by Kal Naismith when he came off the bench in the 70th minute during the Ramsdens Cup second round match against Falkirk.

Now playing in the Scottish Football League, Rangers reverted back to wearing shirts numbered 1-11 with no squad numbers or player names.

THIRD 2012/13

Match worn by **DAVID TEMPLETON**

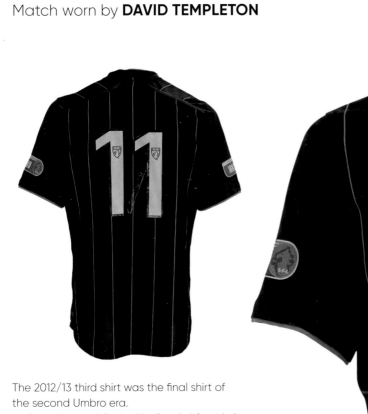

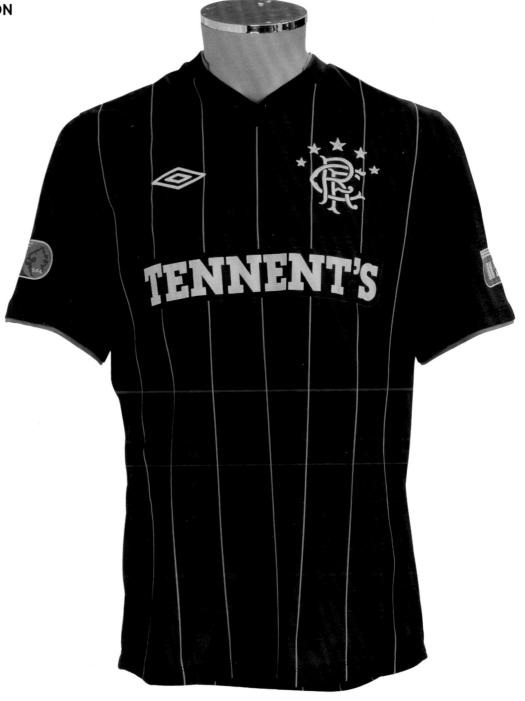

The 2012/13 third shirt was the final shirt of the second Umbro era.

Described as 'black with electric blue trim', the shirt saw a return to a pinstriped design for the first time in 40 years. Made from polyester, the shirt material also contained elastane within the trim, ensuring a tight fit.

The shirt was only used once during the season, in a 4-2 league victory away to Montrose on 15th December 2012 when this example was worn by David Templeton.

Despite dropping down the divisions, Rangers supporters had rallied behind the club with a crowd of more than 49,000 packing Ibrox for the first home match of season – a world-record attendance for a fourth-tier match.

Rangers ran away with the Third Division title, finishing 24 points ahead of their nearest rivals.

140TH ANNIVERSARY 2012

Match worn by **ANESTIS ARGYRIOU**

On 8th December 2012, Rangers celebrated the club's 140th anniversary with a commemorative shirt, which was worn at Ibrox during the Third Division match against Stirling Albion.

The home shirts prepared for the occasion had '1872 Rangers Football Club 2012' inscribed in heat-pressed lettering in a semi-circular pattern above the club crest, with '140 Years' below. Five stars, now in gold, returned to the front of the shirt and sat above the commemorative detail and crest.

Rangers invited around 40 ex-players to the match, representing different eras in the club's history, and they were introduced at half-time to the crowd of just under 50,000, who showed their appreciation for the service and past endeavours of these club legends.

With all the turmoil that the club had faced during the previous six months, when at one point it looked like Rangers might not even reach this milestone, the day was about more than just a football match. It was a celebration of the solidarity between the club and supporters and an opportunity to show the world that Rangers would not be broken.

It was a day to look back with pride at the club's history and forward with optimism towards the future. A banner unveiled by supporters during the match summed up the thoughts of all Rangers fans who were there that day. It quite simply said: 'Rangers Then, Rangers Now, Rangers Forever'.

This shirt was worn by Greek defender Anestis Argyriou as Rangers marked the occasion with a 2-0 victory. Only with the club for a year, the ex-AEK Athens defender would mostly fill the right-back role throughout the 2012/13 season.

A limited number of replicas of the 140th anniversary shirt were produced to mark the occasion and these were very quickly snapped up.

Above: Greek defender Anestis Argyriou made 27 appearances for Rangers before departing for Polish side Zawisza Bydgoszcz

Left: The celebratory club crest

FITTING FINALS

EARLY
1970s

Pre-Umbro deal Rangers wore this blue adidas walkout jacket in matches such as the 1973 Scottish Cup Final.

LATE
1970s

Rangers' first kit sponsorship deal with Umbro in 1978 would see both logos appear on the club's walkout jackets together for the first time.

Since the early 1970s Rangers have often worn pre-match warm-up tops and walkout jackets for their cup final appearances. Many of the later ones would include match details, and players were eventually permitted to keep them as a souvenir of the day.

Before Rangers signed their first kit deal with Umbro in 1978, it was not unusual to see the players wearing Umbro shirts mixed with adidas boots and tracksuits. Umbro were the official distributor for adidas boots in the UK in the 1960s and 1970s, meaning that advertising images marketing both companies were commonplace around the game before the two companies went their separate ways.

Rangers players relax in their adidas tracksuits ahead of the 1972 European Cup Winners' Cup Final

1980
SCOTTISH CUP FINAL

By the 1980 Scottish Cup Final, these stylish walkout jackets from Umbro were adorned with commemorative match embroidery.

1993
SCOTTISH CUP FINAL

The 1993 Scottish Cup Final victory over Aberdeen featured another adidas classic, complete with an embroidered image of the trophy up for grabs.

1996
SCOTTISH CUP FINAL

The warm-up top from Rangers' 5-1 demolition of Hearts in the 1996 Scottish Cup Final – a match best remembered for the outstanding performance of Brian Laudrup despite a Gordon Durie hat-trick.

1998
SCOTTISH CUP FINAL

With Rangers now supplied by Nike, the 1998 Scottish Cup Final warm-up tops were worn by Walter Smith's star-studded team, which featured the likes of Brian Laudrup, Andy Goram and Richard Gough.

2000
SCOTTISH CUP FINAL

The 2000 Scottish Cup Final saw Rangers defeat Aberdeen 4-0, rounding off a domestic league and cup double in Dick Advocaat's second season as manager.

2008
UEFA CUP FINAL

Produced by Umbro, this stylish warm-up top was worn before the final at the City of Manchester Stadium – a match which saw some 200,000 Rangers fans make the long journey south to Manchester.

2009
SCOTTISH CUP FINAL

The 2009 Scottish Cup Final saw Rangers take on Falkirk at a warm Hampden Park, with Nacho Novo coming off the bench to score the winner.

2010
LEAGUE CUP FINAL

The walkout jacket for the 2010 League Cup Final against St Mirren was the first top to also include the opposition's name in the commemorative – and, in this instance, heat-pressed – match details.

2011
LEAGUE CUP FINAL

Rangers stuck with heat-pressed match details for the 2011 League Cup Final warm-up tops, a match which saw Celtic defeated 2-1 after extra-time.

2014
RAMSDENS CUP FINAL

PUMA's first-ever walkout jacket for the club was prepared for the Ramsdens Cup Final match against Raith Rovers at Easter Road on 6th April 2014.

2016
PETROFAC CUP FINAL

2016's Petrofac Training Cup Final was won by defeating Peterhead 4-0 at Hampden, with these tops worn in the pre-match warm-up.

2016
SCOTTISH CUP FINAL

The club's first Scottish Cup Final appearance in six years saw captain Lee Wallace lead out his team in this stylish number from PUMA.

LEST WE FORGET

Rangers is rightly proud of its unique bond with the men and women who serve in the British armed forces, a bond that has only been strengthened by the introduction of the 'Poppy Shirt'.

R angers have always been proud of its association with the armed forces of the United Kingdom, with the club offering soldiers in uniform free admission to matches at Ibrox as early as 1892.

At the start of the First Word War, Rangers allowed Ibrox to be used as a recruiting centre for Lord Kitchener's New Army. Patriotic handbills were produced encouraging young men to join up and fight alongside their fellow supporters.

Showing they weren't just marksmen on the pitch, the Rangers team of 1914 (including the club's first two managers, William Wilton and William Struth), get in some rifle training during the early days of the First World War

"Members and followers of the football clubs of Glasgow. Up till now you have looked on at our game. Now we call upon you to play it.

"We have shown you how, for the honour of our clubs and as clean sportsmen we play to win – obeying our Captain's orders; Fit in body; Steady of foot; Keeping our heads when surrounded on all sides; Working in comradeship as one man, with a single,

constant, determined and sustained effort, overcome the resistance of our opponents and capture their goal with a clean shot.

"We CONFIDENTLY call on you to bring into practice these lessons in the Great Contest of the Nations now raging in which you are now called to join in DEFENCE OF YOUR COUNTRY, YOUR MANHOOD AND YOUR FREEDOM.

"The Battle of Waterloo was said by the Duke of Wellington to have been won on the playing fields of Eton College. WHY SHOULD NOT HISTORY RELATE HOW THIS GREAT WAR WAS WON ON THE FOOTBALL FIELDS OF SCOTLAND.

"FORWARDS WANTED. NO BACKS. PLAY UP RANGERS or Queens Park, Celtic, Partick Thistle, Clyde or 3rd Lanark as the case may be. What true football enthusiast, possessed of the necessary qualifications, could resist such an appeal?"

As the conflict continued, Rangers provided weekly contributions to war relief funds thanks to donations from the staff and also organised collections at home matches to pay for footballs and spare jerseys to be sent to the soldiers on the front. The club even set up a rifle club for players to learn how to handle arms in case they were called up for duty, which many were.

A number of Rangers players who saw active service during the two world wars were presented with bravery awards. Amongst them was Dr James Paterson, who received the Military Cross for "exemplary gallantry in the presence of the enemy" during the First

A gun salute signals the end of a minute's silence as Ibrox remembers the fallen of both world wars during the annual 'Poppy Day' match in 2019

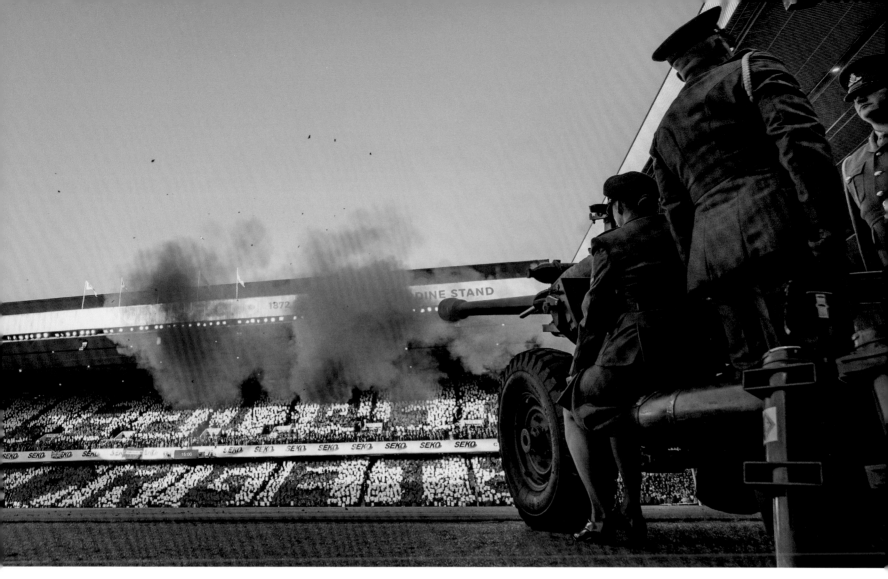

World War. His citation stated: "Under an intense hostile bombardment, he dressed the wounded and cleared them from the road, personally seeing to their removal to the aid post. He then returned and cleared the dead from the road, setting a fine example of coolness and disregard of danger."

Another who received recognition was inside-forward Ian McPherson, who – as a member of the RAF's Pathfinder Squadron – was awarded the Distinguished Flying Cross and Bar in January 1945. Most famously of all, 23-year-old forward Willie Thornton was awarded the Military Medal for valour in the field in Sicily during the winter of 1943.

As hostilities in Europe drew to a close in late 1945, Rangers sent a team to Germany to entertain the troops in a match against

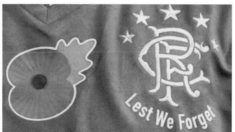

the Combined Armed Services. Such matches were regularly played before and after both wars, and this continued until the end of National Service in the mid 1960s.

To this day, Rangers continue to honour the brave men and women serving in the Army, Navy and RAF by holding an annual Armed Forces Day at Ibrox.

From 2008 the club has produced custom-made 'Poppy Day' shirts, worn as a mark of respect and auctioned afterwards on behalf of relevant charity organisations

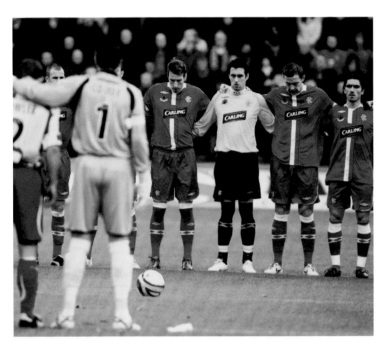

Kilmarnock and Rangers players observe a minute's silence at Rugby Park in November 2008

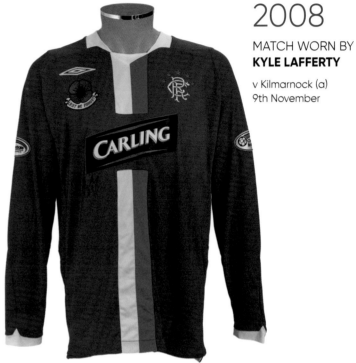

2008

MATCH WORN BY
KYLE LAFFERTY

v Kilmarnock (a)
9th November

POPPY SHIRTS

On 9th November 2003, Rangers players wore a poppy on their shirts for the match against Kilmarnock to commemorate the end of the First World War and to honour the fallen of that conflict and of those since.

This tradition continued until the 2008/09 season, with the poppy emblem being either pinned or stuck on to a standard league shirt, although many would thus unsurprisingly come loose during the subsequent match.

In the winter of 2008, most of the other Scottish Premier League clubs came on board to support the Poppy Scotland Appeal, and the club produced their first 'Poppy Day' shirt featuring detailed embroidery. Worn away to Kilmarnock on 9th November 2008, the red away shirt featured an embroidered poppy above a scroll bearing the inscription 'Lest We Forget'.

After the match, the shirts were distributed to deserving charities to auction or display in support of the armed forces, a tradition that Rangers have continued every year since.

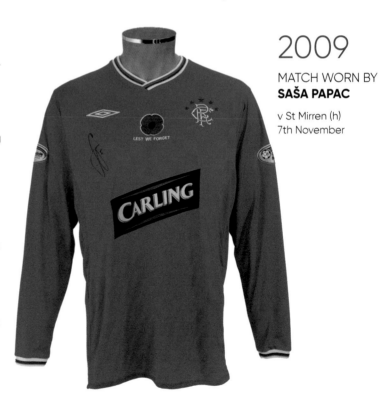

2009

MATCH WORN BY
SAŠA PAPAC

v St Mirren (h)
7th November

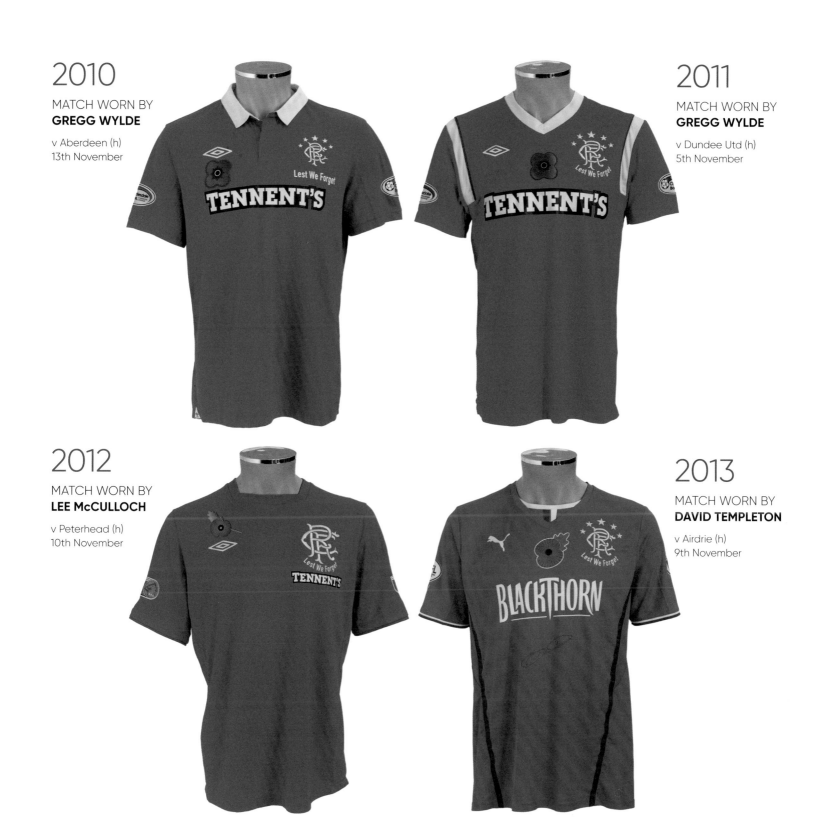

2010

MATCH WORN BY
GREGG WYLDE

v Aberdeen (h)
13th November

2011

MATCH WORN BY
GREGG WYLDE

v Dundee Utd (h)
5th November

2012

MATCH WORN BY
LEE McCULLOCH

v Peterhead (h)
10th November

2013

MATCH WORN BY
DAVID TEMPLETON

v Airdrie (h)
9th November

2014

MATCH SHIRT OF
ARNOLD PERALTA

v Falkirk (h)
8th November

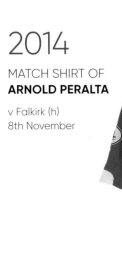

2015

MATCH WORN BY
JASON HOLT

v Alloa (h)
7th November

2016

MATCH SHIRT OF
LEE HODSON

v Kilmarnock (h)
29th October

2016

MATCH WORN BY
KENNY MILLER

v Ross County (a)
6th November

2017

MATCH SHIRT OF
LEE WALLACE

v Partick Thistle (h)
4th November

2018

MATCH WORN BY
RYAN JACK

v Motherwell (h)
11th November

2019

MATCH WORN BY
CONNOR GOLDSON

v Motherwell (h)
27th October
& v Livingston (a)
10th November

2020

MATCH WORN BY
IANIS HAGI

v Hamilton (h)
8th November

EVERYWHERE, ANYWHERE

PUMA & HUMMEL

HOME 2013/14

Match worn by **DEAN SHIELS**

Rangers began the 2013/14 season with a new kit manufacturer, with PUMA having signed a five-year deal with the club in February 2013. The club's chief executive, Craig Mather, welcomed the move by heralding PUMA as "one of the world's most iconic lifestyle brands". There was also the addition of a new main shirt sponsor, with Blackthorn Cider replacing Tennent's for just a single season.

PUMA's first-ever Rangers home shirt featured a royal blue body with a two-stripe 'PUMA King' graphic in red and white on the front neck and an '1872' logo on the rear. The two-stripe design originated from the 1974 World Cup. With his Holland team playing in shirts supplied by adidas but being personally contracted to rivals PUMA and wearing PUMA King boots, Dutch maestro Johan Cruyff refused to wear the three stripes of adidas and asked PUMA to make him a bespoke shirt. The company produced a shirt with just two stripes down the arms and Cruyff wore this design all the way through to the final, much to the anger of adidas.

Rangers went through the League One campaign undefeated, finishing as champions with 102 points out of a possible total of 108. This was the first time since 1899 that the team had gone through a league campaign without losing a single match, albeit at a lower level. Still, it was no mean feat considering that Ally McCoist's side played twice the number of matches that William Wilton's 1899 side had faced. The final of the Ramsdens Cup was also reached, although a disappointing performance saw the trophy go to Raith Rovers.

It was also a season in which the club lost a legend with the death of Sandy Jardine, who had worked tirelessly with Ally McCoist to maintain the standards and traditions of the club during a very difficult period. For the final league match of the season against Dunfermline, captain Lee McCulloch wore the number 2 shirt, normally associated with Jardine, and the whole team wore shirts featuring the inscription, 'Sandy Jardine, 1948-2014, Forever in Blue'.

This shirt was worn by Dean Shiels throughout the 2013/14 season.

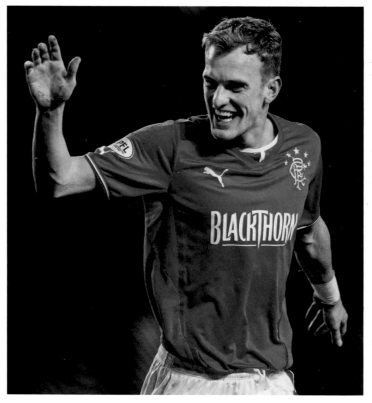

Above: Northern Irish playmaker Dean Shiels joined Rangers from Kilmarnock in July 2012

Right: Lee McCulloch captained Rangers to the Ramsdens Cup Final, their first final appearance since being dropped down the divisions

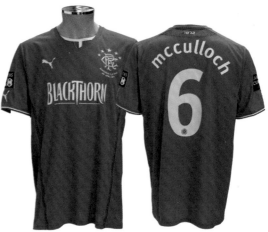

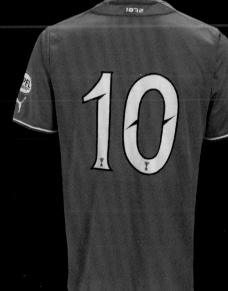

CHANGE 2013/14

Match worn by **NICKY LAW**

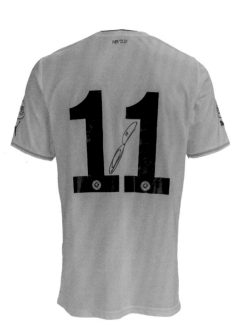

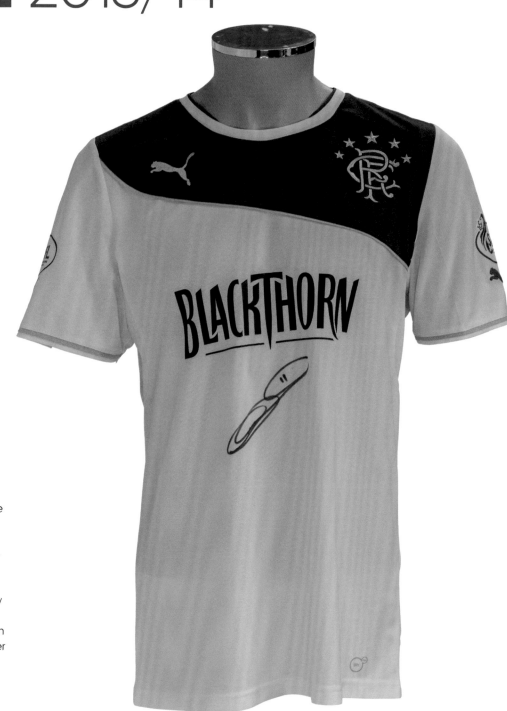

Rangers launched the new PUMA home, change and third kits together on 27th June 2013 at the Rangers Training Centre.

"It is a privilege to be supplying kits to a club with the history of Rangers Football Club," said Ruth How, PUMA's Head of Sports Marketing. "We have put all of our experience and expertise into developing these kits and are delighted with the results. Rangers' players and fans justifiably take a lot of pride in wearing the shirt and that was front of mind for us."

This shirt was given to David Templeton by kitman Jimmy Bell at the end of the season, although it was more likely to have been worn by midfielder Nicky Law, who wore the number 11 shirt in almost all the matches where this style was worn.

THIRD 2013/14

Match worn by **DAVID TEMPLETON**

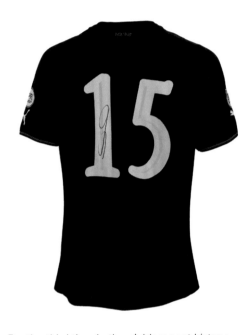

For the third time in the club's recent history, black was favoured as the main colour of the third kit.

All three shirts for the season came from different templates, but all included additional PUMA logos on each sleeve, one of the company's trademark features.

Manufactured in Turkey using PUMA's 'dryCELL' fabric technology, the player shirts featured some slight upgrades in the stitching and printed neck label to set them apart from the replica versions available in the club shop.

This shirt was worn by goalscorer David Templeton against Forfar on 20th January 2014. The 'European' numbers are one of three different fonts used during the season, with Rangers' own branded black numbers used on the change shirt and white SPL-style numbers on the home version.

HOME 2014/15

Match worn by **DEAN SHIELS**

Rangers' home shirt for the 2014/15 season was unveiled during the pre-season tour of the USA and Canada and made its first match appearance in a 2-1 victory over Sacramento Republic in California on 19th July 2014.

The royal blue shirt featured a polo shirt-style collar in white and red with an open button at the front. The non-functioning button was purely a design feature, although midfielder Nicky Law preferred his closed so always made a hole in the shirt so that he could close the collar.

Both sleeve cuffs incorporated an '1872' inscription, and the club crest was heat-pressed on the player shirts but embroidered on the replica version, reversing the trend of previous years. A new shirt sponsor also adorned the design, with 32Red replacing Blackthorn Cider.

The 2014/15 season saw PUMA introduce ACTV taping technology to their professional club shirts. The rubberised taping on the inside of the player shirts was designed to give the shirt a skin-tight feel and micro-massage specific areas of the skin, helping to stimulate muscles and optimise player performance.

On the park it was a turbulent season, with Rangers now competing in the Scottish Championship, just one step below the Premiership. They struggled with consistency and manager Ally McCoist resigned in December 2014 following a loss to Queen of the South. He was replaced by his assistant, Kenny McDowall, in an interim capacity. Then on 12th March 2015 former player Stuart McCall was brought in to steady the ship until the end of the season and try and secure promotion to the Premiership. Unfortunately, finishing a poor third in the league saw Rangers forced into a six-match play-off battle, where defeat to Motherwell confined the club to one more year in the Championship and a delay on the march back to the top flight.

This long-sleeved shirt was worn by Dean Shiels in various matches during the 2014/15 Championship campaign. Also pictured is a short-sleeved version worn in the league campaign by Kenny Miller.

Above: Dean Shiels' injury woes mounted during the 2014/15 campaign, limiting him to 30 appearances in all competitions

Right: Both versions of the pro shirt featured rubberised taping, sculpting the shirt to the shape of the body

CHANGE 2014/15

Match worn by **MARIUS ŽALIŪKAS**

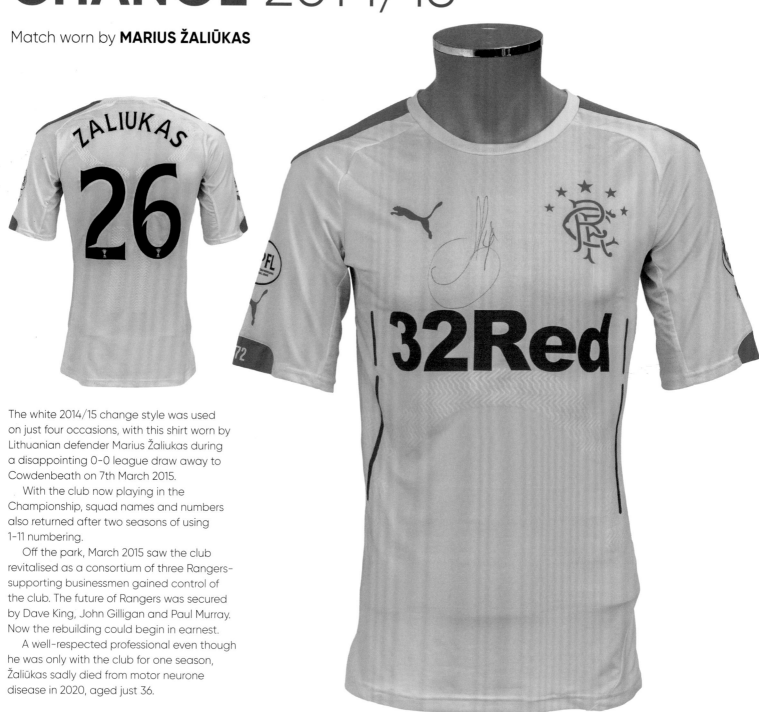

The white 2014/15 change style was used on just four occasions, with this shirt worn by Lithuanian defender Marius Žaliukas during a disappointing 0-0 league draw away to Cowdenbeath on 7th March 2015.

With the club now playing in the Championship, squad names and numbers also returned after two seasons of using 1–11 numbering.

Off the park, March 2015 saw the club revitalised as a consortium of three Rangers-supporting businessmen gained control of the club. The future of Rangers was secured by Dave King, John Gilligan and Paul Murray. Now the rebuilding could begin in earnest.

A well-respected professional even though he was only with the club for one season, Žaliūkas sadly died from motor neurone disease in 2020, aged just 36.

THIRD 2014/15

Match worn by **KENNY MILLER**

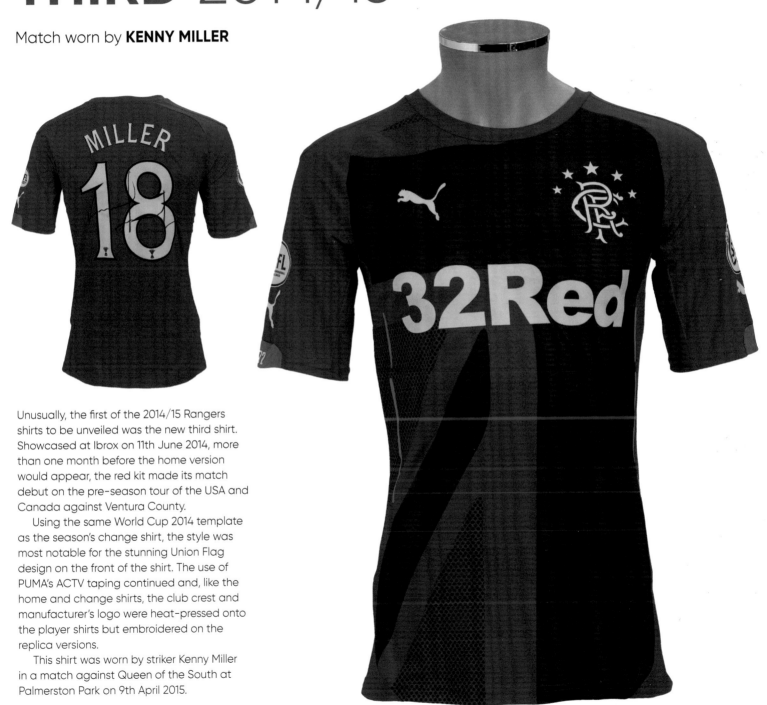

Unusually, the first of the 2014/15 Rangers shirts to be unveiled was the new third shirt. Showcased at Ibrox on 11th June 2014, more than one month before the home version would appear, the red kit made its match debut on the pre-season tour of the USA and Canada against Ventura County.

Using the same World Cup 2014 template as the season's change shirt, the style was most notable for the stunning Union Flag design on the front of the shirt. The use of PUMA's ACTV taping continued and, like the home and change shirts, the club crest and manufacturer's logo were heat-pressed onto the player shirts but embroidered on the replica versions.

This shirt was worn by striker Kenny Miller in a match against Queen of the South at Palmerston Park on 9th April 2015.

HOME 2015/16

Match worn by **ANDY HALLIDAY**

Launched on 15th April 2015 with the marketing strapline of 'Fear No Foe', the new Rangers home shirt was described by PUMA as their most technically advanced shirt to date.

With sports science playing an ever-increasing role in football, kit design and manufacturing was becoming more and more scientific – primarily with a view to maximising player performance.

As a consequence, the new home shirt was constructed using a new style of thermoregulatory fabric, which had seen input from Swiss textile innovators HeiQ. The style also continued to use PUMA's ACTV rubberised taping technology, which mapped the contour of the wearer whilst HeiQ's moisture-wicking fabric kept the player cool.

Constructed from PUMA's 'Stadium' template, the royal blue shirt featured a white band running down each sleeve and the collar returned to a v-neck design in red and blue.

During the course of the season, the players used two versions of the home shirt. Beginning the season with the standard player specification shirt, including ACTV taping and heat-pressed logos, Rangers also occasionally wore the more loose-fitting 'replica' version which was sold to supporters. These tended to be used for one-off matches such as the Petrofac Challenge Cup Final and the Scottish Cup semi-final and final.

On the field, Mark Warburton became the club's 14th full-time manager and successfully guided the club to victory in the SPFL Championship. The team also reached the Scottish Cup Final after a thrilling semi-final victory over Celtic, but unfortunately the double was a step too far as Hibs won the final 3-2. There was further silverware, however, with victory in the Petrofac Training Cup Final when Peterhead were defeated 4-0 at Hampden in April 2016.

This shirt was worn by Andy Halliday on 23rd April 2016 as Rangers faced Alloa Athletic in the last home match of the season, when the player shirts featured a special 'SPFL Championship Winners 2015/16' inscription. Despite being held to a 1-1 draw – with Halliday missing a penalty – it was a day of celebration as Rangers lifted the Scottish Championship trophy and looked forward to the club's return to the Scottish Premiership the following season.

A Rangers fan who lived the dream. Midfielder Andy Halliday poses with the Championship trophy in 2016

CHANGE 2015/16

Match worn by **NATHAN ODUWA**

The change shirt for the 2015/16 season saw Rangers tip a hat to their long association with the district of Govan, where the club has been based since moving from Kinning Park in 1887.

Rangers have long used red and black socks, which are believed to be the colours of the ancient Burgh of Govan, and the new change shirt – created from PUMA's 'Finale' template – was a celebration of this important heritage.

Incorporating PUMA's latest kit technology, including ACTV taping, the red and black change shirt was used in eight SPFL matches during the season as Rangers completed the journey back to the Premiership by finishing top of the Scottish Championship by 11 points.

This shirt was worn by Nathan Oduwa on 27th September 2015 as Rangers cruised to a 4-0 league victory over Greenock Morton.

THIRD 2015/16

Match worn by **NATHAN ODUWA**

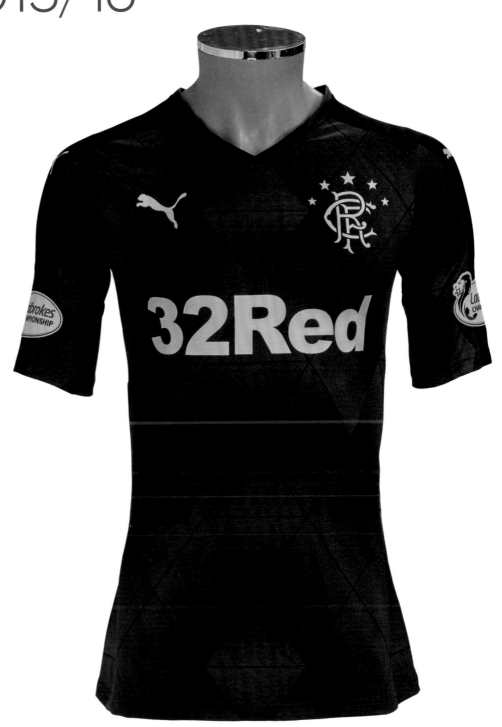

Rangers' third shirt for the 2015/16 season made just a single match appearance in a 2-1 victory away to Dumbarton on 19th September 2015, making it an extremely rare and collectible jersey.

Born out of Puma's 'Swerve' template, which was inspired by the outlandish football shirt designs of the 1990s, the launch press release stated: "The graphic alternative shirt provides a stark contrast to the clean lines seen on the home and change shirts and features the new black 'formstripe' design on the sleeves, with the colour purple symbolising football royalty.

"Rangers has one of the richest heritages in European football. So we wanted to incorporate this into the design of the kits and the alternative shirt gave us the opportunity to deliver a standout graphic inspired by their rich history."

CUP FINALS

CHALLENGE CUP
2016

Match shirt of **NICKY CLARK**

The Rangers shirts prepared for the 2016 Challenge Cup Final (known as the Petrofac Training Cup Final due to sponsorship reasons) were not standard player-issue shirts but the replica version, which was looser fitting and had an embroidered club crest.

The shirts featured match detail embroidery around the lower half of the crest, competition sleeve patches, while the name and number set used was the standard league font. Unusually, the goalkeeper shirt for the match featured different embroidery, with the game details across the front and centre of the chest.

The 4-0 victory over Peterhead went some way to erase the memory of the final two years before and was the first cup silverware that the club had lifted for five years.

This shirt was prepared for unused substitute Nicky Clark.

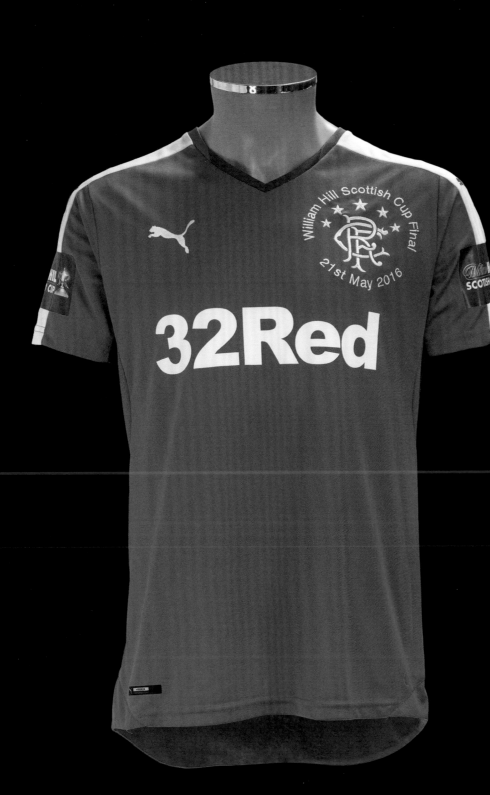

SCOTTISH CUP FINAL 2016

Match shirt of **JAMES TAVERNIER**

One month after winning the Challenge Cup, Rangers were back at Hampden to face Hibs in the Scottish Cup Final, agonisingly losing 3-2 to an injury-time winner.

Like the earlier final, the club again prepared a set of replica shirts for the match, complete with match embroidery and competition sleeve patches.

The final had been reached with victory over Celtic in the semi-final, and despite the loss to Hibs progress continued to be made in the club's fight back to the very top of Scottish football.

This shirt was prepared for James Tavernier, with the future club captain playing in his second domestic final during his debut season at Rangers.

HOME 2016–18

Match worn by **HARRY FORRESTER**

The final home shirt of the seven-year deal with PUMA was worn for two seasons between 2016 and 2018 as the club returned to the top flight of Scottish football.

Taking inspiration from classic Rangers kits of the past – notably the Umbro design worn between 1987 and 1990 – the design featured a shadow effect checkerboard pattern, albeit with much larger squares on the body than seen on the Umbro shirt worn almost 30 years before. Unlike its 1980s predecessor, however, the white collar with blue trim crossed over at the front of the neck.

A PUMA press release stated: "We understand the rich heritage that is intrinsic to Rangers Football Club and as the team return to the Scottish Premiership, we wanted to deliver a kit that was worthy of this."

The logo of betting company 32Red continued to adorn the front of the shirt. However, from the start of the 2017/18 season the Rangers shirt had a sponsor applied to the rear for the first time, namely energy provider Utilita.

Whilst proving an extremely popular design with the fans, the shirts were released during a period when Rangers were struggling to release themselves from a complex merchandise arrangement involving Sports Direct and their joint ownership of Rangers Retail Ltd. This meant that the club did not earn what it considered to be a fair share of the revenue from sales of replica kit.

On the field it was also a period of transition as Mark Warburton left in February 2017 and was replaced by Pedro Caixinha, who would take the managerial reins for a short but unsuccessful period between March and October 2017. Development squad head coach Graeme Murty took control as caretaker manager following Caixinha's departure until May of 2018.

PUMA initially supplied the club with shirts, which once again featured their trademark ACTV rubberised taping technology, but as these shirts were gradually used up during the 2016/17 season, they were often replaced by standard replica shirts. This continued into the 2017/18 season, with the club preferring just to see out the deal with the remaining shirts whilst engaging in the search for a new kit supplier.

This league shirt was worn by Harry Forrester in 2016/17 as the club returned to the Scottish Premier League.

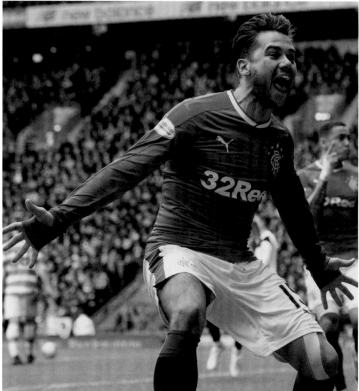

Above: Harry Forrester celebrates his goal against Celtic in the tight-fitting version of this popular shirt

Right: This James Tavernier jersey is the loose-fitting, short-sleeved variant

CHANGE 2016/17

Match worn by **JOEY GARNER**

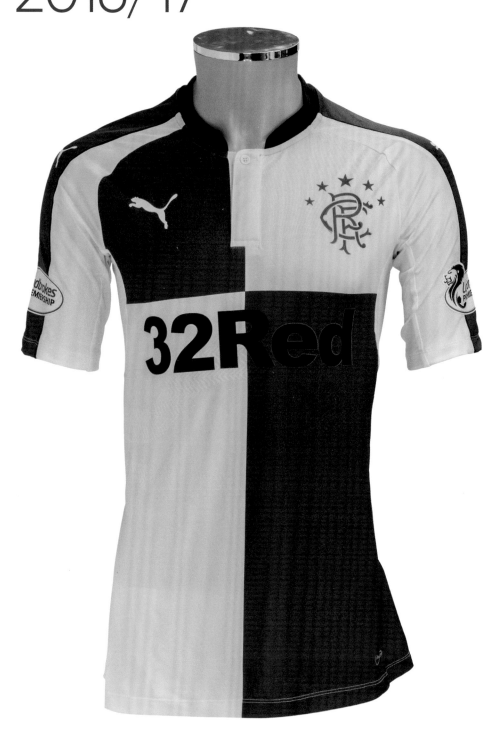

Like the home and third shirts for the 2016/17 season, the change shirt drew inspiration from a popular Rangers shirt from the past.

The red- (or 'chilli pepper', as PUMA preferred to describe it) and-white-quartered design produced for the club's return to the Scottish Premiership was reminiscent of the popular adidas away shirt worn during the 1995/96 season.

The return to the top flight saw the addition of Ladbrokes Premiership sleeve patches and black SPFL names and numbers, and the shirt was worn eight times during the season in away matches against Dundee, St Johnstone, Kilmarnock and Inverness Caledonian Thistle.

This shirt was worn by goalscorer Joey Garner during the match against Dundee at Dens Park on 18th February 2017.

THIRD 2016/17

Match worn by **DAVID BATES**

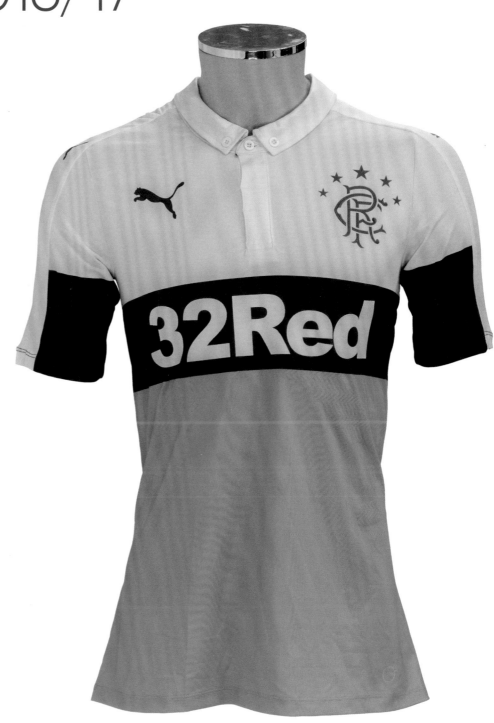

Completing the line-up of PUMA shirts for 2016/17 was the third shirt, similar to the 1999/2000 change style and produced in a classically simple colourway described as 'silverlake blue and peacoat' by PUMA.

The style was only worn in two matches during the season, with the first being a Testimonial for Linfield captain Jamie Mulgrew at Windsor Park on 3rd September 2016. Rangers were delighted to help pay tribute to the long-serving Linfield captain, and Mulgrew was equally thrilled to face the side he had grown up supporting. The shirt featured here worn in that match by defender David Bates.

The other match in which the shirt featured was the 'Poppy Day' match away to Ross County on 6th November 2016.

CHANGE 2017/18

Match worn by **CARLOS PEÑA**

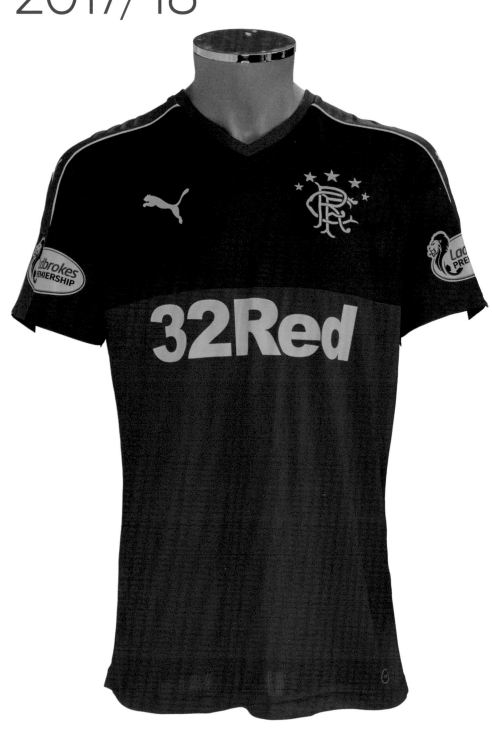

Although a revised commercial agreement with PUMA meant that Rangers had to use the 2016/17 home shirt for a second season, it was agreed that new change and third kits would be produced for the 2017/18 campaign.

The final change shirt was straight out of PUMA's 'Accuracy' template. It was loose-fitting and did not feature any of the manufacturer's ACTV technology, and in fact had actually been produced and released commercially – minus the Rangers logos – as part of the company's teamwear range a year earlier. As with the home and third shirts for the season, the back of the jersey saw the addition of new sponsor Utilita.

This shirt was produced for Mexican international Carlos Peña, who was signed from Guadalajara in June 2017 for a fee of £3.2 million.

THIRD 2017/18

Match worn by **RUSSELL MARTIN**

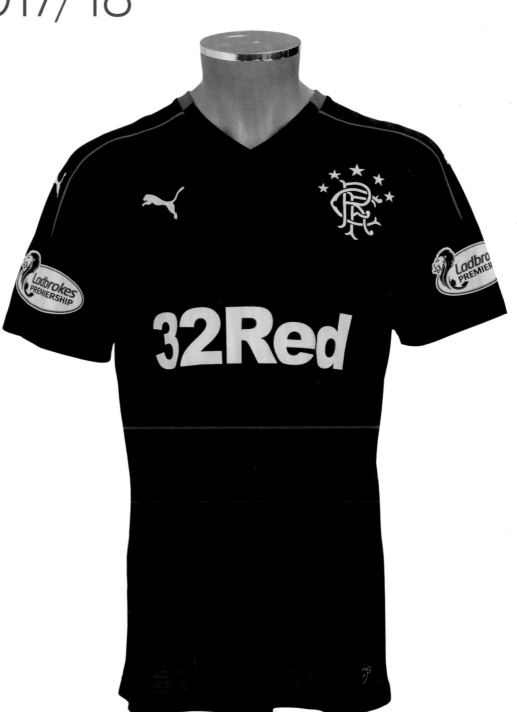

The final Rangers shirt of the PUMA era was released in early October 2017. The new third shirt utilised the same template as the season's change shirt and accordingly did not incorporate ACTV technology. The shirts worn by the players were identical to those purchased from the club shop.

In black with blue piping, the shirt was first used by Rangers during the league match against St Johnstone at McDiarmid Park on 13th October 2017, a game where Rangers secured a 3-0 victory thanks to two goals from Carlos Peña and another from Graham Dorrans.

The example featured here was worn by defender Russell Martin during the match against the same opponents on 27th February 2018, a game which saw Rangers run out 4-1 victors.

HOME 2018/19

Match shirt of **EROS GREZDA**

On 1st June 2018, Rangers announced that the club had signed a three-year kit partnership deal with classic Danish brand hummel, which would see the team wear the famous and distinctive chevrons for the first time in its history.

Allan Vad Nielsen, hummel's CEO, commented: "We are extremely proud to have been chosen as the new Technical Partner to one of the world's oldest and most famous football clubs. Words can barely describe the level of excitement at our Head Office this morning when we announced this fantastic new partnership to our International staff."

Launched with the backing of a promotional video in early July, the company's first home shirt was traditional royal blue with side panels featuring four iconic hummel chevrons down each side of the jersey. The fabric utilised the company's own moisture-wicking technology under the trademark name of 'BeeCool' and the Rangers crest over the left breast was applied in white raised rubber.

The summer of 2018 had seen the appointment of a new management team, with ex-Liverpool legend Steven Gerrard taking control with Gary McAllister as his assistant. Under the new regime, Rangers progressed through three qualifying rounds and a play-off to reach the group stages of the Europa League for the first time since 2010/11.

This home shirt was prepared for new signing Eros Grezda for the Europa League match against Rapid Vienna at Ibrox on 4th October 2018. An Albanian international winger, Grezda had signed for the club just one month earlier from NK Osijek, one of the sides defeated by Rangers en route to the group stages.

Featuring the Europa League and UEFA 'Respect' sleeve patches, the shirt is also notable for the return to a European-style name and number set and the absence of the Utilita logo from the back of the shirt. With only one shirt sponsor allowed under UEFA regulations, the heat-pressed logo has been removed, although the outline is still faintly visible. This was deemed acceptable as it could only be seen on close inspection and would not be picked up by the TV cameras.

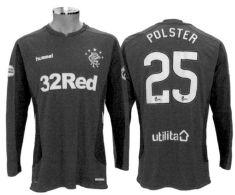

Above: Eros Grezda in Europa League action. Note the rear of the shirt (opposite) with the Utilita logo still visible

Right: The long-sleeved version of this shirt, as worn by American midfielder Matt Polster

CHANGE 2018/19

Match worn by **ALFREDO MORELOS**

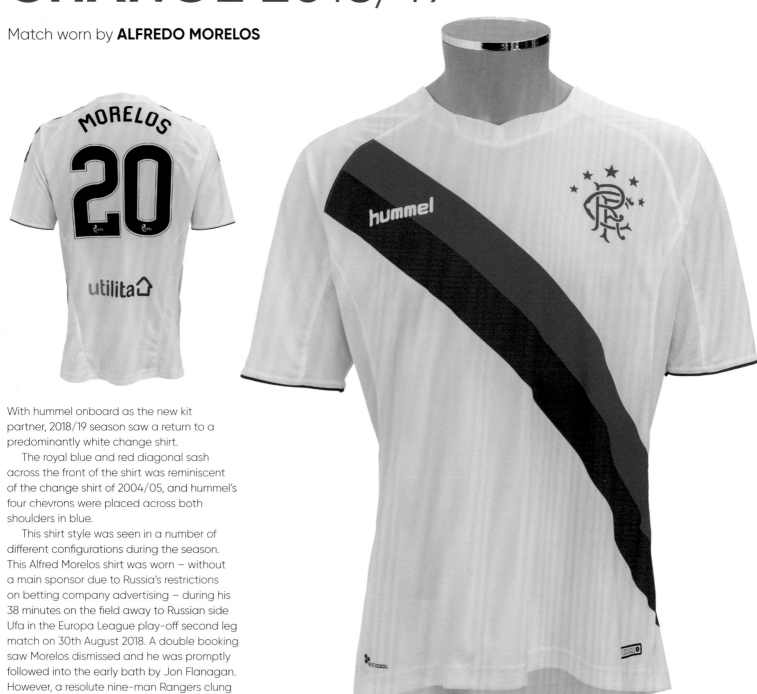

With hummel onboard as the new kit partner, 2018/19 season saw a return to a predominantly white change shirt.

The royal blue and red diagonal sash across the front of the shirt was reminiscent of the change shirt of 2004/05, and hummel's four chevrons were placed across both shoulders in blue.

This shirt style was seen in a number of different configurations during the season. This Alfred Morelos shirt was worn – without a main sponsor due to Russia's restrictions on betting company advertising – during his 38 minutes on the field away to Russian side Ufa in the Europa League play-off second leg match on 30th August 2018. A double booking saw Morelos dismissed and he was promptly followed into the early bath by Jon Flanagan. However, a resolute nine-man Rangers clung on to progress to the group stages.

THIRD 2018/19

Match worn by **DANIEL CANDEIAS**

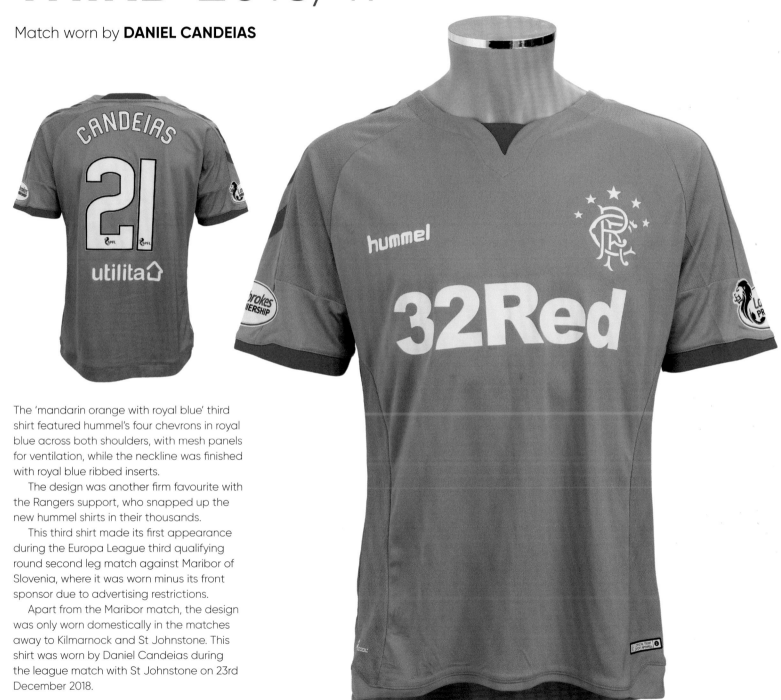

The 'mandarin orange with royal blue' third shirt featured hummel's four chevrons in royal blue across both shoulders, with mesh panels for ventilation, while the neckline was finished with royal blue ribbed inserts.

The design was another firm favourite with the Rangers support, who snapped up the new hummel shirts in their thousands.

This third shirt made its first appearance during the Europa League third qualifying round second leg match against Maribor of Slovenia, where it was worn minus its front sponsor due to advertising restrictions.

Apart from the Maribor match, the design was only worn domestically in the matches away to Kilmarnock and St Johnstone. This shirt was worn by Daniel Candeias during the league match with St Johnstone on 23rd December 2018.

HOME 2019/20

Match worn by **JAMES TAVERNIER**

The 2019/20 season saw the final offerings from hummel, with the kit partnership being concluded after just two of the three initially agreed.

The Danish manufacturer's final Rangers home shirt featured a vertical-striped shadow pattern within the fabric, interspersed with the club crest design. The company's trademark chevrons now ran from the neck across both shoulders. Two mesh panels at the front, running the length of the sleeves, provided ventilation and – like all three of the season's shirts – the design included a line from the club anthem 'Follow Follow' on the bottom inside of the back of the shirt.

The club crest returned to an embroidered version for this season, with hummel's heat-pressed logo now including the bee motif above their name ('hummel' is German for bumblebee, with the company having originated in Hamburg).

Launched once again with an accompanying promotional video, the shirt made its debut on 7th July 2019 in a pre-season friendly at Ibrox as Rangers defeated Oxford United 5-0.

It was another season of improvement for Steven Gerrard's men and once again the team were outstanding in the European arena, this time reaching the last 16 of the Europa League having progressed through qualifying rounds, group stages and the round of 32. Due to the Covid-19 pandemic, worldwide football was suspended with Rangers facing a five-month gap between the first and second legs of their round of 16 tie against Bayer Leverkusen, where unfortunately the European run concluded.

This long-sleeved shirt was prepared for captain James Tavernier – 'Tav' had been appointed to the captain's role by new manager Steven Gerrard in July 2018 – for use during the Europa League group stages. As with the previous season's home shirt for this competition, to comply with UEFA regulations, the Utilita logo was removed.

For the league match against Celtic at Ibrox on 1st September 2019, the 32Red sponsor logo was supplemented by an additional 'Stay in Control' message. Although only used for this one match, the logo with additional strapline would become the main shirt sponsor style from the start of the following season.

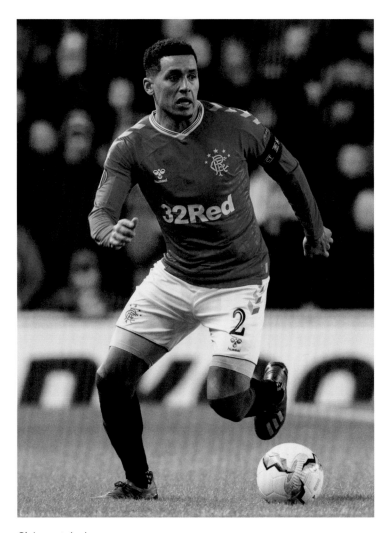

Club captain James
Tavernier in action
in the long-sleeved
Europa League
variant of this shirt

CHANGE 2019/20

Match worn by **SCOTT ARFIELD**

Launched at the end of July 2019, the change shirt for the 2019/20 season was predominantly black with light blue stripes. The same shade of blue was used for the heat-pressed club crest and the manufacturer's logo, as well as the shoulder chevrons. But in a change to the other releases by hummel, the 32Red sponsor was now imprinted into the material.

This shirt, featuring European-style name and numbers, was worn by Scott Arfield in a pre-season friendly versus Blackburn Rovers. The style had first seen competitive action in a Europa League qualifying victory over St Joseph's in Gibraltar.

The shirt was only worn on two further occasions, against Aberdeen at Pittodrie on 4th December 2019 and for the mid-season friendly with Lokomotiv Tashkent in Dubai on 11th January 2020.

THIRD 2019/20

Match worn by **GREG DOCHERTY**

The deal with hummel concluded with a final release in the form of a plain red third shirt.

The round-neck collar design was both simplistic and classical, with the inside of the neck featuring a Union Flag design celebrating Rangers' British heritage. The club crest, sponsor and hummel logo were in heat-pressed white, while only two of the manufacturer's trademark chevrons appeared on the shoulders within a border of blue and red piping.

The third kit was the favoured alternative shirt for the season, seeing action eight times before the early conclusion of the campaign in March 2020 as the Covid-19 pandemic hit.

This shirt was worn by midfielder Greg Docherty in the Europa League qualifier away to Danish side Midtjylland on 8th August 2019.

LEAGUE CUP FINAL 2019

Match worn by **GLEN KAMARA**

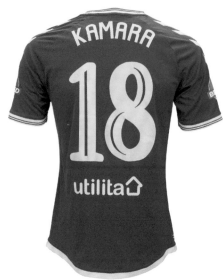

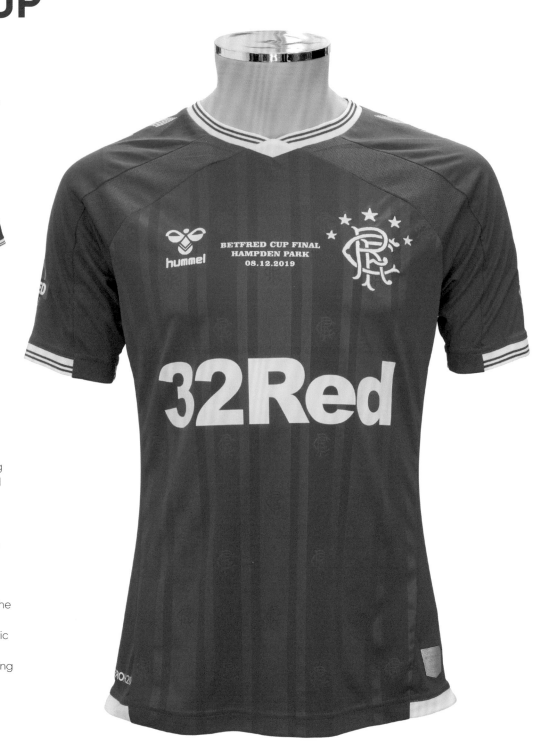

Rangers reached the final of the Betfred Cup and faced rivals Celtic once again on 8th December 2019. Despite an outstanding Rangers performance, the history books will show that Celtic took the title, winning the match 1-0.

This shirt was worn by midfielder Glen Kamara and featured heat-pressed match details across the front of the chest along with competition sleeve patches. For the occasion, Rangers used the name and number font which had been worn during the Europa League qualifying rounds.

Making his first appearance in a domestic final for the club, silky Finnish midfielder Kamara was an outstanding performer during the 2019/20 season.

CHARITY FOUNDATION SHIRT

Match worn by **SCOTT ARFIELD**

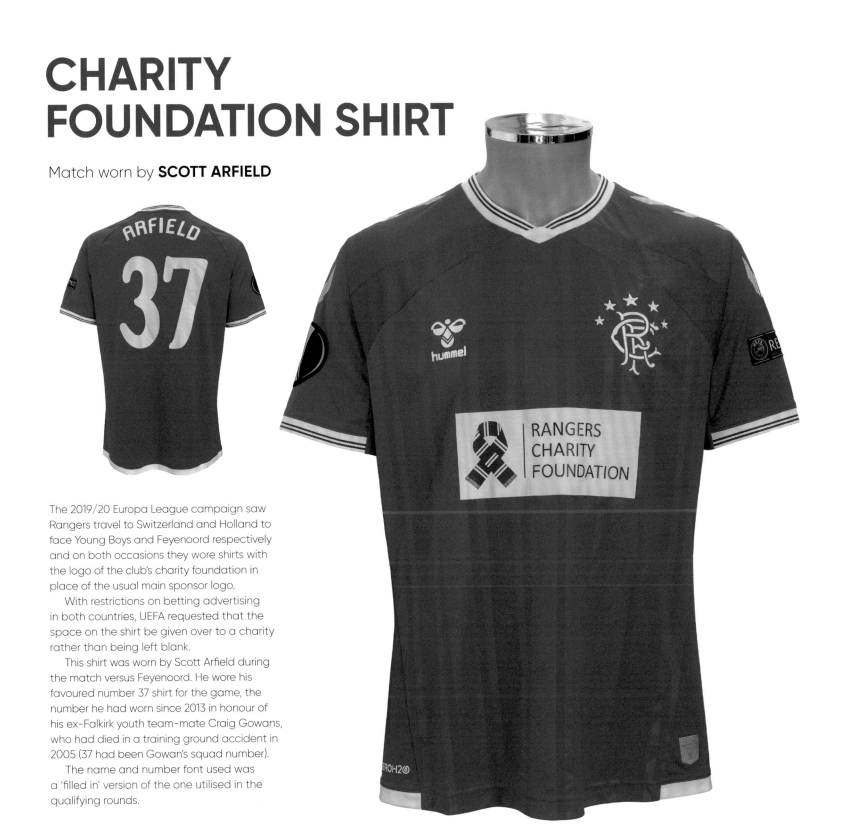

The 2019/20 Europa League campaign saw Rangers travel to Switzerland and Holland to face Young Boys and Feyenoord respectively and on both occasions they wore shirts with the logo of the club's charity foundation in place of the usual main sponsor logo.

With restrictions on betting advertising in both countries, UEFA requested that the space on the shirt be given over to a charity rather than being left blank.

This shirt was worn by Scott Arfield during the match versus Feyenoord. He wore his favoured number 37 shirt for the game, the number he had worn since 2013 in honour of his ex-Falkirk youth team-mate Craig Gowans, who had died in a training ground accident in 2005 (37 had been Gowan's squad number).

The name and number font used was a 'filled in' version of the one utilised in the qualifying rounds.

A RARE BREED

With a history as storied as Rangers', it is unsurprising that there have been several occasions where a truly bespoke shirt has been required, and their rarity makes them highly prized by collectors.

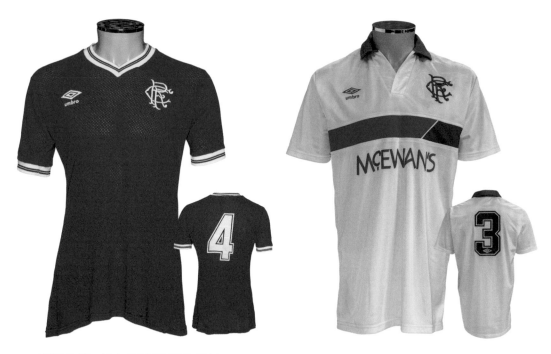

v VALLETTA, 14th SEPTEMBER 1983

In the 1983/84 season, Umbro supplied Rangers with a lightweight shirt designed to be worn in warm conditions. This shirt differed from the normal home variant in that it was made of 100 per cent nylon, was fully perforated to allow maximum airflow and lacked pinstripes. It was worn on only one occasion, against Maltese side Valletta on 14th September 1983. Rangers made good use of this shirt in the heat of Malta, winning the match 8-0. This particular shirt was worn by Dave McPherson – it was a match to remember for the big defender as he scored four goals, becoming the first Rangers player to do so in European competition.

v EVERTON, DUBAI SUPER CUP, 8th DECEMBER 1987

Rangers travelled to Dubai to face Everton in the second annual Super Cup, and as a mark of respect for the local culture played with a shirt missing the word 'Lager', leaving just 'McEwan's' as the sponsor. The match was dubbed as a decider between the Scottish and English champions and Rangers triumphed following an amazing comeback – with 10 minutes left they were 2-0 down (having had six goals chalked off for offside) before two strikes took the match to a penalty shoot-out, which Rangers clinched 8-7. This shirt was worn by Jimmy Phillips and swapped after the match with Everton's Kevin Sheedy.

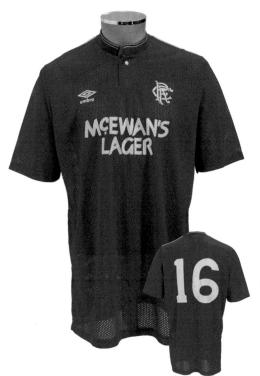

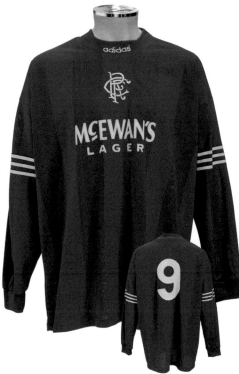

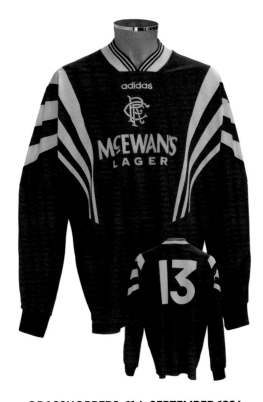

v SPURS, 6th AUGUST 1989 & v HEARTS, 5th MAY 1990

Umbro supplied the club with another lightweight version for the 1989/90 season. This style of shirt would be used on only two occasions during the campaign. The first was during a pre-season friendly versus Tottenham Hotspur at Ibrox on 6th August 1989, which saw the home debut of both Maurice Johnston and Trevor Steven. Manager Graeme Souness had requested Umbro provide Rangers with this style of shirt for the European arena, and although refused at first, Souness would get his way in the end. The shirt's only other appearance came during the last match of the season away to Hearts on 5th May 1990, where a very warm day saw kitman Jimmy Bell bring it out for the final time, as a 1-1 draw saw Rangers clinch the title.

v AEK ATHENS, 10th AUGUST 1994 & v SAMPDORIA, 30th JULY 1995 & v ANORTHOSIS FAMAGUSTA, 23rd AUGUST 1995

A further lightweight shirt was produced by adidas at the start of the 1994/95 season, again for use in hot-weather matches. This shirt was manufactured minus the shadow pattern used in the corresponding home shirt and would see use in the away legs of the Champions League qualifying matches against Greek side AEK Athens and the Cypriots of Anorthosis Famagusta in 1994/95 and 1995/96 respectively. The shirt would also make an appearance on 30th July 1995 against Sampdoria in the pre-season Ibrox International Challenge Trophy as Rangers picked up the trophy after a 2-0 victory over the Italians. This number 9 shirt was prepared but not actually worn, with short sleeves being preferred by Gordon Durie, Ian Durrant and Charlie Miller, who all wore the number 9 jersey in games where this style was used.

v GRASSHOPPERS, 11th SEPTEMBER 1996

Rangers being drawn against Swiss side Grasshoppers in the 1996/97 Champions League group stages created a kit clash, with Rangers the team obliged to change for the away leg on 11th September 1996. For that match, for some unknown reason Grasshoppers elected not to play in their yellow change kit, and as Rangers' home and change shirts were both deemed to clash with the blue and white home shirt of Grasshoppers a third kit was required. Manufacturers adidas supplied Rangers with a shirt based on a template that was being used by – amongst others – the Turkish national side and Swiss side FC Luzern. It has become one of the most sought-after shirts by collectors despite the fact its only appearance came in a 3-0 defeat for the club – this particular shirt was prepared as a spare for that match.

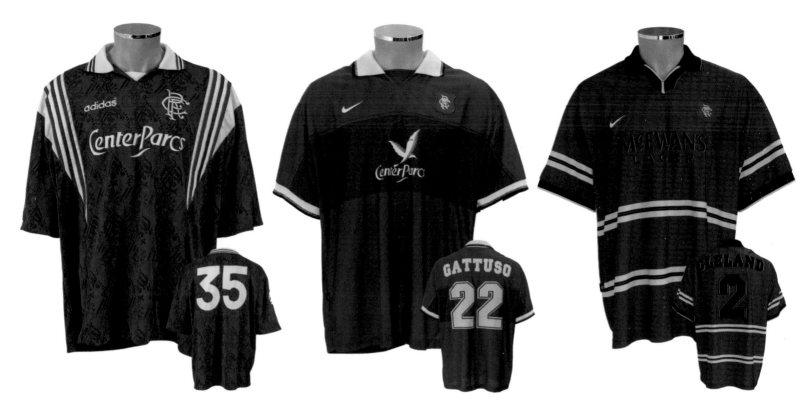

v AUXERRE, 4th DECEMBER 1996

Rangers' Champions League fixture away to Auxerre on 4th December 1996 would require a change of sponsor, as alcohol advertising was prohibited in France at the time. As a result, adidas supplied the club with an unusual set of shirts for the match, which not only featured Center Parcs as the shirt sponsor but also – more notably – had been produced from cuts of the previous season's shirt material, albeit in the style of the current shirt. Unfortunately, it's not known why adidas used this material, but it was its only appearance, making this hybrid shirt highly valued by collectors.

v GI GOTU, 23rd JULY 1997 &
v STRASBOURG, 16th SEPTEMBER 1997

This shirt style was worn on two occasions in European competition, where the advertising of alcohol was not permitted. The first of these matches came on 23rd July 1997 away to GI Gotu in the Faroe Islands as Rangers cruised to a 5-0 victory. The second and final match came during the UEFA Cup first round first leg clash with Strasbourg on 16th September 1997 – with Rangers having dropped into the competition from Champions League qualification – and saw this shirt worn by Italian midfielder Rino Gattuso, who would go on to score in the return leg at Ibrox a fortnight later.

v GOTHENBURG, 27th AUGUST 1997

Nike provided Rangers with a one-off shirt for the Champions League second round second leg qualifier against Swedish side Gothenburg at Ibrox on 27th August 1997. With UEFA rules now stating that the home side must change in the event of a colour clash and with Rangers' white change shirt still clashing with Gothenburg's shirt, another option had to be found. It is unknown whether the shirt was specially commissioned for the match but certainly no other club was using a similar Nike template that season. Two versions of this shirt were supplied by Nike – one with McEwan's Lager (as worn in the Gothenburg match) and one with Center Parcs. Unfortunately, Rangers would lose to Gothenburg over the two legs and the Center Parcs version would never see use. This shirt was prepared for defender Alex Cleland for the Gothenburg match, who was an unused substitute on the night.

v DINAMO ZAGREB & v CANADIAN SOCCER LEAGUE XI, CANADA TOUR 2005

The July of 2005 saw Rangers in Canada for two exhibition matches, firstly versus a Canadian Soccer League XI and latterly the Croatians of Dinamo Zagreb. In order to cater for the local market, the shirts for both matches saw the Carling sponsor logo being replaced by that of their sister company, Coors Light. This particular shirt was worn by utility player Ian Murray during the tour.

v SCHALKE 04, 19th JULY 2008

Rangers rounded off a short pre-season tour of Germany with a friendly against Schalke 04 at the Veltins-Arena on 19th July 2008. With Schalke playing in their usual home shirt of blue, Rangers took to the field wearing a white Umbro training shirt with blue numbers applied; the club had not received the new change kit from Umbro in time for pre-season, forcing kitman Jimmy Bell to improvise. This shirt was made ready for Nacho Novo, with Nacho swapping after the match with American midfielder Jermaine Jones.

v PARIS SAINT-GERMAIN & v ARSENAL, EMIRATES CUP 2009

Rangers accepted an invitation from Arsenal to appear in the third Emirates Cup in August 2009. Midfielder Pedro Mendes would wear these two shirts in different games during the competition – they can be differentiated by the fact that against the French side the shirt featured two sleeve patches instead of one. Also, the kit prepared for the Paris Saint-Germain match featured a name set which went straight across the player's back, whereas the shirts prepared for the Arsenal game featured a curved name set.

v PETERHEAD, 11th AUGUST 2012

The post-administration journey back to the top of Scottish football kicked off in the far north of Scotland as Rangers took on Peterhead on 11th August 2012 while wearing a modified training shirt. The late arrival of a new change kit from Umbro saw Rangers obliged to fight out a 2-2 draw in a training kit hastily adorned with black player numbers and league sleeve patches.

v ATLÉTICO MINEIRO & v CORINTHIANS, FLORIDA CUP 2018

Early January 2018 saw Rangers invited to participate in the fourth annual Florida Cup in the United States. Two matches were played against Brazilian opposition in Atlético Mineiro and Corinthians, and both matches would feature special competition sleeve patches and match details applied to standard replica shirts.

v OSIJEK, 26th JULY 2018

Rangers' new kit deal with hummel was in its infancy when the club travelled to Croatia to face Osijek in a Europa League second qualifying round first leg match on 26th July 2018, with the manufacturer supplying the club with a template shirt in red as Rangers defeated the Croatians 1-0. This shirt was worn during the first half of that game by defender Niko Katiić, who was returning to his homeland having signed for Rangers the previous month.

v WILLEM II, 24th SEPTEMBER 2020

The third qualifying round of the 2020/21 Europa League saw Rangers drawn away to Dutch side Willem II on 24th September 2020. The Dutch side were defeated 4-0, with Rangers wearing their new third kit with a change of sponsor to comply with Dutch advertising rules. The club took the opportunity to advertise their own supporter membership scheme, MyGers. The scheme had launched at the beginning of the season, and within the first couple of months more than 25,000 supporters had signed up.

v ST MIRREN, 16th DECEMBER 2020

As well as the three kits produced by Castore for the 2020/21 campaign, this retro-style shirt, complete with its subtle Castore logo, was to be used in cup competition by Rangers. Unfortunately, defeat in its first outing saw the kit returned to the kit room and never used again. This shirt was made ready for Swedish defender Filip Helander, who was on the bench for the match versus St Mirren.

EVERY SATURDAY WE FOLLOW

2020 · CASTORE

HOME 2020/21

Match worn by **BORNA BARIŠIĆ**

In May 2020, Rangers announced an exciting new kit deal with Liverpool-based high-end sportswear manufacturer Castore. Formed in 2016 and previously mostly supplying sportswear to the tennis industry, it was the brand's first move into the football kit market – but both Castore and Rangers were confident of a successful partnership.

"A number of options were available to us when choosing our first partner – nobody came close to matching Rangers," explained Castore's owners, Tom and Phillip Beahon.

"Rangers players will be wearing the highest quality kit every time they walk on the pitch – the fabrics used will be lighter, more flexible and more durable than anything else in the market and benefit from technical details designed to enhance the performance of world-class athletes. Sport at the very highest level often comes down to the smallest margins and Castore will give Rangers players an edge."

Made in China from a mix of polyester and spandex, the home shirt utilised what Castore described as "phantom fabric, which is ultra lightweight with four-way-flex capability and advance sweat-wicking technology".

This royal blue shirt featured a wave pattern throughout the body, meant to symbolise 'The Blue Sea of Ibrox', while red and white piping gave the collar and cuffs a nod to shirts of the past. Continuing a look back to past glories, the inside of the neck featured the phrases 'The spirit of Bill Struth will carry on' and 'Follow Follow', while Castore added their own strapline, 'Better never stops', to the lower inside of the shirt.

Joining 32Red on this shirt were two new sponsors, one to the lower rear of the shirt and one to the left sleeve – the first time a Rangers shirt featured this type of advertising.

This long-sleeved shirt was worn by Croatian defender Borna Barišić during the first half of the match against Celtic at Ibrox on 2nd January 2021. The 1-0 victory saw Rangers wear shirts honouring the 66 fans who lost their lives in the same fixture exactly 40 years ago to the day.

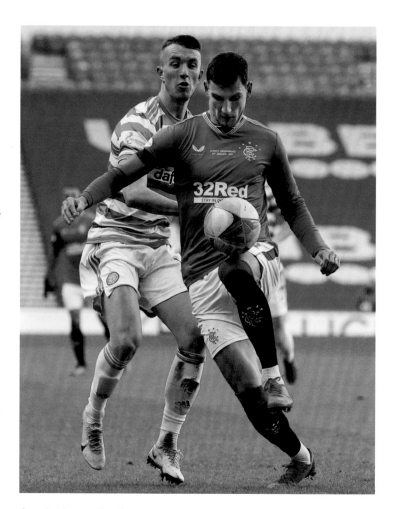

Croatian international Borna Barišić has made the left-back position his own since joining Rangers from Osijek in August 2018

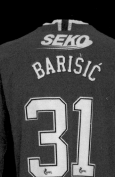

CHANGE 2020/21

Match worn by **ALFREDO MORELOS**

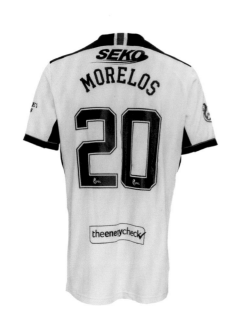

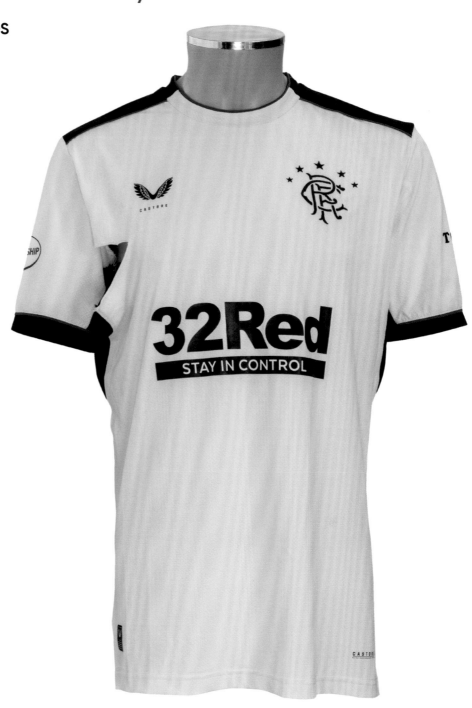

Launched on the opening day of the new league season, Rangers would wear the change kit at Pittodrie as the campaign kicked off with a 1-0 victory over Aberdeen.

This white shirt featured navy mesh panels trimmed in red across both shoulders and underarms, and navy was also used for the logos featured on the shirt. This round-neck shirt also featured embossed retro-print vertical lines down the front of the shirt.

This shirt, torn during the match, was worn by Alfredo Morelos during the opening day 1-0 win over Aberdeen. The 2020/21 campaign saw 'El Buffalo' have his best season at Ibrox so far, his goal against Benfica in the Europa League seeing him pass Ally McCoist's record of 21 goals in European competition for Rangers.

THIRD 2020/21

Match shirt of **LEON BALOGUN**

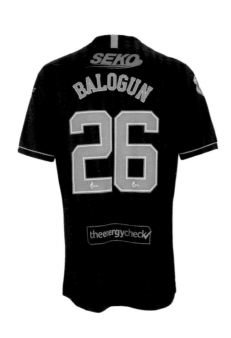

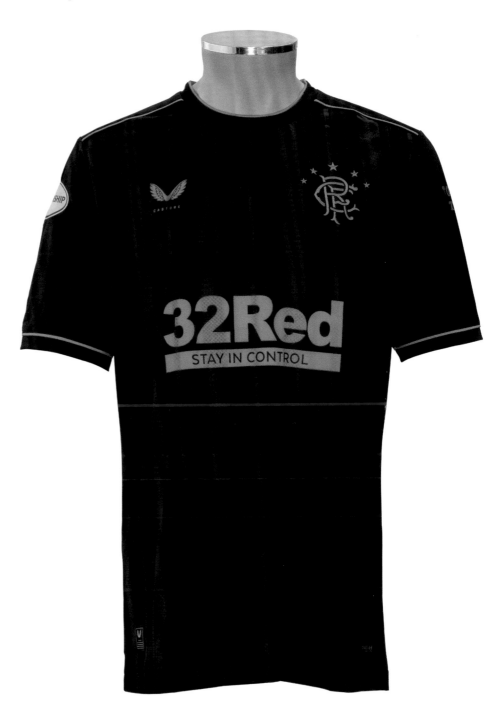

The third and final shirt of Castore's first season was released in mid-August. This jet black shirt with orange trim included black vertical lines running parallel down the shirt. Like all the Castore shirts from 2020/21, the club crest was embroidered while all other logos were heat-pressed, and for this shirt Rangers opted for an orange nameset.

First worn away to Hamilton in late August, this particular shirt was prepared for Leon Balogun (who was an unused substitute on the night), the Nigerian international having joined Rangers in the summer of 2020.

Rangers also wore this shirt with a change of sponsor in the Europa League qualifying match away to Willem II in late September; the shirt featured the club's own 'MyGers' logo for this single appearance.

'INVINCIBLES' 2020/21

Match shirt of **LEON BALOGUN**

Rangers' 55th league title was the culmination of 10 years of striving to get back to the top of Scottish football. A 10-year period of being dropped down the divisions to the fourth tier; of being hit with punishments that might have destroyed another club; of having to rebuild with a skeleton of a squad while their main domestic rivals won multiple titles. It was undoubtably the most troubled period in the club's glorious history, but throughout the dark days the Rangers fans stuck by their team, sharing the hurt but remaining loyal by coming out to support the club in their thousands.

The 2020/21 campaign will be fondly remembered in years to come, not just for being title number 55, but for the manner in which it was achieved. It was a season where manager Steven Gerrard's side became one of the 'Invincibles' by remaining undefeated in 38 league matches throughout the season, registering 32 wins and six draws. It was the first time since 1899 that Rangers had achieved this feat in the top tier of Scottish football.

Speaking after the final match of the campaign, Gerrard said: "I'm so proud of the boys and all the staff around me, but the main thing is the supporters. I was asked to come here at a difficult time, it had been even more difficult before that.

"I have to pay my respects to the people who got it to the point where I took over. After that it was about having a vision, getting the right people in the right places, the right support from the board and fighting for it. We've fought every day for the last three years to get to this point."

For the final match of the season, Rangers wore a shirt proudly proclaiming themselves as 'SPFL Champions 2020/2021', and they finished things off in style by defeating Aberdeen 4-0.

This shirt was prepared for defender Leon Balogun, who missed out on the match through injury but had more than played his part throughout a historic season.

James Tavernier and Connor Goldson embrace as Rangers' 4-0 victory over Aberdeen seals an 'Invincible' season

WOMEN'S HOME 2020/21

Match worn by **MEGAN BELL**

For the 2020/21 season, Rangers broke ground by becoming the first club to produce a bespoke home shirt for the club's women's side. Castore's 100 per cent polyester shirt featured a zigzag pattern throughout the front of the shirt, with a crossover-neck collar in red and white trim. Vented mesh panels across both shoulders and underarms helped provide better ventilation, with moisture-wicking material drawing out perspiration.

The front of the shirt displayed the logo of sponsors DCP Capital, while other sponsor logos could be found on the right sleeve and bottom rear of the shirt. A nameset with featuring the club crest completed the design.

This shirt was worn by attacking midfielder Megan Bell during the campaign. Signing as a full-time professional in January 2020, Bell got her Rangers career off to a flying start, scoring twice in her debut match versus Hearts.

"I think I speak on behalf of the whole team when I say that we love the women's kit," said Bell. "For years, women's team have grown up playing in men's-fit kits, which often looked too big and baggy. Our women's-fit kit makes our team look so smart and more professional, so thanks to Rangers and Castore for their hard work on making this happen because it really does make a massive difference to us.

"This is the first time that the women's team at Rangers have had their own bespoke kit, and for me that shows Rangers' commitment to the women's team and the belief they've put behind the programme. I feel a lot of pride pulling on the Rangers shirt – it's a bit surreal for me. I grew up supporting Rangers and I think there's something that little bit more special when you get to play for a team you support. It's been an amazing journey so far and I can't wait for the next few years."

Megan Bell celebrates her goal that helped Rangers storm to a 9-0 victory over Motherwell in December 2020

HOME 150TH ANNIVERSARY 2021/22

Match worn by **STEVEN DAVIS**

The newly crowned league champions kicked off their 150th anniversary season by unveiling the first of four kits on 26th June 2021. The kit launch was accompanied by a promotional video featuring Glen Kamara, James Tavernier, Nathan Patterson, Megan Bell and Kirsty Howat, which highlighted the relentless attitude, determination and belief required to be a Ranger.

Taking its inspiration from iconic home shirts of the past, the shirt featured a classic white v-neck design, reminiscent of the style graced by Jim Baxter, Ralph Brand and Jimmy Millar in the 1960s, whilst vertical pinstripes brought back memories of Davie Cooper and Ally McCoist in the mid 1980s.

The club crest – rendered in gold embroidery – sat proudly above a new scroll design which celebrated the club's anniversary, with the five stars now repositioned on the rear of the shirt. As reigning champions, the name and number set appeared in gold, with the sponsor details being in the same colour.

Whilst the design of the new shirt celebrated the club's rich history, the shirt itself included state-of-the-art lightweight, high-stretch and breathable fabric to maximise performance and comfort. Manufactured in China from a mix of polyester and elastane, all four bespoke shirts released in this historic season would feature a different collar style. Inside the rear of the collar each of the four shirts would pay homage to the founding fathers of the club, with Moses McNeil's name on the home shirt, Peter McNeil on the change shirt, William McBeath on the third shirt and Peter Campbell on the fourth.

This shirt was worn during an early season fixture by veteran midfielder Steven Davis. Still playing at the top level at the age of 36, a fitting testament to 'Davo's' enduring quality came when be became the most capped international player in UK history in March 2021.

Back for his second spell with the club, Northern Ireland international Steven Davis has provided invaluable experience to Steven Gerrard's youthful squad

CHANGE 150TH ANNIVERSARY 2021/22

Match worn by **GLEN KAMARA**

Reflecting Rangers' long-standing connection with their home in Govan, the 2021/22 change kit showcased the old Burgh of Govan colours of black and red.

The body of the shirt featured subtle vertical stripes in black whilst the front collar was supplemented by a gold flash. Similar to the home shirt, all embroidery and logos were in gold, including sponsor 32Red which would be substituted for European matches – usually by sister company Unibet.

Launched on 23rd July 2021 and debuted at Ibrox in a pre-season friendly against Brighton the following day, this shirt was worn in that game by Finnish international midfielder Glen Kamara.

THIRD 150TH ANNIVERSARY 2021/22

Match worn by **LEON BALOGUN**

Taking inspiration from the adidas-produced fan-favourite 1994/95 lilac kit, Rangers launched the new third kit from the Castore range on 10th August 2021. The initial plan had been to launch later in the month but with European opponents Malmo travelling to Ibrox with a kit which clashed with both Rangers' home and change kits, the home side was requested by UEFA to play in their as-yet-unlaunched third kit.

Due to the last-minute instruction from UEFA, a quick turnaround was required from Jimmy Bell and his team to fully prepare the shirts for use in the Champions League qualifier that same evening.

This shirt was worn by Leon Balogun during the kit's league debut away to Ross County.

FOURTH GALLANT PIONEERS 2021/22

Released in mid-October 2021 alongside an accompanying promotional video entitled 'The Legacy of Ready', the special 150th anniversary white shirt from Castore paid tribute to Rangers' history – in particular the earliest days of the club and the four young men upon whose ideals the club was founded back in 1872.

Manufactured from polyester and elastane, the shirt is a modern twist on a timeless classic and is heavily influenced by the earliest known photograph of a Rangers side – taken in 1877, it shows the team wearing white shirts and shorts with blue-and-white-striped socks around the time of the club's first-ever Scottish Cup Final appearance.

Staying true to the fashions of the late 1800s, the shirt closes at the front via an off-centre three-buttoned collar. Throughout the body of the shirt the words 'The Gallant Pioneers' are embossed, while – as per the three other kits released for the season – the name of one of the club's 'Founding Fathers' is immortalised on the inside collar, in this instance Peter Campbell.

The plain white shirt is further given a timeless, retro feel thanks to an agreement with Rangers' official partners, who agreed that the shirt would remain sponsorless throughout the anniversary season.

A special one-off stitched crest in blue was produced for the shirt based upon the design used by the club from its earliest days, showing the club's initials interlocking and encased within a scroll. Believed to be designed by Tom Vallance, this design features throughout Rangers' history and can be seen on the club's earliest player caps and correspondence, as well as on Rangers' white change shirt for a period during the 1920s and '30s.

Similarly to the other three shirts released for the 150th anniversary season, a special ribbon was added below the crest displaying the dates '1872' and '2022', helping to further celebrate this remarkable milestone for the club.

Yet to be worn in a game at the time of going to print, no match worn example was thus available to be photographed for this book – hopefully one of these remarkable shirts can be included in a future edition.

Released in October 2021, the retro-styled 'Gallant Pioneers' shirt was inspired by the oldest known photograph of a Rangers team

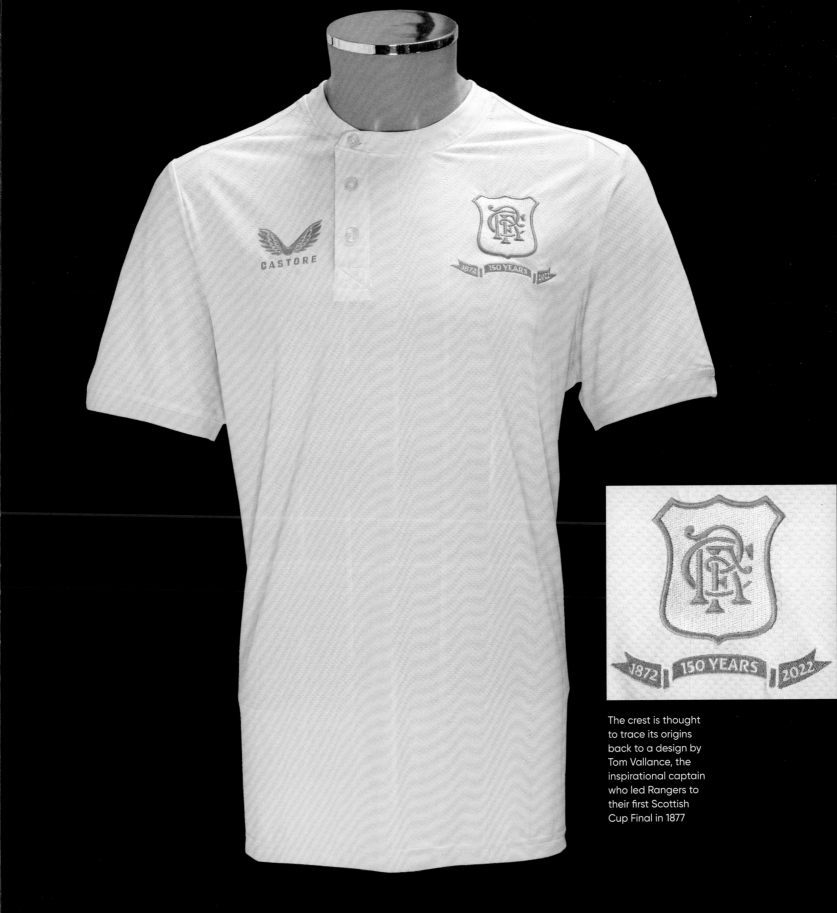

The crest is thought to trace its origins back to a design by Tom Vallance, the inspirational captain who led Rangers to their first Scottish Cup Final in 1877

SUPPORTERS LIST

Thank you to the following for their support of this 150th anniversary book project.

Stewart Adamson
Ricky Alcorn
Gordon Allan
Jason Allan
Michael Allan
Luiz Carlos Almeida
Garry Anderson – Canada
 WATP
Geordie Anderson
John Stodart Anderson
Kevin Anderson
Lewis Anderson
Mark Anderson
Colin Andrews
Holly Angus
Stuart Angus
Ronnie Armstrong
David Arneil
Alfie David Ashmead
Stephen Gordon Auld
John Bailie
Andrew Baillie
Paul W Bain
Cameron Baird
Robin Balfour
Robert, Jamie & Jude Bamford
Ben Bannerman
Bill Bannerman

Scott Bannerman
Gordon Barclay
Ian Barrnett
Andrew Bayliss
Benjamen Beattie
Kenny Beecroft – happy 60th
 from your sons
Luca Martone Beecroft
Cooper Beglin
Gordon Bell – The Founders Trail
Philip Bell
Steven D Bell
Steven Bennett
Éric Birmann
Brian Bissett
David Black
Graeme Black
David Blain
James Booth
Brian Borghardt
Robert Borland
Susan Borland-Dickson
Keith Bowie
Glynn Boyd
Colin Brandon
Stephen Bremner
Yvonne Brooks
Adam Brown

Derek Brown – Vale of Leven
 RSC WATP
Fraser Brown
Gareth Brown
Gary Brown
Gavin Brown
Rory Brown
Thomas Law Brown
Kenny Bruce
Neil Bruce
Benny Bryce
Christopher Bryce
Michael Bryce
Andrew Bryceland
John W Buchan
William Buchan
Jamie Buchanan
Rory Buchanan
Stuart Buchanan
Stewart Bullen
A J Burnett
Robert Alexander Butler
Andrew George Calder
George Callander
Neil Cameron
Alan Campbell
Beth & Lydia Campbell
Greg Campbell

Murdo Campbell
Sandy Campbell
Scott Campbell
Scott Campbell
Stewart Campbell
Graham Cargill
Abie Carson
Melanie Jayne Carson
Samuel Casement
Alisdair Cassells
Darren Cassidy
John Murdo Kennedy Ceos
Blair Chalmers
Gregor D Chalmers
Derek Chisholm
Connor Christie
Stuart Christie
Ben Stewart Clark
Neil Clark
The Clark family
Daniel Clarke
George Clarke
Harry Clarke
Jim Clarkson
Stewart Clarkson
Trevor Clydesdale
Archie Coats
Gavin Cochrane

Kevin Cochrane
Scott Cochrane
Steven Collison
Eric Colvin – Hitchhiking to
 celebrating!!
Jim Connell
Marc Cooper
Peter Corrigan
Robert Alexander Coull
Mitchell Counsell
Alexander Courtney
Neil Cowan
John Cox
Dougie Craig
Caroline Crawford
Paul T Crawford
John Creedican
Jane Crichton
Ronald Crooks
Stevie Cumming
Sandy Cunningham
Tam Cunningham
Harvey J Curran
Desmond Currens
Adam Currie
Chris Currie
Ross Currie
David D'Arcy
Jordan & Victor Dallas
George Davidson
Paul Davidson
Peter Dawson
Barry Dempsey
Jamie Dickie
Ramsay Dickson
Ian Dinsmor
Scott Dobson
Donna Doig
Jim Donaldson
Ryan Doran
Duncan Douglas
Alex Drummond
John Drysdale
Alex Dunnachie
Paul Dunnachie
Colin Eaglesham
John Early
David Edgar
Gavin Alexander Edgar

Ross Edmonds
Dennis Elder
George Evans
Mark Falconer
Alan Ferguson
Craig Ferguson
Ian Ferguson
Nathan Ferguson
Robbie Ferguson
Stewart Ferguson
Megan Field
Luke Finlay
David Fleming
Iain Fleming
Andrew Fletcher
Dan Fogerty
Andrew Scott Forsyth
Sam Forsyth
Bryan Fotheringham
Peter Fox
David Francey
Graeme Fraser
Jamie Frew
Robert Frew
William Kiddo Frew
Patrick Friel
Janet, Millie & Wee Daz
 Gallacher – WATP
Stuart Galsworthy
Dylan William Gauley
Graham Gault
John Gemmell
Adam Gibson
Charlie Gibson
Douglas Gibson
William David Gibson
Shaun Gilchrist
Tom Gillespie
Stephen J Gillies
Alan Charles Gilmour
Charles Gilmour
James S M Gilroy
George Glen
Stewart Glover
Gavin Goslan
Cameron Gow
Charles Graham
Colin Graham
Richard Graham

Colin Grant
Craig Ulrich Grant
Lyle Gray
Gareth Greenan
James Gregg
Alan Greig
Ross Greig
Wayne Greig
Ian Guthrie – True Blue
Holger Habeck
Alan Haig
Gavin Haigh
Andrew Hamilton (Hammy)
Scott Hamilton
Stuart Hamilton
Adam Hammond
John Hanlon
Ian Hanna
Craig Hardie
Alistair Harris
Gordon Harris
Dan Harrison
Cameron Hart
Andrew Hastie
Johnny Hastings
Ricky Hastings
Miller J Hatton
James Hay
David Haynes
Iain Haywood
Andrew Heaney
Steven Henck
George Alexander Henderson
Mark Scott Henderson
Charles Henery
Albert S Hetherington
Gerard Heuker
Carson Hickie
Scott Hill
Barry Hislop
George Hobbins –
 New Jersey, USA
Michael Hobbs
Albert Hoekman
Kenneth Hollis
Callum Hollowood
Calum Hopkins
Iain Hopkins
Luke Hopkins

Samuel S Howie
John Hudson
Jamie Hughes
Andrew Hunter
Craig Alexander Hunter
Robert Granger Hunter
Tam Hunter
William Kenneth Hutton
William Imrie
Scott Innes
William Irvine
Donald Jack
Keir Jack
Otton Jagielko
David S Jenkins
Adam Johnston
George Johnston
David Johnstone
Vivak Kapoor
William Kean
Coreylee Kempton
Isla J Kennedy
John Alexander Kennedy
John Weir Kennedy
Gordon Kerr
Alan Kettlewell – Blackpool True
 Blues
Scott King
David Kinniburgh
Dave Kinnon
James Kirk
Ross Kirk – True Blue
Ally Lamont
Scott Lavery
Harry Lawson
Jack Lawson
David Angus Leckenby
Samuel Leckie
Jason & Jack Lee
Michael Leigh
Ian Leith
Adam Leithead
G Lennox
George Lennox
Thomas Lennox
Colin Mark John Leslie – RIP
John Mann Leslie
Dr Calvin Lightbody
Bobby William Milroy Lindsay

Richard Lindsay
Allan Linton
Kris Linton
David Lissamer
Robbie Livingston
Bobby Lochhead
Graeme, Callum & James Lockie
Graham Logan
Rhys Longridge
Colin Loudon
James Loughran – Belfast
Peter Love
Robert, Iain, Gavin & Cooper
 Love
Hamish Lovie
Andrew Lyall
Duncan Lyon
Roderick MacAffer
Alasdair MacArthur
James MacArthur
Calum Macdonald
George MacDonald
George MacDonald
John Morrison MacDonald
Peter Macdonald – LWF my
 brother
Cameron MacDougall
Gordon MacDougall
John MacDougall
Angus Stewart Mackay
Christopher MacKay 84
Duncan John MacKay
James MacKay
Kenny MacKay
Ross MacKay
Craig Mackenzie
Derek MacKenzie
Karl & Zoe Mackenzie
Scott Mackenzie
Graham Mackie
Innes MacKintosh
Duncan Maclachlan
David MacLean
Gavin Maclean
Ian Maclennan
Angus M MacLeod
Darren Macleod
Frank Macleod
John MacLeod

Kenny Macleod
Neil MacLeod
Stuart Calum MacPhee
Jamie Macpherson
Derek Main
Scott Main
Fraser Maitland
Roberto Manservisi
Kevin March
Carrie Marks
Allan Marshall –
 East Kilbride
Brian Marshall
John Marshall Senior
John A Marshall
Lindsay Marshall
Sammy Martin
Andrew Marwick
Misty & Mason – love from dad
 xxx
Colin, Jessica, Oliver & Lisa
 Mathers
Flynn Maxwell
Harry Maxwell
Scott Maxwell
Jonathan Maxwell-Reid
Dave, Mark & Jack McAloney
Derek Mcarthur
Neil McBain
Logan Mcbride
Matthew McCabe
Gary McCallum
Crawford McCaughie
Scott McClenaghan
Mark McCloskey
Graeme McClumpha
Gillies McClure
John McCluskey
Alan McColl
Andy McConnell
Seth Halliday McCook
Jason McCormick
David McCorquodale
Donald McCorquodale
David McCracken
Derek McCracken
Stephen McCrimmon
Andrew Mccrindle
Gary Mccrindle

Dave McCulloch
Jeanette Mcdonald
Stewart McDonald
William & Iain McDonald
Malcolm McDougall
Fraser McDuff
Andrew Goldie McEwan
Harry McEwan
Samuel Mcfadzean
Paul McFarlane
Billy McGinty
Anne McGowan
Craig George McGrath
David McGregor
Gail McGregor
Wilma McGregor
Andrew McGuire
Jack McGuire
Robert McIlroy
Samuel McIntosh Senior
Graeme McIver
Kieran McKay
Barry McKechnie
David, Calvin & Anna
 McKechnie
Martyn Mckenna
Paul McKernan
Andrew McKnight
David McKnight
Alexandra McLaughlin
Alex McLean
Alexander McLean
Andrew James McLean
Douglas McLean
Alan McLennan
Billy McLeod
Robert McLeod –
 AFB LOL – 111
Marc McLurkin
Calum Robert McManus
Stuart McMaster
John Donnelly McMillan – Great
 Uncle
Derek McMonies
Jodie McNair
Sam & Ben McNaught
Simon McNeill
WA McNicol
Gordon McPherson

Helen & Jim McPherson
Blane McQuillan
Kerr McQuillan
James McSween
Joe Meichan
David Meikle
Ewan Mennie
David Miles – Alfreton,
 Derbyshire
Allan Miller
Archie Miller
Brook Miller – Cleveland, Ohio
Graham Scott Miller
Graham Walter Miller
Peter Miller
John & Linda Mills
Julie Milne
David Minnes
Colin Mitchell
Craig Mitchell
John Mitchell
Johnnie Mitchell
Lewis Mitchell
McKenzie Scott Mitchell
Michael Mitchell
Scott John Mitchell
Robert Moffat
Ethan Monteith
Iain Monteith
Derek Moore
Douglas Alexander Moore
Jimi Moore – Pride of
 Cambuslang
Thomas Moore
Heinrich Mooslechner
Angus Morrison
David James Morrison
Graeme Morrison
William Morrison
Michael Mowat
David Muckersie
Derek Muir
Eoin Muir
Ian R Muir
Nick & Holly Muir
Callum Muldoon
Derek Mulholland – Bo'ness
 Loyal
Grant James Mulholland

Innes Mullen
Colin P Munro
Fraser Munro
Graham Munro
Alan Murray – WATP
Cameron Murray
Craig Murray – WATP
Darren Murray
Iain W Murray
William J D Murray
Richard Myles
Mark Nelson
George Newton
Alex Nimmo
Ross Nimmo – Johnstone
Ross Nolan
Ian O'Donnell
Ilan Osborne
Ross P
Graeme Andrew Palmer
Russell Parker
Ross Parr
Mick Partridge
Alastair Paterson
Christopher Paterson
Jamie Paterson
Ronnie Paterson
Gary Paton – my Godfather
Callum Paxton
Jamie Paxton
Boyd Pearson
Stewart Pendleton
Graham Penman
Jamie Phillips
David Plant
Andy Pollock & Alison Cameron
Doug Pollock
Graham Pottie
Andrew Proffitt
Ian Prosser
James Rainey
John Shearer Rainey
Dave Ulster Rally Ralston
Alan Ramsay
Ross Rankin
Philip Reay
Stephen Rees
Callum Reid
David Reid

Jake Reid
James Reid
Lillie Reid
Michael Reid
Ronald James Reid
Scobbie Reid
William Reid
David Rice
Richard Rice
David Richards
Andrew Rockall
Robert William Roddie
Scott & Rhianne Rodger
Christopher Ronald
Tom Scott Ronaldson
A C Rosie
Jack Ross
Kenneth W Ross
William Ross
William Roy
Andy Russell
Norrie Russell
Bernhard Rychetsky
Jim Lepick Saltcoats
David Schipper
Karsten Schmidt
James Schofield
Will Scott
Alexander Senior
Ian Shanks
David Shearer
Graeme Sheils
Stuart Sheils
Bill Simpson
Calum Simpson
Finlay Thomas Simpson
John Samuel Sinclair
David Singh
Chayanunt Siwarungson
Alan Skeoch
David Skeoch
Billy Smick
Bill Smith
Craig Smith (Smoosh)
Davie Smith
James F Smith
James Mcdonald Smith
Matthew G Smith
John Smithard

Len Smyth –
 Follow Follow
Alan Sneddon
Joanne Spalding
Andrew Stanger
Kenneth Stark
James William John Wallace
 Steele
David Stephen
Derek Stevens
Aaron & Grandpa Stevenson
Derek Affleck Stevenson
Gary Stevenson
Huw Alistair Stevenson
Allan Stewart
George Stewart
Kenneth Stewart – Bishopbriggs
 RSC
Seonaidh Stewart
William David Stewart
Ross Stirling
Dan Strain
Jimmy Street
Graham Stuart
Kevin Stuart
Gordon & Madge Sutherland
Adam Swan
Lucas Swift
David Sykes
Bruce G Taylor
Fraser Samuel Taylor
Gordon Tennent
Ronald David Thompson
Colin C Thomson
Connor Thomson
David John Thomson
Jamie Thomson
Jim Thomson
Richard Thomson
Joey Todd
John Torrance – Nith Valley
 Loyal RSC
William Townsley
David Tweed
Kick Uitgevers
Alan Urquhart
Ian Usher
Alfie Vaughan
G Walker

James Walker
Robert Walker
Robert Walker
M Walkling
Craig Wallace
Graeme Wallace
Andrew Wandrum
Peter Ward
Lewis Wardrope
Derek Warrington
Andrew RA Watson
Gordon Glen Watson
Steven Watson
The Watsons of Gartsherrie
Iain Whannel
Craig Wheatley
Paul Whittle
David Raymond Whyte
David William Whyte
Jack Alexander Whyte
John Whyte
Jason Wildish
Alistair Wilkie
Chris Will
Colin William Hay
Iain Williamson
Paul Williamson –
 Rugby Loyal WATP
Alan Stuart Wilson
Andrew Wilson
Ben Wilson
Callum Wilson
Jamie Wilson
John King Wilson
Leigh Wilson
Ross Wilson
Thomas Wilson
Johnathan Wood
Mark Woodhead
George Woodward
Derek Wright
John Wright
Iain Wylie
The Wylie family
Cerys Wyllie
Donald Young
John Young
Dave Younger
Tom L Zafft

ACKNOWLEDGEMENTS

ABOUT THE AUTHORS

DAVID GRAHAM

Attending his first match at the age of four, David combines his love of supporting Rangers with a long-standing passion for collecting their match worn shirts, seeing them as a tangible link to the history of the club. He enjoys researching the topic and is delighted and proud to see this book come to life. Married with one daughter, he splits his time between family and his working role in a busy Emergency Department.

JOHN SMITH

A collector for more than 40 years, John has been a lifelong Rangers fan since his first match at Ibrox in 1960. He initially got the collecting bug through an interest in Rangers programmes before moving on to match shirts. He has been very fortunate to have been given many shirts over the years and continues to add to his collection through auctions and contacts. Now retired, he is delighted to share a part of his collection through this book.

WITH THANKS

Both authors would like to acknowledge and thank the following who have all contributed in some way to the making of *The Rangers Shirt*.

Firstly, to all Rangers Football Club players and employees past and present, who make the history and without whom there isn't a book to write. Special thanks are offered to Jim Stewart, Peter McCloy, Colin Stein, Stewart Kennedy, John MacDonald, Megan Bell and Neil Alexander for their memories and shirts. Also to Jimmy Bell and Jim McAlister for support, belief and kit info, and to Kirk O'Rourke for his great images.

Grateful appreciation is given to Colin Stewart for listening to the initial pitch, Natalie Nairn for believing and running with it, Robert Boyle for his editorial assistance, and to Joe Morrison for allowing said authors to act like kids in a sweet shop within the club archives.

A big thank you to collectors and fellow bluenoses Greig Morrison, Joe Meichan, Harry McEwan, Stevie Smith, Ash Wright and Fraser McLean for the loan of cherished material. Also to the Brand family and the Gallagher/Love family for similar loans, as well as Barbara Brokx (Gillespie) for the photo of George Gillespie. It is deeply appreciated.

Special mentions go to Gordon Bell and Iain McColl at The Founders Trail, who keep the early history of the club alive. Thanks also to Richard McBrearty and Demi Boyd at the Scottish Football Museum

for your trust, to James Eden for photographic image help and to Willie Neil for use of your wee black book.

Thanks to the team at Vision Sports Publishing, who have supported us through the mysterious art of book publication, especially to Toby, Jim, Ed, Neal, Ulli and Doug who have all politely listened to moans and meltdowns over the past couple of years. It's all been worth it guys.

To Nedka, our photographer, who skilfully brought the images to life – great job. Hope you have not been put off football for life...

Finally, to our long-suffering wives and families who put up on a daily basis with two grown men who have an unhealthy fascination with unwashed football shirts. Thank you so much.

For anyone we may have inadvertently missed out, our most sincere apologies.

PICTURE CREDITS

All shirt photography by Nedka Nikolova, www.axiompic.co.uk

Every effort has been made to contact the copyright holders of the photographs used in this book. If there are any errors or omissions the publishers will be pleased to receive information and will endeavor to rectify any outstanding permissions after publication.

The Rangers Football Club Archives Page 6, 11, 12-13, 14 (top and bottom right), 15 (x4), 16, 16-17, 17, 18 (x2), 19 (x2), 20 (x3), 21 (x2), 22 (bottom), 24-25, 26, 27 (x3), 28, 30, 31, 33 (x2), 34 (bottom), 37, 46 (x2), 47, 65, 66 (left), 67 (x2), 68-69, 70, 71 (right), 73, 74, 75, 76, 77, 94, 96, 105 (left), 107, 150, 156, 162, 186, 256, 263, 308, 314
Alamy/PA 14 (top left), 35, 38, 42, 164, 170, 200, 208
Blantyre Project 22 (top)
Barbara Brokx 104
Colorsport 56
Getty Images 8, 32, 40, 105 (right), 106, 114-115, 136
John Gallagher 70, 71 (left)
John Smith Collection 46 (top)
Scottish Football Museum 14 (bottom left)
SNS Images 4, 9, 10 (left), 34 (top), 44, 48, 50, 52 (x2), 53, 54, 58, 64, 64-65, 66 (right), 68, 72, 72-73, 79, 80, 82, 88, 90, 98, 100, 109, 110 (x2), 115, 118, 123 (x2), 125, 127, 129, 130, 132, 134 (x2), 138, 140, 148, 152, 154, 158, 168, 178, 193, 194, 210, 212, 214, 218, 224, 226, 232, 236, 242, 246, 252, 257, 258, 264, 268, 272, 278, 284, 288, 301, 302, 306, 310
Willie Vass Archive 10 (right), 144, 184, 204, 250, 256-257

"TO BE A RANGER IS TO SENSE THE SACRED TRUST OF UPHOLDING ALL THAT SUCH A NAME MEANS IN THIS SHRINE OF FOOTBALL. THEY MUST BE TRUE IN THEIR CONCEPTION OF WHAT THE IBROX TRADITION SEEKS FROM THEM. NO TRUE RANGER HAS EVER FAILED IN THE TRADITION SET HIM."

William Struth, 1875-1956